RAW
Workflow
from Capture to Archives:

A complete digital photographer's guide to raw imaging

Philip Andrews, Yvonne J. Butler, Joe Farace

ELSEVIER

AMSTERDAM • BOSTON • HEIDELBERG • LONDON • NEW YORK • OXFORD
PARIS • SAN DIEGO • SAN FRANCISCO • SINGAPORE • SYDNEY • TOKYO
Focal Press is an imprint of Elsevier

Focal
Press

Focal Press is an imprint of Elsevier
Linacre House, Jordan Hill, Oxford OX2 8DP, UK
The Boulevard, Langford Lane, Kidlington, Oxford OX5 1GB, UK
84 Theobald's Road, London WC1X 8RR, UK
Radarweg 29, PO Box 211, 1000 AE Amsterdam, The Netherlands
30 Corporate Drive, Suite 400, Burlington, MA 01803, USA
525 B Street, Suite 1900, San Diego, CA 92101-4495, USA

First edition 2006

British Library Cataloguing in Publication Data
A catalogue record for this book is available from the British Library

Library of Congress Cataloging-in-Publication Data
A catalog record for this book is available from the Library of Congress

ISBN–13: 978-0-240-80752-2
ISBN–10: 0-240-80752-9

For information on all Focal Press publications visit our website at www.focalpress.com

Printed and bound in Canada

Layout and design by Karen and Philip Andrews in Adobe InDesign CS2

06 07 08 09 10 10 9 8 7 6 5 4 3 2 1

Contents

Section One: Raw Basics

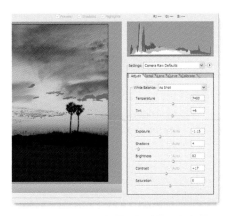

Section Two: Processing Raw Files

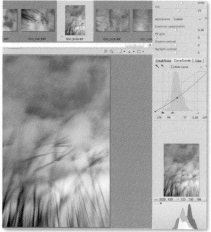

Section Three: Complete Raw Workflow Options

Section Four: Raw File Management

Preface

These days it seems that trying to stay ahead of the game as a digital photographer is like trying to catch the wind. You gradually build your skills and knowledge and no sooner do you get a handle on the best workflow for your style of image making and the industry changes, not only the goal posts, but the very game you are playing.

Shooting raw is such a change for the quality conscious photographer. The way we photograph and process our images has, again, changed for ever. Choosing to shoot raw over other capture formats is not just a matter of changing the file type on your camera, it requires a change in the way that you think about your photography. No longer are we condemned to allowing our camera the lion's share of decision making when it comes to converting the basic picture data that is recorded by the sensor. Choosing to shoot raw is an act that rightly repositions the photographer and his or her skills at the very center of the picture making process.

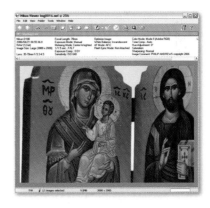

This book is a celebration of the return of the photographer as the master of the whole process – from capture to archive. So join myself and the other authors as we show you the skills, techniques and knowledge that you need to reassert your rightful place in this ever changing world of photography.

Philip Andrews

Introduction

Isn't it sort of a fact of life when you go to a party or social function, a few members of the crowd always seem to find a way to ask for free advice about something having to do with your line of work, special interest or serious hobby? I don't know about you but I always get prepared for the inevitable, the questions about photography (and often computers and peripherals). Of late many of the photography questions beyond what camera or printer to buy are about raw capture. What is raw anyway, what do you do with it, and why would you use it? What's even more interesting, to me anyway, is I'm even getting questions about raw capture from people who not so very long ago went kicking and screaming into digital from film. Go figure!

The line of questioning goes something like this, especially when there is a know-it-all among us who is trying to show off. The first of the raw-curious will start off by asking if I use raw most of the time or only for certain purposes. Then they want to know how they will know if their camera has 'it' or will they need a new one. Are the raw files any bigger? If they're bigger, how much room do the raw files take up on your memory card? Get this, from two guys who cornered me not too long ago: Does shooting in raw dramatically affect your ability to shoot in burst mode and how much time does it take (the camera's processor) to write the file to memory card? And, why would you ever want to add more time to your tried-and-true JPEG workflow? (Wow, these guys are really into it!) When I finally detect a break in the barrage of questions and ask why they're so interested in raw imaging, almost invariably the answer has something to do with 'doing whatever it takes to get the best possible image'.

Having complete creative control over images after taking them and before moving them into imaging software like Photoshop, becoming your own processing lab, is not quite part of every photo enthusiast's repertoire but may find its way into many digital darkrooms fairly soon. Serious amateurs and professionals alike seem to be at least curious about the potential power of raw. Somehow, I don't think the day will ever arrive when we'll see casual shooters move beyond taking and sharing great snapshots with digital cameras and even cell (mobile) phones for that matter, and raw is never going to be practical for or of interest to them. The dead-serious photo enthusiasts who corner me at parties and go to photo club meetings every month to learn everything they can get

their minds wrapped around are the ones who will at least try raw on for size. Personally, I hope these inquisitive party folks go out, buy this book, and read what Philip Andrews, Joe Farace and I have to say about the intricacies and delicacies of raw capture, instead of cutting into my time at the guacamole, salsa and pita bread platter.

With these varied and diverse audiences, skill sets and interests in mind, Philip, Joe and I have taken a simplistic approach to presenting what can be overwhelmingly complex and headache-producing information. Our common approach to writing style is to have a conversation with you, to express our thoughts and share our personal experiences and insights with you the same way we would over a cup of java at a nearby diner. We try to use simple language and illustrations we think you will readily understand instead of trying to impress you with our knowledge and immerse you in gobbledygook you won't want to read, or remember and/or use if you do try to get through it. We've eliminated the technical clutter whenever possible and gotten right down to the nitty-gritty – not that we want to insult your intelligence, but quite frankly we've often overheard other photographers say some books out there are just too technical and difficult to get through – and when we have to use 'big' words we couch them in simple explanations and visuals. And, there's always the Glossary of Terms Joe put together for you that is located in the back of the book.

Finally we have worked hard to organize the book so that it takes you through the components of a digital raw workflow, starting in Section One with an overview of raw concepts, terminology, hardware, software and workflow options. In Section Two we take you through major features and uses of several processing options such as those provided by your camera manufacturer, Photoshop Elements, Photoshop itself and a couple of stand alone converters. In Section Three we look at complete raw workflow options. This is a new area of raw processing as the file remains in its raw state from capture to archive. If you want to see what the future holds look here first. Finally, in Section Four we look at the all important area of raw file management and backup.

Philip, Joe and I stress throughout the book there is no one right way, there are always several ways to do things, and the way you do things is up to you! If we only get you thinking about improving various stages of your raw workflow, we'll be happy. If you consistently capture and process even better raw images than you did before reading the book and trying some of our suggestions we will be very pleased. Let's get started!

Yvonne J. Butler, Philip Andrews and Joe Farace

Dedication

As always, I dedicate this book to the loves of my life – Karen, Adrian and Ellie. Oh, and good coffee, crusty bread and French cheese, but don't tell my wife and kids. OK? Thanks also to the dedicated staff at Focal Press whose aim, thankfully, is always to produce great books.

Philip Andrews

I would like to dedicate my contribution to this book to Randy Jazzman. You're 'the man'. Also, to my friends and family who always support me, no matter what, I am forever grateful.

Yvonne J. Butler

This is the twenty-fourth book I have written or co-authored and I would have never been able to complete the first one – or this book – without the help of my dear wife Mary. She is both my inspiration and my biggest fan and, for that, I'll always be grateful.

Joe Farace

Picture credits

All images and illustrations by Karen and Philip Andrews, Yvonne J. Butler and Joe Farace © 2006 unless otherwise stated. All rights reserved.

Cover photo courtesy of Jade Summer (www.jadesummer.com).

1

Raw
School 101

It's a new day in photography. The earth-shattering change brought on by the availability of instant feedback on the digital camera's LCD, or directly on computer monitor through tethered or wireless camera-to-computer capture, with histogram and capture information displayed, has changed the way we work and play in the realm of photography. Many, if not most of us, have ditched the chemicals and transformed our film darkrooms into digital darkrooms. We're showing our clients or family and friends our work on various devices or as a quick print, right after it's produced and we're printing our own masterpieces or transmitting the image files directly to our imaging bureau. What is the next step in this ongoing digital development? Well, now many of us are embracing the advantages of 'raw' capture and building the new skills necessary to process and enhance our raw files in order to bring them closer to perfection or, at the very least, our liking.

Unless you have been sleeping, or is that hibernating, under a rock for the last few months you will already know that 'shooting raw' is the latest hot topic for digital photographers the world over. More and more mid to high level SLR and compact cameras provide the option for switching from the traditional capture formats of JPEG and TIFF to raw. This capture format change gives photographers even more control over the digital photos they create by taking back a bunch of processing steps that until now have been handled by the camera, and placing them firmly in the hands of the shooter. By providing access to the image data early on in the processing workflow, photographers have more creativity options and better quality control with their pictures but, as with most things, along with this new found flexibility comes increased responsibility. Over the next few chapters we will take a close look at what it means to shoot, process and output raw files, and also get a sneak preview of the new wave of 'complete raw workflow' enhancement tools and techniques that are now entering the market. But before we get to ahead of ourselves let's start at the beginning with some details on the format itself.

The standard camera sensor is made up of a grid of filtered sensor sites colored red, green and blue (RGB). The grid pattern used by most cameras contains twice as many green sensor sites as either red or blue, and in a special Bayer pattern. The RGB color design records both the color and brightness of the various parts of the scene.

What is raw?

To get a handle on what this file format is, and how it can help you make better pictures, we need to start by looking at the capture part of the digital photography process. All single shot digital cameras (except those using the Foveon chip) contain a sensor that is made up of a grid, or matrix, of light sensitive sites. Each site responds proportionately to the amount of light that hits its surface. By recording and analyzing each of these responses a tone is attributed to each sensor position in the grid. In this way a digital picture can be created from the range of scene brightnesses that are focused through the lens onto the sensor's surface. Fantastic though this is, this process only results in a monochrome (black, white and gray) picture as the Charge Coupled Device (CCD) or Complementary Metal Oxide Semiconductor (CMOS) sensors by themselves cannot record the color of the light, only the amount of light hitting the sensor site.

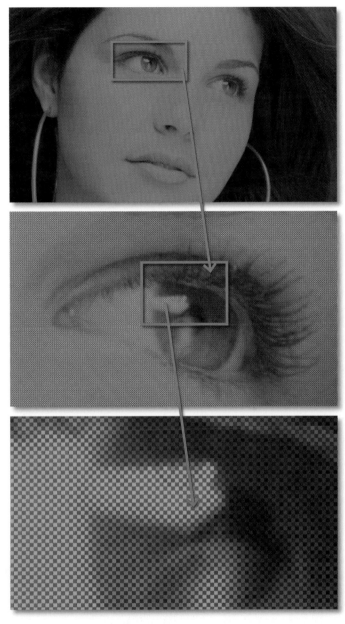

A raw file is the photo converted from its analogue beginnings into a digital format but the photo is still separated into the Bayer pattern, where each sensor site represents one color only.

So how do our cameras create a color photo using mono sensors? Well, to produce a digital color photograph a small filter is added to each of the sensor sites. In most cameras these filters are a mixture of the three primary colors red, green and blue, and are laid out in a special design called a Bayer pattern. It contains 25% red filters, 25% blue and 50% green, with the high percentage of green present in order to simulate the human eye's sensitivity to this part of the visible spectrum. Adding a color

filter to each sensor site means that they respond to both the color and brightness of portions of the scene. Using this system the various elements of a color scene are recorded as a matrix or pattern of red, green and blue pixels of varying brightnesses. If you greatly magnify one of these images you will see the three-color matrix that was created at the time of capture.

The unprocessed sensor data saved at this point is referred to as a raw file. It contains information about the brightness and color of the scene, but in a form that can't be readily edited or enhanced with standard photo software. Until the current influx of raw-enabled digital cameras and software, photographers were blissfully unaware of the existence of such files, as the images that they received from their cameras were already converted from the raw state to the much more familiar (and usable) JPEG or TIFF form. This conversion occurs as an integral part of the capture process, where the raw data coming from the sensor is used to create a full color image. Special algorithms are employed to change the Bayer-patterned data to a standard RGB form; in the process the extra details for a non-red sites, for instance, are created using the information from the surrounding red, green and blue sites. This process is called interpolation, and though it seems like a lot of 'smoke and mirrors' it works extremely well on most cameras.

So when you opt to save your images in JPEG or TIFF formats, this capture and interpolation process happens internally in the camera each time you push the shutter button. Selecting raw as your preferred capture format stops the camera from processing the color separated (primary) sensor data from the sensor, and simply saves this data to your memory card. This means that the full description of what the camera 'saw' is saved in the image file and is available to you for use in the production of quality images.

When selecting raw for image quality, the digital camera stores only the raw image and EXIF or metadata (camera type, lens and focal length used, aperture, shutter, and more). Any camera presets and parameter settings you make, such as contrast, saturation, sharpness, and color tone (found in the Parameters menu on the Canon EOS 20D, for example), do not affect the data recorded for the image. They do, however, become the defaulted values during raw conversion, until you elect to change all or some of them. Only ISO speed, shutter speed and aperture setting are processed by the camera at the time of capture.

An extra processing step

Sounds great, doesn't it? All the quality of an information rich image file to play with, but what is the catch? Well, for the most part raw files have to be processed before they can be used in a standard image editing application like Photoshop. It is true that brand new applications, like Adobe's Lightroom and Apple's Aperture, can enhance raw files without first converting them, but for the most part serious editing can only take place on a converted raw file. So to access the full power of these digital negatives you will need to employ a special raw converter. These programs come as either stand alone pieces of software, or as a dedicated feature in your favorite editing package. Some can process files from capture devices of several manufacturers, others are restricted for use with

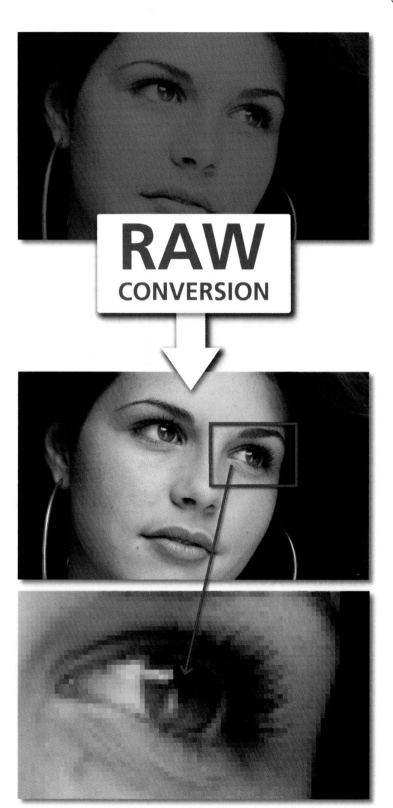

Before a raw file can be enhanced with a standard editing program, the picture has to be converted into a standard RGB picture format. This conversion process is usually handled by a dedicated conversion utility such as Adobe Camera Raw.

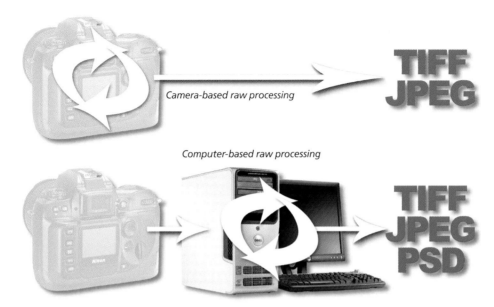

Camera-based raw processing

Computer-based raw processing

Switching your camera to raw format capture removes the conversion step from being handled in-camera and allows more considered and creative conversions on the desktop.

single camera models only. They range from very expensive, fully featured, professional workhorses to free bundled utilities supplied with raw-enabled cameras.

Designed specifically to allow you to take the unprocessed raw data directly from your camera's sensor, and convert it into a usable image file, these editors also provide access to other image characteristics that would otherwise be locked into the file format. Variables such as color space, white balance mode, image sharpness and tonal compensation (contrast and brightness) can all be accessed, edited and enhanced as part of the conversion process.

Behold the new negative

So to put it simply, a raw file is a digital photo file format that contains the unprocessed image data from a digital camera's sensor. Cameras with raw file support save the white balance, saturation, contrast, color, tone and sharpness settings for the file as tags (or place markers) but do not process them at the time of recording. The same settings for JPEG (and TIFF) files are processed in-camera and cannot be undone, if you will, in the digital darkroom. With raw capture you have full control over your raw file's destiny. Capturing what you see in raw mode is the closest you can get to producing pure, unadulterated image data that will be ready for your creative control and interpretation.

A raw file is often called a digital negative for two or more reasons. First, raw files may be processed and converted multiple times without ever damaging the original image data. Second, the photographer is required to process and convert the digital negative in the digital darkroom post-capture, in a way similar to working with a negative in a traditional film darkroom. You always have the negative, whether digital or film, to reinterpret at a later date.

Camera Data
(f-stop, shutter speed, ISO, camera exposure mode, focusing distance etc)

Image Data
(white balance, sharpening, color mode, tonal compensation)

Image
(full 16 or 12-bit color and tone)

RAW File

Differences between raw and other formats

Raw files differ from other file types in that some of the options that are fixed during the processing of formats such as TIFF or JPEG can be adjusted and changed losslessly with a raw format. In this way you can think of raw files as having three distinct sections:

***Camera Data**, usually called the EXIF or metadata, including things such as camera model, shutter speed and aperture details, most of which cannot be changed.*

***Image Data** which, though recorded by the camera, can be changed in a raw editor and the settings chosen here directly affect how the picture will be processed. Changeable options include color space, white balance, saturation, distribution of image tones (contrast) and application of sharpness.*

*The **Image** itself. This is the data drawn directly from the sensor sites in your camera in a non-interpolated form (Bayer pattern form). For most raw cameras, this image data is supplied with a 16-bit color depth providing substantially more colors and tones to play with when editing and enhancing than found in a standard 8-bit JPEG or TIFF camera file.*

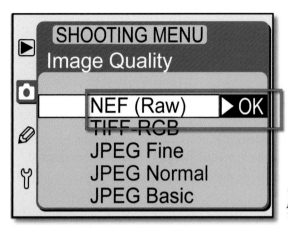

Choosing raw over other capture file formats is not just a matter of preference it is also a choice to take full control of the processing of your digital photos.

Why bother with raw? Why not just stick to JPEG?

OK, I know what you are thinking. Shooting in raw means more processing work for the photographer. So why bother? Why not just stick to JPEG? Well the answer is twofold – better image quality and more creative control.

Not too long ago when asked why I would ever choose raw over JPEG, I often said, 'I shoot raw for the creative control I have over the images'. I've given this broad answer much thought and now think that it does not say quite enough about the power of raw. It's not just about creative control. It's also about quality control and assurance, if you will – not to sound too much like a Ford or General Motors executive or anything. When we tell our camera not to go ahead and process our files in-camera and make the decision to become the processing lab ourselves, we decide we want full creative control over working with our images to make them color correct, void of artifacts and defects (which are inherent in JPEG files), and great images overall and we expect to assure our clients and/or ourselves what we have produced is of top quality. That's creative control, quality control, and quality assurance all rolled into one!

When we shoot raw instead of JPEG (or TIFF) we have as much control over image quality as we want and we can make creative changes to our raw file within the raw converter (or conversion process) well before we even get to the enhancement stage using imaging software. The camera sets markers for the selections we make at capture and we can move (adjust) the markers for exposure, white balance, and more during conversion. This is not the case for JPEG files as they are processed in-camera and after download we take what we get (a fully processed file) and go from there. We have to try our best to recover detail or fix a problem in Photoshop or other imaging software, often using up precious time and creating more frustration than the image is worth to us. With raw capture, if your exposure and white balance are off just a little or, heaven forbid, even way off, you have the advantage of being able to correct and adjust your initial capture settings with a fair amount of success. With JPEG capture, if the exposure and white balance, for example, are a little askew you're stuck, baby! Throw it away!!

When only the best will do!

Just as many photographers pride themselves in only shooting in manual mode, or boast about using the Levels or Curves features in Photoshop, rather than the Auto options, quality conscious shooters eagerly jump at the opportunity that raw capture affords by allowing them to get their hands on their photos early on in the processing chain. The conversion options provided by the camera at the time of capture, good though they may be, still provide an automatic-only approach to this important step. In contrast, armed with the top quality raw editing software that is now available and a raw-enabled camera, the desktop photographer can make careful and considered judgments about the many variables that impact on the picture conversion, providing customized picture-by-picture solutions never possible in the camera.

One of the real advantages of enhancing your photos during raw conversion is the changes are being applied to the full 12- or 14 -bit image rather than the limited color space of the 8-bit JPEG image. The changes are made to the file at the same time as the primary image data is being interpolated to form the full color picture. Editing after the file is processed (saved by the camera in 8-bit versions of the JPEG and TIFF format) means that you will be applying the changes to a picture with fewer tones and colors. And we all know the benefits, or should do, that such high bit editing provides.

Making the switch

The progression from JPEG to raw capture is probably much easier (and more addictive) than you ever imagined, providing you do your homework and learn the fundamentals. What may be difficult at first is finding your way around the raw converter menus and knowing what to do with a range of options. After all you are literally crawling through the attributes of a raw file and you're in control of each attribute's destiny. But once the terminology, control types and settings become familiar you will not want to relinquish your new found creativity and power over the quality of the images that you produce.

For the production photographer there are extra bonuses as most raw conversion programs also contain batch processing options. These allow the user to set up general parameters for a group of images and then instruct the program to process and save each file in turn automatically. This is a real time saver when you have to edit a bunch of pictures taken under the same shooting circumstances. In the same vein, some software also includes the ability to shoot and adjust pictures whilst your camera is attached to the computer. This feature, usually referred to as shooting 'tethered', works particularly well for studio photography and has the advantage of saving files directly to your computer, bypassing the camera's memory card system.

Raw as a learning tool

What's different these days is the rapidly advancing technology of digital cameras, lenses and related equipment, as well as the improved learning curve with instant feedback – and the willingness of more photographers to take courses and workshops on digital subjects, even greater numbers of photographers have a better chance of 'sticking it' and producing 'spot' images earlier in their ongoing learning process and perhaps earlier in their careers or hobby's lifetime pursuit. Making a commitment to learn the important raw-related principles of photography and skill sets of raw imaging, shoot raw in the field and experiment, and work with image winners in the digital darkroom, even if you dislike and abandon a raw workflow in the end, will bring you that much closer to seeing, reading, understanding, interpreting, and painting with light. Isn't that what we're all after, whether it's with a point-and-shoot 'consumer' camera, a full-frame sensor in a digital 8 MP (megapixel) or 16 MP DSLR, or rangefinder and medium format cameras with up to 32 MP digital backs or modules?

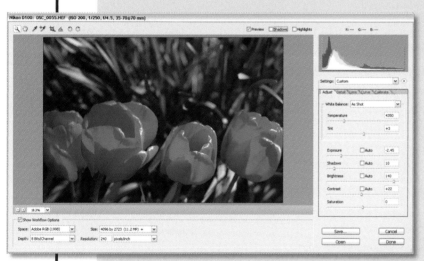

Working your way through the various settings used to process a raw file is a great way to gain more understanding about the digital photography process.

If you find you really understand and can effectively use most if not all of the features of raw file format or raw mode as we often call it, I think you will agree you will have advanced your overall knowledge and hopefully proficiency in photography. Even if in the end you decide raw capture is not for you, you will have learned so much more than ever before about exposure, color management and file processing; much more about white balance, color temperature, tint, histograms, highlights and shadows, brightness, contrast, saturation, and sharpness; luminance and luminance smoothing, and color noise reduction. How about lens issues like chromatic aberration and vignetting; tonal curves; and color management and calibration. If you go deeper, perhaps you will better grasp what those clever copywriters (who constantly make me drool and eventually empty my wallet) put into photography equipment advertisements about what may be going on with your lenses, such as ghosting and flaring. No matter how advanced you are in photography, when working in raw mode you will learn something new or at the very least discover new ways of looking at image making.

Advantages of shooting raw

There are plenty of times when the features and benefits of raw capture make it the file format of choice. If we select an improper white balance at the time of capture or we have exposure or color saturation issues, for example, we can merely click on a drop-down menu tab in our raw converter and make adjustments. If creating the largest possible file size is paramount, raw is an excellent choice. If low light conditions prevail, we can use raw to make small adjustment requirements. These reasons are

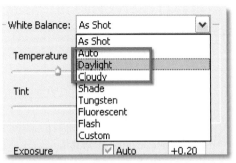

Parameters set in the camera at the time of capture, such as white balance, can be altered at the time of raw processing with no loss to the original file.

all fairly obvious to many of us who have heard about or tried raw capture with even modicum success. Professionals and amateurs alike: listen up! There are other big reasons.

- You get to use the full tonal and color range that was captured by the camera.
- You can remove many of the file processing decisions from the camera to the desktop where more time and care can be taken in their execution (and more importantly, you are in control!). This includes
 - White balance changes
 - Highlight, shadow and mid tone adjustments
 - Applying sharpness
 - Manipulating saturation
 - Color mode (sRGB, Adobe RGB etc.) switches
- You create and save the most comprehensive digital picture file – 'digital negative' – currently available.
- You can make image data changes, such as a switching white balance settings, without image loss. This is not possible with non-raw formats as the white balance settings were applied when the image was processed in the camera.
- You can 'upscale' using primary image data (straight from the sensor) rather than preprocessed information, which arguably leads to better results.
- The original raw file is maintained. You can do a ton of work to your raw image prior to converting it without damaging the original negative, such as cropping (yes even cropping), color correction, and more.
- A digital negative for archiving. With a raw original, you can always go back to an unprocessed file and revisit your approach to converting and processing it. Completely reinterpret the image if you like – warm it up, cool it down. Whatever. And, you can do this over and over and over to perpetuity.
- Work with a wider dynamic range. Dynamic range in a digital camera is the range of black to white the image sensor can detect, from the highest measurable values of white to lowest black.

(Don't confuse this with gamut, the range of different colors the camera or other device, like a printer, can generate.) Our objective is to get the widest possible range of tones between black (shadows) and white (highlights) without clipping the shadows or blowing out the highlights. Our in-camera histogram will give us an approximation of this spread or range of tones within a particular image but we will really find out the truth when we open the file with a raw converter.

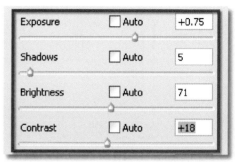

- Embrace high bit editing with 16-bit raw image files. A higher bit depth means more tones to play with which eventually means smoother gradients and transitions in the final photograph. You have ever so much more data to work with in 16-bit mode.

The high bit, high dynamic range nature of raw capture means that it is possible to fine tune or correct minor exposure problems at time of processing.

- Correct poor exposures (somewhat!). Think about this. Not only can you bracket your raw exposures, you can then adjust exposures up or down by one or more stops on your computer. Obviously you should try to nail your exposures in-camera and hope for just a minor tweak to exposure in the raw converter but shooting raw does allow for a larger margin of correctable exposure error than other file types. Now I'm not saying that you can fix major problems, blown out highlights and shadows with lost data are not recoverable even in raw mode, but photos with minor errors are savable.

- Background batch processing: save time by batch processing raw images in the background, for example when using Adobe Bridge as an image adjuster and batch processing command center, or within other programs.

- Edit and correct lens-based problems such as vignetting and chromatic aberration.

Raw disadvantages

There's not many, but it wouldn't be fair of us to overlook the issues that some photographers rate as raw's main disadvantages.

- Bigger file sizes to store on your camera's memory card. That means fewer photos per card.

- Having to process the images before being able to use them in your standard image editing program. Yep, that's more time in front of the screen and less time shooting.

- In some cases, needing specialist raw processing software to convert files, in addition to your favorite image editing package.

The DNG or Digital Negative file format is an open source format proposed by Adobe as a means of creating a common standard among digital cameras.

Proprietary and open raw file formats

By now it should be plain to see that the raw format has many advantages for photographers, offering them greater control over the tone and color in their files, but unfortunately there is no one standard available for the specification of how these raw files are saved. Each camera manufacturer has their own flavor of raw file format. This can make the long-term management of such files a little tricky. What happens, for instance, if over time the specific format used by your camera falls out of favor and is no longer supported by the major editing packages? Will you be able to access your picture content in the future?

In February 2005 Adobe released a specification for a new non-proprietary file format for storing Camera Raw files. The Digital Negative format, or DNG, is being put forward by the company as a candidate for a common raw standard that both camera and software manufacturers can adopt. Most photographers believe that the new format is a step in the right direction, as it brings compatibility and stability to the area along with the assurance that your raw files will be able to be opened long after you camera has gone by the wayside.

The Digital Negative format comprises actual image data and the metadata that describes the image file. The major feature of DNG is its handling of metadata, the information that stays with a file about camera and lens used to capture the file, camera settings, and more. DNG is designed to work with a wide range of camera designs and features and will evolve with introductions of new cameras and technology within them. The Digital Negative specification helps ensure your images are accessible and readable in the future.

In addition to providing a common raw file format, the DNG specification also includes a lossless compression option which, when considering the size of some raw files, will help reduce the space taken up with the thousands of images that photographers accumulate. Also included is the ability to embed the original raw file (in its native format) inside the DNG file. This step does increase the size of the final file but it also provides peace of mind for those users who want to always maintain the original file.

The company hopes that the specification will be adopted by the major manufacturers and provide a degree of compatibility and stability to the raw format area. At the moment Hasselblad, Leica, Ricoh and Samsung have all produced cameras that capture in the DNG format with more predicted to follow.

Adobe has included DNG output options in Photoshop CS2, Photoshop Elements 4.0 and Lightroom and also provides a DNG converter that can change many proprietary Camera Raw formats directly to DNG. The converter is free and can be downloaded from www.adobe. com.

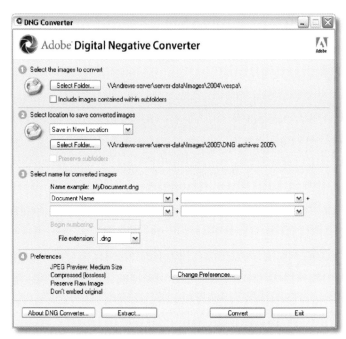

Adobe supplies a free DNG converter that lets you change your proprietary format raw files into the open source DNG format. Get your free DNG converter here: www.adobe.com/products/dng/

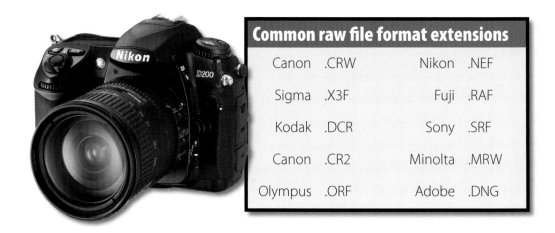

Common raw file format extensions			
Canon	.CRW	Nikon	.NEF
Sigma	.X3F	Fuji	.RAF
Kodak	.DCR	Sony	.SRF
Canon	.CR2	Minolta	.MRW
Olympus	.ORF	Adobe	.DNG

A little more background information please!

In this introduction to raw we have assumed a fair degree of background knowledge on behalf of you, the reader. None more so than in the area of color depth, color space and metadata. As these three concepts may be second nature to some of you, feel free to jump to the start of the next chapter, but as we will be basing more of our thoughts later on these ideas we present here a little more background on these terms.

I'll be back with you in a byte

Computers are digital devices because they represent all data (including photographs) with digits or numbers. These digits are measured as bits or binary digits. Binary is a mathematical system based on working only with the numbers one and zero. This is an ideal method for computers because electrical signals can be represented by current being either positive or negative and off or on. Each electronic signal therefore becomes one bit, but to represent more complex numbers or images, computers combine these signals into 8-bit groups called bytes.

Monitors such as this KDS LCD monitor have the capability to display millions of colors but if you put your nose up next to the screen you might see the digital equivalent of grain – pixels, or picture elements.

If you look closely enough at any traditional photographic print, you'll see silver grain. Isn't that what Antonioni's classic film *Blow-Up* is about? When the hero enlarges a photograph to mural-sized proportions he's unable to tell if the object he is looking at is a gun or several clumps of grain. If you get close enough to a photograph on a computer screen, you might see the digital equivalent of grain called pixels or picture elements. A computer screen is made up of thousands of pixels

arranged in clusters or triads. Each triad is a combination of three colored dots placed close to one another. On the screen, combinations of these pixels produce all of the colors you see.

In a typical CRT monitor three electronic 'guns' fire three separate signals (one for each color) at the screen. If all three guns hit a single pixel's location, it will appear white on the screen. If none of the guns hits a target pixel, it will be black. Similarly, the number of bits of data associated with each pixel determines the visual quality of a photograph and is measured as bit depth not dynamic range as it's often mistakenly called. Bit depth refers to the number of bits assigned to each pixel.

Here's some bit depth options for computer screens that determine the numbers of colors you see:

- 1 bit: each pixel can either be black or white.
- 4 bit: some older computers, especially laptops, have 4-bit video capability, which translates into 16 shades of gray or color.
- 8 bit: with an 8-bit color depth, you can see 256 colors or levels of gray.
- 16 bit: this is fast becoming the new minimum standard and has the potential to display 32,768 different colors. Your computer devotes 5 bits per color and the one remaining bit is used to overlay all of the colors.

An 8-bit image offers 8 bits of data for each pixel and provides you with a palette of 256 colors. A 16-bit image provides more than 32,000 different colors for each pixel. In Adobe Photoshop converting back and forth between 16- and 8-bit file format is just a menu pull (Image > Mode > 16 bits/channel). Though for most photographers 16 bits per channel provides more tonal depth than they will ever need having the extra levels does provide the ability to make 'micrometer' accurate fine tuning adjustments to your photos.

Working with high bit files?

The simplest answer to that question is that the more bits you have the higher quality you'll get. Think of the decision as another version of one facing film photographers. If a landscape image made with 35mm film looks great, it will look even better on 4 × 5 sheet film and even better than when shot with an 8 × 10 view camera. Capturing these larger film images isn't easy. You can hardly pack an 8 × 10 view camera in the same case as a Canon EOS 1v and as the physical demands increase so does the cost of processing these large film images and storage becomes an issue too. Get the picture?

There is no escaping the fact that big, high bit, capture files equal more issues. The secret in making it all work is to find a balance between image size and quality that fits your workflow and expectations. Hey, did I mention cost too. Much as an 8 × 10 Sinar view camera costs more than a Canon EOS 35mm SLR, the digital tools needed to work on large, high bit image files are gonna cost you more too.

Eight or sixteen?

The upside of working with 16-bit images is theoretically better image quality. I say theoretically better because it's still up to you to capture a properly exposed and sharp image. The oft-heard quip, 'just shoot it, I'll fix it later in Photoshop' doesn't work if you are striving for maximum image quality. Since you start with a larger image file containing more levels of tone there is less image degradation that can be created by the inevitable rounding errors that occur when a file is processed in an image editing program such as Adobe Photoshop. Image manipulation using 16-bit techniques also takes advantage of Photoshop's floating-point (that's the math stuff that happens inside the program; which is why there can be rounding errors) operations that produce smoother histograms and tonal transitions.

The downside of working in 16-bit mode is that fewer tools, especially third-party Photoshop-compatible plug-ins or 'power tools', are available to work in that mode. Then there is the 'Hulk' factor. Bigger files take more space and demand more computing resources. That bargain computer you bought at Crazy Charlie's Flea market ain't gonna work that fast with 16-bit files, so you will need a state-of-the-art fast microprocessor chip in that computer, BIG hard drives and recordable DVD drives to store these puppies. At some point you will need to do something you may not be able to accomplish at 16 bits. When that happens you should save a copy and convert it into 8-bit mode, retaining your original 16-bit file in the project folder.

Here's what the Filter menu looks like in Adobe Photoshop when a 16-bit file is opened. As you can see many of Adobe's as well as most third-parties' compatible plug-ins are not available.

SilverOxide (www.silveroxide.com) offers a family of Photoshop-compatible plug-ins allowing digital images to emulate the tonalities of 'real' analog film, such as Kodak's classic Tri-X or my favorite Panatomic X. Their 16-bit Landscape filter includes typical filter options, such as red, orange and the ubiquitous none, but a new purely digital filter called BANG (Blue Algorithm Neutral Gray) acts like a polarizer.

EXIF? What is EXIF?

Exchangeable Image File (EXIF) format is an international standard that lets your digital SLR encode capture information, such as shutter speed, aperture, and the date and time the image was captured, into a JPEG file. Most, if not all, digital cameras store images using EXIF compressed files that use the JPEG DCT (discrete cosine transform) format which means the image data can be read by any application supporting JPEG, including web browsers, image editing, desktop presentation, and document creation software.

JPEG algorithms, especially when used to compress sRGB files and used with consumer level image enhancement software, can produce much less color information than was originally captured by your camera's sensor. EXIF 2.2 is designed to preserve the color range (gamut) that is normally reduced when using sRGB. In order to take advantage of these enhanced capabilities, your image editing software must be able to open, edit, and print file captures using EXIF 2.2. Printers and software that support the Print Image Matching (www.printimagematching.com) standard take advantage of EXIF 2.2, which has been widely adopted.

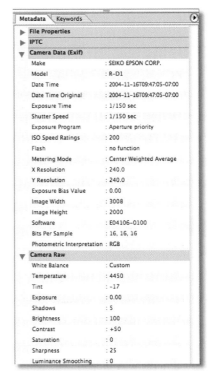

You can read EXIF data in Adobe Photoshop in Image Browser. (It is also visible in Bridge in Photoshop CS2 and Lightroom.) When selecting any image file, its metadata will be displayed on the left hand side of the screen. Here the image data for the photograph that opens this chapter is displayed, so you can see complete technical details of how it was captured using an Epson RD-1 digital rangefinder camera.

Color profiles are an essential part of the way that professionals color manage their image production workflow. Each profile describes the colors that are characteristic of a particular device (camera, scanner, screen or printer) or working space. The profile you choose when processing your raw files will determine how the color is handled in the converted picture.

sRGB color space: you pays your money and takes yer chance

Many digital SLRs give you a choice of capture in sRGB or Adobe RGB, aka Adobe RGB 1998. What's the diff? sRGB (Standard RGB) was created in 1999 with a goal of producing color consistency between hardware devices. It defines a gamut of colors that represents each color well and can be used by CRT monitors, LCD screens, scanners, printers, and digital cameras. sRGB has been incorporated into many web browsers to make sure the colors on web pages match the color scheme of the operating system. Because of the color consistency it creates, most hardware devices that work with images now use it as the default setting. All of which sounds very inviting, doesn't it.

Adobe RGB is designed for photographers whose work will appear in print and offers a broader range of colors than sRGB. If you want to get down and funky with the deals, download the full Adobe RGB specifications at www.color.org/adobergb.pdf. If you want to really make yourself crazy, you can Google 'sRGB vs. Adobe RGB' and read opinions about it from a wide range of viewpoints. Being a pragmatist, I suggest you do the same thing with this color space argument as you do with the 8-bit vs. 16-bit controversy. Shoot some tests, make some prints, and then decide. This is the way we worked back in the film days and the methodology is still valid today, even if the tools are a little different.

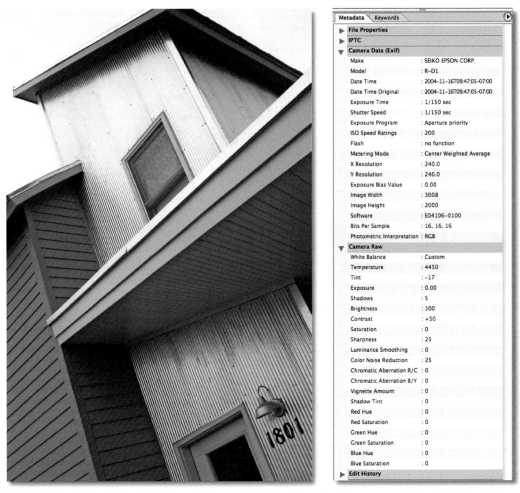

The EXIF data that is associated with images stores useful information about the camera settings at the time that the photo was captured as well as details about file type, size and format.

Perfection?

Eugene Delacroix once said 'Artists who seek perfection in everything are those that cannot attain it in anything.' Opinions are far from unanimous on every aspect of digital image capture with some dissenters on 16-bit capture arguing that there is no discernible difference between it and 8-bit images. Here's my take on the whole deal: for many applications 8-bit image file may be all you need and, perhaps, the best of both worlds is to capture in 16 bits and make global fine quality changes here and then finish your work in 8.

All of these decisions regarding color space and bit depth need to be part of your decision-making process before you begin to think about opening a raw file.

2

Shooting in Raw Mode

SHOOTING MENU

ge Quality

NEF (Raw)
EF-RGB
G Fine
G Normal
Basic

▶ OK

SHOO
Image Q
NEF M

RAW NEF (
RAW

hough the basics of camera control, such as focus, composition and exposure adjustment, remain the same irregardless of the capture format you choose, the inherent differences in the characteristics of JPEG/TIFF and raw mean that some changes in your shooting workflow are warranted. Here we look at the steps needed to shoot in the raw and the issues that surround the practice.

Getting set to shoot in the raw

Making the commitment to go after the best picture file you can get out of your digital camera, an achievable goal with raw files, dictates paying close attention to detail and following through consistently and persistently on several requirements. A commitment to raw necessitates developing a workflow, or sequence of steps, you will routinely use to 'get it right every time (or almost every time).' Your mission, should you choose to accept it, fellow photographers, is to develop your own brand of raw workflow that works best for you, hopefully incorporating some of the observations, analyses, and recommendations that follow.

Most mid to high end compact cameras and almost all digital SLR cameras have the ability to capture in the raw format.

Changing your workflow to accommodate

'Once I have switched my camera to raw will there be any change in the way that I shoot?' Well, the short answer is 'maybe'. Most experienced photographers pride themselves on their ability to control all the functions of their cameras. Often their dexterity extends way beyond the traditional controls such as aperture, shutter speed and focus to 'digital-only' features such as white balance, contrast, sharpness and saturation. For the best imaging results they regularly manipulate these features to match the camera settings with the scene's characteristics.

For instance, a landscape photographer may add contrast, boost saturation and manually adjust the white balance setting of his or her camera when confronted with a misty valley shot early in the morning. In contrast, an avid travel photographer may choose to reduce contrast and saturation and switch to a daylight white balance setting when photographing the floating markets in Thailand on a bright summer's day. It has long been known that such customization is essential if you want to make the best images possible and are capturing in a JPEG or TIFF format. But as we have already seen, settings such as these, though fixed in capture formats such as TIFF and JPEG, are fully adjustable when shooting raw.

Implications for capture variables or camera parameters

What does this mean in our day-to-day photography? Well, if after documenting some interiors you accidentally forget to switch the white balance setting from tungsten back to daylight before commencing to photograph outside, all is not lost. The white balance setting used at the time of capture is recorded with the raw file but is only applied when the picture is processed. This means that when you open the images in a raw converter, the picture is previewed using the capture setting (tungsten) but you can easily select a different option to process the file with. In this example it would mean switching the setting from tungsten back to daylight in the white balance menu of the conversion software. All this happens with no resultant loss in quality. Hooray!

The same situation exists for other digital controls such as contrast, saturation and, with some cameras, sharpness. As before, the settings made at the time of shooting will be used as a basis for initial raw previews but these are not fixed and can be adjusted during processing. This leads some people to believe that there is no longer any need to pay attention to these shooting factors and so consequently they leave their cameras permanently set to 'auto everything' (auto contrast, auto white balance, standard saturation), preferring to fix any problems back at the desktop. Other photographers continue to control their cameras on a shot by shot basis, believing that an image captured with the right settings to start with will end up saving processing time later. Both approaches are valid and which suits you will largely get down to a personal preference and the choice of whether you would prefer to spend your time manipulating your camera or computer.

Switching to raw capture workflow means adjusting the way that you shoot. Factors like white balance, contrast, saturation and sharpness, which were critical when recording to TIFF or JPEG, are less crucial as they can be adjusted losslessly after capture.

Step by step:

Capturing your first raw picture

You will probably realize by now that we still need to emphasize a workflow that strives for excellence during capture and that shooting raw should not be used as a crutch for poor camera technique. Your primary concern should be to check that your exposure settings are carefully chosen as this will help ensure that shadow, highlights and midtone details are all recorded. You will also need to change your standard approach to setting camera parameters as the application of features like contrast enhancement, saturation control and white balance adjustment are pushed into the raw conversion phase. But we are getting a bit ahead of ourselves. Let's spend the next few pages working step by step through the various issues surrounding enabling our cameras for quality raw capture.

1. Enabling the camera

With most raw-enabled cameras, switching from one capture format to another is a simple matter of entering the camera setup menu and selecting the Raw entry from the Image Quality options. This option many also be accessed via a quality toggle or switch elsewhere on the camera.

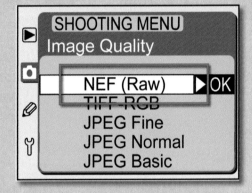

Some models also offer the choice between compressed and non-compressed versions of the file. Compressing will mean that pictures will take up less space on the memory card, but the process of compression does result in longer saving times. For most shooters this isn't an issue but if you like to photograph sports or action, then the extra time taken to compress the file will reduce the frames per second rate of your camera.

There are several cameras on the market that also have the ability to save both raw and JPEG versions of the same file at the time of capture. This option can be a real time saver if you need to access your pictures quickly, but the feature is less of an advantage if you regularly perform many enhancement steps to your files, as in the end the captured JPEG will not resemble the processed raw file.

At the big end of town most of the high-resolution camera backs, which are destined for use with medium format camera bodies, only capture in raw formats. The latest models from Hasselblad, Samsung, Richo and Leica even use Adobe's DNG format, making the transition to Photoshop or Lightroom a simple one.

In practice

For the purposes of this workflow example we have included step-by-step instructions for both Nikon and Canon cameras below.

Canon workflow (example camera EOS 30D)

1. Turn the Quick Control Dial to select the Quality heading and then press Set, this will display the Recording Quality screen.

2. Next, use the Quick Control Dial again to choose one of the raw options from those listed. Depending on the camera model your choices may include Raw and Raw + JPEG. Press Set to set the selected capture mode.

Note: Canon cameras divide the controls into two levels, Basic and Creative (advanced). They name these control subsets different Zones. If your camera is currently in the Basic Zone you won't be able to choose any raw caption options. To do this, you will need to switch to the Creative Zone first, and then alter the Recording Quality. Canon's menu system also varies from consumer to pro models so check with the manual if you are unsure.

Nikon workflow (example camera D100)

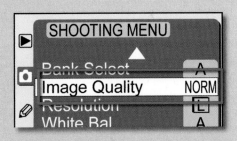

1. To switch the default capture format to raw, activate the menu on the back of the camera and then use the Multi-selector control to navigate to the Shooting Menu (second option on the left side of the screen). Use the right arrow on the Multi-selector control to pick menu options.

2. From the first page of the menu list, select the Image Quality entry. This will display another screen containing a list of quality options – three JPEG, one TIFF and one NEF (Nikon's version of raw). At this screen choose the NEF (raw) heading.

3. Selecting NEF will display a final screen with a choice of two different raw capture modes – 'Comp. NEF (Raw)' or compressed and 'NEF (Raw)' uncompressed. Select one of these options and then exit the menu.

2. Determining pixel dimensions

One step that is normally undertaken when adjusting your camera settings prior to shooting is to select the size or pixel dimensions of the picture that is recorded. Sometimes this setting is incorrectly called the resolution of the photo in camera menus and handbooks. Resolution is a measure of the number of pixels (or dots in the case of printing) per inch or centimeter rather than the total dimensions of the photo. Generally you can choose from the largest capture size possible with your camera, which equates to the one sensor site per image pixel, to a range of progressively smaller dimensions.

Having said this, when working with raw as the capture format, most cameras will not provide the ability to alter the dimensions of your photo. The largest photo possible (one sensor site to one pixel) is recorded in the raw file. If you want to alter these photo dimensions then size changes can be made in a raw conversion utility such as Adobe Camera Raw. This approach has the advantage of enabling upsizing as well as downsizing of the final file.

Pro tip: Cameras with Raw + JPEG capture options often provide choices for altering the JPEG dimensions and image quality. This means that it is possible to automate the production of small dimension, JPEG compressed, web ready thumbnails which can be used for web galleries.

3. Picking bit depth

Most readers would already have a vague feeling that a high bit file is 'better' than a low bit alternative, but understanding why is critical for ensuring the best quality in your own work. The main advantage is that capturing images in high bit mode or 16 bits per channel provides a larger number of colors for your camera to construct your image with. This in turn leads to better color and tone control in the digital version of the scene and finer adjustments in the editing phase.

This line of thinking leads most photographers who are concerned about image quality to adjust their cameras to the 16 or 12 bits per channel capture mode over the standard 8 bits per channel option whenever possible. The higher bit rate provides substantially more colors (and tones) to play with. For example, the standard 8-bit file has the possibility of 256 levels of tone for each of the red, green and blue where as the 16-bit version has over 65,000 levels of tone in each channel. Raw photographers automatically get access to these increased levels of tone because nominating raw as the preferred capture format negates bit depth settings and automatically provides the full depth capable by the sensor.

At time of conversion you can elect the bit depth of the converted file. In Adobe Camera Raw this feature is displayed when the Show Workflow Options is selected (bottom left of screen). Here you can choose from 8 bits per channel or 16 bits per channel entries.

Note: With most camera makes and models the raw file is said to be 16 bits per channel but the sensor only records 12 bits per channel which is then interpolated into a 6 bits per channel file format. Check your camera manual for specific details on the bit depth of raw capture with your model.

4. Adjusting color settings – saturation, white balance and color space

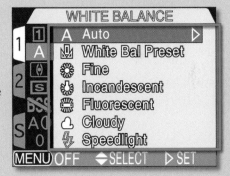

Digital cameras provide much more control over the color that is recorded than was possible when film was king. Even low end models provide saturation and white balance features. But as we have seen, switching to raw capture means that the settings used with these features, though recorded and used as the default values at the time of conversion, are able to be changed later in the process with no image quality loss. So where does this leave us when it comes to setting color options when shooting raw? Do we need to pay any attention to these settings at all now that they can be altered in the conversion process?

Most photographers find it hard to break the habits of a lifetime and so when they shoot raw and are confronted with a scene that contains multiple light sources they adjust the white balance setting manually and tweak the saturation value before pressing the shutter button. Though there is no strict need to do so (as these characteristics can be altered later), they persist in 'matching the camera setup to the scene'. For many practitioners this approach is at the heart of the craft of their beloved photography and I am not here to tell them to stop.

In fact, working this way has three distinct advantages:

1. Correctly captured pictures need less correction when converting saving valuable time,

2. The white balance settings determined at time of capture provide a good starting point for further fine tuning during the conversion process, and

3. If a Raw + JPEG capture mode is being used then the color in the accompanying JPEG photo will better match the processed raw file as it was more accurate at the time of capture.

What of color space?

When it comes to the matter of selecting the color space for capture many authors advocate selecting sRGB for images destined for the screen and AdobeRGB for those photos that will end up as prints. There is merit in this advice as sRGB has a color range (Gamut) that is more suited to the capabilities of the average monitor and the wider gamut of AdobeRGB makes the most of the hues available with the standard printer. When shooting raw the selection of color space again becomes a decision that can be postponed until the time of

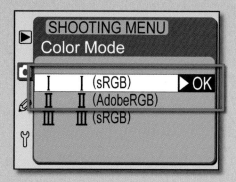

conversion. It is at this point in the process that the colors captured by the sensor (in Bayer pattern) are being interpolated into the standard RGB format that we are all familiar with. One of the processes involved in this conversion is the mapping of the color to a ICC color space. During this conversion process the user can choose which space will be used for the photo.

The space you choose in the camera setup is the default option selected in the conversion software, but doesn't limit you from selecting from the others listed. In Adobe Camera Raw you can select from four different profiles (sRGB, AdobeRGB, ColorMatch RGB, and ProPhoto RGB), which is two more than most cameras offer.

Pro tip: For true color aficionados, or those who need to accurately record the color in the scene before them, the white balance tweaking options offered by most of the raw conversion utilities can be put to good use by including a Macbeth color chart in the first photograph of a series taken in tricky lighting. During the conversion process the way the colors in the chart are recorded can be used as a reference point for sophisticated color correction techniques. See Chapter 9 for more details.

5. Managing the tones – contrast control

Some DSLR cameras have the option to manipulate the contrast with which the scene is recorded at the time of capture. Sometimes called the Tone Compensation or Contrast setting, this control adjusts the scene's tones according to a setting selected by the user. Most cameras have the choice to increase or reduce contrast and some even have an option to build a custom contrast curve that can be uploaded to the camera and applied at will. The feature is invaluable when shooting in difficult lighting scenarios and saving the results back to TIFF or JPEG files. Raw shooters have the luxury of being able to make these types of contrast adjustments much more accurately and on an image-by-image basis back at the desktop. In fact, most cameras will not allow the user to make tonal compensation choices if raw is selected as the capture format.

6. Applying sharpening and noise reduction

The very process of capturing a digital file introduces an inherent fuzziness to the photo. This is true irrespective of the quality of the camera (or scanner for that matter) or the size of the files it produces. For this reason the enhancement process of any digital file is not complete until some sharpening has been applied.

To this end most photographers see sharpening as a 'one-off' activity designed to increase the look of crispness of their photographs and they elect to apply sharpening at time of capture via the options available in their camera setup figuring that it'll be one less task to perform later at the desktop. The problem with this action is that it uses a 'one solution fits all' approach that fails to take into account the content of the photo and the intended use for the image. For the best results both these factors have to be considered when sharpening your photos. This is the reason that informed professionals now employ a sharpening workflow that applies sharpening at three different times during the enhancement process – at time of capture, during enhancement and then when preparing for output.

For raw shooters this means adding a little global sharpening in-camera or at the time of conversion. Both approaches are fine as long as the sharpening is kept to a minimum with the idea that it will be fine tuned later to account for subject matter and output destination.

The problem of noise

Noise is usually seen as a series of randomly spaced, brightly colored pixels that sometimes appear in your digital images. A large amount of noise in an image will reduce the overall sharpness and clarity of the picture. Particularly noticeable in shadow areas there are two distinct factors that control the amount of noise present in a picture:

High ISO – Increasing the ISO setting of your camera will increase the level of noise in the image. Images exposed with an 800 setting will contain more of these randomly spaced and brightly lit pixels than the same photograph exposed with a 100 ISO setting.

Long exposure times – Pictures taken with exposure times longer than ½ second will contain more noise than those shot with a fast shutter speed. The longer the exposure the more noticeable the noise becomes.

As both these factors come into play when shooting in low light situations you will find that the images you take at night are more susceptible to noise problems than those photographed on a bright sunny day.

Features for reducing noise

In a perfect world there would never be an occasion when there was a need for photographers to use either a high ISO value or a long exposure and so all the images produced would be beautifully noise free. But alas this is not the case and all too regularly you will find yourself shooting in environments with very little light. Does this mean that we have to put up with noise filled images for the sake of shooting convenience? The answer is no.

Most mid to high range digital cameras now contain specialized noise reduction features that help to minimize the appearance of random pixels in images produced with either high ISO or long exposure settings. These tools attempt to isolate and remove the errant pixels from the image creating much cleaner and sharper images in the process. Noise can also be minimized via the Reduce Noise feature in Photoshop, when used after the raw conversion, or the Luminance Smoothing and Color Noise Reduction controls located under the Detail tab of Adobe Camera Raw. Cameras, such as those in the Nikon range, have a choice of two noise reduction systems that function in slightly different ways.

NR (Noise Reduction) – This is the standard noise reduction setting that functions on all of the camera's different resolution settings as well as in conjunction with other features such as

Best Shot Selector and Exposure Bracketing. Taking at least twice as long as a standard image to process and record, the camera's in-built software attempts to identify and eliminate noisy pixels in the image.

Clear Image Mode – This setting minimizes noise and increases color graduation by capturing a sequence of three images of the one scene. The first two pictures are exposed with the shutter open, the third with the shutter closed. Using some sophisticated processing the three images are compared and a single 'noise reduced' image is recorded. As several images are recorded it is recommended that a tripod is used when employing this feature.

Noise Reduction functions attempt to rectify the random pixels that appear in photos taken with long exposure or high ISO settings.

Pro's tip: Photographers want the best quality images all the time so why not set up your camera so that the noise reduction features are left permanently on? In theory this sounds fine but in practice the extra processing and recording time taken to reduce the level of noise in an image would greatly increase the time period between successive shots. In most normal shooting circumstances, where noise isn't a problem, the extra time lag between shots would hamper the photographer's ability to shoot successive images quickly. Add to this the fact reducing noise on the desktop, either during raw conversion or afterwards inside Photoshop, provides better overall control over the process and therefore the results than the auto approach adopted in-camera. If you plan on reducing noise with either your raw converter or a third-party digital noise removal program, read the recommendations of the software before using it. Most digital noise removal software recommends that camera noise removal should be disabled.

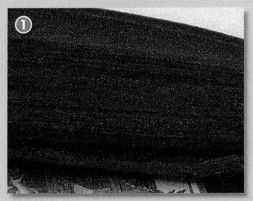

The noise that is a result of selecting a high ISO value can be clearly seen in the example image on the left (1). The second example (2) shows how using the Noise Reduction feature in the camera has removed much of this problem from the photo.

7. Setting the ISO

For those of us growing up with film, the idea of an ISO number (or if I really show my age – ASA number) indicating how sensitive a particular film is to light is not new. These values ranging from slow (50 ISO) through medium (125 ISO) to high speed (3200 ISO) have been one way that photographers have selected which film stock to choose for particular jobs. Each film type had its advantages and disadvantages and selecting which was best was often a compromise between image quality and film speed. If the day's shooting involved a variety of different subjects then the decision was always a difficult one as once the choice was made you were stuck with the same stock for the whole of the roll.

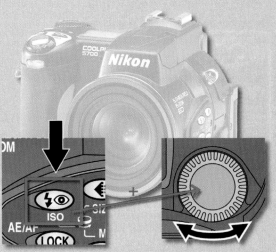

Changing the ISO on your camera is generally a simple operation. On this model you hold down the ISO button and turn the command dial to change the sensitivity setting of the chip.

In the digital era the restrictions of being locked into shooting with a single film with all its particular abilities and flaws has been lifted. The ISO idea still remains. Though strictly, we should refer to it as 'ISO Equivalence' as the original ISO scale was designed specifically for film not CCDs. Most cameras have the ability to change the ISO equivalent setting for the sensor, with a growing number offering settings ranging from 50 to 1600. Each frame can be exposed at a different 'ISO' value releasing the digital shooter from being stuck with a single sensitivity through the whole shooting session. Oh happy days!

The lower the ISO setting you choose the lower the likelihood of introducing noise (digital equivalent of grain) into your images. Often the lowest ISO setting is 100 yet some cameras provide 50 on the regular preset menu or allow you to use a custom preset menu to go lower than 100. On the other hand, some cameras have no noticeable change at an ISO of 200. Determine through a few trials when noise becomes apparent; be sure to zoom in on your image after opening it with the raw converter.

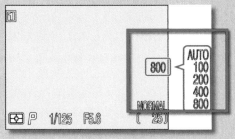

On most cameras the current ISO setting is displayed on the LCD screen and sometimes in the viewfinder as well.

The table below summarizes the benefits and disadvantages of different ISO settings. Use it as a guide when selecting which value to use for your own work.

ISO equivalent	100 – 200	400 – 800	Above 800
Benefits	• Low noise (fine grain) • Good color saturation • Good tonal gradation	• Good noise/sensitivity balance • Good sharpness, color and tone • Can be used with a good range of apertures and shutter speeds	• Very sensitive • Can be used with fast shutter speeds, large aperture numbers or long lenses • Good depth of field
Disadvantages	• Not very sensitive • Needs to be used with fast lens or tripod • Needs bright light	• Not the absolute best quality capable by the camera • May not be fast enough for some low light or action scenarios	• Obvious noise throughout the picture • Poor picture quality
Best uses	• Studio • Still life with tripod • Outdoors on bright day	• General handheld shooting	• Sports • Low light situations with no flash • Indoors

Auto ISO

Some cameras also contain an Auto ISO setting that can be selected instead of specific sensitivity values. This feature keeps the camera at the best quality option, usually 100 or lower, when the photographer is shooting under normal conditions, but will change the setting to a higher value automatically if the light starts to fade. It's a good idea to select and use this option as your camera's default setting. It's good for most situations and you can always change to manual when specific action or low light scenarios arise.

Pro's tip: When using higher ISO settings turn off the camera's sharpening feature as this function can tend to exaggerate the noise that is present in the image.

8. Establishing exposure

Though not normally discussed as part of the process of enabling and setting up your camera for raw shooting, exposure, unlike most of the other factors considered here, is not something that can be adjusted losslessly after capture. In fact, it would not be an overstatement to say that exposure is one of the most important factors to consider when capturing any photos. In later chapters we will talk about how some conversion software allows you to rectify small problems of over- or under-exposure but this option should only be considered as a last resort, and only if the picture cannot be rephotographed with the correct exposure settings.

To guarantee the best quality in your raw conversions and, by extension, your final photographs, ensure that you capture as much of the detail in the scene as possible. This means trying to squeeze in both the highlight and shadow areas of the scene into a single capture. This is not a difficult task if you are photographing on a gray winter's day in London where the difference between highlight and shadow is small, but shooting at midday in the desert is another story. In these sort of conditions the brightness range (difference between shadows and highlights) can be so great that it is beyond the capabilities of the camera. Well-calculated exposure in this situation is critical. As some detail is bound to be lost or clipped it is up to you as the photographer to determine where to position your exposure and, consequently, which details to record and which to abandon. This should be a conscious decision taken by the photographer and not one that is left up to the automated exposure options of the camera. By manipulating the shutter speed and aperture (f-stop) combination you can selectively choose how highlights, shadows and midtones are recorded. This includes how bright each of these

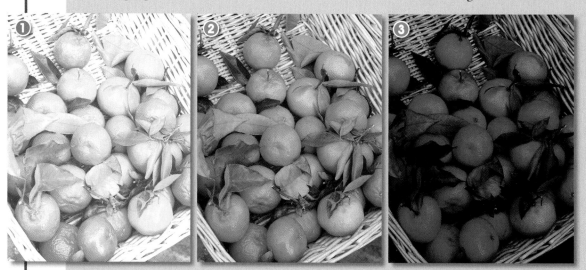

Establishing a good exposure for a picture is one of the most critical steps in creating a great photograph. Overexposure (too much light) produces washed-out photos (1) with little or no details in the highlights. In contrast underexposed pictures (3) suffer from too little light during exposure and appear dark with shadow areas containing no detail. A well-exposed photo produces an image that is a happy medium (2) showing detail from shadows through midtones to highlights.

tonal areas is in the final image (yes, you can make the deep folds in black fabric white just by adjusting the f-stop and shutter speed you use to record them) as well as where any clipping occurs. For more details about controlling how tones are recorded check out the 'Exposure essentials' section below.

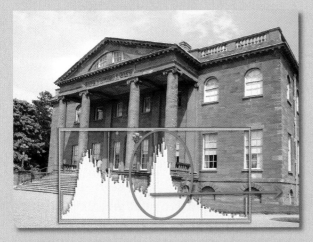

Substantially more detail is present in digital photos where the exposure has been carefully adjusted so that as much of the detail as possible falls to the right hand end of the histogram. This approach is called 'Exposing Right'.

Exposing to the right

Though most camera techniques that underpin good exposure have remained the same with the transition from film to digital, in some areas your thinking may need to be realigned slightly to take into account how the new technology works. One such area is the capture of highlight details. Because of the way that the camera sensor responds to light the highlight area of the image is captured with more levels of tone than the mid areas. Similarly the midtone areas of the picture are recorded with more tones than the shadows.

'What impact does this have on how we photograph?' Well, I'm glad you asked! Keep in mind that our aim is to capture as much detail in the scene, from shadow to highlights, as possible and that recording comparatively fewer tones in the shadow areas means that there are fewer discrete tones to represent precious shadow detail. Add to this the fact that underexposure pushes all of the scene's details towards the shadow end of the spectrum (where there is less detail) and you will see how critical it is to position the majority of your scene's details in the mid to highlight area. This technique has be termed 'Exposing Right' because you are placing the bulk of the detail to the right end of the histogram.

This isn't a simple matter of overexposing your photos though. It's true adding more light will move all the scene's details towards the highlight end of the tonal range but you must make sure that you don't clip the highlights in the process. The Histogram function or Highlight Warning feature found on most cameras can help in this regard. Use these devices to check that you are balancing shifting the details to the right and at the same time not losing (clipping) any highlights. Your reward for all this effort is more detail to play with especially in the shadow areas.

Exposure essentials

The mechanics of creating a photograph are based on controlling the amount of light entering the camera and falling on the sensor. This process is called 'exposing' the sensor. All cameras have mechanisms designed to help ensure that just the 'right' amount of light enters the camera. Too much light and the image will appear washed out and too light – overexposed. Too little and the picture will be dark and muddy – underexposed.

Two different camera parts are used to control the amount of light entering the camera – the aperture and the shutter.

* The **aperture** is basically a whole in the center of the lens. The smaller the hole the less light is able to enter the camera. Conversely if the hole is larger more light can enter. Various size holes are referred to as f-numbers or f-stops. Confusingly, the smaller the f-stop number the bigger the hole. It may be helpful to think of the aperture as being similar to your eyes' iris. In bright light the iris is small, restricting the light entering the eye. In dark situations the iris grows larger to encourage more light into the eye. The aperture in your camera should be used in the same way – increase the size of the hole to lighten the photograph, decrease the hole to darken.

Apertures (f-stops)

* The **shutter** works a bit like a roller blind in an office window. Opening lets light into the room and closing stops the light entering. The length of time that the camera's shutter is open, called the shutter speed, determines the amount of light that enters the camera. Fast shutter speeds are used when photographing bright scenes to restrict the light coming into the camera, whereas long shutter speeds are used for night or indoor photography. Faster shutter speeds are represented by a series of numbers that are fractions of a second. Longer speeds are displayed in whole seconds.

Shutter speeds

'But how do I know what shutter speed and aperture setting will be suitable for a particular scene?' All cameras have a built-in metering system designed to measure the amount of light entering the camera. The camera uses this measurement as a basis for setting the correct shutter and aperture. Simple cameras use an 'auto exposure' system which performs this function without the photographer even being aware that it is happening. More sophisticated models also include manual override options. These features allow the photographer to take more control of the exposure process, select the shutter speed and aperture that suits and even disregard the camera's recommendations altogether.

For 85% of the time there may be no need to disagree with the camera's meter or the settings it uses but there are occasions when the camera can be fooled. It is on these occasions when you as the photographer need to anticipate the problem and take control.

Use the following Exposure Commandments list as a guide to making better exposures.

Commandments for better exposure
1. Use the camera as a guide
The metering system in your camera is a very sophisticated device and for the most part your camera will choose the right exposure settings for a scene. All but the most basic models will allow you to see the settings for shutter and aperture in the viewfinder or on the LCD screen. Start to take notice of these settings and recognize how your camera reacts to different lighting situations.

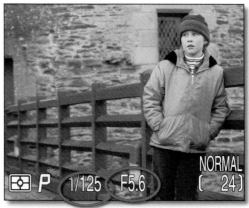

Shutter speed and aperture or f-stop settings are often displayed in the viewfinder.

2. Fill the frame with your subject
Most meters use the subject that is in the center of the frame as a guide for the exposure of the whole image. A good way to ensure that your image is well exposed is to make sure the most important parts of the picture feature in the center of the frame and are therefore used to calculate exposure. Be warned though, filling the center of the frame on all occasions for the sake of good exposure can lead to monotonous symmetrically balanced compositions.

If your meter is center weighted then make sure that this part of the frame is over an important subject area when setting your exposure.

3. Off center can mean bad exposure

In wanting to be more creative in your compositions you may wish to try designing the frame with your subject a little off center. Doing this may help the look of your images but your exposures may suffer. To solve this it is helpful to know that most cameras have the ability to lock exposure (and focus) by pushing down the shutter button halfway. For the situation where you want to create an off-center shot, point your camera at the subject and press the button halfway and then, without removing your finger, recompose the picture before pushing the button down fully to expose the photograph.

Use the lock exposure feature to gauge the exposure of an off-center subject.

4. Watch out for dark subjects

The camera's meter works on averages. When you point your lens at a scene the meter averages the various colors, tones and brightnesses in that scene to a mid-gray. The shutter speed and aperture recommended by the camera are based on reproducing this mid-gray. Now for most multi-colored scenes this is a good approach but in special circumstances it just doesn't work. For example, in a scene containing mostly dark subjects the camera will try to suggest using settings that will result in the picture being too light (overexposed). Knowing this you can adjust your settings to compensate. Simply increase your shutter speed setting by one or two speeds, or close down your aperture by a couple of f-stops. The amount you will need to alter these settings will be determined by your scene, but the beauty of digital is that you can preview your results straightaway and reshoot if necessary.

Keep an eye out for subject matter that will fool the camera's meter. Here the meter's suggested aperture and shutter speed combination resulted in a picture that was too bright (1). Reducing the exposure by 1 f-stop or EV setting produced more accurate results (2).

5. Keep an eye on light color scenes

For the same reason you should always be wary of light colored scenes as well. Prime examples are the type of images that we all take on holidays to the beach or the snow fields. Most pictures in these environments contain large areas of lightly colored subjects. Leave the camera to its own devices and you will end up with muddy, underexposed (too dark) pictures. The solution is to add more exposure than is recommended by the camera. You can do this manually as detailed in Commandment 4 or try using the Exposure Compensation feature on your camera. Usually labeled with a small plus and minus sign, this feature allows you to add or subtract exposure by simply pressing and turning the command dial. The change in exposure is expressed in fractions of f-stops. For the beach and snow scenes add 1.0 or 1.5 stops using this control.

6. Be careful of backlighting

A nice portrait taken in front of an open window with a beautiful vista in the distance sounds like the scenario for a great photograph, but often the results are not the vision of loveliness that we expected. The person is too dark and in some cases is even a silhouette. Now this is not necessarily a bad thing unless of course you actually wanted to see their face. Again your meter has been fooled. The light streaming in the window and surrounding the sitter has caused the meter to recommend using a shutter speed and aperture combination that causes the image to be underexposed.

For light toned subjects you may need to increase the exposure beyond the shutter and aperture that the camera suggests to correctly record the tones. In this example the picture taken with the camera reading is too dark (1) whereas opening up (adding extra exposure) the aperture by 1.5 f-stops produced a more realistic result (2).

The light from behind subjects can also fool the camera's meter. Be sure to add extra exposure to compensate in these situations.

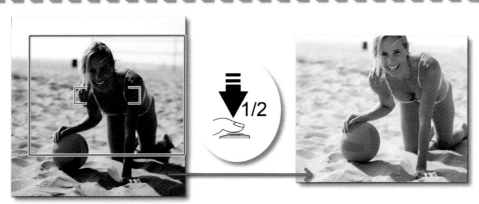

One way to overcome the effects of backlighting is to ensure that the center portion of the viewfinder is positioned over the main subject area, then press the shutter button halfway down to lock exposure (and focus) and then recompose the frame before pressing the button fully to take the photo.

To rectify this increase the amount of light entering the camera either manually, zoom into the main subject and press the shutter button halfway to set your exposure or use your camera's exposure compensation feature. Shoot the portrait again and preview the results on screen. If need be change the settings and shoot again.

7. Histograms to the rescue

Being able to preview your work immediately on the LCD panel on the back of your camera is a real bonus for digital photographers. This means that a lot of the exposure mistakes made during the days when 'film was king' can be avoided via a simple check of the picture. Any under- or over-exposure problems can be compensated for on the spot and the image reshot. But let's not stop there. Many cameras also contain a built-in graphing function that can actually display the spread of tones in your image. This graph, usually called a histogram, can be used to quickly and easily diagnose exposure problems. A bump of pixels to the right hand end of the graph means an underexposed picture, a bump to the left end means overexposure.

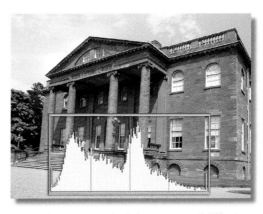

Use the histogram to check the exposure of difficult images rather than rely on how the photo appears in the monitor.

Shooting tethered

Many DSLR cameras now offer the option of capturing raw photos whilst the camera is connected to a computer. Some photographers would never need nor see the benefits of shooting in this fashion as in their chosen area of speciality the added burden of dragging around a laptop computer as well as all their camera gear is a complication that they can do well without. But for studio, product, architectural and even some landscape photographers the ability to preview, and even process, the photos captured almost immediately on a large screen is too good to miss.

The utility software that comes bundled with most mid to high end DSLR cameras and medium format camera backs does an admirable job of providing the required software link between camera and computer. The physical connection is generally provided via a USB or Firewire connection, although some models can now connect wirelessly using a pretty standard setup.

The typical tethered setup works in the following manner:

1. Install camera drivers
Before connecting the camera ensure that you have installed any camera drivers that were supplied with the unit. These small pieces of software ensure clear communication between the camera and computer and are usually installed along with other utility programs such as a dedicated browser (e.g. Nikon View or Canon's ZoomBrowser/ImageBrowser) and camera-based raw conversion software (e.g Nikon Capture or Canon's Digital Photo Professional). Follow any on-screen installation instructions and, if necessary, reboot the computer to initialize the new drivers.

2. Connect the camera
The next step is to connect the camera to the computer via the USB/Firewire cable or wireless network. Make sure that your camera is switched off, and the computer on, when plugging in the cables. For the best connection and the least chance of trouble it is a good idea to connect the camera directly to a computer USB/Firewire port rather than a hub.

3. Check the connection

With the cables securely fastened switch the camera on and, if needed, change to the PC connection mode. Most cameras no longer require this change but check with your camera manual just in case. If the drivers are installed correctly the computer should report that the camera has been found and the connection is now active and a connection symbol (such as PC) will be displayed on the camera. If the computer can't find the camera try reinstalling the drivers and, if all else fails, consult the troubleshooting section in the manual. To ensure a continuous connection use newly recharged batteries or an AC adaptor.

4. Start the remote shooting software

With the connection established you can now start the remote capture software (e.g. Nikon Capture Camera Control or Canon's Digital Photo Professional). With some models the action of connecting the camera will automatically activate the software. Most versions of these utilities provide more than just a means of releasing the shutter from the computer and instantly (well nearly, it does take a couple of seconds to transfer big capture files) viewing captured photos. They contain options to set most camera functions as well. This can include items such as shutter speed, ISO, aperture, capture format, contrast, saturation and white balance controls.

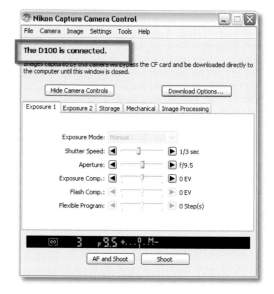

5. Set download options

With all these settings to play with where do you start? Start by adjusting the download options. The four big settings are:
• Where the files are to be transferred to,
• How they are to be labeled,
• What metadata is to be added to the files during this process, and

• What happens to the file once it is transferred. It is a good idea to create a new folder or directory for each shooting session and to nominate this as the place to download the captured files. Now select a naming scheme that provides enough information to allow easy searching later. This may mean a title that includes date and name of shoot or subject as well as a sequence number. In terms of additional metadata at the very least you should always attach a copyright statement as well as any pertinent keywords that describe the subject. Finally you need to nominate what happens to the captured files. Most users will want to transfer the pictures directly to a preview utility such as one of the browser programs or alternatively if you want to process the photo on the spot you could pass the file directly to a raw converter.

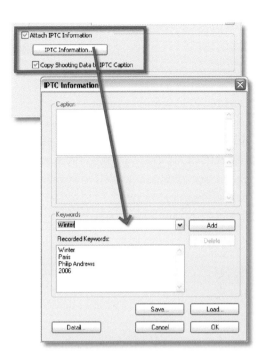

6. Adjust camera settings

As we have already covered which of these camera settings should be used by the raw shooter we won't spend too much time on how to adjust these settings here. It is worth noting, however, that with most systems aperture and shutter speed can both be set remotely and that exposure aids, such as highlight warnings and the histogram, are also available.

7. Compose, focus and release the shutter

Now the nuts and bolts of the capture. Most remote capture systems don't offer a live preview feature so composing and framing is still a through the viewfinder and lens event. Some photographers adopt a shoot and review policy preferring to shoot a couple of test images and review these full size on their computer screens to check composition, focus and even exposure. Once you are happy with all your settings you can release the shutter and automatically transfer the file from camera to computer.

8. Disconnecting the camera

Before turning the camera off or disconnecting the cable make sure that any transfer of information or images is complete. Mac users can drag the camera volume from the desktop to the trash. Windows users should click the Safely Remove Hardware icon in the system tray (bottom right of the screen) and select Safely Remove Mass Storage Device from the pop-up menu that appears.

Pro's tip: Some remote capture software like that offered by Nikon's Capture Camera Control program, contains batch processing features designed to automate the capture and processing phases. Predetermined raw image conversion and enhancement options are applied to photos on-the-fly as they are captured. The converted file is then saved straight to disk. This streamlined and efficient workflow is designed for processing large numbers of files that have been captured under similar lighting and exposure conditions.

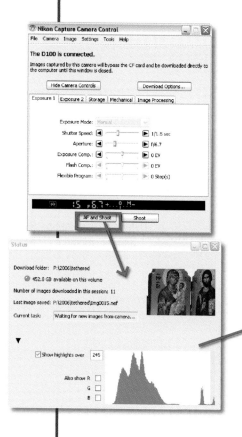

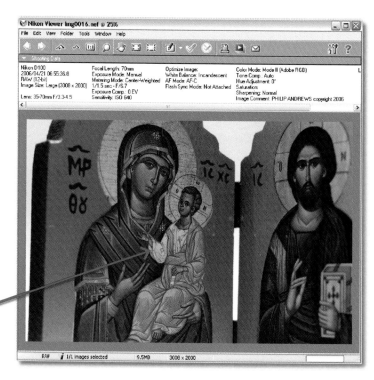

Raw versus non-raw capture workflow

This table summarizes the steps involved in three different approaches to photographing depending on the file format used for capture. Notice that the bulk of the raw image optimization happens in the processing stage back at the desktop. This is in contrast to the situation for JPEG and TIFF capture where color, contrast, sharpening, color mode and pixel dimension options are set at time of capture.

Shooting workflows compared

	Select capture format – **JPEG**	Select capture format – **TIFF**	Select capture format – **Raw**
Before shooting	Choose image quality (level of compression)	–	–
	Pick color depth (8 or 16 bits per channel)		–
	Select pixel dimensions of capture		–
	Set color mode or space (sRGB for web work, AdobeRGB for print work)		–
	Set saturation		–
	Set white balance (for the dominant light source or using the customize option)		–
	Set tonal compensation (more or less contrast)		–
	Set ISO value		
	Select Sharpening setting		–
	Set Noise Reduction options		–
During shooting	Arrange composition		
	Adjust focus (check depth of field)		
	Set exposure (check histogram/highlight warning)		
After capture conversion processing	–		Determine orientation and set cropping
	–		Set highlight and shadow points
	–		Alter brightness and contrast
	–		Adjust white balance and saturation
	–		Select colour space
			Determine image dimensions and resolution
	–		Apply Sharpening and Noise Reduction

Raw capable cameras

Canon – EOS-1D, EOS-1Ds, EOS-1D Mark II, EOS-1Ds Mark II, EOS 1D, Mark II N, EOS 5D, EOS 10D, EOS 20D, EOS 20Da, EOS 30D, EOS D30, EOS D60, EOS 300D (Digital Rebel/Kiss Digital), EOS Rebel XT (EOS 350D/EOS Kiss Digital N), PowerShot 600, PowerShot A5, PowerShot A50, PowerShot Pro 1, PowerShot S30, PowerShot S40, PowerShot S45, PowerShot S50, PowerShot S60, PowerShot S70, PowerShot G1, PowerShot G2, PowerShot G3, PowerShot G5, PowerShot G6, PowerShot Pro70, PowerShot Pro90 IS

Contax – N Digital

Epson – R-D1

Fujifilm – FinePix E900, FinePix F700, FinePix S5000 Z, FinePix S5200/5600, FinePix S9000/9500, FinePix S7000 Z, FinePix S2 Pro, FinePix S3 Pro, FinePix S20 Pro

Hasselblad – H2D

Kodak – DCS 14n, DCS Pro 14nx, DCS720x, DCS760, DCS Pro SLR/n, EasyShare P850, EasyShare P880

Konica Minolta – DiMAGE A1, DiMAGE A2, DiMAGE A200, DiMAGE 5, DiMAGE 7, DiMAGE 7i, DiMAGE 7Hi, Maxxum Dynax 5D (Europe), Maxxum 5D (USA), Maxxum 7D/Dynax 7D

Leaf – Aptus 22, Valeo 6, Valeo 11, Valeo 17, Valeo 22

Leica – Digital-Modul-R, D-Lux 2, Digilux 2

Mamiya – ZD

Nikon – D1, D1H, D1X, D100, D200, D2H, D2Hs, D2X, D50, D70, D70s, Coolpix 5000, Coolpix 5400, Coolpix 5700, Coolpix 8400, Coolpix 8700, Coolpix 8800

Olympus – E-10, E-1, E-20, E-500, SP-310, SP-350, SP-500UZ, EVOLT E-300, C-5050 Zoom, C-5060 Zoom, C-7070 Wide Zoom, C-8080

Panasonic – DMC-FZ30, DMC-LC1, DMC-LX1

Pentax – *ist D, *ist DS, *ist DS2, *ist DL

Ricoh – GR Digital

Samsung – Pro 815

Sigma – SD9, SD10

Sony – A-100, DSC-R1, DSC-F828, DSC-V3

Other considerations when capturing raw

As we have seen there are a variety of settings that need to be considered when enabling your camera for raw capture. Before you turn on your camera be sure to consider memory card requirements to handle storage of large raw files, unless of course you have managed to acquire wireless file transfer capability or are shooting tethered. In that case you need to consider hard disk and offline storage issues.

Memory cards

It is worth investing in memory cards of at least 1GB or 2GB capacity, preferably with some sort of accelerated read/write speed. In case you're wondering what that 120X or 60X label means, card performance is based on a benchmark of megabytes per second of read/write rate. Using a starting point of 3MB/sec equaling a 20X memory card read/write rate, typical rates will be:

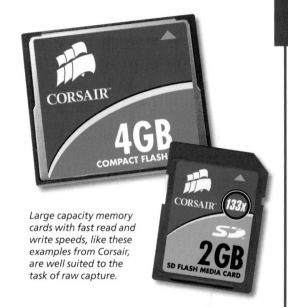

- 9MB/sec = 60X

- 10MB/sec = 66X

- 20MB/sec = 133X

Large capacity memory cards with fast read and write speeds, like these examples from Corsair, are well suited to the task of raw capture.

For example, a 120X 2GB SD card has a read rate of 21MB/sec and a write rate of 18MB/sec. Such read/write speeds will provide not only fast storage of large image files to card, they will also facilitate quick viewing of images and faster transfer rates during downloading than, say, a 60X card. The Lexar Professional 4GB compact flash card with Write Acceleration provides 80X read/write speed. Many photographers prefer to use two 2GB cards instead of one 4GB card. If you are creating huge files from a 22MP camera then 4GB or even 8GB will be attractive.

A variety of DSLRs have dual memory card slots and allow you to designate what should go where. You can elect to put JPEGS on one card and raw files on the other or you can use only one card and then switch to the other card without having to remove one.

After you scroll through your menu selections in-camera for Image Quality, select the raw setting and decide whether you would also like to simultaneously capture JPEG and raw files. If so, select the file size and image quality of the JPEG files. Check your display to determine how many images may be saved to memory card. If you think you will need to save more to one card, perhaps a 4GB or higher memory card will be more appropriate.

Other hardware considerations

Memory cards aren't the only items to think about when capturing raw files. Other devices that you should also consider include:

Portable storage device – Make sure you have plenty of cards for your shoot and consider bringing a portable data bank or tank, actually an external hard drive sometimes. Several types of devices are available, from cheap to expensive; I recently found basic hard drives encased in durable plastic that will directly accept your cards for copying without a computer. More sophisticated devices are available with or without screen displays and other features, such as the Nikon Coolwalker, the SmartDisk™ FlashTrax and Fotochute products, or Delkin eFilm PicturePAD device.

Portable storage options like Nikon's Coolwalker provide a means of downloading the contents of full memory cards when on the move.

Computer – Raw files are much larger than JPEG files, more than twice as large in most cases. And, if you also save a large to medium JPEG with every raw file you will definitely need to be prepared with adequate RAM (Random Access Memory) to download efficiently without slowing down your system and an internal or external hard drive big enough to store the raw files.

Operating system – Install the latest Windows and Mac OS X version and check frequently for updates for raw file browsing and handling.

Backup – Ideally, your computer will have a CD/DVD burner for file backup; a DVD burner is advisable as each disk holds considerably more data than a CD. Another alternative is an external hard drive such as the OneTouch backup systems offered by Maxtor. As we really do not know the life expectancy of CDs or DVDs many photographers institute a combined backup system for precious photos which involves both DVD and hard drive options.

External hard drives such as Maxtor's OneTouch system are a good way to ensure up-to-date and secure storage of precious picture files.

3

Downloading Raw Files

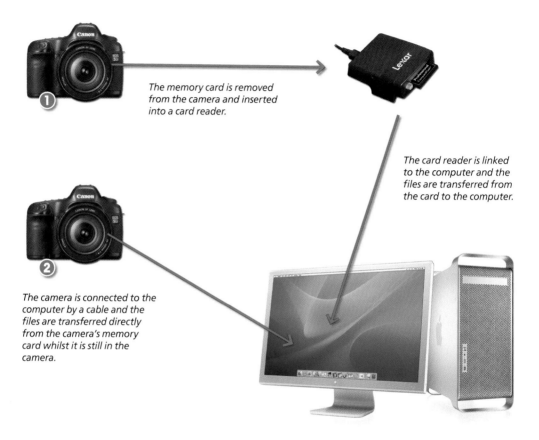

The memory card is removed from the camera and inserted into a card reader.

The card reader is linked to the computer and the files are transferred from the card to the computer.

The camera is connected to the computer by a cable and the files are transferred directly from the camera's memory card whilst it is still in the camera.

There are two main ways to transfer your files from camera to computer – (1) via a card reader or (2) directly.

After enabling the camera and then spending your time creating a bunch of masterpieces, saved in the raw format of course, the next step is to download these photos to your computer. As with most things raw, we have several different download options. Some photographers love to connect their cameras directly to the computer, others who use multiple memory cards make use of a dedicated card reader to transfer their images. And a third group of image makers who shoot tethered are able to capture and download in one action.

In this chapter we will outline the various ways you can port your photos to the computer and take particular notice of some of the automated download options that are now provided by the image editing and raw conversion programs.

Camera to computer

As we saw in the shooting tethered section in the last chapter, when connecting your camera to the computer it is important to ensure that the drivers for the devices are installed before plugging in the cables.

The drivers are generally installed at the same time that you load the utility software that accompanied the camera. If you haven't yet installed any of these applications then you may need to do this first before the computer will recognize and be able to communicate with the camera. During the installation process follow any on-screen instructions and, if necessary, reboot the computer to initialize the new drivers.

To download images directly from the camera the computer needs to communicate with the connected camera as it would a hard drive or temporary removable drive. For this to occur you may need to change the basic communications setup on the camera before connecting the unit. The need to alter the default setup for the camera is largely based on the operating system (and version) that you are using. Typically you will have a choice between connecting your camera as a mass storage device (the most common option) or via PTP (Picture Transfer Protocol). Check with your camera documentation which works best for your setup and then use the mode options in the camera's setup menu to switch to the transfer system that you need.

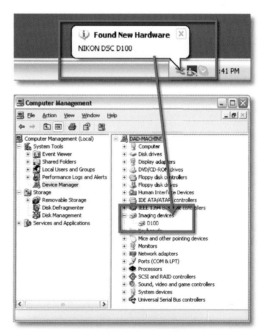

The next step is to connect the camera to the computer via the USB/Firewire cable. Make sure that your camera is switched off, and the computer on, when plugging in the cables. For the best connection and the least chance of trouble it is also good idea to connect the camera directly to a computer USB/Firewire port rather than an intermediary hub.

Now switch the camera on. Some models have a special PC or connect-to-computer mode – if yours is one of these then change the camera settings to the PC connection mode. Most cameras no longer require this change, but check with your camera manual just in case. If the drivers are installed correctly the computer should report that the camera has been found and the connection is now active and a connection symbol (such as PC) will be displayed on the camera. If the computer can't find the camera try resinstalling the drivers and, if all else fails, consult the troubleshooting section in the manual. To ensure a continuous connection use newly recharged batteries or an AC adaptor.

Card reader to computer

Like attaching a camera to your computer, many card readers need to be installed before being used. This process involves copying a set of drivers to your machine that will allow the computer to communicate with the card reader. Some readers do not require extra drivers to function and simply plugging these devices into a free USB or Firewire port is all that is needed for them to be ready to use.

After installing the reader, inserting a memory card into the device registers the card as a new removable disk or volume. Depending on the imaging software that you have installed on your computer, this action may also start a download manager

Many modern card readers can be used with multiple card types making them a good solution if you have several cameras in the household or office.

Note:

Before turning off the camera, disconnecting the cable to camera/card reader, or removing a memory card from the reader make sure that any transfer of information or images is complete. Mac users should then drag the camera/card volume from the desktop to the trash icon or select the volume icon and press the eject button. Windows users should click the Safely Remove Hardware icon in the system tray (found at the bottom right of the screen) and select Safely Remove Mass Storage Device from the pop-up menu that appears.

Camera and card reader connections

The connection that links the camera/card reader and computer is used to transfer the picture data between the two machines. Because digital photographs are made up of vast amounts of information this connection needs to be very fast. Over the years several different connection types have developed each with their own merits. It is important to check that your computer has the same connection as the camera/card reader before finalizing any purchase.

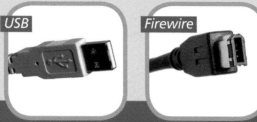

CONNECTION TYPE:	MERITS:	SPEED RATING:
USB 1.0	• No need to turn computer off to connect (hot swappable) • Can link many devices • Standard on most computers • Can be added to older machines using an additional card	Fast (1.5Mbytes per sec)
USB 2.0	• Hot swappable • Can link many devices • Standard on most models • Can be added to older machines using an additional card • Backwards compatible to USB 1.0	Extremely fast (60Mbytes per sec)
Firewire	• Hot swappable • Can link many devices • Becoming a standard on Windows machines especially laptops • Can be added using an additional card • Standard on Macintosh machines	Extremely fast (50Mbytes per sec)
Firewire 800	• Hot swappable • Can link many devices • Can be added using an additional card • Not yet standard but some new machines feature the connection	Fastest connection available (100Mbytes per sec)

or utility designed to aid with the task of moving your raw files from the card to hard drive. In the 'Photoshop Elements' and 'Camera specific download' sections later in this chapter you will see examples of these utilities in action.

Failing this, Windows users will be presented with a Removable Disk pop-up window containing a range of choices for further action. One of the options is 'Copy pictures to a folder on my computer'. Choosing this entry will open the Microsoft Scanner and Camera Wizard which acts as a default download manager for transferring non-raw-based picture files. If your card contains raw files then the current version of the wizard will report that there are no photos present on the card. This situation will change as the Windows software becomes more raw aware, but for the moment the solution is to select the open folder to view files option and manually copy the pictures into a new folder on your hard drive.

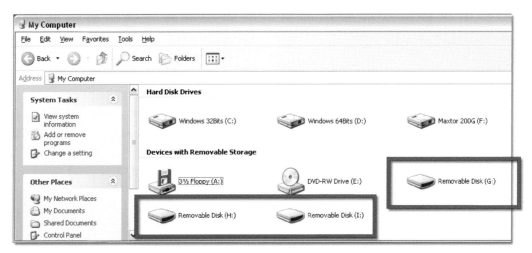

After a multi-card reader has been installed on a Windows computer the various card slots are displayed in the My Computer window as separate removable drives.

Cards inserted into a Macintosh connected reader will appear as a new volume on the computer's desktop. Users can then copy or move the picture files from this volume to a new folder on their hard drive.

The important last step on both Macintosh and Windows platforms is to ensure that the card is correctly disconnected from the system. Macintosh users will need to drag the volume to the Wastebasket or Eject icon whereas Windows users can use the Safely Remove Mass Storage Device feature accessed via a button in the Taskbar (bottom right of the screen).

Complete step-by-step instructions for Windows and Macintosh transfer processes can be found in the 'Operating system-based downloads' section in the next part of this chapter.

Windows users need to use the Open folder to view files option to copy their raw files to the computer as these picture types are not recognized with the current version of the Microsoft Scanner and Camera Wizard.

Memory cards will appear as a new volume on the Macintosh desktop.

Memory cards are used to store your camera's pictures. Various capacity sizes and speeds are available in the four main formats shown here. (1) Compact flash. (2) Multimedia. (3) MemoryStick. (4) Smart media.

MEMORY CARD TYPE:	MERITS:	CAMERA MAKES:
Compact flash	The choice for professional cameras Matchbook size	Most Canon, Nikon, Hewlett-Packard, Casio, Minolta, and pre-2002 Kodak
Smart media	Credit card thickness Usually colored black Matchbook size	Olympus and Fuji digital cameras, Sharp camcorders with digital still mode, and some MP3 players
Multimedia (MMC) or Secure Digital (SD)	Most popular card Postage stamp size Credit card thickness SD are second generation MMC cards	Most Panasonic camcorders with digital still mode, some MP3 players, and the Kyocera Finecam S3, KB Gear JamCam, Minolta DiMAGE X, and most Kodak digital cameras produced after 2001
xD Picture Card	Smallest of all cards About the size and thickness of a thumbnail	Fuji and Olympus cameras
MemoryStick and MemoryStick Pro	Smaller than a stick of chewing gum Longer than other card types	Used almost exclusively in Sony digital cameras, camcorders, handhelds, portable music players, and notebook computers

Operating system-based downloads

For non-automated download of raw files you will need to perform a basic copy or move process to transfer your pictures from the card/camera to a folder/directory on your computer. The steps taken to facilitate the transfer vary slightly between Macintosh- and Windows-based machines – two different step-by-step summaries are provided below.

Windows step by step

1. Ensure that the card reader is correctly installed and then insert the camera's memory card into the appropriate slot. Windows will display a generic Removable Disk dialog and ask you to select an option to determine how you want to proceed. For standard picture files (non-raw) you would generally select Copy pictures to a folder on my computer but raw shooters need to work

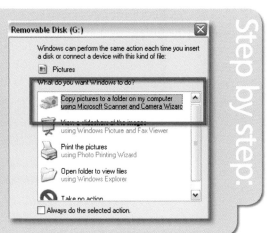

in a slightly different fashion as the operating system doesn't natively recognize raw files as photos.

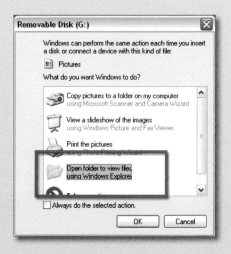

2. So instead select the Open folder to view files using Windows Explorer. This will simply display the contents of the card as if it were a standard hard drive or CD ROM. If you want to bypass this dialog in the future tick the Always do the selected action option. Windows will then remember your selection and perform this action every time you insert a camera card.

3. A new Windows Explorer dialog will open displaying the default folder created by your camera when saving the pictures to the card. There may be nested folders that you have to work your way through before reaching the actual picture files.

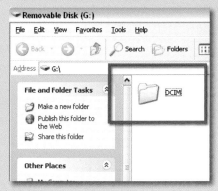

 Pro's tip: The default file and folder structure used for saving your photos to memory card is determined by options in the setup menu of your camera.

4. As the raw files are not recognized as photos in the current version of Windows you will not be able to preview the contents of the files as thumbnails. So switch the View mode to Details (View > Details) which will present the files in list form.

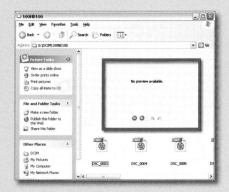

 Note: Recently Microsoft released a free raw thumbnailer and viewer utility for XP that allows the contents of raw files to be viewed in standard Windows file browsing dialogs. See 'The Microsoft Raw Image Thumbnailer and Viewer for Windows XP' section on the next page for more details of this utility.

5. Next open a second window by pressing the My Computer icon. Navigate your way to the My Pictures folder (or the directory you wish to move the raw photos to) and create a new folder to house the transferred files.

6. With both Explorer windows sitting side by side select all the files in the memory card folder and then hold down the Ctrl key and drag the files across to the new folder. This will copy the files to the new position.

 Note: Holding down the Shift key whilst dragging will move the files from the card to the new folder removing the need to delete the files after the transfer is complete.

7. After the files have been copied or moved and whilst they are still selected in the card window, choose File > Delete to erase the raw pictures from the card. Before removing the card from the reader, right-click the Safely Remove Hardware icon in the System tray. At the next screen select the Stop button to allow you to unplug the memory card (USB Mass Storage Device).

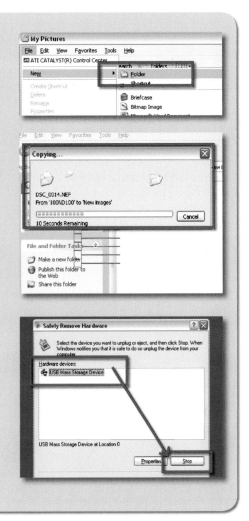

The Microsoft Raw Image Thumbnailer and Viewer for Windows XP

In response to the growing number of Windows users who are also raw shooters, Microsoft released a utility that can be installed on XP driven machines to provide previews of raw files within the file browsing windows of the operating system. Available as a free download from www.microsoft.com the utility or Power Toy currently provides thumbnails, previews, printing, and metadata display for raw images from supported Canon and Nikon digital cameras in Windows XP. Much of this type of functionality is expected to be built into Microsoft's next generation operating system, Vista, but in the meanwhile you can organize and preview your raw files in XP with this utility.

Photoshop and Raw Image Thumbnailer and Viewer working together

Despite the obvious advantage of installing this utility for file management and organizational purposes it is worth noting that the Viewer and Thumbnailer only displays the pixels from the

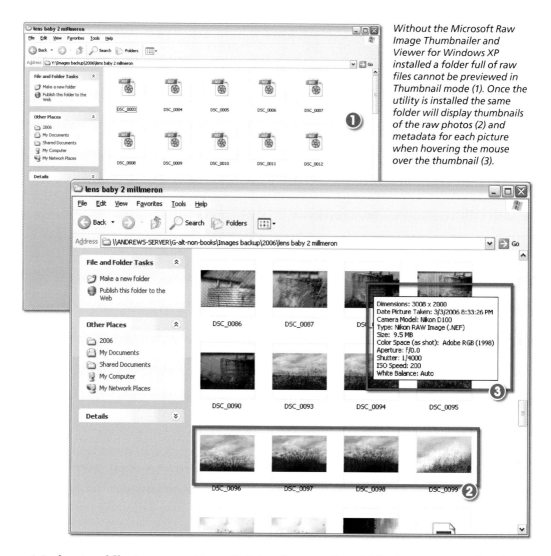

Without the Microsoft Raw Image Thumbnailer and Viewer for Windows XP installed a folder full of raw files cannot be previewed in Thumbnail mode (1). Once the utility is installed the same folder will display thumbnails of the raw photos (2) and metadata for each picture when hovering the mouse over the thumbnail (3).

original captured file. Any processing applied via software such as Adobe Camera Raw will not be reflected in the previews, slideshows or prints. Also setting the Raw Image Viewer as the default way to view your raw files takes your image editing or raw conversion software out of this position in your raw workflow.

Some photographers who want to thumbnail their raw photos in Windows XP but still retain a specific program such as Photoshop as their default raw conversion/editing program alter the settings in the File Types tab of the Raw Image Viewer Options.

The raw utility in action
When Windows users who don't have the utility installed point their file browsers at a folder full of raw photos, the dialog can display the files in tile, icons, list and details views but not the thumbnails

option. At the most basic level installing the utility enables this thumbnailing option to function in all file browser windows but there is more to this utility than just the preview options.

The Viewer and Thumbnailer is not intended to replace the raw conversion utilities provided by the camera manufacturer or those found in your imaging software, rather it is designed to make the management tasks regularly performed via operating system (OS) dialogs as simple as they are with other picture formats.

The utility has two main components:

1. A Windows XP 'Shell Extension' which provides the thumbnail rendering, printing and metadata display for raw files (of supported cameras), and

2. A raw image view application that provides previews, printing and slideshow options for raw files. This application looks and works like the Windows Picture and Fax Viewer but with added features designed specifically for raw shooters.

Digital photographers will benefit from installing this utility in several ways. Obviously being able to preview your raw files directly in the OS dialogs will aid in locating and organizing your photos. Add to this the fact that software makes use of the camera manufacturers' own coding libraries to generate the high quality and color correct (yes it is ICC profile aware) previews and you have the ability not only to manage but to accurately preview your raw files natively. Cool!

Top features

Previewing – After installing the utility you can preview raw files by either right-clicking the file and selecting Preview from the menu that pops up or double-clicking the file. Both options will launch the Microsoft Raw Image Viewer for those raw files types (.nef, .crw) selected during the utility installation process.

Metadata viewing – Hovering the mouse over a raw image in Windows Explorer will display the metadata for the file in a pop-up window. Alternatively clicking the yellow properties button at the bottom of the Raw Image Viewer will display the same information in a floating window.

Custom properties columns – New levels of information can be displayed in the Details view of Windows Explorer. This information is based on the metadata associated with the raw file and it can be shown in a new column by right-clicking the column header bar and then selecting the new data type from those listed.

Slideshows – You can include raw images in an impromptu slideshow by clicking the Slideshow button at the bottom of the Raw Image Viewer. The duration that each slide stays on screen is governed by the Slideshow setting in the General tab of the viewer's Options.

Printing – Raw files can be printed directly from the Raw Image Viewer using the button at the bottom of the dialog and the photos are set up for output via the Photo Printing Wizard.

Limitations

Whilst the Raw Image Thumbnail and Viewer does extend raw functionality to many OS areas it doesn't enable all the digital photography features that XP users may be familiar with. In particular the Windows Filmstrip view doesn't show raw files, the Picture Task options in the Windows Task Pane are not supported, but print and slideshow features are supported in the Raw viewer application itself, and the Windows Camera and Scanner Wizard and Picture and Fax Viewer do not support raw files.

Step by step:

Macintosh step by step

1. Macintosh users can follow a similar route when manually downloading their files from a card reader or camera. After connecting the reader, insert the memory card. The card will be displayed as a new drive icon on the desktop.

2. With the way that most cameras save their captured photos the next step will be for you to navigate your way through a series of folders until you reach the primary folder that contains the raw files. Now open another Finder window and create a new folder on your hard drive in which to save your transferred photos.

3. Select all of the raw files and then drag them to the new folder. This will move the files from the card to the folder. If you wish to copy rather than move the photos hold down the ALT key as you drag the selected files.

4. Once the pictures are safely in the new folder on your computer you can delete the files from the memory card. Select the photos and drag them to the trash can. This step won't be necessary if you moved instead of copied the files in the previous step. Now eject the card from the system by click dragging the drive from the desktop to the Eject/Trash Can icon in the dock. When the drive icon is no longer on the desktop you can safely remove the card.

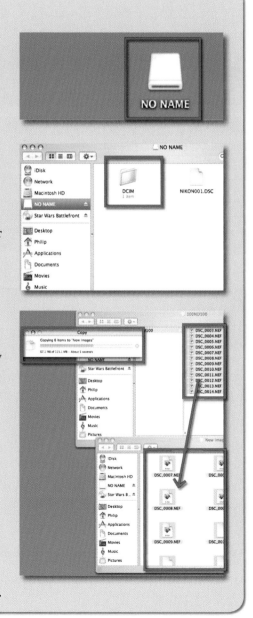

Camera specific download

Most digital cameras now ship with a host of utilities designed to make the life of the photographer much easier. As part of this software pack the camera manufactures generally include an automated download utility designed to aid the transfer of files from camera or card reader to computer. These camera specific download managers are clever enough to know when a camera or card reader is connected to the computer and will generally display a connection dialog when the camera is first attached or a memory card inserted into the reader.

As we will see in the next section of this chapter some software programs such as Photoshop Elements load their own download manager when they are first installed. For this reason it is not unusual for a couple of utility windows to appear whenever you insert a memory card into a reader. The particular software you select to handle the file transfer will depend largely on your own preferred workflow. Some photographers download using the camera software and then convert/ edit using their imaging program, others prefer to keep to one system from beginning to end using a single program such as Photoshop Elements for both tasks.

Once you have made a decision about which route to use then look for a disable option in the preferences of the manager software that you want to bypass. Failing that you can always nominate your preferred method of handling downloads via the Windows Removable Disk or Camera dialog. Simply select the download utility from those selected and then tick the Always do the selected action option at the bottom of the dialog. The next time you insert a card into the reader Windows will automatically open the download manager of your choice.

Nikon's download manager

Nikon owners have the option to use the Nikon Transfer manager, a small pop-up utility that automates the moving of files from card/camera to hard drive. The manager is installed along with camera drivers, photo browser and basic raw conversion software when you load the software on the disk that accompanies your camera.

Generally this type of software provides settings for choosing destination directories, renaming files on the fly, adding in copyright information and determining if the files are deleted from the camera or card after transfer.

Software specific download

Many photographers will choose not to rely on the download options available with their camera-based software or the manual copy route provided by the operating system. Instead they manage the download component of their workflow with the main imaging software package. This may be an editing program, such as Photoshop or Photoshop Elements, or the raw conversion software that they employ. Either way making this approach generally provides time savings as the raw files are transferred from camera, or card reader, and during the same action they are imported into the editing or conversion program.

To give you an idea of the options available with this style of download the following few pages contain step-by-step examples for the major software titles.

Photoshop Elements and the Adobe Photo Downloader

Over the history of the development of Photoshop Elements one of the most significant additions to the program has been the Photo Browser or Organizer workspace. This feature provides a visual index of your pictures and can be customized to display the images in browser mode, date mode or sorted by keyword tags or collection. Unlike the standard file browsers of previous editions which created the thumbnails of your pictures the first time that the folder is browsed, the Photo Browser, or Organizer as it is also called, creates the thumbnail during the process of adding your photographs to a collection.

To commence downloading your raw files and, in the process, create your first collection, simply select the View and Organize option from the Welcome screen and then proceed to the Organizer: File > Get Photos menu option. Select one of the listed sources of pictures (camera or folders) provided and move through the steps and prompts in the dialogs that follow.

Option 1: Getting your raw files from camera or card reader

To demonstrate the process let's start by downloading some photographs from a memory card or camera. This will probably be the most frequently used route for your raw images to enter the Elements program. Connect the camera being sure that you have first installed the drivers for the unit. Alternatively you may wish to eject the memory card from the camera and insert it into a card reader that is already attached to the computer. Next select the From Camera or Card Reader option from the File > Get Photos menu.

Raw files can be downloaded directly from the camera or by inserting the memory card into an attached reader.

After attaching the camera, or inserting a memory card into the reader, you will see the Adobe Photo Downloader dialog. This is a new utility and dialog designed specifically for managing the download process. The first step is to locate and then select the source of the pictures (the card

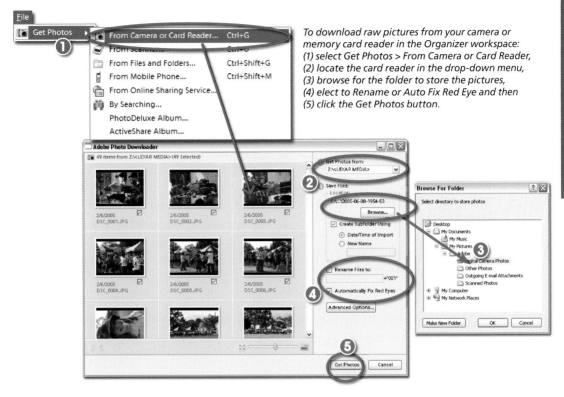

To download raw pictures from your camera or memory card reader in the Organizer workspace:
(1) select Get Photos > From Camera or Card Reader,
(2) locate the card reader in the drop-down menu,
(3) browse for the folder to store the pictures,
(4) elect to Rename or Auto Fix Red Eye and then
(5) click the Get Photos button.

reader or memory card in the camera) from the drop-down menu in the top right of the dialog. Next, a series of thumbnail size pictures of the files stored on your camera or card will be displayed.

By default all pictures on the card will be selected ready for downloading and cataloging. If for some reason you do not want to download all the images then you can deselect them by unchecking the tick box at the bottom right hand of the thumbnail. Now browse for the folder where you want the photographs to be stored and check the tick box if you want a new folder to be created automatically. To help with finding your pictures you can also add a meaningful name, not the labels that are attached by the camera, to the beginning of each of the images by ticking the Rename Files To option and typing a new prefix.

Finally click the Get Photos button to import the pictures. After the process is complete Elements will tell you that the files have been successfully imported and ask you if you want to delete the files from the memory card. Selecting No at this point will preserve the originals on the card; the Yes option will remove the images from the card, freeing up the memory and preparing the card/camera for further use.

After downloading your pictures from the memory card, or the camera itself, you are given the option to delete the original files. This frees up the memory space on the card readying it for further use.

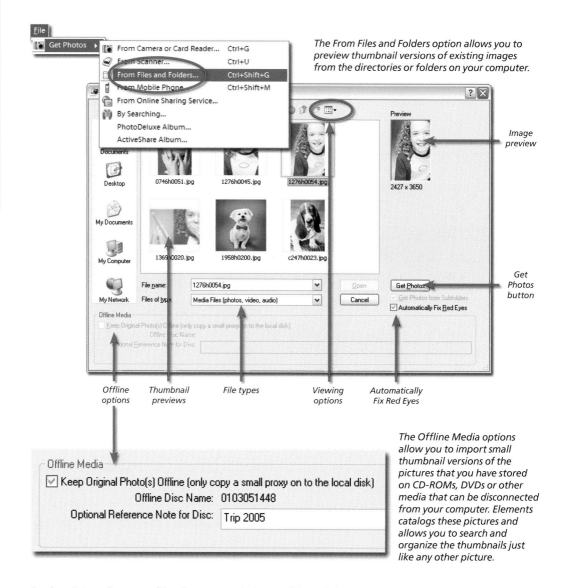

The From Files and Folders option allows you to preview thumbnail versions of existing images from the directories or folders on your computer.

Image preview

Get Photos button

Offline options | Thumbnail previews | File types | Viewing options | Automatically Fix Red Eyes

The Offline Media options allow you to import small thumbnail versions of the pictures that you have stored on CD-ROMs, DVDs or other media that can be disconnected from your computer. Elements catalogs these pictures and allows you to search and organize the thumbnails just like any other picture.

Option 2: Loading raw files from an existing archive, disk or drive

Acting much like the File > Open option common to most programs the Get Photos > From Files and Folders selection provides you with the familiar operating system browse window that allows you to search for and open pictures that you have already saved to your computer. Though slightly different on Windows and Macintosh machines, you generally have the option to view your files in a variety of ways. Windows users can choose between Thumbnails, Tiles, Icons, List and Detail views using the drop-down menu from the top of the window. The thumbnail option provides a simplified file browser view of the pictures on your disk and it is this way of working that will prove to be most useful for digital photographers but keep in mind that some versions of operating systems will not be able to preview raw files as thumbnails. After selecting the image, or images, you wish to import into the Photo Browser or Organizer, select the Get Photos button.

How to multi-select the files to import

To select several images or files at once hold down the Ctrl key whilst clicking onto the pictures of your choice. To select a complete list of files without having to pick each file in turn click on the first picture and then whilst holding down the Shift key click on the last file in the group.

Basic organization and management after download

Immediately after downloading your photos you will be confronted with a range of organizational and management options. Though we will be looking more fully at these issues in Chapter 15, let's highlight some of the main points here.

Backup – When you bring in a group of photos (image files) into the browser a backup reminder message box will appear. You can back up now or later. If you choose to back up at a later date ensure that this task is one that you don't put off for ever. There is nothing worse than losing irreplaceable photos as a result of a hard drive crash when Photoshop Elements provides an easy to use automated backup system.

Sort, edit and delete – Face it, you probably could not bear to part with some of your images when you scrutinized them in your camera and now you are faced with the tough task of taking an even closer look to edit and perhaps even delete the poorest photos.

You can examine them as a set (seen here) or in Full Screen View.

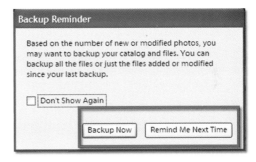

Edit via a slideshow – Look for images taken under similar lighting conditions. They will be candidates for processing and converting in groups. I took these water lily shots in a special botanical garden in the Dominican Republic in midday when the sun was trying its level best to blow out my highlights. The opening hours of the garden on Sundays, the only day I could visit the site, prevented me from working under better lighting conditions.

The images were made with a Leica Digilux 2 with its Leica Vario-Summicron f2.0 lens. A circular polarizer and lens hood were present. All shots were handheld literally from the water's edge. In this situation you look for movement in the shot, zooming in close to examine them at 100%. After the images pass this first round and then at Full Screen View they are moved to the next stage for raw processing and conversion. Tools in the Camera Raw dialog box will tell the real story and still some may fall by the wayside, into the trash can as it were. You'll know then whether some of the questionable, borderline images with exposure, shadow and highlight problems can be salvaged.

Get organized – Organize, rename, tag (including rating), caption and add metadata to the selected photos.

Batch as much of this work as you can. Automate repetitive tasks, such as batch renaming, tagging and captioning. In most cases the same name, tag or caption can be added to multiple photos by selecting several thumbnails first before accessing the renaming or tagging feature.

Disable the Adobe Photo Downloader

1. For Elements 4.0 users select Organizer: Edit > Preferences > Camera Or Card Reader.

2. Deselect 'Use Adobe Photo Downloader to get photos from Camera or Reader'.

Enable the Adobe Photo Downloader

1. For Elements 4.0 users select Organizer: Edit > Preferences > Camera Or Card Reader.

2. Select 'Use Adobe Photo Downloader to get photos from Camera or Reader'.

Photoshop and Bridge

Photoshop users don't have the option of transferring their images with the Adobe Photo Downloader. Instead they will need to use an alternative method of importing the pictures from card or camera. Bridge is essentially a browser program and unlike Lightroom it does not contain a built-in download or import feature. Bridge's job is to provide preview and management options for files that have already been transferred to the computer so Photoshop users will have to employ either:

 • a manual method of transferring files using the computer's operating system or

 • a camera specific download manager such as Nikon Transfer.

Once the files have been downloaded they can be managed and sorted using the features in Bridge.

Adobe Lightroom

Though still in beta stage at the time of writing this book, the main structure and workflow stages of Adobe's Lightroom are plain to see. One key area that the engineers have worked on is the Library module. Designed to make managing your many raw files a breeze, this module also contains a dedicated import feature.

Rather than simply providing a means to transfer files from camera/memory card to hard drive, the File > Import command (1), contains options for renaming and adding customized metadata as well (4).

Several different options are available when it comes to downloading files into Lightroom (3). You can opt for the traditional route of transferring the photos from the memory card or camera to a Lightroom library. To do this you will need to select the Copy or Move files to Lightroom Library feature. Both options perform the transfer and at the same time gather preview and metadata details for each picture.

But unlike other raw workflow solutions Lightroom also has the option to reference photos in their original locations, copying the pictures or downloading the files (2). The act of importing these pictures does not move them from their original positions but rather just builds the preview and metadata details from these source files and then maintains the link between preview and source for all editing operations. In this way photographers who prefer to use another method for transferring raw photos can bypass the copy or move steps altogether. Or companies that use a file server for picture storage can keep their central repository structure.

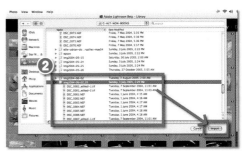

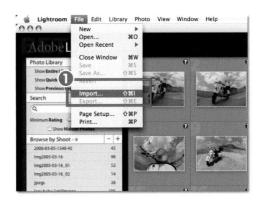

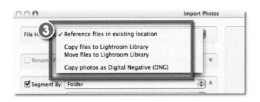

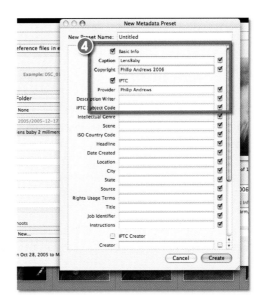

Aperture from Apple

Aperture from Apple is a full raw workflow program just like Lightroom. It too builds preview and metadata details about the pictures it imports during the transfer process. All files imported into Aperture are placed in a Project. If you don't select an existing project to import to the program creates a new one for you. Like Lightroom many of the management features of the program are performed with the details generated at the time of import so this process can take a while especially if you are working with large image files.

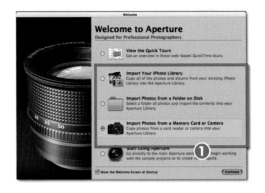

In the Welcome screen (1) to the program Aperture provides the option of importing from three separate sources – an existing iPhoto library, a folder of photos or from a camera or memory card (in a card reader).

After selecting an option from the File > Import menu or after connecting a camera or card reader (if Aperture is set to start when either of these devices is connected) the Import panel is displayed on the left of the screen (3). The images that are contained on the camera/ card will be displayed in the center panel of the screen. Aperture then places an arrow on the interface that indicates the source (card/ camera) of the import and the destination (new or existing project) where these files will be stored. If you want to import the images into an existing project then select the project entry in the Projects panel.

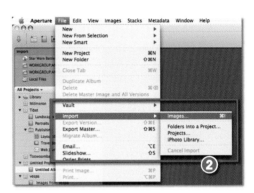

The time stamp for images can be adjusted and they can also be renamed and metadata details added during the import process. This information is set in the input sections on the right of the dialog (4). When complete, you can commence the transfer process by clicking

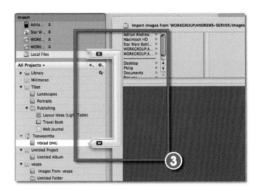

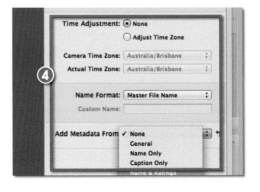

the import arrow or the Import button in the bottom right hand corner of the dialog.

After importing is complete the card or camera can be ejected by selecting either Eject Card, Eject and Erase Card or Done.

You can set Aperture as the default program to start whenever a camera or card reader is connected to the computer. This default is set via the Aperture > Preferences dialog (5).

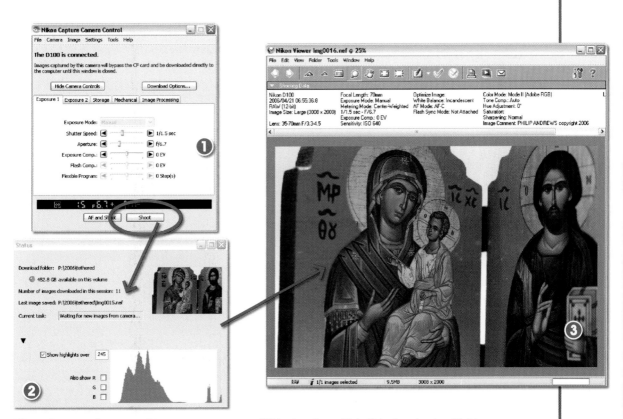

Nikon's Capture software provides remote capture capabilities together with built-in download and full image preview functions.

Shooting tethered – capture and download in one step

For those photographers who are shooting with their camera attached to the computer, or tethered as it is usually known, the download process takes a different form. Rather than being a completely separate activity that occurs after capture, most tethered systems bypass the camera's memory card and save the photos directly to the computer's hard drive. This means that there is generally a small time lag between the moment when the photo is captured and when it first appears on screen. Systems such as Nikon Capture use three separate windows/utilities for

1. adjusting camera settings and tripping the shutter,
2. tracking the download or transfer progress from camera to hard drive, and
3. previewing the resultant photo on screen.

Because the capture and download occurs in one action it is important to nominate the folder used for transferring newly photographed images before the shooting session commences. Depending on the software used for tethered shooting it may also be possible to add in date, time, copyright and even customized shoot information as part of the download process.

4

Raw Editor Round-up

When you select a piece of software to handle the conversion and management of your raw files one of the first questions to ask is which product will produce excellent results consistently? Which converter will get the job done in the least amount of time with the least amount of effort without compromising the quality of my raw image files? Phewww! After having made the decision to skip in-camera processing and produce raw files, it seems logical that whatever is done with the files after downloading them, should maximize the wealth of information in each image and make the most of the high bit files.

Figuring out what is best for you

Part of the madness connected with the advent of the raw file format is the whole question of which raw converter/processor software application or combination of converter and editing application makes sense for your workflow needs, expertise and interests. Perhaps we have too many alternatives to consider. So to make choosing a little easier establish some criteria for selection. General categories may include: (a) intuitiveness and learning curve; (b) ease of use; (c) length and complexity of its raw workflow; (d) camera and lens compatibility options; and (e) price. Then, for managing your digital assets, your raw files, consider whether you would like to work from a digital asset management software application such as Extensis Portfolio 8 that helps you manage, keep track of and process raw and other files with Photoshop, or handle archiving and cataloging within Photoshop using Bridge or one of the new complete workflow solutions such as Lightroom or Aperture.

How to choose:

Raw converter selection criteria

(a) Intuitiveness and learning curve
Raw converter makers and users alike want the raw conversion process to work 'right out of the box' and produce excellent results, quickly and painlessly, every time. Some converters may take longer than others to figure out and learn. If you are familiar with Photoshop Camera Raw menu navigation you will find similar menu design in many other converters. Ideally you will recognize how menus and submenu trees work and finding your way through the steps toward successfully and accurately processed raw files should be easy and not so bad at the very least.

(b) Ease of use
Ease of use is a function of intuitiveness and smooth flow from start to finish. Some examples of true tests are: time it takes to download images; making basic adjustments and allocating settings; getting through single image and batch processing; backing up, saving as DNG,

PSD and TIFF, without closing images inadvertently. It is also important to be able to quickly revert to previous settings or even remove all conversion changes altogether. When making your choice have a play with a trial or demo version of the software and check for yourself how easy the product is to use.

(c) Length and complexity of raw workflow

Some photographers will opt for the shortest possible route to completely converted and processed raw files and, at the other extreme, some will want to poke, tweak and double-check every teeny piece of data in their most important images. Others will want raw converters that allow processing based on the camera's ICC profile and the converter's algorithms for this profile, as well as the option of crawling through exposure, color management, lens correction controls and special features to handle more tricky issues such as moiré correction.

(d) Camera and lens compatibility

Some raw converters or browsers are not able to read the proprietary raw files that come out of some cameras. Check the converter for compatibility with your camera's raw file format. In the same way several converters take into account details of the lens and its settings at the time of capture when performing the conversions. If you desire this extra functionality then ensure that the raw software you select contains these features.

(e) Price

Price of the raw converter solution may or may not be an issue. The marketplace has some excellent third-party converters that are free or inexpensive. There are also pricier products that offer much more than simple conversions. But if you own a relatively recent version of Photoshop you can work with the Camera Raw plug-in without the need for additional purchase. Photoshop CS2 and CS both ship with Adobe Camera Raw as does Photoshop Elements 3.0 and 4.0. For the ultimate in economy most camera manufacturers ship a simple raw converter with their raw-enabled cameras. These small utilities usually perform a basic conversion with little or no chance of user manipulation of the conversion settings. Often these simple converters are installed as the default program for handling raw files and this action may mean that other software like Adobe Camera Raw will not automatically spring into action when first opening a raw file. To fix this problem you may need to remove the plug-in from your computer. Check out the Help documents for the utility for specific steps you need to follow.

Later in the chapter we will round up the most popular raw conversion and workflow software so that you have a clearer view of the candidates.

Raw software common features

There is a common set of features present in most raw conversion and workflow programs. Having a basic understanding of each of these components will help you make a more informed choice. Here we look at each feature in turn.

Downloading options

As we have already seen most raw converters can handle downloading of the raw image files from a card reader, direct from camera or other device. For example, if you use Phase One immediately upon inserting a memory card into the reader, a download setup Phase One menu pops up by default and handles the transfer process. Prompts appear in most converters to select a destination folder and there are often options for renaming and adding metadata details. The downloading dialog box should be easy to use.

File browsing, organizing, image ranking, and backup

Generally raw software will provide menus for organizing, sorting through, and marking image files for conversion. This browsing feature provides a good place to delete unwanted images and sort those you wish to keep. One convenient feature is the option to rank images on a scale of one to five, number of stars, or with a color label. This provides an excellent way to streamline your raw workflow early on by selecting which images should be carried through to the next stages. Winners, or near-winners, get processed first and then you can go back later and decide whether any others warrant your attention. Ranking is an important step in organizing your folders or catalogs of images and should be a feature that is high on your 'wanted' list when it comes to choosing software.

DNG export

If your camera does not save raw files directly to the DNG format then it is worth looking for this option in the conversion software.

In addition to its ability to save raw images in a smaller file size with lossless compression, the other two big advantages of using this format for archiving are

1. its inherent future sharing and proofing ability, and

2. readability among varied people.

Adobe promises that because of the open source nature of the format, DNG files will be readable well into the future and that the raw files saved as DNGs may be shared with others regardless of the proprietary camera software that generated the files. In the meanwhile it is good practice to save your original raw files to the DNG file format and then burn them along with the proprietary

file format version of photos to CD/DVD before putting them away for safekeeping. Saving to DNG from inside Adobe Camera Raw or via the DNG converter lets you store with lossless compression in a converted linear interpolated (demosaiced) format. You can also embed the original raw file and JPEG previews in the DNG file.

White balance eyedropper tools provide a single-click method for balancing the color in your photos.

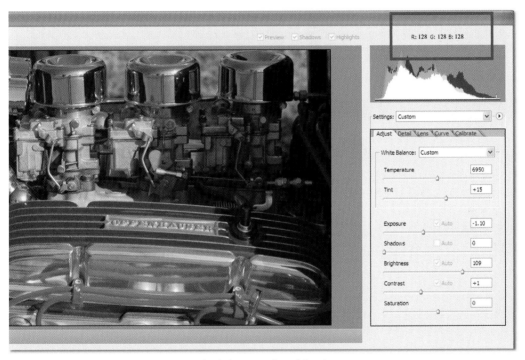

RGB readouts provide an objective way to check the neutrality of the photo.

White balance and color space options

Most users will choose to optimize the raw file within the converter and then move to an editing package like Photoshop to handle any pixel-based changes. For this reason the conversion software should include the ability to selecting a color space for your photo and features for performing any white balance corrections necessary. Typically the software will have a white balance eye dropper that you can use to neutralize an image by clicking on a gray spot in the image as well as a Red, Green, Blue (RGB) info panel. Note, when you move the eye dropper over the image the RGB color value will appear for that area of pixels. I like to find what I consider a 20% gray or neutral gray and click on it; often the RGB reading will be close to the ideal balance of 128-128-128 for RGB. In

the window pane reflection example image I clicked first on the area circled in red, then skimmed over the area again to look for areas with values close to 128 and clicked again. Sure this maneuver might be overkill but I find it reassuring and often a slight improvement when viewed on my calibrated monitor.

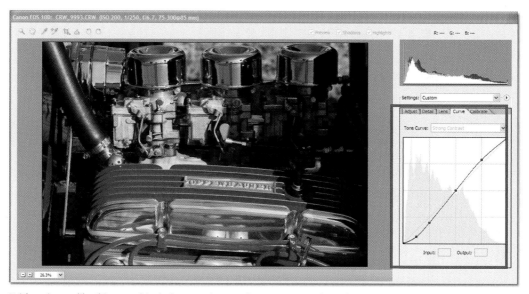

With an image like this one white balance and curves features are used to adjust the overall color as well as specific hues such as the reds in the photo.

Along with the eyedropper tool and standard white balance presets (Auto, Daylight, Shady, Cloudy, Tungsten, Fluorescent and Flash) also look for features where you can customize or fine tune the settings in the photo. Adobe Camera Raw provides a Temperature slider for yellow/blue changes and a Tint slider for green/magenta.

Many converters offer several other options for color space. The Nikon raw converter program offers several default color space options beyond Adobe RGB (1998) and sRGB. They are Bruce RGB, NTSC (1953) RGB, CIE RGB, Adobe Wide RGB, Apple RGB and Color Match RGB (used for desktop publishing and commercial printing work). Having a range of options will meet the needs of photographers who regularly produce their work for several different output formats (web, print, magazine).

Preview image area

The ability to accurately preview the raw images you are converting is critical for any software. Most programs not only provide a preview of the raw file but the preview is updated either automatically when you make a change to the conversion settings or after pressing an Update Preview type button. In the same vein, shadow and highlight clipping warnings that display as a colored area on the preview are crucial for accurate adjustment of white and black points.

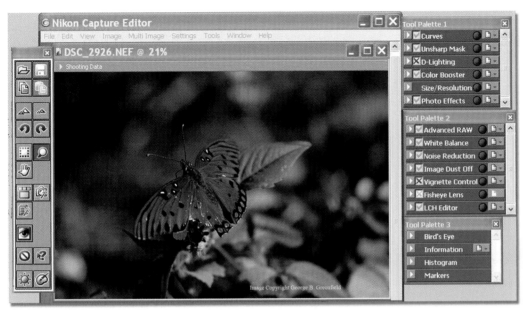

The importance of an accurate live preview window cannot be understated as the quality of your conversions will be based largely on what you see here. Simple conversions utilities that don't offer a preview should be avoided.

Passing raw files to image editing software

Apart from the newer workflow programs most raw software provides conversion only with the bulk of the editing workload falling on the shoulders of a separate imaging program. For this reason it is important that the program you select links seamlessly with your favorite editing program. For most of us this will mean linking with Photoshop and generally there are options during setup or installation that allow the user to nominate an editing program to link to the conversion software. Once linked it is a simple job to pass the converted file to the editing software. In Raw Shooter you select Convert the image and the finished file(s) go directly to the default program. When you are working with Camera Raw within Photoshop, you click Open, rather than Save, to move the picture into Photoshop proper.

Passing your converted file to Photoshop is simple when working with Adobe Camera Raw, just click the Open button (1), other programs contain link buttons (2) or menu items set up at time of installation.

Batch processing

At the very least you will want your converter to let you rename files in batch mode. In most converters you can save settings for images taken in similar or exact lighting conditions and apply the settings to subsequent and/or selected images. When you capture a set of raw images under similar or exact conditions this is a good time to use batch processing to get your images converted

quickly. You can save the camera raw settings that work for this set and apply them to a batch of files and, if need be, open individual files from the group to fine tune the general settings later.

Rotating, straightening and cropping

Rotating, straightening and cropping when converting can save processing time later. In some raw programs these changes can be applied to files losslessly (without destroying or changing the original pixels) and can be reversed later if necessary.

Adobe Camera Raw 3.0 contains both rotate and straighten buttons.

Exposure adjustment

One of the key building blocks for creating great photos is exposure and getting it right at capture should be in the forefront of your mind when pushing the shutter button. Of course you are not going to hit it perfectly every time and one of the thrills of shooting raw is being able to recover, within reason, slight mishits on exposure. This not to say that you can be less disciplined with your exposure control but rather to let you know that you have more room to move with raw files than JPEG versions of the same scene.

Anything beyond a 1 to 1.5 step adjustment (either plus or minus) to exposure will still cause deterioration in the final result but changes within this range are possible.

Clipping warnings

DSLRs have a large dynamic range or the ability to capture extensive shadow (black point) and highlight (white point) detail in the scene. What you don't want to do is lose this important data during the conversion process. So make sure that your raw software has aids for exposure adjustment that provide a warning if you are clipping details. A good histogram goes part of the way by displaying tonal values crawling up the left side (shadows) and right side (highlights) of the graph but a dedicated warning system is better. ACR 3.0 (and later) provides a separate warning feature for both highlight and shadow pixels (top right of the window for Photoshop CS2 and window bottom for Photoshop Elements). When switching on highlight clipping shows up in red patches on the preview image if any one of the RGB channels is clipped; shadow clipping shows in blue if all three channels are clipped. Be sure that the converter you use has this level of scrutiny.

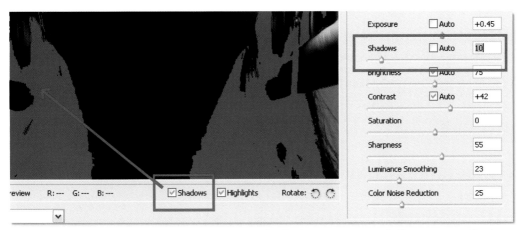

Clipping warnings provide immediate, and much needed, feedback on how your tonal adjustments are affecting the highlight/shadow areas of your photo.

Histogram display

A histogram display not only displays the distribution of pixels (from shadow to highlight) within your photo but also indicates what happens to your image when you adjust sliders and make other enhancement changes. The histogram is one of the most important tools for working successfully in raw conversion. Watching the histogram is tantamount to keeping your eye on the prize. Your job is to make slight adjustments to shadows, midtones and highlights so that the picture's tones are distributed along the base of the graph without causing clipping. Ensuring that your conversions software has a live histogram will help make these changes possible.

Noise control

These features help rid your images of problems with noise normally introduced at medium to high ISO settings or long shutter speeds. Some cameras show noise sooner than others but most exhibit the problem in varying degrees as soon as you exceed the minimum ISO level for the camera. Luminance noise is often easily seen by the eye – be sure to zoom in on your image – at 300% and is similar to what we used to call grain in the days of film. Color noise is different in that it is the random red, green and blue pixels that often invade dark areas of the image at higher ISO values.

Software such as DxO Optics Pro not only provides automated raw conversions that are pre-determined for different camera and lens combinations but also has a noise engine feature which can provide up to a 2-stop noise improvement. That is, with a 2-stop noise gain if you shoot at ISO1600 you end up with noise that is similar to that of a picture photographed at an ISO of 400. In addition the DxO Optics engine automatically removes lens distortion, vignetting, lens softness and color fringes. Many other raw converters have additional features for noise reduction and lens correction and if these are key parts of your own workflow then compare those that offer these solutions as part of the conversion process.

The DxO Optics engine automatically removes lens distortion, vignetting, lens softness and color fringes and also contains special functions for noise reduction.

Some photographers still prefer to work on noise reduction and sharpening in Photoshop after conversion, using the Reduce Noise and Smart Sharpening filters. Of course, working on these problems after raw conversion means that you will lose the non-destructive benefits of performing them via a product like Adobe Camera Raw.

Lens aberration correction

Chromatic aberration, usually a red/cyan or blue/yellow fringe of color in an image, is a bothersome lens problem. What happens is the lens fails to handle all the color frequencies (color signals) thrown at it in the same spot.

We can take comfort in the fact that lens manufacturers are alleviating much of the problem with lenses used with digital cameras; however, the made-for-digital lenses will probably never be perfect in all lighting scenarios. Chromatic aberrations (color fringes) disperse wavelengths of light and monochromatic (white) aberrations do not but both cause problems in our images.

Vignetting (darkened picture edges) can be both a good and bad thing. It's good when it is added to a portrait and it's bad when it appears around the edges of your image when you did not plan on having it there. Bad vignetting is like an awful shadow that sometimes appears around the edges of an image.

Thankfully many raw conversion programs now include features designed to correct color fringing and remove the effects of vignetting. In Adobe Camera Raw these tools are located in the Lens tab. Though not a critical element for a full raw workflow having these corrective features available means that on the odd occasion when you need to use them they are at hand.

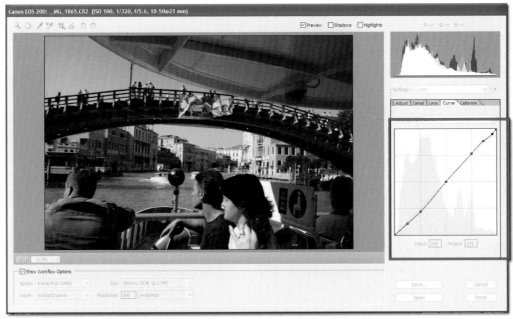

Adjusting the middle areas of your image is a key enhancement task so make sure that your raw conversion software allows easy changes to brightness and contrast of these tonal areas.

Tonal control

Having the tools available for fine tonal control is critical for good raw conversions. We have already seen that this involves being able to adjust the white point and black point areas of the photo carefully but that's not where the changes should end. We also need the ability to manipulate the brightness of the midtone regions of the photo and also a way to increase or decrease the contrast of these values as well.

Different software packages provided different approaches to these tasks. Some offer curves controls while others add in extra sliders designed to manipulate midtones whilst leaving shadows and highlights be. These controls are some of the most important that you will ever use so make sure they are easy to understand and apply to your photos.

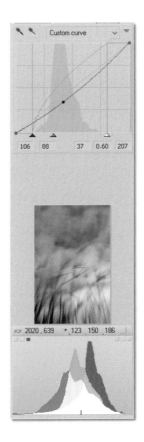

Pixmantec's Raw Shooter also contains a curves feature. It is designed to provide fine-tuning control over the tones in your pictures beyond that offered by the standard contrast and brightness sliders.

'What are my options?' Editor round-up

To help get you started down the raw editing track, we tried several of the packages that provide interpolation and editing options for your files. This is by no way an exhaustive list, nor does it fully cover all the manufacturer specific programs that are supplied with your raw ready camera, but it will give you an idea of the range of utilities that are available on the market.

To satisfy yourself about which package suits your needs best, our advice is to always test run 'trial' versions of the programs for yourself. Most software companies provide such time-limited demo versions via their websites. Download them, install them and then put them through their paces. It will become obvious which ones fit your workflow and which ones are way off the mark.

Note: Whilst this list was current at the time of printing new and improved raw converters are appearing all the time.

New developments

Professional photographers who are Mac users now have the option of using the new Apple Aperture software, set up to work in conjunction with Photoshop. The new post-capture software allows users to work, manage, enhance and output to web or print without converting the raw files. Both Aperture and Adobe's new offering, Lightroom, use this approach and together they are the new breed of complete raw workflow programs. For professionals for whom time is definitely money and image quality is bread and butter, investing in highly sophisticated raw workflow-based software packages like these is easily justified. For the rest of us the jump might be a little too much but don't disregard these programs as there are real efficiency gains to be made with a dedicated raw workflow program.

Doing it yourself

Only you can decide whether you want to always think through how each session's images should be adjusted and handled, if you are willing to leave the raw file optimization mostly up to the experts who wrote the programming code for the software and do your creative thing in Photoshop, or if

you want to optimize and manage your digital assets from start to finish, bringing Photoshop into play only when appropriate.

Your camera manufacturer makes life simple for you, at least initially. You can always get your feet wet with the camera's raw converter, and then step back, evaluate it and consider all the other options out there. You can use the camera's software to get you to a point at which you are comfortable and then move the images over to your favorite image editing program.

If you dislike some features of the camera's raw converter and/or you are more comfortable working inside Photoshop, you can seamlessly use the, now built-in (no longer plug-in), Adobe Camera Raw (ACR) converter. This approach fully integrates with Adobe Photoshop CS2 and its companion Bridge, an expanded file browser. Photoshop Elements users get similar integration with a slightly modified version of ACR and Elements PhotoBrowser or Organizer. Adobe Camera Raw together with Photoshop or Elements provides end-to-end raw processing and image enhancement for amateurs and professionals.

If you are a relative newcomer to Photoshop and/or prefer keeping life simple don't ignore the potential power of using Elements 4.0. Its raw converter has many of the raw adjustment and detail features found in CS2, handles raw images with little fuss and is able to move the converted files to an editor workspace for final enhancement and output. The key feature areas covered in the Adjustments and Details tabs are common to both versions of the converter.

Photoshop CS2 has the same converter engine but with a few more expert controls and will work for those of you who are professional photographers, graphic artists or otherwise enjoy using the features of Photoshop CS2. The Photoshop CS2 version of ACR also contains Lens, Curve and Calibrate controls.

There are many third-party software applications that also provide raw workflow or conversion solutions. These applications allow you to do everything from downloading and converting raw files to shooting whilst physically or even wirelessly tethered to your computer. Most raw-enabled applications work in conjunction with Photoshop and via the software preferences you will be able to nominate Photoshop as the default destination for further image enhancement. Products like Raw Shooter and Phase One Capture One are examples of popular raw workflow-based programs that can pass the finished files to Photoshop.

One of the biggest challenges all camera manufacturer specific raw software developers constantly face is keeping pace with new releases of cameras. Not every raw converter can read your camera's proprietary raw file. Raw converter companies frequently make announcements about the latest list of new camera and lens additions to their arsenal. One admonition for you is to frequently check your raw converter's site(s) for updates for your camera and/or lenses. Every time you purchase a new camera you will need to upgrade your third-party software and make certain your specific camera's profile is supported by your favorite converter.

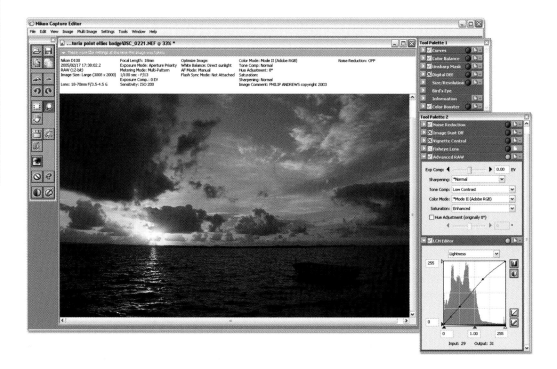

Nikon Capture Editor

Web: www.nikon-image.com/eng/software/
Cost: US$99.00
Trial download available: yes or use the free trial that comes with your browser software (Nikon View)

This is the dedicated Nikon raw editor designed for use with all the models in the Nikon line-up that are capable of raw capture. A trial version of the program comes with the camera browsing software but to extend your use beyond the trial you will need to purchase the software. Now in version 4.3, Nikon Capture provides editing and enhancement tools to alter brightness, contrast and color balance and specific raw-based adjustment of white balance, tone compensation, color mode, and sharpening. The latest version features new options for color noise reduction, edge noise reduction, saturation control, automatic vignetting correction and rectilinear remapping of extreme wide angle lenses. This is the option to stick with if you want to keep the whole image download and raw conversion process with Nikon.

Note: At the time of writing Nikon was in the process of completely overhauling their Capture program. The new converter is called Nikon Capture NX. It is a much improved version of the software with many automated features and a completely new interface.

Similar manufacturer specific utilities are available for other camera makes such as Canon, Fuji and other hardware manufacturers.

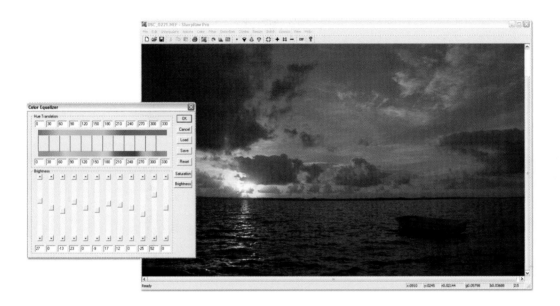

SharpRaw

Web: www.logicaldesigns.com/Imaging1.htm.com
Cost: US$99.00
Trial download available: yes

This is the only editing software in the group that uses Neural Network technology in the interpolation of raw files to create pictures with a balance between high resolution and low noise.

The program provides no less than three other methods of interpolation and an option to view the unprocessed Bayer pattern as well. SharpRaw can be used with Canon, Nikon, Minolta, Kodak, Fuji, Sigma, Sony, Pentax, Contax and Olympus generated files.

The program features three different methods for auto white balancing, built-in controls for lens distortion and color balance correction, image resizing with perspective control levels and an unsharp mask filter.

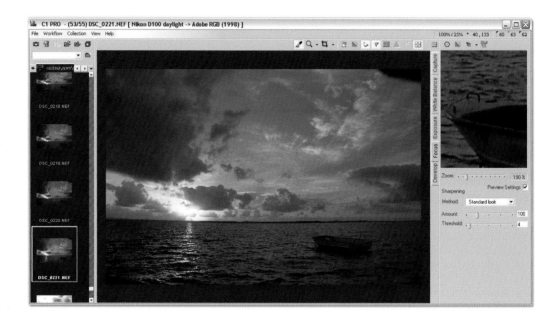

Capture One

Web: www.phaseone.com
Cost: US$99.00 for the LE version,
US$499.00 for Pro edition
Trial download available: yes

With support for a range of cameras, including the ability to drive the famed Phase One digital camera backs, this software is an industry strength editor from a company who has been at the forefront of raw capture for years. The software provides clean and sharp results. The program can be used with Canon, Pentax, Nikon, Fuji, Olympus, Leica and Epson cameras.

The software allows a range of image adjustments such as gray balance, levels/curves, contrast, crop, sizing, unsharp masking to be carried out in one process with instant feedback on the screen. For the color conscious photographer, the Color Edit option allows you to adjust existing color profiles directly.

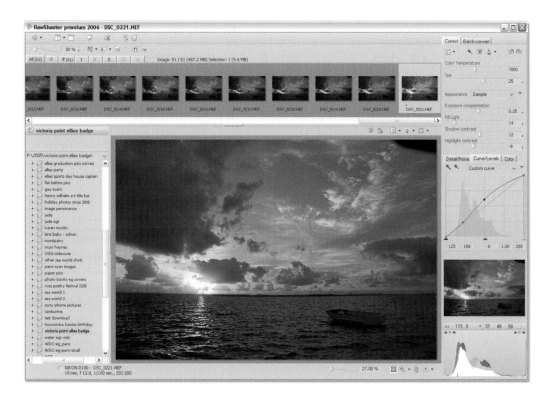

Raw Shooter

Web: www.pixmantec.com
Cost: Raw Shooter Essentials 2005 – Free,
Raw Shooter Premium 2006 – US$99.00
Trial download available: yes

The new contender in the raw conversion ring is Pixmantec's Raw Shooter. The product is shipped in two different Windows-only versions: a free light edition called Essentials 2005 and a beefier professional release titled Premium 2006.

The core technology between the two packages is the same, with the free version containing a smaller enhancement and editing feature set. Like most of the software featured here, Raw Shooter is as much a raw workflow tool as a conversion utility. Users can download, browse (with great speed), edit, correct and convert individual as well as batches of raw files.

A recent addition to the Raw Shooter line-up is a new Color Engine. The module acts as a plug-in for the Premium edition and helps to provide better color matching and accuracy.

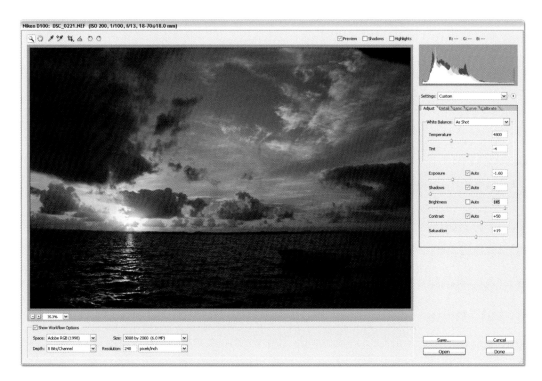

Adobe Camera Raw (Bridge, Photoshop and Photoshop Elements)

Web: www.adobe.com
Cost: included in Photoshop and Photoshop Elements
Trial download available: yes as part of download trials of Photoshop and Photoshop Elements

Designed to act as a plug-in for both Photoshop, Bridge and Photoshop Elements, the Adobe raw converter starts when you open a raw file from inside either program. The big pluses with this editor is the fact that it is fast, easy to use, has a great preview, it is well laid out and works seamlessly with the king of digital imaging software – Photoshop – or his little brother – Photoshop Elements.

No need to process the raw file in one program and then open the processed file in Photoshop to finish the editing job. The transition between the raw conversion program and Photoshop proper is smooth and effortless and in the latest version many of the enhancement tasks can be applied to the file without having to pass it to the main editing space at all.

The workflow is simple – move through the controls on the right hand side of the screen from top to bottom, select your output size, color space and bit depth, press OK and you're done.

The differences between Photoshop and Elements versions of Adobe Camera Raw are listed in Chapter 7. Step-by-step conversion techniques for ACR are described in Chapters 7 and 8.

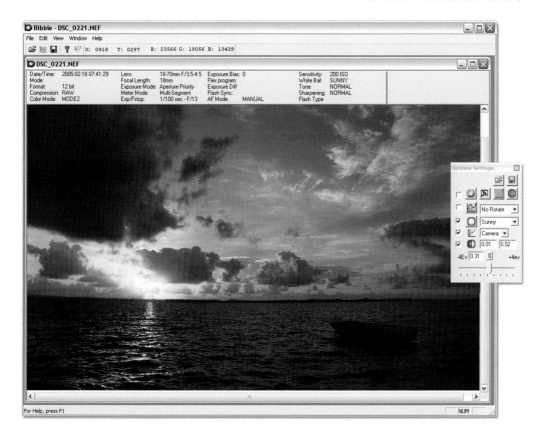

Bibble

Web: www.bibblelabs.com
Cost: US$129.00 (Pro)
$69.00 (Lite)
Trial download available: yes

A long time favorite with the raw shooters, Bibble provides a quick and easy way to convert and enhance your raw files. It has support for Nikon, Fuji, Olympus, Kodak and Canon cameras. The program can be used in stand alone mode or as a plug-in for Photoshop, allowing raw files to be opened from the program, processed via Bibble and then loaded into Photoshop.

Bibble is a good performer with a long history of dedicated supporters. Image adjustments include One Click White Balance, Advanced Highlight Recovery, RGB Color Balance, HSV Balance, Contrast/Brightness, Hi-quality Image Size Re-sampling, Image Rotation, Image Equalize and Image Auto-level. Image processing filters include: Blur, Sharpen, Median Cut, Unsharp Mask and Magenta Fix. The latest Pro version now also provides Noise removal and a cool technology called Perfectly Clear.

What's more this software comes in Pro and Lite versions and editions that are suitable for Windows, Macintosh and Linux platforms. Yes, you heard, even Linux is included!

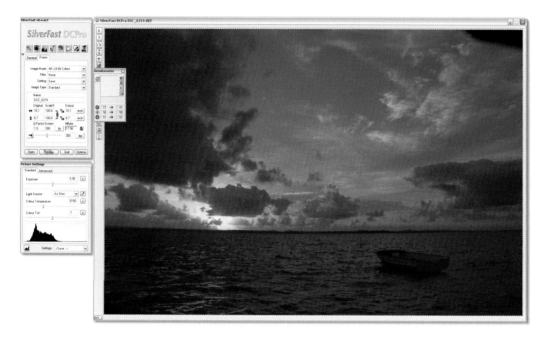

SilverFast

Web: www.silverfast.com
Cost: DCSE US$49.00, DCVLT US$85.00,
DC PRO US$399.00, DC PRO Studio US$499.0
Trial download available: yes

Probably more well known for their scanner control programs than their camera software, SilverFast produces a range of products designed specifically for the digital photographer. There are no less than four different versions of their products ranging in price and sophistication from entry level to die-hard professional.

The program is based around the concept of a virtual light table where files can be viewed, organized and managed; the software provides automated raw conversions for a range of supported camera formats. Double-clicking a thumbnail on the table moves the file into the full SilverFast editing workspace. In addition auto raw conversion of each of the products includes a variety of essential image correction tools such as red-eye removal, color correction, white balance adjustment and exposure control. As you move up the SilverFast DC product range the sophistication and power of the included tools increases. The highest level products include facilities for IT8-calibration of cameras, smart removal of defects, selective color correction, adaptive color restoration, grain and noise elimination, and removal of multiple casts. In this way SilverFast DC products provide good image enhancement control but limited control over the raw conversion itself.

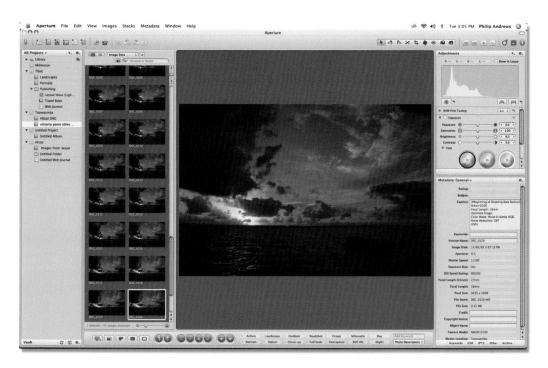

Aperture

Web: www.apple.com
Cost: US$299.00
Trial download available: No

Built from the ground up as a complete workflow solution for the professional photographer Aperture is one of the new breed of raw-enabled software. Unlike other programs, where you need to convert from raw to another format such as TIFF or JPEG before commencing the real work, Aperture maintains the original raw file throughout the many enhancement and management tasks possible within the program. It is a true lossless workflow from capture to archive.

The interface is slick and well designed (well what else would expect from Apple?) and provides easy access to the main functions provided by the software, namely, importing, editing, cataloging, organizing, retouching, publishing and archiving.

The program supports all the major camera brands and provides quality interpolation of their native raw files as well as providing the opportunity for saving all your hard work to the DNG format. As you would expect from a professional level program Aperture contains multiple tools for tweaking your raw file including those designed for adjusting, white balance, exposure, tonal levels, the position of highlights and shadows, saturation, conversion to black and white, sharpening, straightening and cropping. For a step-by-step walkthrough of Aperture go to Chapter 14.

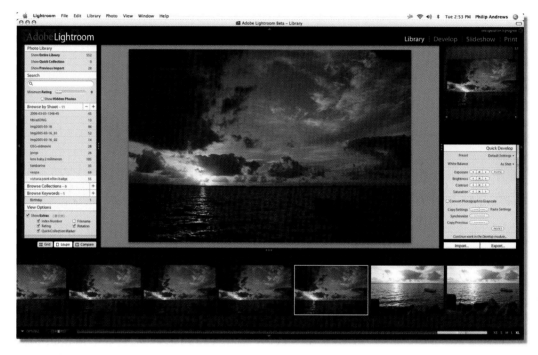

Lightroom

Web: labs.adobe.com
Cost: Unknown
Trial download available: Beta download available from the website at time of writing

Lightroom too offers the working photographer the chance to use a full raw workflow from capture to print or web without the need at any point to convert the file from its original capture format. At the time of writing the program was still in beta release but this new Adobe software is so important to the world of raw shooters that we couldn't not include it here. Even in this development stage the product structure is plain to see. The main functions are separated into four different modules – Library, Develop, Slideshow and Print.

Download, management and organizational functions are taken care of in the Library module. Editing and enhancement tasks are performed in the Develop module and selected pictures are output to either a slideshow or prints via the last two modules. The program is very fast and, as you would expect from the company who brings you Photoshop and Adobe Camera Raw, contains a host of powerful editing and enhancement settings that allow the user to fine tune the color, tonal distribution, sharpness, white balance, convert to gray and cropping of the image. In addition metadata can be added quickly to individual and groups of images and whole collections of photographs sorted and managed with ease. To see Lightroom in action go to Chapter 13.

5

Establishing a Raw Workflow

By now you have plenty of information with which to start to make a decision on what type of digital raw workflow will work for you. At least you have some sort of idea whether you want to do everything yourself or let your converter do most of the work for you. You probably have an initial idea whether camera, Photoshop, third-party software or some combination is right for you. What you may not yet have in place is a list of the basic raw workflow components in order of execution. This chapter will fulfill that remaining piece of the puzzle.

What is a digital raw workflow anyway?

Workflow for just about anyone in any profession, vocation or serious hobby is an established set of steps one routinely and efficiently goes through to achieve a specified task of the highest possible quality and outcome (and often at the lowest possible expense). A digital raw workflow is a subset of the master digital imaging workflow that specifically includes steps for capturing, converting, processing, outputting and archiving image files from digital raw files, files that are not processed in the camera.

The digital raw workflow overlaps with, and often includes, other types of standalone imaging workflows: DNG, color management (or color managed workflow), printing, and archiving. All four are integral parts of the essential components of a basic digital raw workflow.

Establishing a workflow that works for you

As with many things digital there are a range of different ways to process your raw files. Here we will present a variety of workflow approaches, all designed for specific photographic environments. It will be your task to pick the approach that fits best with how you work. Like an old glove, the workflow that you choose should fit comfortably. Most workflows fit within two different methods of working. To get us started let's look at each of these approaches as well as the generic components that form the base of all workflows.

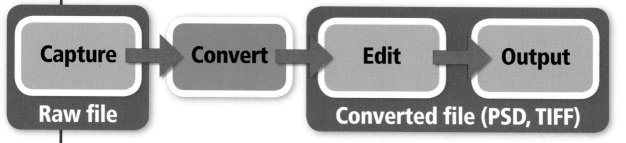

The **Convert then Edit** approach is the most popular workflow currently used by raw shooting photographers. The raw file is downloaded from the camera and the first task in the process is to convert the file to a type that is more readily supported by photo editing programs such as TIFF or PSD.

The 'Convert then Edit' approach

Until recently, the only way to deal with raw files was to convert them from their unprocessed format to a file type that could be manipulated by photo editing software. The conversion process was handled by specialist software such as Adobe Camera Raw, Pixmantec Raw Shooter or the raw utilities supplied with the camera. As we already know there are a variety of global enhancements (contrast, brightness, color, white balance etc.) that can be applied to the photo during the conversion process but for many photographers the real work only commenced after this process was finished. For this reason this workflow is often referred to as a *Convert then Edit* approach.

The workflow structure sits well with new raw users as it allows them to carry on with their standard editing approach after the conversion is complete. It also mimics the traditional photographic process where a single negative (raw file) could be processed in many ways providing a variety of different outcomes. The process takes full advantage of the quality gains available from careful processing of the raw file and it is still the primary way that most photographers unleash visual power of their raw files.

The disadvantages of this approach is that once the conversion has taken place the ability to adjust the conversion settings are lost. Yes it is possible to reconvert the file with different settings to facilitate a different outcome but essentially the core of the workflow is that at a specific stage in the process the raw file will now longer be the base reference for the image. The processing that used to occur in the camera is delayed and handled, albeit more consciously and carefully, on the desktop but the result is the same – the raw file is converted to another file type and factors such as white balance become fixed and irreversible in the conversion.

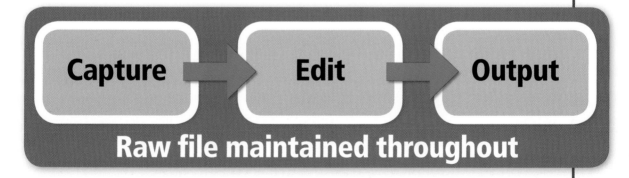

Capture → **Edit** → **Output**

Raw file maintained throughout

*In contrast to the previous approach, programs that provide a **full workflow** approach, maintain the raw file throughout the whole digital imaging process. This completely non-destructive workflow is the way of the future for raw shooters as is growing in support with both Apple and Adobe releasing dedicated raw workflow products for the professional photography market. Not to be left out, new editing and enhancement techniques and 'workarounds' for Photoshop CS2 and Bridge users that adopt this workflow approach are being promoted all the time.*

Full raw workflow options

Until the release of Aperture, Lightroom and, to a lesser extent, Bridge and Photoshop CS2, *Convert then Edit* was the only option open to dedicated raw shooters. But that was then, and this is definitely now! Raw shooting and processing is no longer in its infancy and along with the area's growing maturity has come new ways of working and new products to facilitate new workflows.

With the new full workflow programs it is possible to maintain the raw state of the picture file throughout the whole digital imaging process. The multitude of raw conversion settings can be edited, reversed or even cleared at any time in the process. The primary image data is never destructively altered, only the way that this data is interpolated and previewed on screen is changed. This is the future of raw processing and more and more image editing products will adopt a full workflow attitude as raw shooting becomes the norm, rather than the exception, for quality hungry shooters.

New complete raw workflow products like Adobe's Aperture provide end to end processing of the raw file without the need to convert the file type to any other picture format.

More details later

To provide you with a good overview of these two fundamentally different ways of working with raw files we have dedicated the next two sections to these workflow types (see contents list for details):

Section Two: Processing Raw Files

Section Three: Complete Raw Workflow Options

Workflow components

Behind every workflow is a basic skeleton to: (a) capture; (b) organize and download; (c) process and store; (d) share, print and send to web; and (e) archive. You can make a raw workflow simple or complex, short or long.

Here are the steps involved in a basic raw workflow:

Raw capture:
- Take your best shots with proper settings, particularly focus and exposure
- Check captures by zooming in on portions of image and analyzing histogram
- Delete poor images in camera

Raw file organization and management:
- Download
- Sort
- Organize, tag, rank, and caption, if desired
- Add metadata
- Back up as DNG in separate storage location
- Automate repetitive tasks, such as batch renaming, batch captioning

Raw processing, conversion and optimization in raw converter
- Process to obtain maximum quality
- Color balance
- Crop, straighten and sharpen, if desired
- Save converted raw files to DNG and back up converted files to offline storage

Raw file, or converted file, optimization in image editing program
- Open image and perform any required image enhancements
- Clean up any flaws
- Perform creative enhancements
- Apply actions and batch procedures
- Prepare for printing, web, PDF documents, and other output

Image output
- Print enhanced file
- Create online gallery or slideshow with processed files

Raw file archiving and cataloging
- Establish and implement an archival plan, using Adobe Bridge, Extensis Portfolio, or iView Pro for Photoshop CS2, the Elements 4.0 Organizer or other archival and image management software
- Save files on external devices and media for easy access and retrieval

Basic workflow components:

Workflow timesavers

Whilst we are talking about workflows it is good to consider the fact that many photographers don't like capturing in raw as they feel that the extra time taken to process the file format is time they can ill afford in their already busy lives. So when considering which workflow approach to adopt ensure that there are opportunities to speed up the task of raw processing.

One such opportunity for saving time is to use any batch processing features contained in your raw software. Some even offer the opportunity to have the batch functions operating in the background while you are performing other tasks in the foreground. Of course, using actions, droplets, automated scripting and keyboard shortcuts can also be equally helpful.

The following is an example of how raw processing can be performed quicker and more efficiently.

Synchronize settings across images

When we go on a specific shoot, or off to a particular destination, often the lighting conditions for a series of images on the same subject are very similar. We might use the exact same exposure settings for every image in the series. Why not put together a group of settings for the entire series and apply them simultaneously? Photoshop CS2, using Bridge, has this type of batch processing function. It's called synchronization.

1. First create the settings to be synchronized across the folder. Open Adobe Bridge to locate the folder with shots made under similar conditions. Select All. Then go to File > Open in Camera Raw.

2. When the Camera Raw window opens, you will see a filmstrip of images on the left hand side. Select an image. Using the settings here make changes to the raw file that is active in the thumbnail window: white balance, exposure slider and others.

3. Next synchronize the settings across all images in the selected folder. Choose Select All and then click Synchronize.

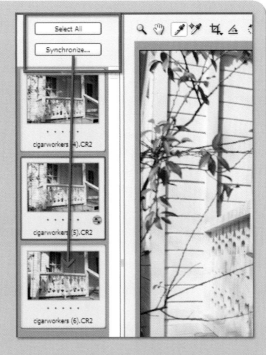

4. Select the settings you want to apply to the images. For example, choose Everything from the pop-up menu and then click OK.

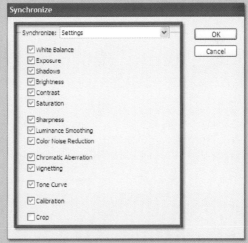

5. You can also apply new settings to the selected images simultaneously. Go to the Curve panel, for instance, and make some adjustments to the tone curve. Click Done and the tonal curve changes will be made to all selected images in the filmstrip.

Step by step synchronization:

6. Now let's have some files working in the background. Open six images in Camera Raw and select three of them in the filmstrip. Now click the Save 3 Images button. Make some changes, such as format options and file naming, and click OK. Go back to what you were doing in Camera Raw and the three selected files will be processed in the background while you are working on other images.

More techniques for batch processing and multi-file conversions that are guaranteed to save you time and effort can be found in Chapter 9.

Browser J:\Images backup\2006\d

View Image Folder Tools Window

ing Data

13 10:01:08.7
-bit) Lossless
ze: 3040 x 2014

-55mm F/3.5-5.6 G

Fo
E
M

Apertu

200

Folders

2005
2006
 d50 examples
 Hblad DNG
 Joys 50th
 Justin@ion
 kids birthday aliens sho
 lens baby 2 millmeron
 lens baby examples
 lens baby millmeron
 milmeron show
 nephew sleepover
 tethered
 color test image
 d100
 ellies pictures
 fstop
 general pictures
 IMAGE-DATA-TRIP04
 JPEG
 karen's fav
 kevs
 media images
 pans
 phils fav
 pica
 d pictures

6

Camera-based Converters

All camera companies that manufacture models with raw capture capabilities also supply picture management and raw processing software. In most cases, the applications include a dedicated image browser, a workspace where photos can be enhanced and edited, some raw conversion utilities, management and sorting options and a means for outputting to print and screen.

The sophistication, features list and abilities of these programs vary from company to company and camera model to model. In addition there are often several different levels of conversion and management functions depending on if you are using the free package that came with the camera or the upgraded pro version that is purchased and shipped separately.

In the Nikon system for instance basic browsing, management, conversion and output options are all available with the software that accompanies the camera drivers on the freely supplied install disk. However, professionals can opt to purchase an upgrade to this software which provides more functionality for the end user. The upgrade provides more options for raw processing plus the ability to control the camera remotely for tethered shooting scenarios.

In this chapter we will look at how these camera-based converters work and how they compare with other raw workflow solution options.

Camera-based converters software

Camera make	Software
Nikon	Capture Editor Capture Camera Control
Canon	Digital Photo Professional
Sigma	Photo Pro
Leica	SilverFast DC
Samsung	Photofun Studio
Kodak	EasyShare

Camera make	Software
Olympus	Olympus Studio
Pentax	Photo Laboratory
Sony	Image Data Converter
Fuji	Hyper-Utility
Samsung	Digimax Master

Which is better – the raw conversion software that came with your camera or the one that is included in your favorite editing program?

Advantages and disadvantages of a camera-based system

As digital photography authors one of the questions we are asked constantly is 'Which is better, converting and editing my raw files with software created by my camera manufacturer, or with utilities produced by the maker of my editing software?' This is not an easy question to answer as there are advantages and disadvantages with each approach.

Camera-based converters are arguably better able to handle the conversion of raw files than their generic counterparts. After all, the guys that are deciding how the image details will be encoded in the raw file are the same guys who are producing the raw conversion software for the camera. If anyone should understand how to get the best from the camera files it should be these folks. 'So I should go with my camera-based software?' 'Well, maybe?'

Keep in mind that the accumulated image processing knowledge that a company like Adobe has developed over the last decade or so provides a substantial foundation for the creation of their own conversion programs. Add to this the fact that a product like Adobe Camera Raw fits so snugly in the Bridge/Photoshop workflow that using any other utility seems like too much hard work to be seriously contemplated and you start to see how compelling the argument is for adopting an all Adobe workflow.

Does it sound like I am hedging my bets? Well, yes I am! At the moment there is no definitive answer to this question. The best advice is to try each approach and see which is the best fit for you and the way you work. When testing don't forget to compare the quality of the converted files, the ease of working and the size and range of the feature and tool set.

Most software producers supply free trials of their products. So don't be backward, download several candidate programs and spend some time comparing the way they work.

Different levels of support – the Nikon system

The Nikon system for handling raw provides a good example of how a camera-based conversion system can function in conjunction with your normal image editing workflow.

Basic features

A basic level of raw support is installed onto your system when you first load the utilities that came with your camera. During this process, not only are camera drivers installed on your computer but Nikon also loads a browsing application called Nikon View. The program is used to view the photos that are downloaded onto your computer. The interface contains thumbnail previews of the pictures including those captured in the Nikon raw format (.NEF), a display area where shooting data is listed along with a modest range of tools in a simple toolbar. The features grouped here are designed for tagging (rating), searching, printing, emailing and creating slideshows. No editing tools are available in the browser application or even the enlarged preview window which is displayed when

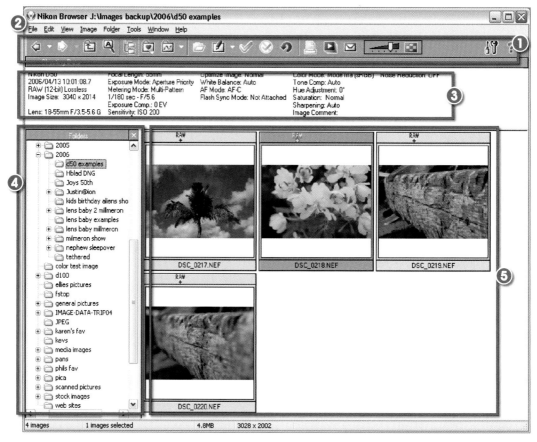

The Nikon View browser interface – (1) Toolbar. (2) Menu and title bars. (3) Shooting or metadata area. (4) File/ folder navigation area. (5) Thumbnail previews.

a thumbnail is double-clicked. Instead these options are made via linked helper programs. Nikon's own Capture Editor is listed by default as is the standard Editor and the Large Preview Generator for the NEF utility. Other programs can be added to the list and it is here that photographers who want to browse in Nikon View but convert with Adobe Camera Raw add a Photoshop option. Images to be edited in Photoshop are simply highlighted in the browser workspace and then the Photoshop option is selected from the pop-up menu accessed via the Edit button.

The Edit button in the Browser and Preview windows of Nikon View provides a quick way to transfer the select photo to your favorite editing application.

Note: Though listed, the Capture Editor is only available as a trial with the basic install and needs to be purchased separately if it is to be used past the trail period. As this programs provide the most comprehensive raw conversion options serious raw shooters will need to pay the extra cash or alternatively shift the bulk of their processing requirements to another conversion program.

The NEF Photoshop plug-in

The basic install assumes that photographers will be using a package such as Photoshop for most of their pixel by pixel editing changes so as well as loading the browser a small NEF plug-in is also placed in the plug-ins folder of Photoshop. It is designed to provide basic (white balance and exposure only) conversion settings when a NEF file is opened from inside Photoshop. Interestingly, when this plug-in is installed Adobe's own raw utility ACR ceases to function.

The NEF plug-in is designed as a simple way to convert raw files when opening them into Photoshop. It provides exposure and white balance controls.

Pro's tip: After installing the drivers for a new camera you may find that you no longer have access to ACR and that instead the Nikon plug-in keeps appearing when you are attempting to open raw files. If this occurs and you want to restore ACR as the default raw utility then you will need to remove the NEF plug-in from the plug-ins\Adobe Photoshop Only\File Formats folder in Photoshop.

More sophisticated control

If you want a little more control over your raw conversions than white balance and exposure controls provided by the NEF plug-in then Nikon also produces a dedicated software program called Nikon Capture Editor. Unlike the simple Editor that comes free with Nikon View Capture Editor is a full blown raw converter. The package is one part of a two program upgrade that can be purchased separately from Nikon dealers. The second software component is the Nikon Capture Control which provides remote camera operation for studio use. See Chapter 2 for more details on this software.

The adjustment options in Capture Editor are grouped in three separate tool palettes. Palette one (1) contains a Curves control, the Unsharp Mask filter, a Red-Eye Correction tool, and a Size/Resolution control. Also in this palette is the D-Lighting feature that opens shadow detail and boosts picture color, and Photo Effects control with options for creating black and white and toned monochromes.

The second palette (2) houses more advanced adjustments some of which are only available for raw file processing. Here you can alter white balance, exposure, tone compensation (contrast), change color modes and adjust the saturation of the photo. In addition, a Noise Reduction option and Vignette Control are both included along side a specialist LCH (Lightness, Chroma, Hue) curves control.

The Image Dust Off and Fisheye Lens features are great examples of what is possible when the hardware manufacturer is involved in creating their own image processing software.

The Image Dust Off option lets you eradicate the dust marks that can appear in photos as a result of having a dirty camera sensor. The feature is used via a two step process. To start, you create a reference photo by switching to the Dust Off Ref Photo selection of the camera's setup menu and then shooting a flat white featureless subject from a distance of 10cm. This file is then referenced in the Image Dust Off palette where the program uses the reference file to locate and eliminate the dust in the photo.

The Fisheye Lens control automatically dewarps the bulging images that are captured with extreme wide angle lenses. The feature uses the lens information contained in the metadata of a picture file to correctly identify the lens used at the time of capture. The pixels in the photo are then remapped to a rectilinear format.

The Nikon Capture Editor palettes.

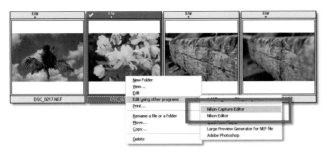

You can choose from a range of editing options from inside the Nikon View browser. Simply right-click the photo to be edited, select the Edit using other programs option and then choose the application from the list provided. To add another editing program to the list select the Add/Remove editing program option and locate the program to be added to the list.

This level of lens correction is only possible if the characteristics of the lens are fully known. Its true that other editing programs, such as Photoshop CS2, have sophisticated lens correction features but generally these apply generic adjustments rather than ones designed specifically for the lens in question.

The third palette (3) contains a Navigator like control Nikon calls Bird's Eye as well as a histogram display, the Nikon equivalent of the History palette called Markers and an Information palette. The

The Nikon Capture Editor interface – (1) Toolbar. (2) Preview area. (3) Tool Palette 1. (4) Tool Palette 2 – Advanced Raw options. (5) Program menu bar.

last feature is designed to allow the user to sample the RGB values of various pixels in the image and track these values during tonal and color changes.

A hybrid approach

Because of the camera and lens specific corrections such as 'dust off' and 'fisheye lens fix' many photographers prefer to stick with the raw software offerings provided by their camera manufacturer. Though it is not possible to apply and save these corrections to the raw file and then complete the conversion in another program such as Adobe Camera Raw, the corrected file can be passed directly to Photoshop. This hybrid approach to editing means that all raw correction and conversion settings are applied in the camera-based software, after which the file is sent to Photoshop where the pixel-based editing is completed.

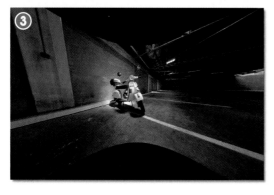

The Fisheye Lens control provides lens specific dewarping adjustments to images photographed with ultra wide angle lenses. The feature interrogates the metadata of the file to retrieve details about the lens type and settings.
It is in this circumstance that using a piece of software designed by your camera/lens manufacturer really comes into its own. The software understands how the lens records the very wide scene and via the Fisheye Lens feature it is possible to remap the bulging photo back to a more normal perspective.

(1) Non-corrected photo taken with a 10.5mm Nikon fisheye lens.
(2) The same image after remapping with the Fisheye Lens feature in Capture Editor.
(3) After remapping with the Include areas where there is no image data option selected.
(4) The Fisheye Lens correction palette.

7

Processing with Photoshop Elements

After downloading raw files or importing raw files into a designated folder, the next step if you are using a 'Convert and then Edit' workflow is to process the files using a raw converter. In this phase of the workflow you examine each raw image or a group of similarly executed files, making note of any problems with shadows, highlights, exposure, white balance, and more. This is the time to make adjustments to bring your images within their acceptable dynamic range and to fine tune them to your personal taste. It is also the time to save files to DNG format and archive them in a safe storage location.

In this section we will walk you through the process of conversion with what is arguably the most widely used raw software in the world – Adobe Camera Raw (ACR). Coming in two slightly different flavors, one shipped with Photoshop Elements and the other with Photoshop and Bridge, ACR provides a logical approach to enhancing your raw files during the conversion process. This chapter concentrates on the steps involved for Photoshop Elements users with Chapter 8 delving into the intricacies of the utility when used with Photoshop and Bridge.

ACR score card

The features of any raw converter tell the story about its effectiveness, efficiency, and compatibility with your workflow style. Look at the following features and see how the ACR plug-in in Photoshop Elements 4.0 works for you:

- browser capability to open, import, retrieve and rank raw files;

- support for your camera(s);

- handling of your camera's profile for producing acceptable tonal curves that work well on your exposure, shadow and highlights, yet producing pleasing results – not all converters are equal;

- saving and recalling settings from previous image(s) worked on;

- a histogram with RGB color channels that works with previews of shadow and highlight problems;

- large display of thumbnail image and ability to zoom in at various percentages to examine areas of displayed image;

- effective white balance correction;

- recovery of modest under- and overexposure;

- handling of color corrections and settings, brightness, contrast, and saturation;

- availability of sharpening, noise removal (luminance smoothing), color noise reduction (moirés);

- save to DNG prior to sending image(s) to the application (in this case, Elements 4.0 Editor or Quick Fix menus); and

- handling of multiple files in batch to save time.

Adobe Camera Raw

The Adobe Photoshop Elements 4.0 PhotoBrowser is an excellent file browser and manager.

The PhotoBrowser – the starting point

The Elements 4.0 PhotoBrowser or Organizer, as it is sometimes known, is a great file browser and picture manager. Once files are imported into the browser the feature will become a pivot point for all your photo management activities. The PhotoBrowser is an excellent starting point as it provides functions to open, import, tag, search for, catalog and retrieve raw files from a long list of supported cameras. Even though it is possible to open raw files directly into the Editor workspace of Photoshop Elements, to use the program to its fullest you should always import your photos into the Organizer (PhotoBrowser) workspace first.

Anatomy of the Camera Raw dialog

Before commencing to process our first raw file, let's take a close look at the Adobe Camera Raw feature as it appears in Photoshop Elements 4.0. The ACR dialog, the user interface between you and what goes on inside the Camera Raw plug-in, provides tools to adjust, process, convert and save raw files. After opening a raw photo from inside either the Organizer or Editor workspaces, this dialog will be displayed. Inside a histogram, the Adjust and Detail tabs, as well as several tools and drop-down menus, will help you enhance images requiring only slight improvements or moderately improve images requiring several adjustments to bring them into an acceptable dynamic range and aesthetic level.

Across the top of the Camera Raw dialog box you will find the name of the camera you used to take the image, its file name and EXIF data (ISO, shutter speed, aperture, focal length). Just below in the left hand corner are five tools for zoom, hand, white balance (eyedropper), 90 degree counterclockwise (left) and clockwise (right) image rotation.

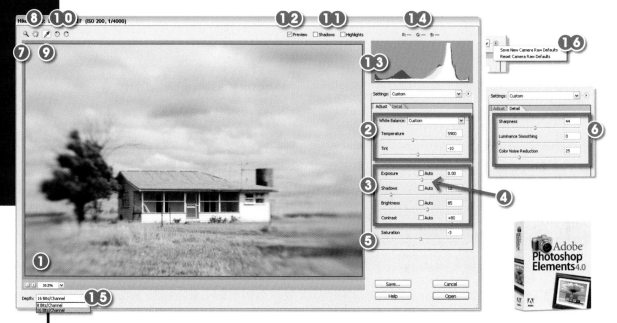

Features of the Adobe Camera Raw dialog box in Photoshop Elements 4.0.
(1) Preview area. (2) White balance settings. (3) Tonal controls.
(4) Auto checkboxes for tonal control. (5) Saturation slider. (6) Sharpness and noise
options. (7) Zoom tool. (8) Hand tool. (9) White balance tool. (10) Rotate buttons.
(11) Shadow and Highlights Clipping Warnings. (12) Preview checkbox.
(13) Color Histogram. (14) RGB values readout. (15) Color depth options. (16) Save
settings.

The zoom tool is useful for looking closely at the image for problems with focus and execution –
slow shutter speed, lack of stabilization, incorrect aperture setting. At 25% an image may appear
to be quite impressive, yet when examining it at 100% often a bit of movement and/or lack of focus
appear. Be sure to zoom in on various parts of the image using the hand tool to easily move it
around at 100%.

The white balance tool is very powerful. Clicking this tool on a picture portion that is meant to be
neutral (even amounts of red, green and blue) removes any color casts and adjusts the hue of the
entire image in one fell swoop.

In the center of the dialog's top you will find Preview, Shadows, and Highlight view checkboxes
which you can toggle on and off. Blue and red areas will appear in the image to indicate loss of
shadow (in blue) and highlight (in red) detail. These correspond to clipping also shown in the
histogram. To the right of the View options are the RGB values, separate values for red, green and
blue corresponding to what is present in the area where your cursor is positioned. When used in
conjunction with the white balance tool RGB values for the selected area on which to click will be
apparent in advance. In the lower left hand corner a zoom level drop-down menu is provided. Below
it is the Depth option with a drop-down menu to select 8 or 16 bits per color channel.

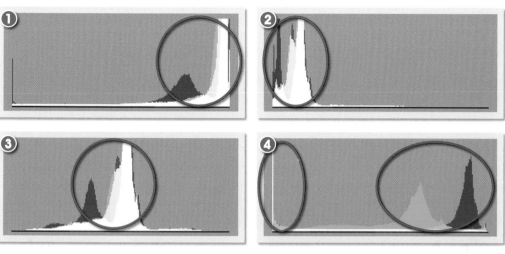

The histogram in ACR shows the distribution of pixels across the image. Areas with the most pixels are the tallest areas of the graph. The shape of the histogram indicates the look of the picture. (1) An overexposed image has a histogram with the pixels bunched to the right end of the graph. (2) Conversely, underexposed photos have pixels pushed to the left. (3) Flat or low contrast pictures typically have all their pixels grouped in the middle. (4) High contrast photos or those that have 'clipped' highlights and shadow areas usually have many pixels at the extreme ends of the graph.
(5) For the best results you should always aim to spread the pixels between the maximum black and white points without clipping any of the image pixels.

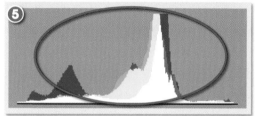

Histogram

A full color histogram is located under the RGB values. The feature graphs the distribution of the pixels within your photo. The graph updates after changes are made to the color, contrast and brightness of the picture. By paying close attention to the shape of the graph you can preempt many image problems. The aim with most enhancement activities is to obtain a good spread of pixels from shadow through midtones to highlights without clipping (converting delicate details to pure black or white) either end of the tonal range.

The Settings option is set to Image Settings. Use this option to restore the original settings of the current image.

Image Settings

Below the histogram is the Settings drop-down menu which contains the Image Settings, Camera Raw Defaults, Previous Conversion, and Custom entries (see page 113).

Image Settings: The Image Settings option restores the original settings of the current photo. Use this selection when you want to reverse changes that you have made and wish to restore the photo to its virgin state.

Camera Raw Defaults: This option applies a group of slider settings that are default values associated with a specific camera and photograph. The raw file of the flower photo (opposite) was created with a Leica Digilux 2. Here you can see that when a photo is opened for the first time, the settings and white balance will be altered to Camera Raw Defaults (based on the camera model) and As Shot (based on the camera settings used for the photograph), respectively. After testing preset or custom white balance settings and finding them unacceptable (or wanting to start over) return to As Shot. After testing changes to exposure through Saturation and wanting to start over, click in one or more Auto boxes to return to the original settings.

Previous Conversion: Another option in the Settings drop-down menu is Previous Conversion. This setting stores the 'last used' values for all controls and is an efficient way to apply the enhancements used with the previous image to one currently open in the dialog. Using this option will help speed up the conversions of a series of photos taken at the same time under the same lighting conditions. Simply make the adjustments for the first image and then use the Previous Conversion option to apply the same settings to each of the successive photos from the series in turn.

Custom: Moving any of the slider controls such as Temperature or Tint sliders under the White Balance menu automatically changes the settings entry to Custom. Once the settings have been customized for a particular photograph the values can be saved as a new Camera Raw Default entry using the save option in the pop-up menu accessed via the sideways arrow next to the Settings menu.

Pro's tip: As ACR recognizes the raw file created with different cameras the new Camera Raw Default will be applied to only those photos captured with the specific camera that the settings have been saved for.

Large preview

The dialog box also contains a large preview of how the raw file will appear with the current settings applied. The preview has a couple of zoom-in and -out options. You can alter the magnification of the preview using the Zoom tool, the Zoom Level menu or buttons at the bottom of the dialog or with the Ctrl/Cmd + or Ctrl/Cmd - keystrokes.

The preview can be magnified via the (1) Zoom Level buttons or menu or the (2) Zoom tool.

Examining parts of the image close in is important and useful, particularly in areas where shadows and/or highlights are problematic.

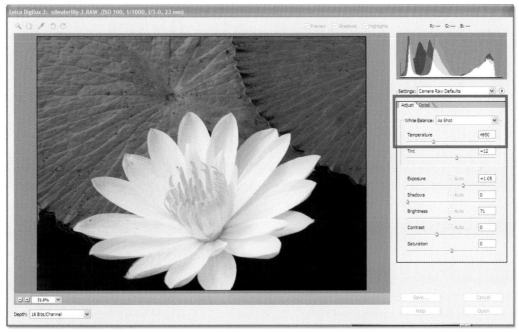

When an original file is opened for the first time in the dialog, the Settings and white balance values will be set to Camera Raw Defaults (based on camera model and make) and As Shot (determined by the camera settings at the time of capture), respectively.

White balance correction

White balance is used to correctly balance the color of the scene to the lighting conditions at the time the shot was taken. Leaving white balance set at As Shot means you elect to keep the white balance values that were used when taking the picture. See page 116.

As you know one of the advantages shooting raw is that this setting is not a fixed part of the picture file. Altering the specific white balance setting at the time of raw conversion is a 'lossless' action. This is not the case if you have used an incorrect setting and have shot in JPEG or TIFF. Use either of these two formats and the white balance setting will be fixed in the file and can only be changed with destructive adjustments using features like Color Variations or Remove Color Cast. In this regard raw shooters have much more flexibility.

For instance, if you selected a Daylight setting in-camera and think that Shade or another white balance preset may be closer to the actual lighting conditions you may select one of the options from the list of presets under the White Balance drop-down menu. Moving either the Temperature or Tint sliders switches the setting to Custom. These controls are used for matching the image color temperature with that of the scene.

Temperature: The Temperature slider is a fine-tuning device that allows you to select a precise color temperature in units of degrees kelvin. When an image is too yellow, meaning it has a lower color temperature than you prefer, move the Temperature slider to the left to make the colors bluer and compensate for the lower color temperature. When an image is too blue, or higher in temperature than you prefer, move the slider to the right to make the image warmer, adding more yellow compensation. So, left is to make image colors cooler and right is to make image colors warmer.

Tint: The Tint slider fine tunes the white balance to compensate for a green or magenta tint. Moving the Tint slider to the left adds green and to the right adds magenta. This control is often used to neutralize a color cast caused by lighting from fluorescent tube or strip sources.

White Balance tool: The quickest and perhaps easiest way to adjust white balance is to select the White Balance tool and then click in an area that should be neutral gray or even amounts of red, green and blue. For best results, use a dark to midtone as the reference and be careful not to click on an area with pure white or specular highlights. These will produce unreliable results so keep away from the bright highlight areas of highly reflective or chrome surfaces. One suggestion for working with neutral gray is to:

1. Click on the White Balance tool.
2. Move the White Balance tool cursor over a midtone area which should be neutral gray but contains a color cast in the preview.
3. Click on the image location to neutralize the cast not just in the selected area but in the whole photo.

WB tool workflow

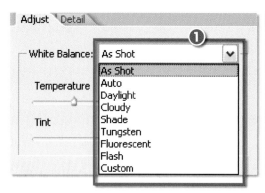

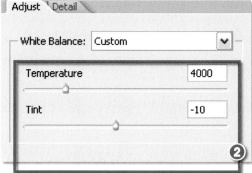

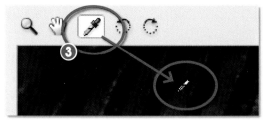

The white balance in your raw photo can be adjusted in one of three ways:
(1) Selecting the light source specific entry that best matches the lighting in the scene from the drop-down list.
(2) Manually adjusting the Temperature and Tint slider values until the preview appears neutral and free from color casts.
(3) Selecting the White Balance tool and then clicking on a picture part that should be neutral.

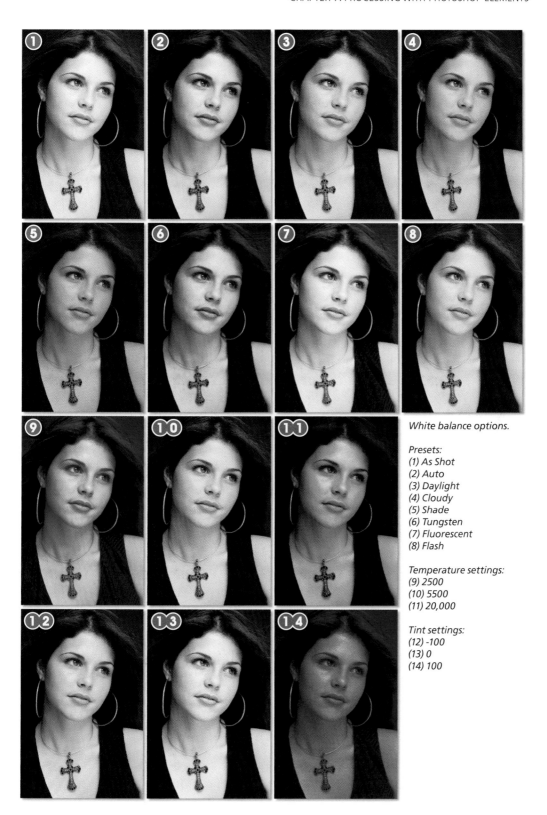

White balance options.

Presets:
(1) As Shot
(2) Auto
(3) Daylight
(4) Cloudy
(5) Shade
(6) Tungsten
(7) Fluorescent
(8) Flash

Temperature settings:
(9) 2500
(10) 5500
(11) 20,000

Tint settings:
(12) -100
(13) 0
(14) 100

Adobe has positioned the slider controls that adjust the tones within the image in the order (top to bottom) that they should be applied within the ACR dialog.

The Exposure and Shadows sliders should be used first to set the white and black points in the photo. Use the Alt/Option keys in conjunction with these sliders to preview the pixels being clipped and to accurately peg the white/black points. Or alternatively switch on the Shadows/Highlights Clipping Warnings which perform the same function whilst leaving the full color preview visible.

Next lighten or darken the photo using the Brightness slider. Unlike the Exposure control this slider doesn't affect the white and black points of the image but rather adjusts the appearance of the photo by compressing or extending the altered tones.

Making tonal adjustments

Exposure, Shadows, Brightness, Contrast and Saturation sliders are available for making adjustments to raw files. Adobe has positioned these controls in the dialog so that when working from top to bottom you follow a specific enhancement workflow. For this reason you should following these steps in order:

1. Set the white clipping points using the Exposure slider.
2. Set the black clipping points using the Shadows slider.
3. Adjust the overall brightness using the Brightness slider.
4. Adjust contrast using the Contrast slider.
5. Adjust saturation, if needed, using the Saturation slider.

Tonal changes workflow

Exposure

The Exposure slider adjusts the brightness or darkness of an image using value increments equivalent to f-stops or EV (exposure values) on a camera. An image is underexposed when it is not light enough or too dark and it is overexposed when it is too light. Simply move the slider to the left to darken the image and to the right to lighten (brighten) the image.

What do the f-stop or EV equivalents indicate? An adjustment of -1.50 is just like narrowing the aperture by 1.5 (one and a half) f-stops. Moving the slider 1.33 places to the left will dramatically darken an image and to the right the same amount will result in a bright image. If you have to move more than two full stops in either direction this probably indicates your settings at capture were inaccurate. Making adjustments beyond two stops starts to deteriorate image quality as invariably shadow or highlight detail is lost (clipped) in the process.

For those of you who are interested, the Exposure slider sets the white clipping points in the image. Clipping shows as values creeping up the left (shadow) and right (highlight) walls of your histogram (and red and blue areas in the image if shadow and highlight previews are turned on), and occurs

To ensure that you don't accidently convert shadow or highlight detail to pure black or white pixels ACR contains two different types of 'Clipping' warnings. (1) When the Shadows and Highlights Clipping Warning features are selected at the top of the dialog areas of highlight clipping are displayed in the preview as red and shadows as blue. (2) Holding down the Alt/Option key whilst moving either the Exposure or Shadows sliders will convert the preview to black (for Exposure) or white (for Shadows). Any pixels being clipped will then be shown as a contrasting color against these backgrounds.

when the pixel values shift to the highest highlight value or the lowest shadow value. Clipped areas are completely black or white and contain no detail. As you want to maintain as much detail in the shadows and highlights as possible your aim should always be to spread the picture tones but not to clip delicate highlight or shadow areas.

Shadows

Moving the Shadows slider adjusts the position of the black point within the image. Just as was the case with the Exposure slider you should only make Shadows adjustments when the clipping warning is active. This will ensure that you don't unintentionally convert shadow detail to black pixels. Remember movements of the slider to the left decreases shadow clipping. Moving it to the right increases or produces clipping.

Brightness and Contrast

The Brightness slider is different to the Exposure slider although both affect the brightness of an image. Brightness compresses the highlights and expands the shadows when you move the slider to the right. When adjusting your photos your aim is to set the black and white points first and then adjust the brightness of the midtones to suit your image.

Contrast adjusts the spread of the midtones in the image. A move of the Contrast slider to the right spreads the pixels across the histogram, actually increasing the midtone contrast. Conversely movements to the left bunch the pixels in the middle of the graph. It is important to adjust the contrast of midtones after working on exposure, shadows and brightness.

Auto tonal control

When first opening a picture ACR will automatically adjust the tonal controls to an average setting

for the picture type and camera make/model. The Auto checkbox is selected when these settings are in place. Moving the associated slider will remove the selection but these values can be reinstated by selecting the checkbox again.

Pro's tip: In some instances you may need to readjust Exposure and Shadow sliders after Brightness and Contrast to fine tune your enhancements.

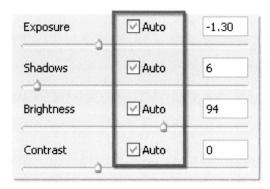

There are Auto options for Exposure, Shadows, Brightness and Contrast controls inside the ACR dialog. These options are selected when a picture is first opened but are deselected as soon as you move any of the slider controls.

Saturation

If desired, the Saturation slider may be used to adjust the strength of the color within the photo. A setting of -100 is a completely desaturated monochrome image and a value of +100 doubles the saturation. Watch changes in the histogram when you move the Saturation slider in either direction.

The Saturation slider controls the strength or vibrancy of the color within your raw photos.
(1) Dragging the slider all the way to left (-100) will remove all color from the photo creating a monochrome picture. (2) A value of 0 is the default setting where the saturation is neither boosted nor reduced. (3) Moving the slider all the way to the right to a setting of +100 produces twice the saturation of the normal or default setting.

Sharpening, Luminance Smoothing and Color Noise Reduction

Sharpening, Luminance Smoothing and Color Noise Reduction are all controls that can be accessed under the Detail tab.

Sharpening is an enhancement technique that is easily overdone and this is true even when applying the changes at the time of raw conversion. The best approach is to remember that sharpening should be applied to photos as the very last step in the editing/enhancement process and that the settings used need to match the type of output the photo is destined for. In practice

ACR contains two noise reduction controls – Luminance Smoothing for grayscale noise and Color Noise Reduction for minimizing errant color pixels. Like most noise reduction controls effective use is a balance between removing digital grain and creating flat featureless areas of color. This example demonstrates how the different settings alter the look of noisy photographs.
(1) 50, 0 (Luminance Smoothing, Color Noise Reduction).
(2) 100, 0.
(3) 0, 50.
(4) 0, 100.
(5) 50, 50.
(6) 100, 100.
(7) 0, 0 (no noise reduction).

this means images that are not going to be edited after raw conversion should be sharpened within ACR, but those pictures that are going to be enhanced further should be sharpened later using the specialist filters in Photoshop Elements.

When a picture is first opened into the ACR the program sets the sharpening and noise values based on the camera type and model used to capture the image. For many photographers making further adjustments here is an exception rather than a rule as they prefer to address sharpening in the Editor after cropping, straightening, enhancing, resizing and going to print.

ACR contains two different noise reduction controls. The Luminance Smoothing slider and the Color Noise Reduction control. The Luminance Smoothing slider is designed to reduce the appearance of grayscale noise in a photo. This is particularly useful for improving the look of images that appear grainy. The second type of noise is the random colored pixels that typically appear in photos taken with a high ISO setting or a long shutter speed. This is generally referred to as chroma noise and is reduced using the Color Noise Reduction slider in ACR. The noise reduction effect of both features is increased as the sliders are moved to the right.

Save to DNG

Now to the business end of the conversion task – outputting the file. At this stage in the process ACR provides several options that will govern how the file is handled from this point onwards. To this end, the lower right hand corner of the Adobe Camera Raw dialog has four buttons: Save, Cancel, Open and Help and a further three, Save (without the options dialog), Reset and Update, when the Alt/Option button is pushed.

Help: Opens the Photoshop Elements help system with raw processing topics already displayed.

Cancel: This option closes the ACR dialog not saving any of the settings to the file that was open.

Save: The normal Save button, which is includes several dots (...) after the label, displays the Save options dialog. Here you can save the raw file, with your settings applied, in Adobe's own DNG format. The dialog includes options for inputting the location where the file will be saved, the ability to add in a new name as well as DNG file specific settings such as compression, conversion to linear image and/or embed the original raw file in the new DNG document. It is a good idea to Select Save in Different Location in the Destination drop-down at the top to separate processed files from archive originals. Clearly the benefits of a compressed DNG file are going to help out in the storage issue arena and compression is a big advantage with DNG. Embedding the original raw file in the saved DNG file begs the questions of how much room you have in the designated storage device and whether you really want to have the original raw file here.

Save (without save options): Holding down the Alt/Option key when clicking the save button skips the Save Options dialog and saves the file in DNG format using the default save settings.

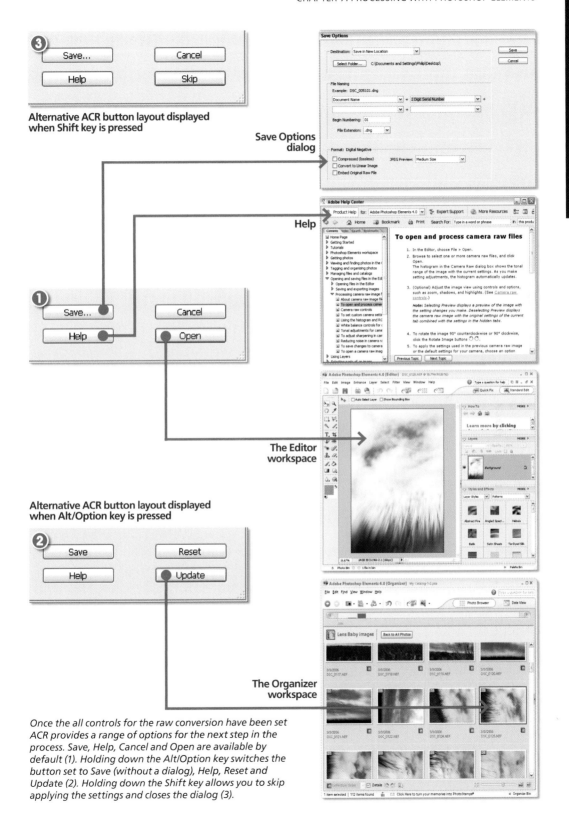

Alternative ACR button layout displayed when Shift key is pressed

Save Options dialog

Help

The Editor workspace

Alternative ACR button layout displayed when Alt/Option key is pressed

The Organizer workspace

Once the all controls for the raw conversion have been set ACR provides a range of options for the next step in the process. Save, Help, Cancel and Open are available by default (1). Holding down the Alt/Option key switches the button set to Save (without a dialog), Help, Reset and Update (2). Holding down the Shift key allows you to skip applying the settings and closes the dialog (3).

The Save Options dialog is displayed when the Save... button is pressed. To skip this dialog and still save the processed file in DNG format hold down the Alt/ Option key whilst clicking the Save button.

Open: If you click on the Open button Elements applies the conversion options that you set in ACR and opens the file inside the Editor workspace. At this point, the file is no longer in a raw format so when it comes to saving the photo from the Editor workspace Elements automatically selects the Photoshop PSD format for saving.

Reset: The Reset option resets the ACR dialog's settings back to their defaults. This feature is useful if you want to ensure that all settings and enhancement changes made in the current session have been removed. To access the Reset button click the Cancel button whilst holding down the Alt/ Option key.

Update: Clicking the Open button in conjunction with the Alt/Option key will update the raw conversion settings for the open image. Essentially this means that the current settings are applied to the photo and the dialog is then closed. The thumbnail preview in the PhotoBrowser workspace will also be updated to reflect the changes.

Pro's tip: If the thumbnail doesn't update automatically, select the picture and then choose Edit > Update Thumbnail in the PhotoBrowser workspace.

Skip: Holding down the Shift key whilst clicking the Open button will not apply the currently selected changes and just close the dialog. In this way it is similar to the Cancel button.

Differences between Adobe Camera Raw (ACR) in Photoshop/Bridge and Photoshop Elements

The Adobe Camera Raw utility is available in both Photoshop Elements and Photoshop (and Bridge) but the same functionality and controls are not common to the feature as it appears in each program. The Photoshop Elements version contains a reduced feature set but not one that overly restricts the user's ability to make high quality conversions.

The following features and controls are common to both Photoshop/Bridge and Photoshop Elements:

> White Balance presets, Temperature, Tint, Exposure, Shadows, Brightness, Contrast, Auto checkboxes for tonal controls, Saturation, Sharpness, Luminance Smoothing, Color Noise Reduction, Rotate Left, Rotate Right, Shadow and Highlights Clipping Warnings, Preview checkbox, Color Histogram, RGB readout, Zoom tool, Hand tool, White Balance tool, Color Depth, Open processed file, Apply conversion settings without opening

These options are only available in ACR for Photoshop/Bridge:

> Chromatic Aberration, Vignetting, Curves, Calibration controls, Color Sampler tool, Crop tool, Straighten tool, Color Space, Image size, Image resolution, Save settings, Save processed file direct from ACR

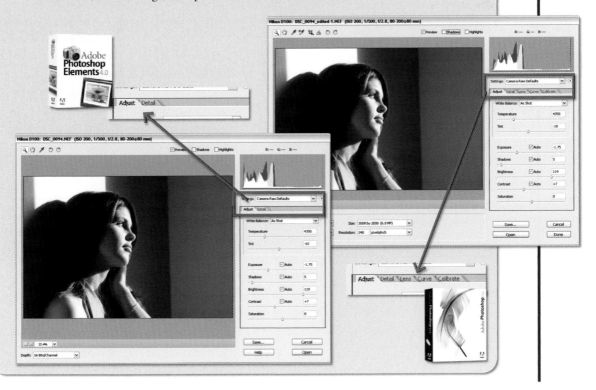

Processing with Photoshop Elements and Adobe Camera Raw

Now that we have a good understanding of the various controls in the Adobe Camera Raw dialog let's walk through the complete process.

Opening

This seems like a simple step but just as there are many roads that lead to Rome so too are there a variety of ways to open a raw file in Adobe Camera Raw.

1. Opening the raw file in the Editor workspace

Once you have downloaded your raw files from camera to computer you can start the task of processing. Keep in mind that in its present state the raw file is not in the full color RGB format that we are used to, so the first part of all processing is to open the picture into a conversion utility or program. Selecting File > Open from inside Elements will automatically display the photo in the Adobe Camera Raw (ACR) utility.

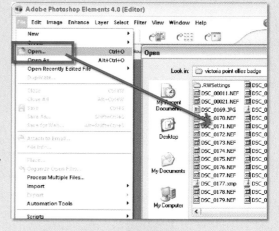

2. Starting with the PhotoBrowser

Starting in the PhotoBrowser or Organizer workspace simply right-click on the thumbnail of the raw file and select Go to Standard Edit from the pop-up menu to transfer the file to the Elements version of ACR in the Editor workspace.

Rotate

3. Rotate Right (90 CW) or Left (90 CCW)

Once the raw photo is open in ACR you can rotate the image using either of the two Rotate buttons at the top of the dialog. If you are the lucky owner of a recent camera model then chances are the picture will automatically rotate to its correct orientation. This is thanks to a small piece of metadata supplied by the camera and stored in the picture file that indicates which way is up.

Adjusting white balance

Unlike other capture formats (TIFF, JPEG) the white balance settings are not fixed in a raw file. ACR contains three different ways to balance the hues in your photo.

4. Preset changes

As we have seen you can opt to stay with the settings used at the time of shooting ('As Shot') or select from a range of light source specific settings in the White Balance drop-down menu of ACR. For best results, try to match the setting used with the type of lighting that was present in the scene at the time of capture. Or choose the Auto option from the drop-down White Balance menu to get ACR to determine a setting based on the individual image currently displayed.

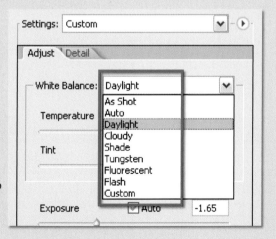

5. Manual adjustments

If none of the preset white balance options perfectly matches the lighting in your photo then you will need to fine tune your results

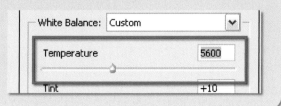

with the Temperature and Tint sliders (located just below the Presets drop-down menu). The Temperature slider settings equate to the color of light in degrees kelvin – so daylight will be 5500 and tungsten light 2800. It is a blue to yellow scale, so moving the slider to the left will make the image cooler (more blue) and to the right warmer (more yellow). In contrast the Tint slider is a green to magenta scale. Moving the slider left will add more green to the image and to the right more magenta.

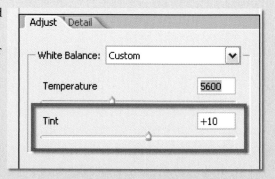

6. The White Balance tool

Another quick way to balance the light in your picture is to choose the White Balance tool and then click on a part of the picture that is meant to be neutral gray or white. ACR will automatically set the Temperature and Tint sliders so that this picture part becomes a neutral gray and in the process the rest of the image will be balanced. For best results when selecting lighter tones with the tool ensure that the area contains detail and is not a blown or specular highlight.

Tonal control

Then next group of image enhancements alters the tones within the photo. There are five different slider controls each dealing with a specific group of image tones. Each of the controls has an Auto option that when checked will let ACR decide on the best tonal setting to use. Use the following steps if you want a little more control.

7. Setting the white areas

To start, adjust the brightness with the Exposure slider. Moving the slider to the right lightens the photo and to the left darkens it. The settings for the slider are in f-stop increments with a +1.00 setting being

equivalent to increasing exposure by 1
f-stop. Use this slider to peg or set the white
tones. Your aim is to lighten the highlights
in the photo without clipping (converting
the pixels to pure white) them. To do this,
hold down the Alt/Option whilst moving
the slider. This action previews the photo
with the pixels being clipped against a
black background. Move the slider back
and forth until no clipped pixels appear but
the highlights are as white as possible.

8. Adjusting the shadows

The Shadows slider performs a similar
function with the shadow areas of the image.
Again the aim is to darken these tones but
not to convert (or clip) delicate details to pure
black. Just as with the Exposure slider, the
Alt/Option key can be pressed whilst making
Shadows adjustments to preview the pixels
being clipped. Alternatively the Shadow and
Highlights Clipping Warning features can
be used to provide instant clipping feedback
on the preview image. Shadow pixels that
are being clipped are displayed in blue and
clipped highlight tones in red.

9. Brightness changes

The next control, moving from top to bottom
of the ACR dialog, is the Brightness slider.
At first the changes you make with this
feature may appear to be very similar to
those produced with the Exposure slider
but there is an important difference. Yes,
it is true that moving the slider to the right
lightens the whole image, but rather than
adjusting all pixels the same amount the
feature makes major changes in the midtone

areas and smaller jumps in the highlights. In so doing the Brightness slider is less likely to clip the highlights (or shadows) as the feature compresses the highlights as it lightens the photo. This is why it is important to set white and black points first with the Exposure and Shadows sliders before fine tuning the image with the Brightness control.

10. Increasing/Decreasing contrast

The last tonal control in the dialogue, and the last to be applied to the photo, is the Contrast slider. The feature concentrates on the midtones in the photo with movements of the slider to the right increasing the midtone contrast and to the left producing a lower contrast image. Like the Brightness slider, Contrast changes are best applied after setting the white and black points of the image with the Exposure and Contrast sliders.

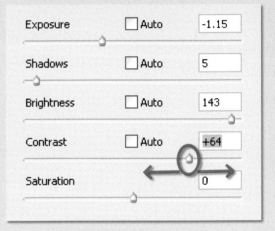

Color strength adjustments

As one of the primary roles of the Adobe Camera Raw utility is to interpolate the captured colors from their Bayer mosaic form to the more usable RGB format it is logical to include a color strength adjustment as one of the controls in the process.

11. Saturation control

The strength or vibrancy of the colors in the photo can be adjusted using the Saturation slider. Moving the slider to the right increases saturation with a value of +100 being a doubling of the color strength found at a setting of 0. Saturation can be reduced by moving the slider to the left with a value of -100 producing a monochrome image. Some photographers use this option as a quick way

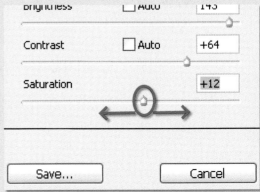

to convert their photos to black and white but most prefer to maker this change in Photoshop proper where more control can be gained over the conversion process with features such as the Channel Mixer.

Sharpness/Smoothness and Noise Reduction

With the tones and colors now sorted let's turn our attention to sharpening and noise reduction. Both these image enhancements can be handled in-camera using one of a variety of auto settings found in the camera setup menu, but for those image makers in pursuit of imaging perfection these changes are best left until processing the file back at the desktop.

12. To sharpen or not to sharpen

The sharpening control in ACR is based on the Unsharp Mask filter and provides an easy to use single slider sharpening option. A setting of 0 leaves the image unsharpened and higher values increase the sharpening effect based on Radius and Threshold values that ACR automatically calculates via the camera model, ISO and exposure compensation metadata settings.

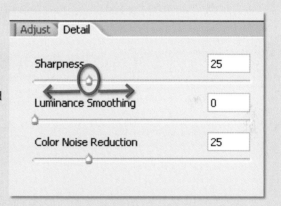

13. Reducing noise

ACR contains two different noise reduction controls. The Luminance Smoothing slider is designed to reduce the appearance of grayscale noise in a photo. This is particularly useful for improving the look of images that appear grainy. The second type of noise is the random colored pixels that typically appear in photos taken with a high ISO setting or a long shutter speed. This is generally referred to as chroma noise and is reduced using the Color Noise Reduction slider in ACR. The noise reduction effect of both features is increased as the sliders are moved to the right.

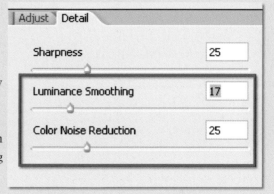

Remember: When using these tools keep in mind that overuse can lead to flat, textureless photos so ensure that you zoom into the image (at least 100%) and check the results of your settings in important areas of details.

Output options

Now to the business end of the conversion task – outputting the file. The Photoshop Elements version of ACR contains only the Color Depth output option.

14. Controlling color depth/space and image size/resolution

The section below the main preview window in ACR contains the output options settings. Here you can adjust the color depth (8 or 16 bits per channel) of the processed file. Earlier versions of Photoshop Elements were unable to handle 16 bits per channel images but the last two releases have contained the ability to read, open, save and make a few changes to these high color files.

Save, Open or Done

The last step in the process is to apply the enhancement changes to the photo. This can be done in a variety of ways.

15. Opening the processed file in Photoshop Elements

The most basic option is to process the raw file according to the settings selected in the ACR dialog and then open the picture into the Editor workspace of Photoshop Elements. To do this simply select the OK button. Select this route if you intend to edit or enhance the image beyond the changes made during the conversion.

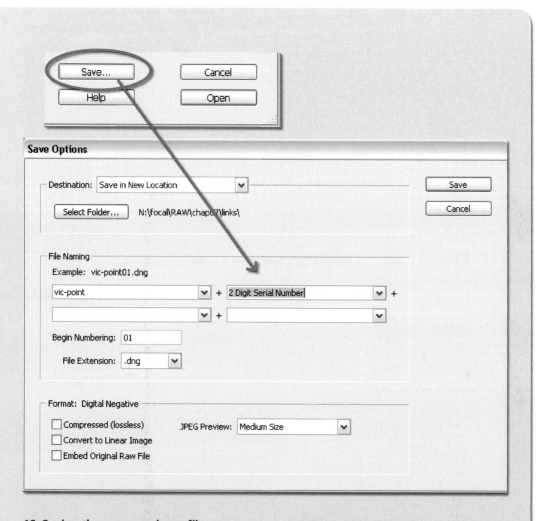

16. Saving the processed raw file

Users have the ability to save converted raw files from inside the ACR dialog via the Save button. This action opens the Save Options dialog which contains settings for inputting the file name and as well as file type specific characteristics such as compression. Use the Save option over the Open command if you want to process photos quickly without bringing them into the editing space.

Pro's tip: Holding down the Alt/Option key whilst clicking the Save button allows you to store the file (with the raw processing settings applied) without actually going through the Save Options dialog.

17. Applying the raw conversion settings

There is also an option for applying the current settings to the raw photo without opening the picture. By Alt-clicking the OK button (holding down Alt/Option key changes the button to the Update button) you can apply the changes to the original file and close the ACR dialog in one step.

The great thing about working this way is that the settings are applied to the file losslessly. No changes are made to the underlying pixels only to the instructions that are used to process the raw file.

When next the file is opened, the applied settings will show up in the ACR dialog ready for fine tuning, or even changing completely.

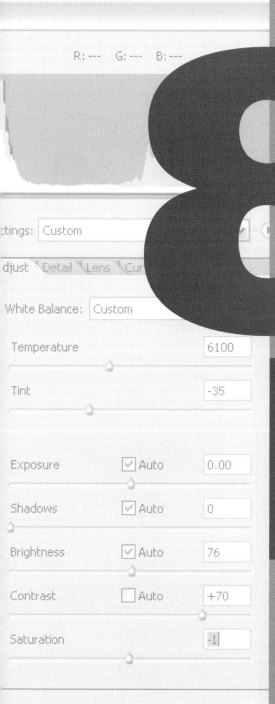

R: --- G: --- B: ---

Settings: Custom

Adjust Detail Lens Cur

White Balance: Custom

Temperature 6100

Tint -35

Exposure ☑ Auto 0.00

Shadows ☑ Auto 0

Brightness ☑ Auto 76

Contrast ☐ Auto +70

Saturation -1

Save... Cancel

Open Done

8

ACR, Photoshop and Bridge

ow do you process your raw photographs in Adobe Photoshop? You start by opening them. To do this you can always use the ubiquitous Open command but you also have the option to open files via the File Browser (CS) or Bridge (CS2).

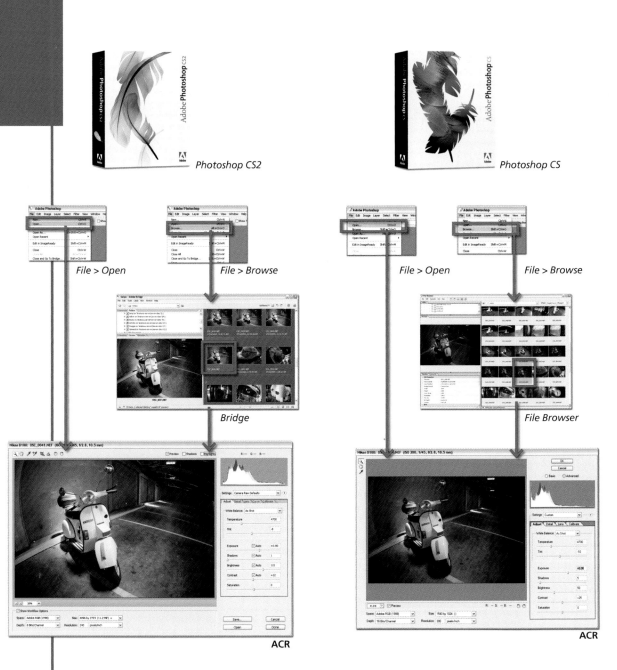

Photoshop CS2

Photoshop CS

File > Open

File > Browse

File > Open

File > Browse

Bridge

File Browser

ACR

ACR

Photoshop users can open their raw files into Adobe Camera Raw by selecting File > Open or selecting from either Bridge or the Photoshop File Browser.

All roads lead to Adobe Camera Raw (ACR)

Selecting File > Open displays a file dialog where you can select and open your raw photo. File > Browse, on the other hand, opens either Bridge or the File Browser, depending on which version of Photoshop you are running. Both utilities provide a thumbnail view of the raw files you have on your hard drive. To open a photo, just double-click the picture's thumbnail.

Both methods for opening a file will eventually lead to the photo being displayed in Adobe's raw conversion utility – Adobe Camera Raw (ACR). Slightly different versions of the ACR are shipped with Photoshop CS and Photoshop CS2. Changes to the list of features present in the utility as well as the cameras supported by ACR are made from time to time so to ensure that you have the very latest incarnation of ACR download the most recent version from www.adobe.com and install it by following the steps below:

Keeping ACR up to date

Point your browser to **www.adobe. com** and then look for the Adobe Camera Raw update page. Next download the latest version of the utility and install using these steps:

1. If Photoshop CS2 is open exit the program.

2. Open the system drive (usually C:).

3. Locate the following directory **Program Files/Common Files/ Adobe/Plug-Ins/CS2/File Formats**

4. Find the Adobe Camera Raw.8bi file in this folder.

5. Move the plug-in to another folder and note down its new location just in case you want to restore the original settings.

6. Drag the new version of the Adobe Camera Raw plug-in, the Adobe Camera Raw.8bi file (that you downloaded), to the same directory as in step 3.

7. Restart Photoshop.

Note: If after installing the new version of ACR your raw files are not displayed as thumbnails start Bridge and then select Tools > Cache > Purge Central Cache. Keep in mind that this action deletes the stored thumbnail data for all folders as well as any labels, ratings, and rotation settings for files that don't have XMP support.

Photoshop CS2's standard operating system Open dialog box (File > Open) lets you navigate to the file you are looking for and will even, in the Mac OS version shown here, give you a thumbnail preview (1) of the image.

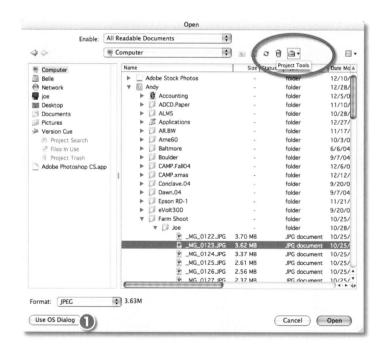

Need more opening dialog power? Click on 'Use Adobe Dialog' in the OS's Open dialog box and the interface changes to one unique to Adobe Photoshop that gives you many more tools to manage the image and any projects that are associated with it. To switch back to the standard dialog click on the Use OS Dialog button (1).

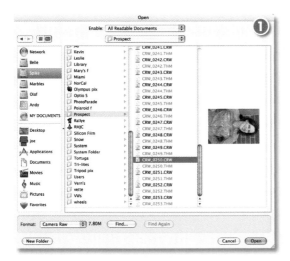

Macintosh (1): *Choosing Open (File > Open) presents the ubiquitous dialog in the Mac OS X version of Adobe Photoshop. You can view the names of many raw and other format files, but can only see a thumbnail for an individual file making it a slow way to find a specific file.*

Windows (2): *Choosing Open (File > Open) presents this dialog box in the Windows XP version of Adobe Photoshop. You can view the names of files, but can only see thumbnails for files that are stored inside the 'My Pictures' folder or those folders nominated as storing photo files. Raw files can seen as thumbnails if the Windows Raw Image Thumbnailer utility is downloaded from www.microsoft.com and installed.*

Back to the future: using the File Browser in CS

In the previous two versions of Photoshop, the File Browser function lets you search for image files visually rather than by name, saving time and effort. Using thumbnails, you can quickly organize and retrieve images from your hard or external drives, CDs, or DVDs. You can also rotate images and batch rename, rank, and sort files. Bridge also displays metadata about the images, including date created, date modified, and all of the EXIF (Exchangeable Image File) information captured on digital cameras.

You can get into File Browser via two methods: choose File Browser from the Window menu (Window > File Browser) or click the Toggle File Browser icon in the Options bar. By default, File Browser's interface window consists of four main panes – Thumbnail, Preview, Metadata and Folder view.

The *Thumbnail* pane displays thumbnails of the image files within a selected folder or disk. It provides five options for displaying thumbnails including Small, Medium, Large, Custom, and Detail which are selected from the View menu in File Browser's menu bar. Small allows you to see most of the images at once; Medium and Large display increasingly bigger thumbnails and Custom lets you make them really BIG.

By using the buttons and menu in the interface File Browser lets you manage folders and files. You can create and rename folders and delete, open, move, copy, or rename image files. The Batch Rename feature lets you easily rename multiple files. One of the handiest features is being

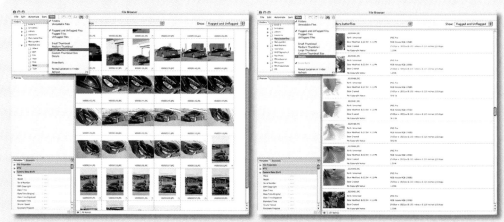

On a standard monitor, File Browser with Large thumbnails and Rank selected allows you to see a (relatively) large thumbnail along with each image's rank.

The Detail option displays the fewest number of thumbnails but provides information about each image shown, such as file name, date created and modified, copyright, file format, color mode, image size (in pixels), file size, and rank.

The Preview pane displays any selected image larger than the thumbnail pane view.

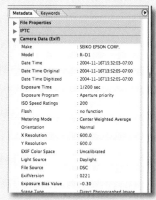

The Metadata pane also displays EXIF information about images created with digital cameras such as creation date, exposure settings, image size, and resolution.

If you click on the arrow at the end of the Metadata/Keywords pane and select Metadata Display Options you can customize the display to see the information you are interested in.

The Tree view is designed for navigating folders and disks that contain your image files. In Photoshop CS, when clicking on a folder to select it, all of the image files inside, including RAW, will be displayed. In Photoshop 7.0, which has a similar File Browser capability, you will need to have the Adobe Camera Raw plug-in installed.

able to rotate one or multiple images at once by 90 degrees clockwise and counterclockwise or by 180 degrees.

The *Metadata/Keywords* pane displays information about a selected image beyond that which is displayed in the thumbnail pane. The Metadata pane shows keywords associated with a selected image as well as captions, resolution, and bit depth. Keywords are also part of the Metadata window, but unlike camera setting metadata, you get to add this information to the image file.

The *Preview* pane shows a scalable display of the currently selected thumbnail. Adjusting the size of the pane will automatically alter the size of the preview image.

The *Folder View* pane provides a folder or directory view similar to that which is found in most operating system dialogs. Use this view to quickly navigate to directories of images that are stored on your hard drive or network.

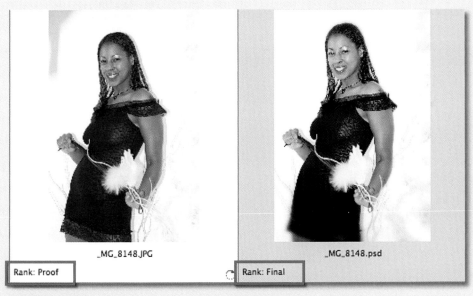

_MG_8148.JPG _MG_8148.psd

Rank: Proof Rank: Final

The Rating or Labels feature in the File Browser provides a handy way to sort pictures from a shooting or editing session.

Add ranking to image files

You can create a personalized ranking system within File Browser for identifying and grouping images. By selecting View > Show Rank, thumbnails are displayed with space for you to write a ranking, such as 'Proof' or 'Final', for each file that lets you sort by those rankings later on to differentiate between images that have been approved and those that haven't. In addition to Rank, File Browser lets you sort images by file name, file width and height, file size, file type, resolution, color profile, date created, date modified, and copyright. When images are sorted by file size in ascending order, for example, the smallest files are listed first and the largest are listed last.

A Bridge to image making – Photoshop CS2

Bridge is Adobe's next-generation File Browser and, since it's configured as a stand alone application, frees up Photoshop CS2 to process images while you work in Bridge and vice versa. It is the hub for automation and file management across the entire Adobe Creative Suite. Crossing the Bridge is as simple as clicking the icon in the Options bar that kinda, sorta looks like the old File Browser icon.

Because Bridge supports Illustrator, InDesign, and GoLive, it allows Photoshop users to leverage the features in those applications by creating a contact sheet in InDesign that's richer and more editable than what's possible using just Photoshop's Contact Sheet plug-in, or creating a richer Web Photo Gallery using GoLive as easily as you would use Photoshop CS2. The bottom line is that if you already know how to use File Browser, you've got a head start on Bridge.

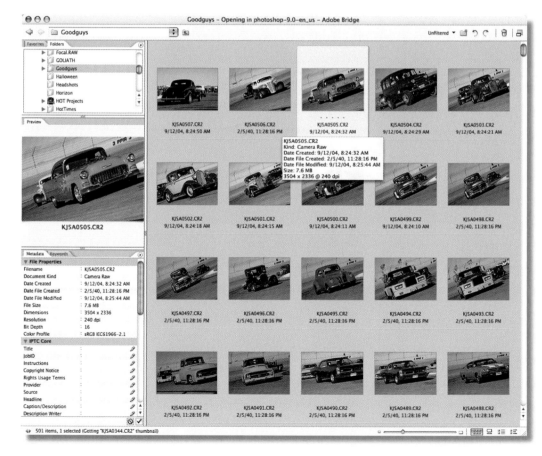

It's not your father's File Browser. Adobe Bridge can be configured to look similar, as in this example, but in fact is completely customizable in appearance having many views and ways to access images and image file information.

Other features found in Bridge include multi-file Adobe Camera Raw editing and conversion, multiple browser windows, and enhanced flagging and labeling and better metadata display editing, which can be seen in this Details view.

Scalable previews in all views, including this Filmstrip view adds the ability to look at really large image previews when scrolling though the filmstrip showing image files along with some metadata.

One of Bridge's coolest features is the ability to run in Compact Mode. Bridge supports multiple monitors, but not everyone has that setup, so having Bridge in compact mode will be especially useful for those with single, especially widescreen, monitors.

Raw enhancements before Photoshop

Every digital camera uses its own proprietary raw file format (some manufacturers have two) for storing image data. As with Adobe Photoshop Creative Suite, raw file support is directly built into CS2. (With Photoshop 7.0, Adobe's Adobe Camera Raw plug-in must first be installed.) The latest version of Adobe Camera Raw is 3 and contains many new features that will enable you to get even better results from your files starting with automatically selecting and assigning your specific camera model. Access to Adobe Camera Raw is through Bridge (File > Open in Adobe Camera Raw).

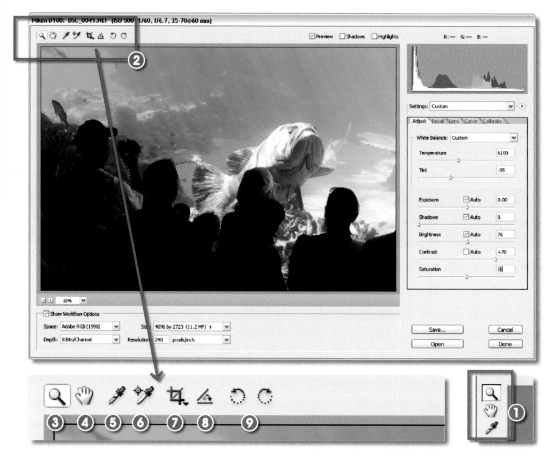

The first thing that you will notice about Adobe Camera Raw 3 is that there are more icons across the top left hand side of the dialog box than before. The version of ACR that shipped with Photoshop CS contained only three icons (1); Photoshop CS2 has eight (2). Adobe Camera Raw 3 tools: Zoom tool (3), Hand tool (4), White Balance tool (5), Color Sampler tool (6), Crop tool (7), Straighten tool (8) and Rotate buttons (9).

The first three tools in the Adobe Camera Raw dialog are the same ones found in previous versions of the utility. Clicking the *Zoom* tool (aka Magnifying Glass) inside the preview window allows you to zoom in and out of the details on a raw file. Holding down the Option key (Mac OS) or Alt key (Windows) while clicking reverses the zoom effect. The *Move* (Hand) tool does its same job of dragging the image around in the preview window after you've used the Zoom tool.

My favorite tool was always the *White Balance tool*; clicking anywhere that is neutral on the image in the preview windows brings the image into a 'normal' white balance (even amounts of red, green and blue). It is always my first step before doing anything else with a raw image file. The Rotate Image icons (90 degrees Clockwise and Counterclockwise) have been moved from their previous location to keep all the tools together. You'll find them at the end of the line. In between these original tools lies the new stuff.

What's new, pussycat?

The first new tool is the Color Sampler tool whose icon looks a lot like the White Balance tool. In fact it displays different Red, Blue and Green values when clicking on up to three places in your image. When used in conjunction with the White Balance tool it helps you determine neutral colors or show where a certain neutral color may be heading – warmer or cooler.

The next two tools provide functionality that's already available in current and previous versions of Photoshop but add a new twist or two. The Crop tool gives Adobe Camera Raw so much more functionality than previous versions that it almost starts to feel like a separate application, much like Bridge. Unlike CS2 prime, you can only show the cropping area (the rest of the image is grayed out) and the actual crop is not applied until after you've finished other adjustments and clicked Done. The Straighten tool accomplishes the same goals as the Measure tool does in Photoshop but actually permits cropping the image, so you don't have to use the Rotate command to complete the operation and then crop to remove extraneous white space.

There are three new buttons to the left of the new tools. Preview lets you toggle back and forth between your original raw files and any adjustments you make with the slider (we'll get to them, don't worry) on the right hand side of the Adobe Camera Raw dialog box. Next are checkboxes to show the Gamut Clipping warning for Shadows, Highlights or both. Clipping is the shifting of pixel values to either the highest highlight value (255) or the lowest shadow value (0). Areas of a photo that are clipped are either completely white or completely black and have no image detail. Both boxes can be checked together so you can see warnings for Highlights and Shadows.

The Preview checkbox allows the user to switch between before (unchecked) and after (checked) processing views of the raw file.

Adobe's Adobe Camera Raw 3 has a tick box to for the Gamut Clipping warning for both Shadows, where the affected areas are shown in blue, and Highlights, with clipped areas displayed in red.

What's missing from previous versions? There used to be checkboxes allowing you to choose between using 'Basic' or 'Advanced' modes for using Adobe Camera Raw. Both of these choices are gone. My guess is that Adobe Systems thinks that if you are smart enough to use Adobe Camera Raw you're an advanced user so you should have immediate access to all the functions.

Show Workflow Options

Before getting to what the Show Workflow Options checkbox provides, take a second to look at the plus and minus buttons above it. Clicking either of these buttons will make the image in the preview window larger or smaller depending on which button you click. I think you've already figured out what each one does. There is also a pop-up menu with presets allowing you to get to where you to make the preview image the size you want in a hurry. 'Fit in View' is my favorite but you can also have preset viewing options from 6 to 400%.

Don't be bashful, click the Show Workflow Options checkbox – you know you want to – but when you do you come face to face with yet more choices. Let's get the fear and loathing over with and jump in to see what all this gobbledygook really means.

Space: not necessarily the final frontier

The first choice you face when unlocking Show Workflow Options is assigning a color space to the file. If some of the terms used to describe color space are new to you, don't panic. You can find them in the Glossary at the back of this book. The color space choices available in Adobe Camera Raw's pop-up menu are Adobe RGB (1998), ColorMatch RGB, ProPhoto RGB, and sRGB (IEC619664-1). Why do you even care? Here's the problem in a nutshell: computer monitors are RGB. Most popular desktop printers use CMYK inks but the software that drives the printer uses an RGB model to interpret the colors, so you're gonna need some help.

sRGB was developed to match a typical computer monitor's color space and is the default for Microsoft Windows XP and other software on the Windows platform. It is also the color space tucked inside most digital cameras.

The Adobe RGB color space, on the other hand, is designed for printing using CMYK inks and includes a wider range of colors (gamut) than sRGB. Some digital cameras, especially SLRs, give you a choice of sRGB or Adobe RGB. Take time to look up how to change color space in your camera's user's guide.

ColorMatch RGB was originally based on the Gamma of the Radius PressView Monitor and is a color space that is smaller and less uniform than Adobe RGB (1998). Those photographers with archives of old scanned images will find this color space useful.

ProPhoto RGB has a larger gamut than Adobe RGB, which itself cannot represent some of the colors that can be captured by the newest digital SLRs. ProPhoto RGB has a large gamut that's especially useful if your devices can display saturated colors.

All of these color spaces, except ProPhoto RGB, show some clipping, especially in the Red channel, which means if you choose one of the other color spaces you will lose some data. Yet, most labs want sRGB files because their digital printers can output any pixel data as long as it fits inside their standard gamut space. Out of gamut colors will not be printed and simply disappear causing loss of detail and flat areas of color. Try to avoid bouncing back and forth between color spaces because every time you convert a file you lose some data. If you want to use a color space that's not listed in the Space menu, choose ProPhoto RGB, and then convert to the working space of your choice after the file opens in Photoshop.

Some photographers, especially those working under repeatable studio conditions, find that having camera profiles created for their specific camera is the best solution and Adobe Camera Raw 3 is the first version that will let you do that before opening the image in Photoshop. You can read more about that in a later section of this chapter.

Depth: but not the abyss

Here you face two simple choices: whether to assign a 16- or 8-bit color or bit depth to your image. The information to help you make your decision about which bit depth to use is covered in Chapter 1, so if you skipped over it to come here to get the good stuff, jump back a few pages and find out the advantages and disadvantages of either choice.

Pro's tip:
Some photographers maintain that upsizing in ACR provides better results than performing the same action in Photoshop. The downside of this approach is that you need to know the final size of the file at the time of raw conversion. If, instead, you want to change image dimensions later in Photoshop you can use the Image Size command to upsample your photo. But instead of doing one big jump try making the change in successive steps, increasing image size by 10% in each step, using Bicubic Interpolation. Some have called this process 'Stair Interpolation' and maintain that this approach produces sharper resized files.

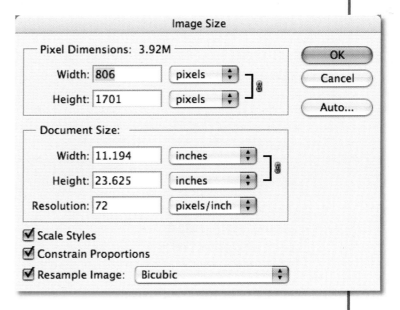

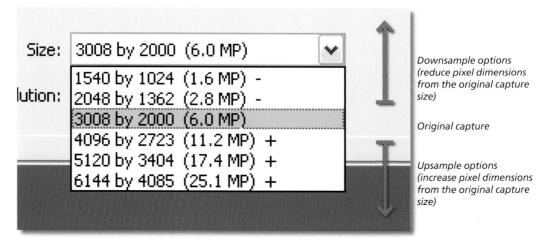

The size drop-down menu provides options to up- or downsample the photo from its original pixel dimensions.

Size: does matter

This pop-up menu shows the choices available in making your image dimensions smaller (downsampling) or larger (upsampling). Photoshop itself provides a way to make larger images using the Image Size (Image > Image Size) command and there are third-party solutions including Lizard Tech's (www.lizardtech.com) Genuine Fractals Photoshop-compatible plug-in. Most users will find that using the Adobe Camera Raw upsample will produce acceptable results, especially if starting with files from mid-sized (8 megapixel) or larger image files.

Resolution: of the matter

Two choices are provided here: one if you want to measure your pixels using English measurements and the other in metric. The key is not how you measure but what you measure.

What's the difference between 'dots per inch' (dpi) or 'pixels per inch' (ppi)? PPI and DPI are measures of resolution:

- PPI relates to the smallest point that can render varying levels of tone and is the number of pixels per inch in your image file that affects print size and output quality. If there are too few pixels per inch, the pixels will be large and your image will appear 'pixilated'. The 'correct' ppi to use depends on print size. Larger prints are viewed at a different distance than smaller ones, so a lower PPI can still work.

- DPI is simply how many dots of ink (or whatever you have) per inch and refers to the printer output. The higher the DPI, the better the print's tonality will be and transitions between colors are smoother, but your printer may be rated 2880dpi, while the ppi could only be 300. This is why the suggested file resolution for printing photographs on an inkjet printer is most often around 300ppi (or sometimes as low as 240 depending on the printer).

The right hand side

Up until now, the rest of the tour of Adobe Camera Raw 3 has been an overture, now it's time to start the symphony.

At the top of this section of Adobe Camera Raw, you'll find a color histogram (1). The histogram simultaneously shows all three channels (Red, Green and Blue) of the image and is automatically updated as you make changes to the settings below. The histogram displays the tonal range of the entire image and gives an overall snapshot of the image's tonal range or key.

A low-key image has detail in the shadows; a high-key image has detail in the highlights; and an average-key image has detail concentrated in midtones.

An image with a full tonal range has a number of pixels in all of the areas. Being able to identify the tonal range helps determine what appropriate tonal corrections are needed – if any. See the figure on page 113 for visual examples of how the histogram will appear for each of these image types.

Settings? Not more settings?

Adobe Camera Raw's Settings pop-up menu lets you choose one of the following options:

Image Settings uses data from the selected raw image file. When a batch of raw images is selected, this setting becomes the 'First Selected Image'. The settings for the first image in the selected batch will be applied to all the images in the batch.

Camera Default uses the saved default settings for a specific digital camera.

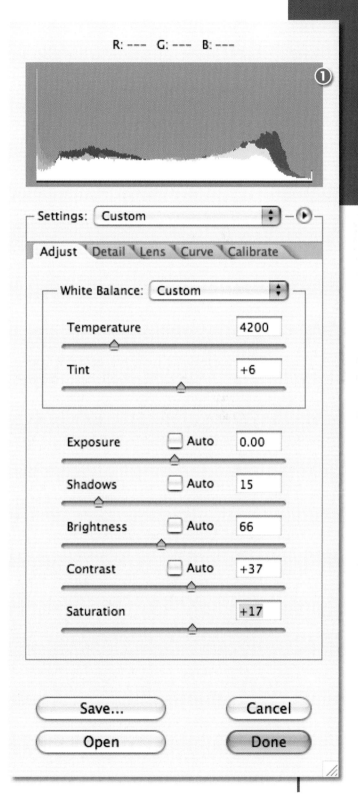

Previous Conversion uses settings from the previous image made with that same camera.

Custom lets you create unique one-time-only custom images that you don't want to save for the future.

The Settings drop-down menu houses four headings – Image Settings, Adobe Camera Raw Defaults, Previous Conversion and Custom, as well as any custom settings that you have saved from previous editing sessions.

When a raw image file is opened with Adobe Camera Raw, settings are stored in the Adobe Camera Raw database file or a sidecar XMP (Extensible Metadata Platform) file. It lets Photoshop remember the setting for each individual Adobe Camera Raw image file so that when you open a raw image the next time, all the settings' sliders default to the same values used the last time to open that specific Adobe Camera Raw image. Image attributes such as target color space profile, bit depth, pixel size, and resolution are not part of the stored settings.

Pro's tip: You can determine where the settings are stored using the Adobe Camera Raw Preferences by clicking the flyout menu next to the 'Settings' pop-up menu and selecting Preferences. These sidecar XMP files can be used to store IPTC (International Press Telecommunications Council) caption data or other metadata.

You can save Photoshop Adobe Camera Raw settings for a specific camera or specific lighting conditions and reapply them on other raw images. You can also save a settings file that contains only a subset of the Adobe Camera Raw plug-in settings. When this subset file is then loaded, only certain sliders are updated. This lets you create settings presets for custom white balances, specific lens settings, and so forth. Using the Bridge (Edit > Apply Adobe Camera Raw Settings) you can also update all or a subset of the settings applied to Adobe Camera Raw images.

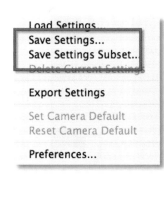

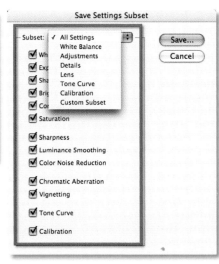

After you tweak all the settings in Adobe Camera Raw 3 you can save them in an XMP file that can be applied to images made at the same time. The customized setting will appear in the Settings menu which can be accessed via the flyout menu below the Histogram display.
The Save Settings Subset dialog allows you to pick and choose which of the controls currently being applied are stored as a group in the Settings menu.

After making adjustments in the Adobe Camera Raw dialog box, do one of the following: you can Save Settings (or Save Settings Subset) from the flyout menu to save the current settings and add them to the Settings menu allowing them to be applied to another image. You might want to save as 'Set Camera Default' to set a default setting for other images from the same camera and you can even have multiple defaults for different cameras.

To save a settings subset

1. Choose Save Settings Subset.

2. Specify the settings to be saved by choosing an option from the Subset menu or select/deselect settings from the 'Settings' list.

3. Click Save.

4. In the Save Raw Conversion Settings dialog box, name and save the file.

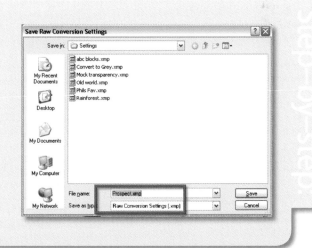

Later on the process can be reversed to apply any saved Adobe Camera Raw settings. All you have to do is choose the name from the Settings pop-up menu. In this case I saved the settings file as 'Prospect', which was the name of the small town in which I made this collection of raw image files. Other settings in the menu include Camera Default that uses the saved default settings for a specific camera and Previous Conversion that uses the settings from the previous image of the same camera. Up to 100 file names can appear in the Settings menu.

The Adjust tab

Under Settings are the five tabs that contain the 'meat and potatoes' of Adobe Camera Raw including Adjust, Detail, Lens, Curve, and Calibrate.

For most Adobe Camera Raw users, Adjust will be the only tab that they will ever use and contains controls for color and exposure. Unlike the last edition (found in Photoshop CS), some of the sliders (Exposure, Shadows, Brightness, and Contrast) in Adobe Camera Raw 3 contain an 'Auto' checkbox that, when selected, automatically sets these parameters and it does a pretty good job of it too. The terminally geeky will want to turn them off, but every time I tried I ended up with near-identical slider settings. Let's start at the top of the list of sliders and work our way down:

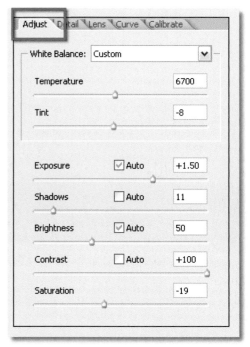

The Adjust tab contains the main controls that you use for enhancing the tones and colors in your raw photos.

White Balance: Digital cameras record the white balance at the time of exposure as metadata. Adobe Camera Raw reads this data and uses it as the initial setting when opening an image in Adobe Camera Raw's dialog box. This initially usually comes close to being the correct color temperature, but you can fine tune the adjustments if it's not quite right. The Adjust tab in the Photoshop Adobe Camera Raw dialog box also has three controls for making adjustments to remove a color cast from the image.

White Balance sets the color balance of the image to reflect the lighting conditions under which the photo was originally made but you may prefer to customize the white balance using the Temperature and Tint sliders that are located below this pop-up menu. Adobe Camera Raw reads the original white balance settings of most digital cameras and leaving the White Balance menu set to 'As Shot' uses the camera's white balance settings. For cameras whose white balance settings are not recognized by Adobe Camera Raw, setting the White Balance menu to As Shot is the same as choosing Auto. The Photoshop Adobe Camera Raw plug-in reads the image data and automatically adjusts white balance.

Other choices from the pop-up menu include Daylight, Cloudy, Shade, Tungsten, Fluorescent, Flash and Custom, which let you create a specific white balance for this image. You might try one of these if the image's color is obviously not correct using the As Shot and Auto options, but I have found that they seldom produce positive results. You may find that using the Temperature and Tint sliders (below) is a good combination when used with either of the automatic settings. Don't take my word for it. Experiment and make up your own mind.

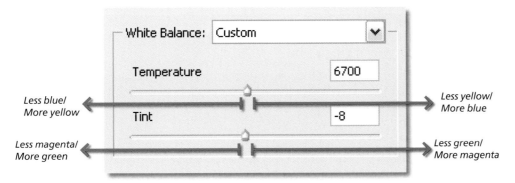

The Temperature slider is used to adjust the balance between yellow and blue in the photo and is linked to an incremental scale called degrees kelvin which is a photographic measure of color temperature. The Tint slider balances the magenta/green light in the image and is typically used to eliminate color casts caused by fluorescent strip lighting.

Temperature lets you fine tune the white balance to a custom color temperature using the kelvin color temperature scale (See 'Who is this Kelvin guy'). Moving the slider to the left corrects for a photo taken with a lower color temperature of light; Adobe Camera Raw makes the image colors bluer to compensate for the lower (yellow) color temperature of the ambient light. Moving the slider to the right corrects for a photo taken with a higher color temperature of light; the plug-in makes the image colors warmer (yellow) to compensate for the higher (blue) color temperature of the ambient light.

Tint is a less complex slider and lets you fine tune the white balance to compensate for green or magenta tint in your photograph. Moving the slider to the left (negative) adds green to the photo, whilst moving the slider to the right (positive) adds magenta.

To adjust white balance quickly, select the White Balance tool in the top left hand side of the dialog, and then click an area in the preview image that should be a neutral gray or white. When you do, the Temperature and Tint sliders automatically adjust to make the selected color exactly neutral.

If the photo contains a picture element that is meant to be neutral such as an area of gray then you can use the White Balance tool to quickly neutralize any color casts in the photo. Just select the tool from the top left of the ACR dialog and then click onto the neutral area. Using the color mix of this area as a guide Adobe Camera Raw automatically alters the red, green and blue values so that they are even, which in turn naturalizes the rest of the photograph.

Who is this Kelvin guy?

I am constantly amazed at the misinformation about the kelvin scale. On the Internet, a power company states the 'History of Kelvin temperature originally comes from the incandescent lamp'. Duh? Long before Edison invented the incandescent light, Lord Kelvin, an Englishman, proposed a new temperature scale suitable for measuring low temperatures. During the nineteenth century, he suggested that an absolute zero temperature should be the basis for a new scale. His idea was to eliminate the use of negative values when measuring low temperatures using either Fahrenheit or Celsius scales. In honor of Lord Kelvin's contributions, this system is called the kelvin scale and uses the unit 'kelvin' or sometimes just 'K'.

There's an old computer adage that goes: 'Garbage in, Garbage out'. You can use any of Adobe Camera Raw's controls to make up for a hopelessly under- or overexposed image. If your digital camera has a histogram feature use it to home in on exposures while you're shooting! If it doesn't, use the camera's auto bracket control, or put the camera in manual mode and bracket exposures for critically important photographs. One of the undisputed laws of the computing universe is that 'The best captured files make the best photographs.'

This digital infrared image of a classic Buick Skylark convertible was photographed with the FinePix S3 Pro in black and white mode and mounted on a tripod. Exposure, in manual mode at ISO 1600, was f-11 and four seconds, using a Hoya CR72 filter. Final exposure settings were determined by viewing the file's histogram on the camera's preview screen.

The Exposure slider adjusts an image's brightness or darkness. Moving the slider to the left darkens the image, while moving the slider to the right brightens the image. The values are in increments equivalent to f-stops. A +1.50 adjustment is similar to increasing the aperture 1½ stops. A –1.50 adjustment is like reducing the aperture by 1½ stops. When using this control remember that your aim is to spread the tones so that you are making full use of the spectrum available but under no circumstances should you clip any pixels. Clipping effectively means losing captured details by converting pixels to either pure white (at the highlight end) or pure black (at the shadow end).

Pro's no clip tip – exposure

Holding the Alt (Windows) or Option (Mac OS) key while moving the Exposure slider gives you a preview of where the highlights become completely white with no detail or are clipped. You can adjust the slider until the highlights (not specular highlights) are clipped, and then back off on the adjustment. Black indicates areas that are not clipped, and color indicates areas that are being clipped in only one or two channels.

The most critical areas of raw processing involve white balance and exposure. Many of the other controls in this tab are replicated in Photoshop CS prime, so that you can make these adjustments later without the loss of gamma that occurs during raw processing. These other controls include: Shadows, Brightness, Contrast and Saturation and the next chapter shows ways to adjust these image factors using Photoshop prime's controls or using third-party Photoshop-compatible plug-ins.

And now for the rest of the story

Shadows controls what input levels will be black in the final image. Moving the slider to the right increases the areas that are mapped to black. Using the Shadows slider is similar to using the black point slider for the input levels in the Photoshop Levels command (Image > Adjustments > Levels). Sometimes this produces the impression of increased contrast.

Pro's no clip tip – shadow

Holding down the Alt (Windows) or Option (Mac OS) key while moving the Shadow slider previews where the shadows become completely black with no detail. Move the slider until the shadows begin to get clipped, and then back off slightly on the adjustment. Color indicates areas that are being clipped in one or two channels, while white indicates areas that aren't clipped.

The Brightness slider adjusts the brightness or darkness of the image, similar to the Exposure slider. Instead of clipping the image in the highlights (areas that are completely white, with no detail) or shadows (areas that are completely black and no detail), Brightness compresses the shadows and

By holding down the Alt/Option key when adjusting Shadow and Exposure controls you can preview the pixels that are being clipped. Here you can see the standard preview (1) and then how it appears when the highlight pixels are being clipped (2).

expands the highlights when the slider is moved to the left. A good rule of thumb, but by no means the only way is to use this slider to adjust the overall brightness or darkness after setting the white and black clipping points using the Exposure and Shadow sliders.

Contrast adjusts an image's midtones. Higher values increase midtone contrast, while lower values produce an image with less contrast. Generally, you use the slider to adjust the contrast of the midtones after setting the Exposure, Shadow, and Brightness values.

Saturation adjusts the color saturation of the image from minus 100 (pure monochrome) to plus 100 (double the saturation) and is similar to controls that you would find inside Photoshop CS2 prime. The only reason you might want to apply these last three corrections inside Adobe Camera Raw instead of later is when converting a raw file to an 8-bit image. Another good rule of thumb is to make global changes to the image file in Adobe Camera Raw and local changes later on inside Photoshop CS2.

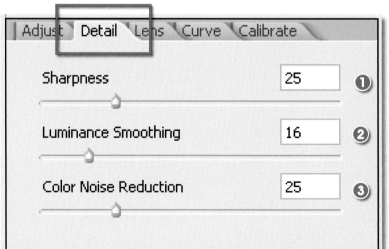

There are three controls grouped under the Details tab. The Sharpness slider (1) is used to apply unsharp mask-based sharpening to the photo. The Luminance Smoothing control (2) reduces grayscale-based noise in the picture and the Color Noise Reduction feature (3) adjusts the level of random color pixels in the photo.

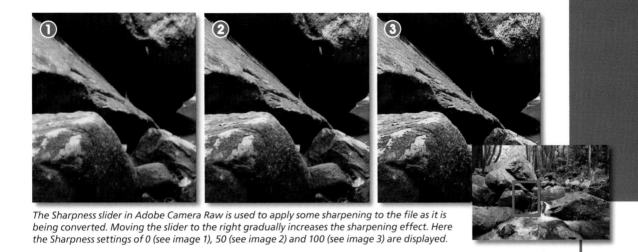

The Sharpness slider in Adobe Camera Raw is used to apply some sharpening to the file as it is being converted. Moving the slider to the right gradually increases the sharpening effect. Here the Sharpness settings of 0 (see image 1), 50 (see image 2) and 100 (see image 3) are displayed.

The Detail tab

The Sharpness slider is a variation of Photoshop's Unsharp Mask filter, which locates pixels that are different than the surrounding pixels based on the threshold you specify and increases the pixels' contrast by the amount you specify. When opening a raw image file, Adobe Camera Raw plug-in calculates this threshold based on your camera model, ISO, and exposure compensation, but you can choose whether sharpening is applied to all images or just the previews.

Almost all digital images, whether captured by scanner or digital camera, can stand a little sharpening, but the edge sharpening techniques used by Photoshop CS2 can create as many problems as they correct. I prefer to not sharpen in Adobe Camera Raw (or in-camera for that matter) and use some of the techniques covered in Chapter 12 to sharpen the image. Adobe Systems' official recommendation is not to use Adobe Camera Raw sharpening if you plan to edit the image extensively later, and then only use Photoshop's sharpening filters as the last step after all other editing and resizing is complete. But I recognize that some of you may want to sharpen right now, so if you wanna do it, use these steps to apply sharpening at the raw conversion stage:

Sharpening with ACR

1. Double-click the Magnifying Glass tool to zoom the preview image to 100%.

2. Move the slider to the right to increase the amount of sharpening and to the left to decrease the amount of sharpening. A zero setting turns off Adobe Camera Raw sharpening. For cleaner images set the Sharpness slider to a low value. (Nothing is uglier than an oversharpened image.)

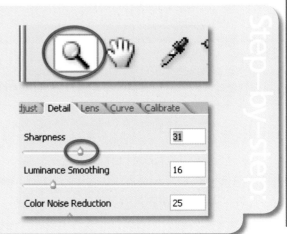

Using either Luminance Smoothing or Color Noise Reduction will reduce an image file's noise. Luminance Smoothing reduces grayscale noise, while Color Noise Reduction reduces chroma noise. (Chroma is a measurement of the relative purity of a color.) Moving the slider to zero turns off its noise reduction. When making adjustments to either Luminance Smoothing or Color Noise Reduction, first zoom in on the image for a close-up look so you can see the effect of the noise reduction. See Chapter 7 for examples of ACR's noise reduction features in practice.

Digital noise

The chips in all digital cameras add noise to images. Like grain in film, digital noise is worse at high ISOs and more noticeable in areas of uniform color, such as skies and shadows. Since noise can be objectionable in an image, there are more than 20 different DNR (Digital Noise Reduction) software products in addition to what's built into Adobe Camera Raw. Chapter 11 will introduce you to several other alternatives for fixing noise.

At 600% magnification, but visible at smaller sizes, the noise from compact digicams such as Canon's SD-10 are noticeable at ISO 400. Surprisingly at ISO 200 the noise is significantly less. So the old rule of thumb for film applies to digital imaging as well: to maintain the maximum image quality, always use the lowest ISO settings that are practical.

The Lens tab

Chromatic aberration is a common lens defect where the lens elements focus different frequencies (colors) of light differently, so there are controls in the Lens tab address this problem. One type of chromatic aberration results in the different colors being in focus, but each color's image is a slightly different size. This type of aberration results in color fringing in areas away from the image's center. The fringing can appear red on the side of an object toward the center of the image, and cyan on the side away from the center of the image. The Fix Red/Cyan Fringe and Fix Blue/Yellow Fringe sliders adjust the red and blue channels making them larger or small to remove fringing and increase corner sharpness.

Some, especially, wide angle lenses create vignetting or a darkening of the corners. Panoramic cameras, such as the Hasselblad Xpan, offer 'Center' filters that are darker in the corners to even up the exposure across the image area in-camera. In the Lens tab, two vignetting controls are provided: Amount and Midpoint. To lighten the photograph's corners, move the Amount slider to the right (positive) side. To darken the image's corners, move the slider to the left (negative). Move the Midpoint slider to the left (lower value) to apply the Amount adjustment to a larger area away from the corners, or move the slider to the right (higher value) to restrict the vignetting Amount

adjustment closer to the corners. You can enter a value in the Amount and vignetting Midpoint text boxes.

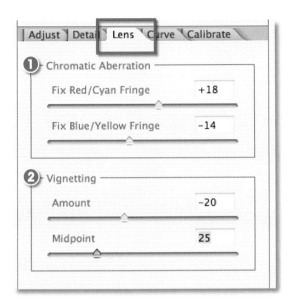

The features located under the Lens tab are designed to aid in the correction of typical lens faults. The first two sliders are used to correct chromatic aberration (1) or the strange color edges that can fringe the sides of contrasting picture elements. Also included in this dialog is the ability to correct vignetting (2) or the darkening of the corners of a photo. The Amount slider controls the strength of the correction effect and the Midpoint alters how much of the image is included in the enhancement.

Super Curve

Hiding behind the new 'Curve' tab is a version of Photoshop's Curves control that overlays an adjustable curve over a histogram of the image file. The Tone Curve drop-down menu (1) lets you apply some presets including Linear, Medium Contrast, Strong Contrast, or Custom. The last option allows you to yank the curve (2) at any point to make the fine tuning of an image based on what you see in the preview window a breeze. You can also enter specific numeric values in Input and Output boxes (3).

Don't know what values to enter? As you move the mouse over the curve, the pointer becomes cross hairs that when placed over different areas of the curve change the values shown on the Input and Output boxes. For more details on how to use curves for the ultimate tonal control see Chapter 9.

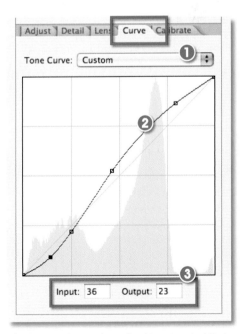

The Curves tab contains a visual tonal control that is very similar in look and function to the Image > Adjustments > Curves feature in Photoshop.

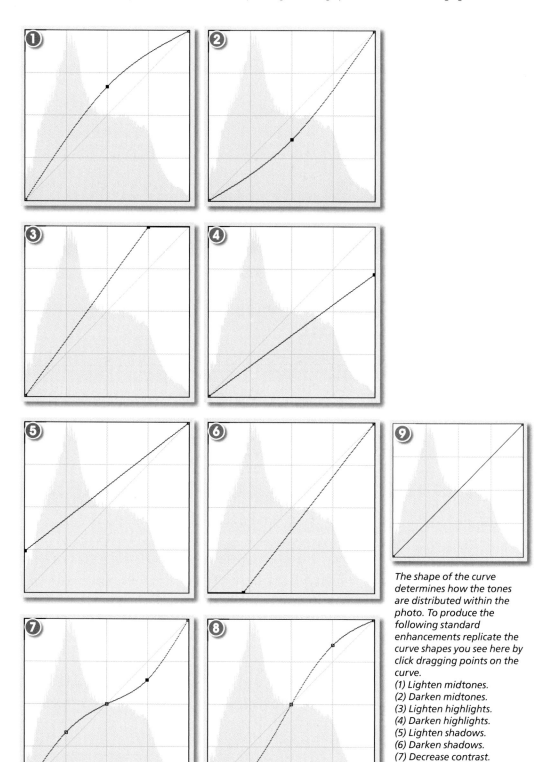

The shape of the curve determines how the tones are distributed within the photo. To produce the following standard enhancements replicate the curve shapes you see here by click dragging points on the curve.

(1) Lighten midtones.
(2) Darken midtones.
(3) Lighten highlights.
(4) Darken highlights.
(5) Lighten shadows.
(6) Darken shadows.
(7) Decrease contrast.
(8) Increase contrast.
(9) Default or Linear curve.

Calibrate, calibrate, dance to the music

If we haven't already said this enough, not only make sure that your monitor is calibrated, make sure that it's been calibrated recently. Otherwise nothing in this chapter will help.

Calibrate houses a set of fine-tuning controls for the color within your photos. The Camera Profile drop-down menu will contain different options depending on if the file has:

1. An embedded camera-based profile already,

2. If the file has been previously processed with an earlier version of ACR (version 2.4), and

3. If you are currently using the latest version of the utility (ACR 3.0).

In the example here (right), all three options are listed – Embedded, ACR 2.4 and ACR 3.0. This indicates that the file has an embedded profile, has been processed before and that ACR 3.0 is installed. In this circumstance, the user can choose to work with the embedded profile (designed for the camera) or opt to handle the colors using the profile provided for your camera by ACR 2.4 or ACR 3.0. The way that color is handled for certain cameras changes between these two ACR releases, so if you have already optimized the color in photos with the previous release of Adobe Camera Raw then choose the 2.4 option; if the file is not yet to be enhanced, then select version 3.0. With the basis of the profile now set let's move onto the specific controls.

Finer white balance control

Every digital camera is unique. Most camera manufacturers apply some sort of correction or profile to their capture files, but in general they apply the same corrections to pictures produced by every camera. These camera specific profiles will go a long way towards ensuring accurate color but every camera/sensor/lens combination will record color slightly differently. Add to this capture equation different light sources, reflective surfaces and subject qualities and you will easily see how important it is to have a tool at your disposal that enables white balance fine tuning. The sliders contained in the Calibrate section of the ACR dialog provide just such control.

So for those times when even after adjusting highlight white balance with the Temperature and Tint sliders, there is still a color cast in the shadow areas of the photo the Calibrate tab's Shadow Tint sliders can change the color in the shadows as well. Moving the slider to the left (negative) adds green and moving the slider to the right (positive values) adds magenta.

The Calibrate tab also has Hue and Saturation sliders for the red, green and blue components of the image. ACR uses these sliders to adjust the built-in camera profile to help render areas that have a color cast more neutrally. To use adjust the Hue first and then move its corresponding Saturation control. Moving a Hue slider to the left is like a counterclockwise move on the color wheel and moving the slider to the right is similar to a clockwise color wheel move. Moving the Saturation slider to the left desaturates the color and moving the slider to the right (positive value) increases the saturation. Watch the preview image as you make the adjustments until the image looks correct.

At this point in the book we will simply introduce you to the controls under the Calibrate tab. In the more advanced techniques covered in Chapter 9 we will overview the complete process for creating a customized profile for a specific camera/lens/sensor/scene scenario.

This split screen shows the Adobe Bridge display for two sets of files that were made at the same time. The top half of the image shows the raw files made with a Canon EOS 20D and the bottom shows the black and white JPEG's that were simultaneously captured.

Converting to black and white

Many digital SLRs have the ability to directly capture digital images as monochrome files but because there is image processing involved in producing the monochrome the final result is usually recorded as a JPEG file. Some SLRs, such as Canon's EOS 20D, offer the ability to capture raw and JPEG files at the same time, so one of my favorite techniques is to shoot raw (color) images along with a large JPEG (monochrome) file at the same time.

If your camera doesn't have this option then our advice is to always capture in full color and, of course, raw mode. The picture can be changed into a monochrome either at the time of raw conversion, by dragging the Saturation (under the Adjust tab in ACR) to 0, or when the file is brought into Photoshop. For the ultimate control use the advanced convert to black and white technique detailed in Chapter 9.

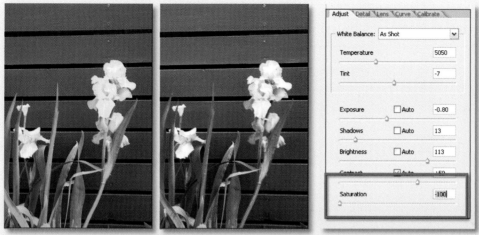

Raw files are unmanipulated and so when Adobe Camera Raw shows one of them to you for the first time it's in color like this image made with a Canon EOS D60. Turning a color raw file into monochrome is simple: go to Adobe Camera Raw's Adjust tab and move the Saturation slider all the way to the left. Bingo, here's a black and white raw file. Is this the best way to make a monochrome image from a color file? Nope. Check out Chapter 9 for other ways to accomplish this conversion.

Transfers: gateway to Photoshop

Many photographers choose to complete the editing and enhancement of their raw photos in Photoshop. As we already know, Photoshop cannot generally handle these files natively and so they need to be converted to a Photoshop friendly format before processing can continue. I say generally because in the next chapter we do present some fancy editing techniques which can be used to handle raw files within Photoshop itself, but in the meanwhile let's assume that you need to convert the files before continuing to process them.

To this end Bridge provides many ways to bring single or multiple image files into Photoshop for final preparation and editing of the photograph. The simplest method is to click on the thumbnail inside Bridge and then select File > Open With > Photoshop CS2. This will transfer the photo to Adobe Camera Raw which is displayed inside the Photoshop workspace. Multi-selecting several thumbnails in Bridge before choosing the Open option will transfer all the files into ACR and stack them neatly in a slide view to the left of the main preview window. After adjusting the conversion settings click Open to close the ACR dialog and transfer the file to Photoshop.

In CS2 several raw files can be imported into ACR and then Photoshop by firstly multi-selecting their thumbnails in Bridge and then choosing File > Open With > Photoshop.

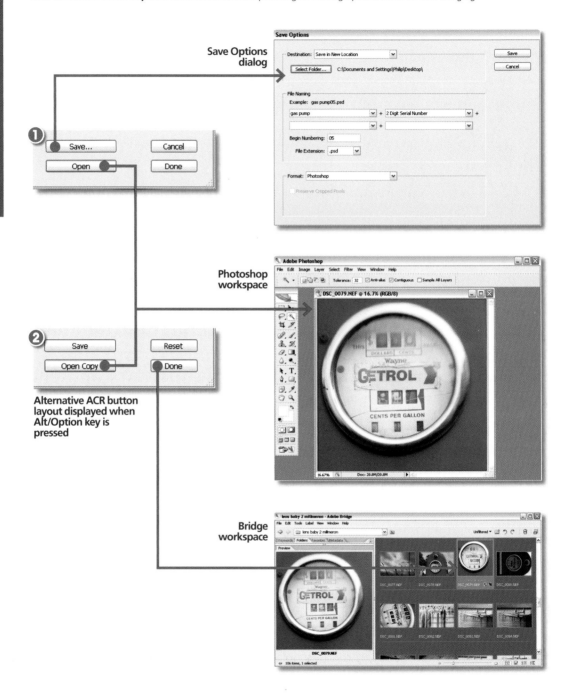

Save Options
dialog

Photoshop
workspace

Bridge
workspace

**Alternative ACR button
layout displayed when
Alt/Option key is
pressed**

*Once you have adjusted all the controls in the Adobe Camera Raw dialog the last step is to choose how to handle
the results of the conversion. To this end the utility contains four default buttons (1) Save (with options) Cancel,
Open, and Done plus an extra three when the Alt/Option key is pressed (2) Save (without options), Reset and Open
Copy.*

ACR output options

Apart from the Open button ACR provides several other options that will govern how the file is handled from this point onwards. To this end, the lower right hand corner of the dialog has four buttons: Save, Cancel, Open and Done and a further three, Save (without the options dialog), Reset and Open Copy, when the Alt/Option button is pushed.

Cancel: This option closes the ACR dialog not saving any of the settings to the file that was open.

Save: The normal Save button, which includes several dots (...) after the label, displays the Save options dialog. Here you can save the raw file, with your settings applied, in Adobe's own DNG format as well as TIFF, JPEG and PSD formats. The dialog includes options for inputting the location where the file will be saved, the ability to add in a new name as well as format specific settings such as compression, conversion to linear image and/or embed the original raw file for the DNG option.

It is a good idea to Select Save in Different Location in the Destination drop-down at the top to separate processed files from archived originals. Clearly the benefits of a compressed DNG file are going to help out in the storage issue arena and compression is a big advantage with DNG. Embedding the original raw file in the saved DNG file begs the questions of how much room you have in the designated storage device and whether you really want to have the original raw file here.

Save (without save options): Holding down the Alt/Option key when clicking the save button skips the Save Options dialog and saves the file in DNG format using the default save settings which are the same as those last set.

Open: If you click on the Open button ACR applies the conversion options and opens the file inside the Photoshop workspace. At this point, the file is no longer in a raw format so when it comes to saving the photo from the Editor workspace Photoshop automatically selects the Photoshop PSD format for saving.

Reset: The Reset option resets the ACR dialog's settings back to their defaults. This feature is useful if you want to ensure that all settings and enhancement changes made in the current session have been removed. To access the Reset button click the Cancel button whilst holding down the Alt/Option key.

Done: Clicking the Open button in conjunction with the Alt/Option key will update the raw conversion settings for the open image. Essentially this means that the current settings are applied to the photo and the dialog is then closed. The thumbnail preview in the Bridge workspace will also be updated to reflect the changes.

Open Copy: Holding down the Alt key whilst clicking the Open button will apply the currently selected changes and then open a copy of the file inside the Photoshop workspace.

Processing with Photoshop, Bridge and Adobe Camera Raw

With the basics now out of the way let's concentrate on the steps that you would take when processing a raw file in Photoshop, Bridge and Adobe Camera Raw.

Opening

With the introduction of Bridge in Photoshop CS2 there are now more ways to open your raw files.

1. Opening the raw file in Photoshop

After downloading from the camera you can start processing the raw files. To do this you must start by opening the picture into the conversion utility. The simplest option is to select File > Open from inside Photoshop. This will import the photo into the Adobe Camera Raw (ACR) utility.

2. Using Bridge to open ACR in Photoshop

Bridge users can achieve the same result by right-clicking the file's thumbnail and then choosing Open With > Photoshop CS2.

3. Opening into ACR in Bridge

Alternatively the photo can be imported directly into ACR without having to open Photoshop first by right-clicking and then selecting Open in Camera Raw. This new CS2 allows for faster raw processing as the conversions take place without the need to share computer resources with Photoshop at the same time.

Pro's tip: The preferences for Bridge can be adjusted so that by double-clicking a thumbnail of a raw picture will automatically open the file in Camera Raw in the Bridge workspace. If this option is not selected then double-clicking will open the file in ACR in the Photoshop workspace.

Rotate and Straighten/Crop

4. Rotate Right (90 CW) or Left (90 CCW)

Once the raw photo is open in ACR you can rotate the image using either of the two Rotate buttons next to the preview window. If you are the lucky owner of a recent camera model then chances are the picture will automatically rotate to its correct orientation. This is thanks to a small piece of metadata supplied by the camera and stored in the picture file that indicates which way is up.

5. Straighten horizons or verticals

Photoshop CS2 and Bridge users can fine tune the rotation of their pictures with the new Straighten tool. After selecting the tool click and drag a straight line along an edge in the photo that is meant to be horizontal or vertical. Upon releasing the mouse button ACR automatically creates a crop marquee around the photo. You will notice that the marquee is rotated so that the edges are parallel to the line that was drawn with the Straighten tool. When you exit ACR by saving or opening (into Photoshop) the picture the rotated crop is applied.

6. Cropping to suit

Also new to the latest release of ACR which can be found in Photoshop CS2 or Bridge is the Crop tool. The feature works just like the regular Crop tool in Photoshop proper, just select and then click and drag to draw a marquee around the picture parts that you want to retain. The side and corner handles on the marquee can be used to adjust the size and shape of the selected area. The crop is applied upon exiting the ACR dialog. Predefined crop formats are available from the menu accessed by clicking and holding the Crop tool button. Also include a Custom option where you can design your own crops to suit specific print or other outcome requirements.

Adjusting white balance

Unlike other capture formats (TIFF, JPEG) the white balance settings are not fixed in a raw file. ACR contains three different ways to balance the hues in your photo.

7. Preset changes

You can opt to stay with the settings used at the time of shooting ('As Shot') or select from a range of light source specific settings in the White Balance drop-down menu of ACR. For best results, try to match the setting used with the type of lighting that was present in the scene at the time of capture. Or choose the Auto option to get ACR to determine a setting based on the individual image currently displayed.

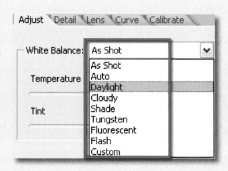

8. Manual adjustments

If none of the preset White Balance options perfectly matches the lighting in your photo then you will need to fine tune your results with the Temperature and Tint sliders (located just below the Presets drop-down menu). The Temperature slider settings equate to the color of light in degrees kelvin – so daylight will be 5500 and tungsten light 2800. It is a blue to yellow scale, so moving the slider to the left will make the image cooler (more blue) and to the right warmer (more yellow). In contrast the Tint slider is a green to magenta scale. Moving the slider left will add more green to the image and to the right more magenta.

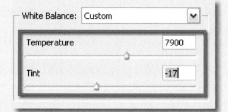

9. The White Balance tool

Another quick way to balance the light in your picture is to choose the White Balance tool and then click onto a part of the picture that is meant to be neutral gray or white. ACR will automatically set the Temperature and Tint sliders so that this picture part becomes a neutral gray and in the process the rest of the image will be balanced. For best results when selecting lighter tones with the tool ensure that the area contains detail and is not a blown or specular highlight.

Tonal control

Then next group of image enhancements alters the tones within the photo. There are five different slider controls each dealing with a specific group of image tones. Each of the controls has an Auto option that when checked will let ACR decide on the best tonal setting to use. Use the following steps if you want a little more control.

10. Setting the white areas

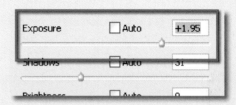

To start, adjust the brightness with the Exposure slider. Moving the slider to the right lightens the photo and to the left darkens it. The settings for the slider are in f-stop increments with a +1.00 setting being equivalent to increasing exposure by 1 f-stop. Use this slider to peg or set the white tones. Your aim is to lighten the highlights in the photo without clipping (converting the pixels to pure white) them. To do this, hold down the Alt/Option whilst moving the slider. This action previews the photo with the pixels being clipped against a black background. Move the slider back and forth until no clipped pixels appear but the highlights are as white as possible.

11. Adjusting the shadows

The Shadows slider performs a similar function with the shadow areas of the image. Again the aim is to darken these tones but not to convert (or clip) delicate details to pure black. Just as with the Exposure slider, the Alt/Option key can be pressed whilst making Shadows adjustments to preview the pixels being clipped. Alternatively the Shadow and Highlights Clipping Warning features can be used to provide instant clipping feedback on the preview image. Shadow pixels that are being clipped are displayed in blue and clipped highlight tones in blue.

12. Brightness changes

The next control, moving from top to bottom of the ACR dialog, is the Brightness slider. At first the changes you make with this feature may appear to be very similar to those produced with the Exposure slider but there is an important difference. Yes it is true that moving the slider to the right lightens the whole image, but rather than adjusting all pixels the same amount the feature makes major changes in the midtone areas and smaller jumps in the highlights. In so doing the Brightness slider is less likely to clip the highlights (or shadows) as the feature compresses the highlights as it lightens the photo. This is why it is important to set white and black points first with the Exposure and Shadows sliders before fine tuning the image with the Brightness control.

13. Increasing/Decreasing contrast

The last tonal control in the dialog, and the last to be applied to the photo, is the Contrast slider. The feature concentrates on the midtones in the photo with movements of the slider to the right increasing the midtone contrast and to the left producing a lower contrast image. Like the Brightness slider, Contrast changes are best applied after setting the white and black points of the image with the Exposure and Contrast sliders.

Color strength adjustments

As one of the primary roles of the Adobe Camera Raw utility is to interpolate the captured colors from their Bayer mosaic form to the more usable RGB format it is logical to include a color strength adjustment as one of the controls in the process.

14. Saturation control

The strength or vibrancy of the colors in the photo can be adjusted using the Saturation slider. Moving the slider to the right increases saturation with a value of

+100 being a doubling of the color strength found at a setting of 0. Saturation can be reduced by moving the slider to the left with a value of -100 producing a monochrome image. Some photographers use this option as a quick way to convert their photos to black and white but most prefer to maker this change in Photoshop proper where more control can be gained over the conversion process with features such as the Channel Mixer.

Lens corrections

The Lens tab contains tools for correcting two of the most common lens faults – color fringing and vignetting.

15. Reducing the appearance of color fringing

Chromatic aberration is essentially a lens flaw where color edges appear around the perimeter of picture parts. This occurs because the lens fails to focus all colors at the same point in the picture. The two sliders in this part of the dialog are designed to correct this problem. To obtain the best results zoom into the raw preview and locate an area that contains fringing. The sliders are split into two groups, Red/Cyan and Blue/Yellow. Move one at a time back and forth until you find a point where the fringing is least apparent.

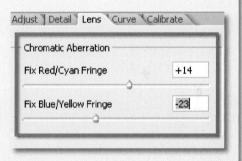

Pro's tip: Holding the Alt/Option key down whilst adjusting either slider hides the other fringing colors.

16. Counteracting vignetting

Vignetting or the darkening of the corners of a photo is another lens aberration that can be corrected with the help of the controls grouped under the Lens tab. To start adjust the zoom of the preview so that you can see the whole image. Move the Amount slider to the right to lighten the corners and to the left to darken them. The Midpoint slider controls the

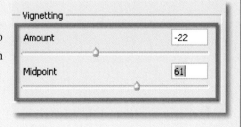

amount of the picture changed by the feature. Moving
the slider to the left includes more of the picture,
movements to the right restrict the changes to just
the immediate area around the corners.

Curve controls

Need even more control over the tones in your photo? Then it is time to tweak those pesky shadow
and highlight pixels with the Curves feature. For straight changes to highlight and shadow
points and the brightness of the midtones look to the controls found under the Adjust tab but for
sophisticated compression and expansion of specific ranges of tones then Curves is the feature to
use. Many photographers apply a little Curves adjustment as the final enhancement step in the
raw conversion process. The alteration may be to better suit the picture tones to the way that a
temperamental printer prints or as a way of providing a signature 'look' to their photographic
work; either way, Curves offers great flexibility for tonal enhancement.

17. More tonal adjustments

In this example I have tweaked the curve to add a
little more contrast to the whole image. I start by
pegging the midpoint (adding a control point to the
middle of the curve). This will act as a pivot for the
other Curves alterations and will ensure that the
middle tones in the image stay put. Next I click on
the highlight area (upper right) and push this part of
the curve upwards slightly. This lightens these tones.
Now to the shadows. Here I click on the shadows
and push down slightly and then add a second point
lower on the curve and do the same thing. Two points
in this region give me better control over how the
shadow detail is represented. The overall effect is that
of a simple contrast increasing curve.

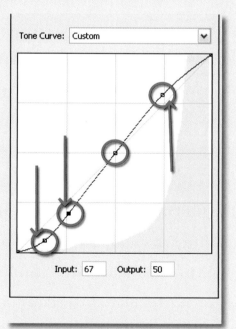

Fine tune color with calibration

In most photographs the occasional cast appearing in the shadow area of a picture that is different to the highlight is not a major problem. For these majority of images the Temperature/Tint controls under the Adjust tab will suffice but for those occasions where absolute control is needed then most professionals click onto the Calibrate tab.

18. Controlling shadow color

Start by choosing the Camera Profile you want to modify. If you are not using an embedded profile and haven't enhanced the image before in a previous version of ACR then choose ACR 3.0.

Next move the Shadow Tint slider to try to obtain a neutral shadow tone. In most cases moving the slider to the left adds green to the shadows and to the right adds magenta but this is largely dependent on the way that your camera sensor functions.

Refine the color of the shadow areas further by adjusting the Hue and Saturation of the individual color channels (red, green and blue).

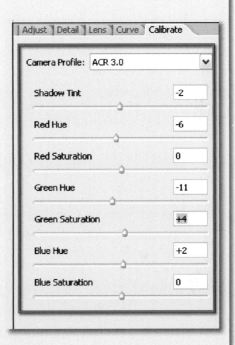

Sharpness/Smoothness and noise reduction

With the tones and colors now sorted let's turn our attention to sharpening and noise reduction. Both these image enhancements can be handled in-camera using one of a variety of auto settings found in the setup menu, but for those image makers in pursuit of imaging perfection these changes are best left until processing the file back at the desktop.

19. To sharpen or not to sharpen

Sharpening is an enhancement technique that is easily overdone and this is true even when applying the changes at the time of raw conversion. The best approach is to remember that sharpening should be applied to photos as the very last step in the editing/enhancement process and that the settings used need to match the type of output the photo is destined for.

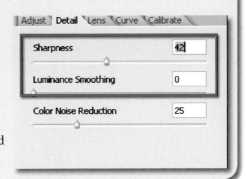

In practice this means images that are not going to be edited after raw conversion should be sharpened within ACR, but those pictures that are going to be enhanced further should be sharpened later using the specialist filters in Photoshop. This said, the sharpening control in ACR is based on the Unsharp Mask filter and provides an easy to use single slider sharpening option. A setting of 0 leaves the image unsharpened and higher values increase the sharpening effect based on Radius and Threshold values that ACR automatically calculates via the camera model, ISO and exposure compensation metadata settings.

20. Reducing noise

ACR contains two different noise reduction controls. The Luminance Smoothing slider is designed to reduce the appearance of grayscale noise in a photo. This is particularly useful for improving the look of images that appear grainy. The second type of noise is the random colored pixels that typically appear in photos taken with a high ISO setting or a long shutter speed. This is generally referred to as chroma noise and is reduced using the Color Noise Reduction slider in ACR. The noise reduction effect of both features is increased as the sliders are moved to the right.

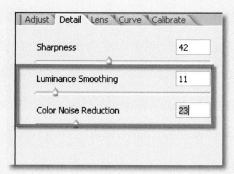

Pro's tip: When using these tools keep in mind that overuse can lead to flat, textureless photos so ensure that you zoom into the image (at least 100%) and check the results of your settings in important areas of detail. The golden rule is apply the least amount of Smoothing and Reduction to get the job done.

Output options

Now to the business end of the conversion task – outputting the file. At this point in the process ACR provides options that will govern the type of file generated in the conversion.

21. Controlling color depth/space and image size/resolution

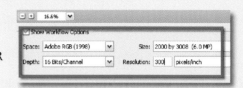

The section below the main preview window in ACR contains the output options settings. Here you can adjust the color depth (8 or 16 bits per channel), the color space (ICC profile), the image size (maintain capture dimensions for the picture or size up or down) and the image resolution (pixels per inch or pixels per centimeter).

Save, Open or Done

The last step in the process is to apply the changes. This can be done in a variety of ways in both Photoshop and Photoshop Elements.

22. Opening into Photoshop or Photoshop Elements

The most basic option is to process the raw file according to the settings selected and then open the picture into the editing workspace of Photoshop or Photoshop Elements. To do this Elements users simply select the OK button and Photoshop aficionados click the Open button. Select this route if you intend to edit or enhance the image beyond the changes made during the conversion.

23. Saving the processed raw file

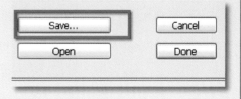

Photoshop users have the ability to save converted raw files from inside the ACR dialog via the Save button. This action opens the Save Options dialog which contains settings for inputting file names, choosing file types and extensions as well as file type

specific characteristics such as compression. Opt for this approach for fast processing of multiple files without the need to open them in Photoshop. Unfortunately the same functionality is not available for Photoshop Elements users. Instead they will need to open (click the OK button) the converted file in the Editor workspace and then select File > Save As to perform the same function.

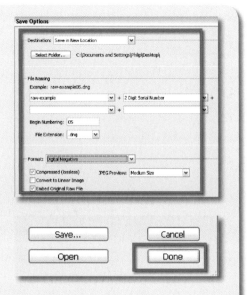

24. Applying the raw conversion settings

Both versions of ACR allow the user to apply the current settings to the raw photo without opening the picture. In Photoshop Elements this is undertaken by Alt-clicking the OK button (holding down Alt key changes the button to Update). Photoshop users simply click the Done button. The great thing about working this way is that the settings are applied to the file losslessly. No changes are made to the underlying pixels only to the instructions that are used to process the raw file. When next the file is opened, the applied settings will show up in the ACR dialog ready for fine tuning, or even changing completely.

Beyond ACR Basics

I n the previous chapter we saw how we could take a camera file in raw format and, using the features of Adobe Camera Raw (ACR), process the image, enhancing color, tone and sharpness. Let's now look at some more specialized Adobe Camera Raw techniques that the professionals are using daily to speed up their workflow whilst maintaining the ultimate image quality.

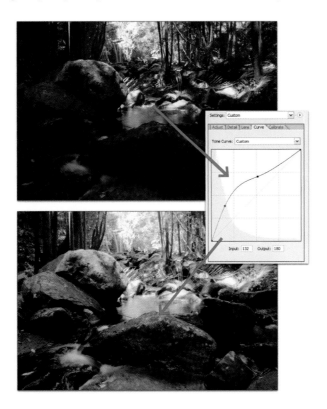

The Curves feature in ACR works in a similar way to the similarly named tool in Photoshop and provides custom control over the tones in your raw photos.

Technique 1: Curves provide advanced tonal control

Available in: ACR for Photoshop/Bridge

Experienced digital photographers who want a little finer control over the tones in their pictures often turn to the Curves feature in Photoshop. The feature contains a graph-based workspace with a light gray histogram preview of the picture's tones and a straight line that represents the relationship between input values and output tones. By manipulating the line in the curves dialog, the user can finely tune the appearance of different tones in the photo without unduly affecting other areas of the image.

Several of the more sophisticated raw converters, such as Adobe Camera Raw (Photoshop and Bridge), now contain curves features so that such fine-tuning steps can be applied to raw files just as easily as standard PSD, JPEG or TIFF images. The feature is located under the Curve tab in the Settings area of the ACR dialog. The user can select from three different curve presets located in the Tone Curve drop-down menu or create their own 'custom' settings. Do this by clicking to place a control point on the curve and then click-dragging the point to a new position to alter the tones in this part of the image.

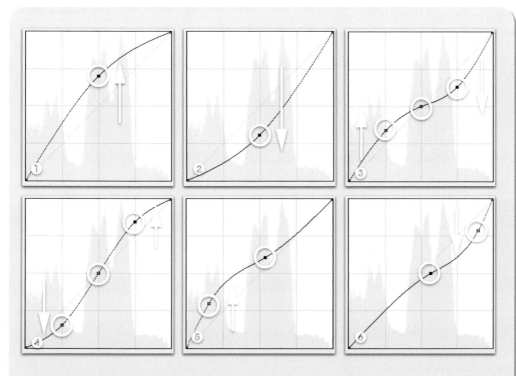

Quick start Curves summary

1. **To lighten midtones but no change to highlight and shadow areas** – Click and drag a middle control point upwards

2. **To darken midtones but no change to highlight and shadow areas** – Click and drag a middle control point downwards

3. **To decrease contrast** – Click to add a control point to the middle and then click and drag a shadow control point upwards and a highlight point downwards

4. **To increase contrast** – Click to add a control point to the middle and then click and drag a shadow control point downwards and a highlight point upwards

5. **To lighten shadows only** – Click to add a control point in the middle and then click and drag a shadow point upwards. Now adjust the middle point until the highlight area of the line is almost straight again

6. **To darken highlights only** – Click to add a control point in the middle and then click and drag a highlight point downwards. Now adjust the middle point until the shadow area of the line is almost straight again

Technique 2: Color fine tuning with the Calibrate feature
Available in: ACR for Photoshop/Bridge.

As well as the white balance presets and Temperature and Tint sliders, Adobe Camera Raw also contains a set of color specific controls grouped under the Calibrate tab in the Settings section of the dialog. Though daunting to start with, the options found here do provide an amazing amount of control and are used by many professional photographers to 'profile' the way that the color from their cameras is interpreted by the raw converter. This is particularly useful for building a profile for neutralizing the casts that are present in images photographed under mixed artificial lighting conditions.

The process involves photographing a Macbeth Color Checker reference board under the lighting conditions that are typical for the scene. The raw file is then opened into Adobe Camera Raw and the color and tones of the captured file is adjusted to match the 'true' values of the patches. The RGB values that each patch should be (in a variety of color spaces) can be obtained from Bruce Lindbloom's great website (www.brucelindbloom.com). These synthetic values will act as a reference when making your adjustments.

Start by setting a basic white balance by clicking onto the light gray patch of the Color Checker with ACR's White Balance tool. Next use the Exposure and Shadow sliders to adjust the contrast of the image. Use the Color Sampler tool to check the patch values in the raw preview against those synthetic values found on Lindbloom's site.

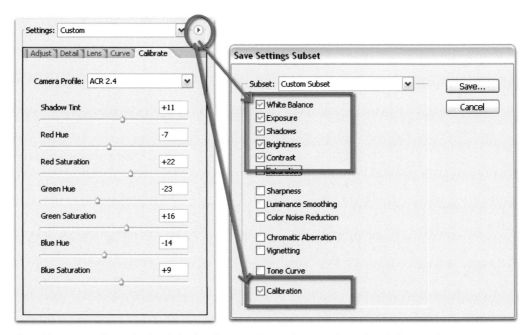

The Calibrate control provides the ability for photographers to fine tune their white balance in their pictures to match difficult non-standard lighting conditions. After performing making these settings you can then save the values to be used with other pictures photographed under the same lighting conditions.

Next switch to the Calibrate tab and use the sliders to start to adjust the color of the test patches. Again your aim is to match as closely as possible the captured (sampled from the preview) values with the synthetic values of the Color Checker. This can be a pretty exacting task as moving one slider will not only affect its color but also the value of the other two. Matching the two values is a process of adjust, check and then adjust again but once completed the final color settings can be saved as a new settings subset and applied to all photographs taken under the same lighting conditions.

Synthetic RGB values for the Macbeth Color Checker patches (Adobe RGB)

Red 106	182	103	95	129	133
Green 81	149	122	108	128	189
Blue 67	130	154	69	174	170
194	79	170	84	167	213
121	91	85	62	186	162
48	162	97	105	73	57
54	101	152	228	164	63
62	148	48	199	83	134
149	76	58	55	144	163
242	200	159	122	84	53
241	200	160	121	84	53
236	199	159	120	84	53

The table is laid out in the same 6 × 4 array as the Color Checker chart, and within each cell, the color components are shown in red, green, blue order from top to bottom. When adjusting the sliders in the ACR Calibrate tab aim to replicate these RGB values.

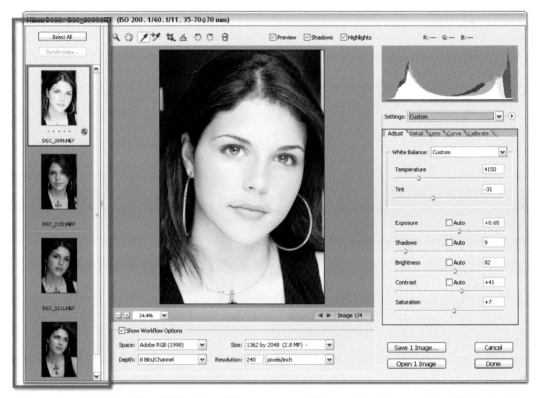

The version of ACR that ships with Photoshop CS2 can process multiple raw files at the same time. Multi-selected files are displayed as thumbnails to the left of the main preview area.

Technique 3: Applying raw conversion settings without opening files

Available in: ACR for Photoshop/Bridge

The version of Adobe Camera Raw that ships with Photoshop CS2 includes many new features, including the ability to open and process multiple raw files at the same time. Previous versions of the utility, as well as the iteration that ships with Photoshop Elements, are only able to work on one file at a time.

To process several files at once, multi-select their thumbnails in the Bridge workspace and then select File > Open with Camera Raw (Alt/Option R). The first selected file is previewed in the ACR workspace and highlighted in the slide table section (left) of the dialog. The rest of the pictures are also displayed here in thumbnail form.

To process the files simply click on each thumbnail in turn making your enhancements using the slider controls and then clicking Save or Done to apply the changes. For images shot at the same time under the same lighting conditions, the enhancement process is even quicker. Start by adjusting the settings for the first photo in the series. Next choose the Select All button at the top left of the dialog (you can also multi-select specific thumbnails) and then click Sychronize. ACR then

displays the Synchronize dialog where you can select the specific enhancements that you want to apply to all selected images. Click OK to exit the dialog and apply the changes to the thumbnails. Press the Save or Done buttons to apply the changes to the photos.

And remember that the enhancements have not been applied permanently – you can always reopen the raw file and change the settings or even remove the enhancements all together.

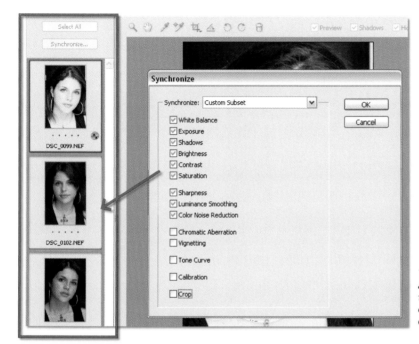

The Synchronize option allows the user to apply the settings created for one file to a selection of other raw photos.

One step further...

This multi-image processing idea can be taken a step further with the ability to apply saved Camera Raw settings directly to thumbnails from within Bridge. The settings are listed in the pop-up menu that is displayed when you right-click a raw thumbnail in the Bridge workspace. The default options include Camera Raw Defaults and Previous Conversion. To apply these to an unopened raw file, simply right-click onto the thumbnail and select the entry from the pop-up menu.

To set a new Camera Raw Default, open a file, make any adjustments and then click the sideways-arrow button beside the Settings drop-down menu in the top right of the dialog and select the Save New Camera Raw Defaults option from the menu that is displayed. This records the current settings as the new defaults. To reset all the settings choose Reset Camera Raw Defaults from the same menu.

To store custom raw conversion values as new entries on the right-click pop-up menu, open an example file, make the changes necessary to achieve the look you want and then select the Save Settings entry from the pop-up menu. In the Save window that follows you will get a chance to name the settings with a title that will become a new entry on the right-click menu.

Now to apply these new custom raw conversion settings to a series of images, choose several thumbnails from within Bridge, right-click on one of the photos and select your custom settings entry from those listed. ACR will then apply the group of settings to all the selected photos and automatically update the thumbnails to reflect the changes.

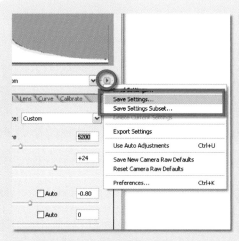

The Save Settings option is used to store a specific group of raw conversion values.

Saved conversion settings can be applied to raw files by right-clicking the thumbnail and then selecting the setting entry from the menu list.

Raw settings (1) and cropping (2) icons are displayed on thumbnails in Bridge when the picture has had conversion settings applied to the photo.

The Save New Camera Raw Defaults replaces the stored default settings with those applied to the currently selected photo.

Managing ACR settings:

Use the Chromatic Aberration sliders in the Lens tab of Adobe Camera Raw to correct the color fringes that sometimes occur on photos taken with wide angle lenses. (1) Before chromatic correction. (2) After chromatic correction.

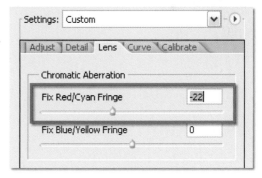

Technique 4: Correcting color fringes and vignetting

Available in: ACR for Photoshop/Bridge

The ultra wide angle lenses that are now available for many DSLR cameras can capture incredible angles of view but in doing so some images from these lenses exhibit color fringing and vignetting problems.

The fringing is the result of different wavelengths of light not being focused at the same position on the sensor. Known as chromatic aberration, the visual results of this lens defect is most noticeable on areas of contrast around the borders of the photo. Most users will see the problem as colored lines hugging the sides of edge detail. In the example image, there is distinct red/cyan fringing (1) visible along the main structural element in the photo. The Lens tab in Adobe Camera Raw contains two sliders that are designed to reduce the appearance of chromatic aberration in your photos. The

feature contains two sliders. One that concentrates on Red/Cyan fringing and a second that works on Blue/Yellow fringes. To reduce the effects of this lens problem, zoom into the photo in the preview and navigate to a part of the picture where the colored lines are clear and easy to see. Now carefully move one of the sliders and watch the preview. Move the slider enough to reduce the effects of the fringing but be carefully not to overcompensate and introduce fringing of the opposite color to your photo.

The darkening of photo edges or vignetting can be corrected with the aid of the Amount and Midpoint sliders in the Vignetting section of the Lens tab part of ACR. (1) Before vignette correction. (2) After vignette correction.

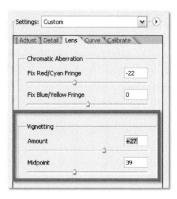

Vignetting is another visual effect that results from a lens problem. This time it is the lenses' inability to maintain even exposure across the whole sensor. This results in the darkening (sometimes lightening) of the corners of the frame. Now sometimes this effect can be artistic, and many photographers actually introduce a little vignetting into their photos as part of the enhancement process, but dark corners, when they are not wanted, are a problem.

Included alongside the Chromatic Aberration controls under the Lens tab are two sliders that help counteract the vignetting effect. The Amount slider lightens the corners of a photo when moved to the right and darkens them when moved left. The Midpoint control adjusts the amount of the picture that the lightening or darkening is applied to. To reduce the vignetting in your photos drag the Amount slider until the brightness of the corners is similar to the rest of the picture then use the midpoint slider to fine tune the lightening effect so that the transition to the rest of the photo is even.

10

Stand Alone Converters

Here we present three examples of stand alone converters. Unlike Adobe Camera Raw which is linked to either Photoshop or Photoshop Elements, these programs are self-contained and provide a valuable alternative to the offerings from Adobe, Apple and the camera manufacturers.

Of the options presented, Raw Shooter is what I consider a lean and mean machine for photographers who seek results with little effort or intervention. DxO should be particularly attractive to photographers who are concerned about 'zeroing in' on concerns related to their cameras and/or lenses. Capture One, with or without iView Media Pro, is designed to appeal to professionals, particularly those who work with Phase One and other supported digital backs. The converter is especially useful when tethered to a computer, with on-screen results appearing within the Capture One windows and palettes.

Pixmantec Raw Shooter

Raw Shooter executives introduced a new raw management package in 2005. The release is what the company deems a 'complete' workflow management solution. Their goal all along has been to make Raw Shooter the fastest raw workflow gun in the West (my words). Much in the spirit of Photoshop Elements, to make the process go quickly Raw Shooter menus are set up to get you to work on only two tabs with sliders, Correct and Batch Convert. The program also handles ranking and organization, DNG conversion and image and lens corrections.

The operative words for this package are 'speed' and 'quality' – if you want top quality results in a hurry, try this package. Raw Shooter has been designed for photographers of all levels and in the end offers saving converted files to TIFF or JPEG for use in Photoshop or a long list of graphics programs.

Raw Shooter:

1. The Raw Shooter workflow is lean and mean: start by viewing the images after downloading them.

2. Identify the best images and rank them numerically. Do this by hovering the mouse over one of the thumbnails and then selecting a rating from the pop-up buttons. Rotate any pictures that need reorientating using the buttons at the top of each thumbnail.

3. Correct raw files using a combination of the controls in the Correction panel. Start by working through the slider controls from top to bottom of the dialog. Then move onto the individual correction areas of Detail/Noise, Curve/Levels and Color.

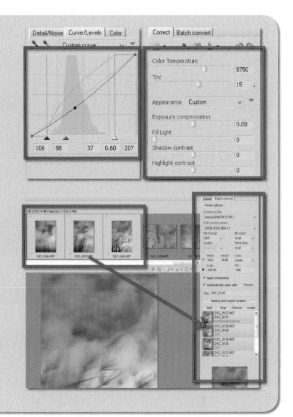

4. Apply the adjustment settings and save the converted files using the options in the Batch convert section. Raw Shooter will then automatically open the converted images into Photoshop ready for the next step in the process.

Conversion and processing using Dx0 software

Dx0 is a simple-to-use yet sophisticated and effective raw converter and processor that makes short order of an often complex raw workflow. You must select the exact camera model and lens you used to capture a batch of images or your ability to open files will be limited.

1. Start up the program, select the folder or set of images you want to convert and process. The program automatically corrects the images according to the camera and lens you selected. You are then presented with an option to convert more photos or view the converted images.

2. Select special options:

a. Image Enhancement Options
 that emphasize DxO's strengths
 for lens adjustments within
 raw conversion and processing:
 blur, distortion, chromatic
 aberration (when light from one
 point of an object ends up in a
 different point(s) in the image),
 and vignetting (a shadow that
 appears around the edges of the
 image due to a reduction in image
 brightness in these areas).

b. Output: select the DNG option for
 output here.

c. ICC profiles: select As Shot,
 Predefined ICC Profile, or Custom
 ICC Profile.

3. Move the images to an image editing
 program you may indicate as a
 default earlier in the setup process.

DxO is a streamlined approach to a raw workflow. Try it and see if you like the results after
working with your images in any of the other raw converters discussed in subsequent chapters.

Capture One and iView

The executives at Phase One who produce Capture One PRO, the professional-level end-to-end raw workflow software, suggest employing the simple workflow that follows:

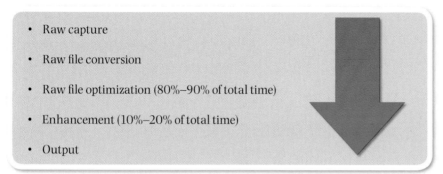

- Raw capture

- Raw file conversion

- Raw file optimization (80%–90% of total time)

- Enhancement (10%–20% of total time)

- Output

As you can see most of the workflow is spent on file optimization in the raw workflow software and then enhancement in Photoshop.

Capture One PRO and iView MediaPro offer, through a collaborative arrangement, a full workflow from capture to archives, with digital asset management from iView. MediaPro works with TIFF, JPEG, PSD and DNG files and also reads TIFF previews from Phase One camera backs. Capture One is also available in DB and LE versions for non-professionals. New camera support announcements are frequently released for the Capture One range. So even though the companies' raw processing software started as a means of control for the Phase One camera backs and processing for the pictures the backs captured, the program now caters for the raw output from many other camera makers.

Let's take a closer look at using the Capture One PRO/iView MediaPro combination to illustrate what makes this combination a good digital raw workflow.

Capture One PRO handles raw images for you through the entire workflow by performing color correction tasks and honing-in on artifacts, banding, noise and other known issues. Capture One PRO and DB versions have a new feature called Pattern Noise Suppression to remove noise and unwanted patterns that occur when using ultra wide lenses on cameras with medium-format cameras with Hasselblad and Phase One digital backs and on tethered DSLRs.

A banding suppression slider in the latest PRO version is also available. Two special ICC color profiles for Canon and Nikon D-SLR cameras are also included. They are designed for high saturation (HiSat) and low saturation (LoSat) scenarios; other profiles are under development or made available as prototypes for the Leica Digital Modul R for the Leica R8/R9, Olympus and other high-end cameras. It is worth checking the update section of the Capture One site regularly to ensure that you have the latest version of the software and any customized profiles designed for your hardware.

The iView MediaPro/Capture One Pro workflow

The iView MediaPro and Capture One PRO combined workflow comprises the following steps:

1. To start, set up new catalogs, thumbnails, and labeling with MediaPro. Next, capture a series of images with your camera. I recommend you get rid of the poor images in-camera at this stage.

2. Download (import) to hard drive and backup storage. Also catalog raw files. At this stage you can assign author, copyright and other data in what is called the Annotations panel. Set a folder watching feature that tells MediaPro how often to automatically catalog additional images when they are downloaded from memory cards to computer.

 Catalog raw files in MediaPro, with optional backup. I suggest immediately burning the CD/DVD. If you have a camera that automatically saves images to DNG, save the DNG files to disk. Keep the DNG and original raw files in separate storage locations. I also recommend not embedding the original raw files with the DNG files.

3. Review and Mark for ranking, slide shows. MediaPro uses color labels and star ratings for ranking.

 In the Preferences dialog box you can customize the color labels to tell you what has been done to the file.

4. Color Correct and Convert Raw in Capture One. At this stage you launch Capture One and begin a processing and conversion job. Professionals will want to create a job named or numbered folder; perform work on images; import new folders and subfolders into MediaPro catalogs that track processing, color corrections, retouching and final images; and ask MediaPro to automatically update all related folders. The overall MediaPro/Capture One workflow assumes you will spend approximately 80–90% of your time with raw files in this phase. Take care of cropping and straightening, color balance and correction, lens corrections, and other issues.

You can use Capture One to batch color correct and convert raw files to TIFF, PSD or JPEG. I recommend you save to TIFF or PSD and make the conversion to JPEG in Photoshop when you need to prepare an image for emailing, the web or other purpose. More than likely you will have selected an Adobe RGB color space and 16-bit depth for the raw images and when you convert to JPEG for the web you will choose the sRGB color space and 8-bit depth.

5. Modify photos in an image editing program, with retouching and batch processing. This workflow assumes you will spend approximately 10–20% of your time in post conversion. Use Photoshop or other programs to perform additional work on images that need it and prepare files for output. As with many other end-to-end raw workflow-

based applications, a toolbar drop-down menu or dialog box flyout menu is available to let you select the image editing program you will use to modify images.

6. Professionals will create subfolders within the main job folder for each state: originals, job captures and processed files, color corrected files, retouches and final files. Save files to the appropriate subfolders after making corrections in Photoshop.

7. Embed metadata for IPTC and XMP. Now you are back in MediaPro in which metadata is called annotations. IPTC and XMP metadata may be embedded into TIFF, JPEG and Photoshop file formats.

8. Publish, Present and Share for email, print, PDF and web. Assuming you are using these two applications for your business, you are now ready to burn images to CD/DVD, present a slideshow, and create a web gallery. Other programs like Extensis Portfolio also provide many of the above-mentioned features, including web gallery creation.

9. Archive project by backing up originals to storage media and devices. Don't lose those precious image assets. Be sure to back up all files. The iView program has a nice Action feature to hastily perform a batch backup. Go to Action > Transfer to Folder > Duplicate Files, choose a destination folder and click. Or you can use the backup functions for burning CDs and DVDs.

11

Lossless Image Enhancement Comes of Age

As we have already seen in Chapter 5 the current state of play for most raw processing is a workflow that involves a 'Convert and then Edit' approach. The conversion step is handled by a dedicated raw utility such as Adobe Camera Raw, Raw Shooter, Nikon Capture Editor and the editing operations fall to Photoshop. But this way of working doesn't take full advantage of the possibilities that abound in the area of non-destructive or lossless editing.

For years photographers have advocated using a non-destructive editing workflow whenever possible. On a simple level this meant doing things like applying changes to images in Photoshop via adjustment layers rather than altering the original pixels themselves. Until recently no matter how much a photographer wanted to adopt a non-destructive editing workflow the first step was to convert the raw file from its original state (unprocessed raw pixels) to a picture format that enabled further processing. Sure from this point forward it was possible to make use of non-destructive editing techniques but these changes were made to the converted file not the original raw picture.

Well, thankfully, 'times are a changin''. Companies such as Adobe and Apple have taken up the challenge and have started to create non-destructive editing options for raw shooters that maintain the integrity of the original raw file throughout the editing process. With dedicated programs such as Adobe's Lightroom and Apple's Aperture now on the market the future for raw shooting photographers is looking decidedly rosy.

But how does it work?

Providing a workflow that is non-destructive is pretty tricky, but how do the software developers actually make the process work? Well the underlying principle of the approach is to maintain the original raw files as a separate entity from the conversion and editing settings that are applied to the picture. With Adobe's system these conversion settings are stored in an XML (Extensible Markup Language) file that is named the same as the picture itself.

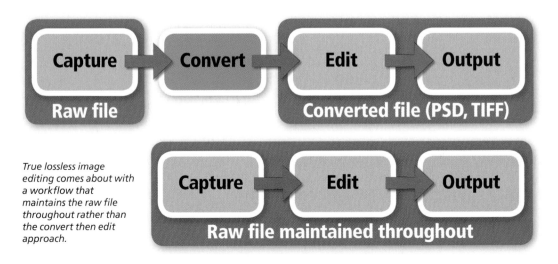

True lossless image editing comes about with a workflow that maintains the raw file throughout rather than the convert then edit approach.

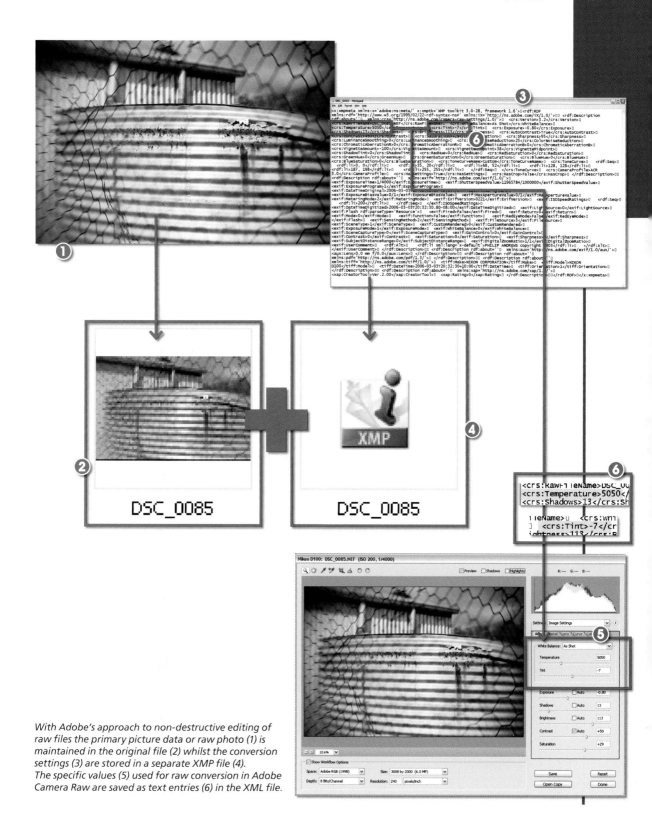

With Adobe's approach to non-destructive editing of raw files the primary picture data or raw photo (1) is maintained in the original file (2) whilst the conversion settings (3) are stored in a separate XMP file (4). The specific values (5) used for raw conversion in Adobe Camera Raw are saved as text entries (6) in the XML file.

Check this out yourself. Have a look at the folders containing pictures that have been processed through Adobe Camera Raw (ACR) you will see a series of XML files associated with the raw files. The XML file is essentially the full set of conversion settings that were selected in ACR at the time of processing. When the raw file is reopened ACR uses these values to automatically set up the dialog's controls as well as adjust the preview of the raw photo so that it matches how the picture will look when processed. Making a change to conversion settings such as white balance, exposure or saturation merely adjusts the appropriate entry in the settings file, which in turn updates the preview in the ACR dialog and the thumbnail displayed in Bridge.

Working this way means that the original raw file pixels are never destructively changed. The settings can always be altered at a later date or even removed without any loss of quality – it is, if you like, the ultimate form of 'Undo'.

Note: This method of providing a live preview of the how the image looks with the conversion settings applied is one of the reasons why some full workflow programs require substantial system resources (processor and video power as well as high levels of available RAM) to function quickly.

What happens when I want to print or create a slideshow?

This doesn't mean that raw files can remain so forever. At this stage in the development of full workflow tools there are some functions that only work with converted files. This includes the application of many of the filters currently available in Photoshop as well as much of the current ways of making changes to just portions of photos (via selections). A lot of development work is being done in this area and my guess is that you will see a range of new non-destructive, raw-enabled tools and features being added to your programs in the next few months.

Also for the moment, tasks such as creating a slideshow, or outputting a series of prints require the program to make the conversion in the background before constructing the page to be printed off the web gallery.

State of play

Over the next couple of chapters we will look at the current state of play for photographers who want to maintain their raw files but still be able to manage, manipulate and output these pictures as easily as if they were stored in more traditional formats (PSD, TIFF or the dreaded JPEG). In particular we will look at the workflows and techniques associated with Bridge/Photoshop, Lightroom and Aperture.

12

Bridge and Photoshop Combine

U ntil recently, raw files were viewed as a capture-only format with the first step in any workflow being the conversion of the picture to another file type so that editing, enhancing and output tasks could be performed. I say recently because with the release of products such as Aperture from Apple, and Lightroom from Adobe, it is no longer necessary to change file formats to move your pictures further through the production workflow.

Even Bridge is sufficiently raw enabled to allow the user to produce contact sheets, PDF presentations, picture packages and web galleries all from raw originals. Yes, the files are converted as part of the production process for these outcomes, but I can live with this intermediary step if it means that my precious pictures stay as raw for more of the production workflow. With a little trickery associated with Photoshop's Smart Object technology it is even possible to edit individual pictures inside a standard Photoshop document.

So with this in mind let's look at some of the output options that are available for the raw shooter who wants to use Photoshop CS2 and wants to maintain his or her picture's raw status for longer.

Bridge contains an automated slideshow feature that can be accessed directly from the View menu or by pressing Ctrl/ Command L.

Options for screen output

Instant slideshows

Slideshow is one of the new view modes available in the Bridge workspace. Selecting this option creates an automatic self-running slideshow containing the images in the current workspace or those multi-selected before choosing the feature. Pressing the H key displays a list of commands that can be used to navigate, edit and adjust the slideshow.

This feature provides a great way to quickly edit and label a bunch of images that you have just photographed. Multi-select the photos within the Bridge workspace and then click Ctrl/Command L to switch to Slideshow view. As each of the photos is being displayed you can rate the pictures by clicking the number keys 1–5 or label them by pressing 6–9. Some photographers use this approach with their clients interactively rating the pictures based on the client's feedback to the slideshow.

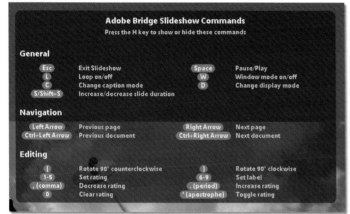

By clicking H you can display the list of shortcut keys used to control the slideshow or add labels to pictures during the presentation.

Portable slideshows

If you need to send a series of photos to a friend or client, rather than showing them directly from your desktop, you can create a special portable slideshow which Adobe calls a PDF Presentation. The end result is a self-running slideshow saved in the PDF or Adobe Acrobat format that can be emailed or saved to a CD and then forwarded.

As before, start the process by multi-selecting the photos to be included in the presentation from the thumbnails inside the Bridge workspace. Next, select the PDF Presentation option from those listed in the Tools > Photoshop menu. Photoshop opens and the PDF Presentation dialog is then displayed. Here you have the option of adding to the files selected or removing any that are already on the list. Next, select the Presentation option at the bottom of the dialog and adjust the Advance and Transition settings before clicking the Save button.

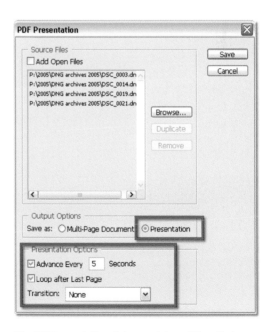

The PDF Presentation dialog contains settings that control the timing and transitions in the slideshow.

Select a name and folder for the presentation before clicking Save for a second time. Choose the Screen Res setting from the PDF Presets dialog that is displayed, before pressing the Save PDF button. Photoshop now does its magic opening, converting, sizing and saving the pictures in the presentation format. The final result can be viewed in Adobe's free Acrobat Reader.

The completed slideshow is produced in the form of a self-running PDF presentation which can be viewed with Adobe's free Acrobat Reader.

Exporting to other file formats

Automated conversions using the Image Processor

Back when CS was first released Adobe evangelist Russell Brown developed the Image Processor to demonstrate the power of the scripting engine within Photoshop and at the same time to provide a very handy image conversion utility. Now the Image Processor is a permanent part of both Bridge and Photoshop's feature lineup.

The utility is designed to quickly convert a range of raw files into JPEG, PSD and TIFF versions. There is an option to manually adjust

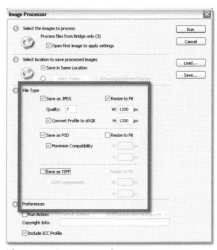

The Image Processor script generates up to three different file format versions of the original raw file automatically.

the raw conversion settings for the first file and then apply these settings to the rest of the images. The utility can also rename, run a pre-saved action, add copyright details and size at the same time as converting between formats, providing a fast and efficient workflow for processing images that have been captured in a single session.

After processing, the files are stored in three separate folders on your hard drive. To use the utility, select your raw files from inside Bridge and then choose Tools > Photoshop > Image Processor. Set the location where processed files are to be saved, the file type and any associated settings (size, compression, color profile), add in copyright details and then choose any actions to apply to the files.

The copies created by the Image Processor are conveniently stored in separate folders labeled with their file type.

Printing from raw files

Producing a contact sheet

The familiar Contact Sheet option that has been present in Photoshop for the last few versions can be used from Bridge to print 'proof' sheets of raw files. Thumbnails are multi-selected from the Bridge workspace before accessing the utility via the Tools > Photoshop menu.

The options contained within the Contact Sheet dialog allow the user to select the number of columns of image thumbnails per page and the content of the text labels that are added. The page size and orientation can also be chosen via the Page Setup. Pressing the OK button instructs Photoshop to open each image in turn, resize the picture and then position it in a new document ready for printing.

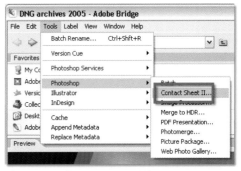

The Contact Sheet option in Bridge can generate proof sheet versions of multiple files from raw files.

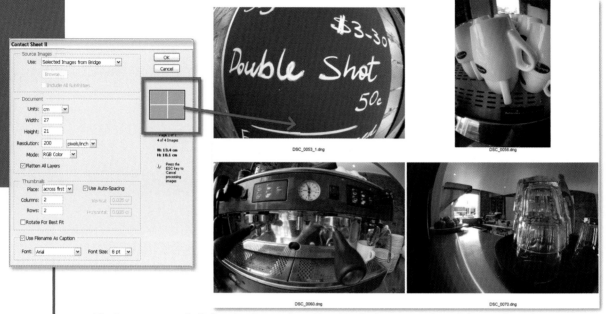

The feature automatically lists the photos selected in Bridge in the Contact Sheet dialog. It is here that you can alter the sheet's layout and design before producing the group of thumbnails as a new Photoshop document.

Picture package

The multi-image printing idea is extended via the Picture Package utility which is also located under the Tools > Photoshop menu in Bridge. With this print utility you have the option of laying out several images of different sizes on a single page. Alternatively you can produce several copies of the same photo in a range of template designs. Use this utility to efficiently put together multi-print pages that are destined for cutting up and presenting separately.

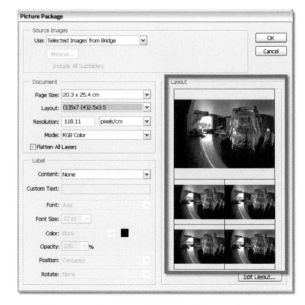

As well as producing contact sheets raw files can be collated into other multi-print designs using the Picture Package feature also located in the Tools > Photoshop menu in Bridge.

Printing individual photos without conversion

Unfortunately Bridge doesn't contain a straight print option that allows individual raw files to be printed directly from the workspace. But don't despair! The Smart Object technology that was released in Photoshop CS2 provides a neat workaround for the problem. Smart Objects are a way of embedding the original file within a special layer in a Photoshop document.

Here's the trick!

Embedding a raw file as a Smart Object within a Photoshop document is a key technique that grants Photoshop/Bridge users the ability to manipulate their raw files without having to first convert them to another format. As well as providing a much needed print option this method is also used as the basis of the editing techniques that follow. Here's how we do it:

1. Create a new document preset

Start by finding out the exact pixel dimensions of the raw file. Switch to Photoshop and create a new document using these dimensions in the New Document dialog. Save this document as a new preset. Label it something like 'Nikon/Canon Raw Embed'. It will now be installed as a new entry on the preset document list.

2. Place the raw file

Next, jump back to Bridge and click onto the thumbnail of the raw file. Now Select File > Place > In Photoshop. Bridge opens Photoshop and then displays the raw file inside the Adobe Camera Raw dialog. Make any adjustments, but don't fuss as you will be able to readjust the raw settings later on. Click the Open button and then Enter/Return to place the raw file into the Photoshop document.

Note: Make sure that the new document you create is the same orientation (portrait or landscape) as the raw file you are trying to embed.

Step by step:

3. Create a Smart Object layer

Notice in the Layers palette that the raw picture has been placed as a special Smart Object layer rather than standard image layer. The raw file is now embedded into the Photoshop document. To make any changes to the raw settings, simply double-click onto the layer's thumbnail. This action displays ACR allowing you to tweak the raw settings until you are satisfied with the results. From this point onwards the file can be treated as a standard Photoshop document.

...and now for the printing

With the embedded raw file now resembling a standard Photoshop document printing can be handled via the traditional File > Print with Preview route.

Making changes to an embedded file

OK, so you have successfully managed to embed your raw file and you now have a new Photoshop document complete with a Smart Object layer. The original conversion settings that were applied to the photo at time of embedding look fine but you want to fine tune the color and contrast of the file. Or maybe there are a couple of marks on the photo that need removing. How can we make these changes in Photoshop without having to first convert the raw file to a standard format such as PSD or TIFF?

Well, the following collection of techniques will provide you with a full raw workflow similar to that which is available in Lightroom and Aperture whilst working with Photoshop CS2 and Bridge.

But you can't edit a Smart Object. Not true!

Using this approach simple retouching tasks are also not out of the question and they don't require that the smart object be rasterized first. Jobs like removing a pimple from the face of an otherwise glamorous model are possible by creating a new layer above the Smart Object layer and then selecting the Spot Healing Brush (set to Use All Layers). Proceed to make the retouching corrections

on the new layer. This is great way to maintain the original raw file and provide the retouching options that are sometimes needed.

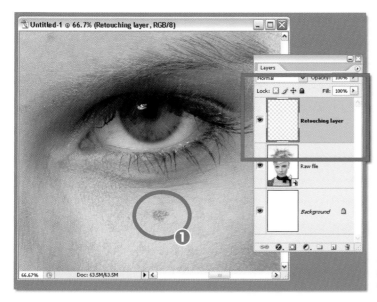

To remove marks and blemishes (1) from an embedded raw file start by creating a new layer above the Smart Object layer.

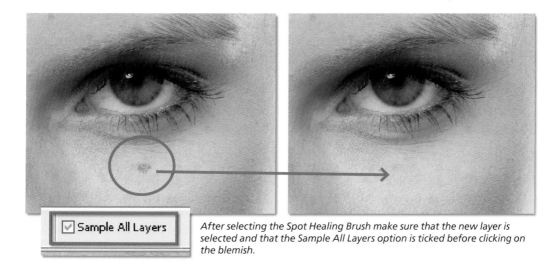

After selecting the Spot Healing Brush make sure that the new layer is selected and that the Sample All Layers option is ticked before clicking on the blemish.

Pro's tip: Keep in mind that any changes made directly to the color, contrast and brightness of the raw file Smart Object will not be reflected in the retouching image layer. If you want to make such changes to both layers, create a new adjustment layer above both the retouching and smart object layers and use this for your enhancements.

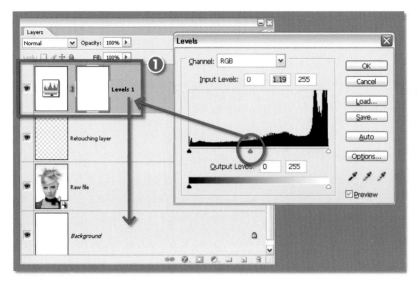

Tonal and color changes via the raw file

For color and tonal enhancements that don't involve an existing retouching layer use the editing abilities of the Smart Object to make these changes directly to the raw file. Double-clicking the Smart Object layer opens the file inside the program of origin. For placed Illustrator files this means that the file is opened inside Illustrator ready for editing, for our embedded raw file the picture is opened inside Adobe Camera Raw. Cool!

All the settings for the values used for the current conversion are set in the dialog and it is a simple matter to adjust contrast, brightness, white balance, sharpness or any of the other variables available in the dialog. Clicking the Done button then saves the changes back to the Smart Object layer and in the process updates the view of the document in the Photoshop workspace. This way of working might seem a little convoluted but it provides a radical lossless method of manipulating your raw files as Photoshop documents.

Double-click the Smart Object layer or choose Layer > Smart Objects > Edit Contents to open ACR and edit the conversion settings of the raw file.

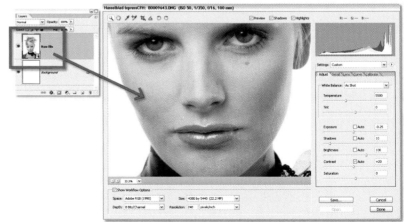

Image courtesy of Hasselblad

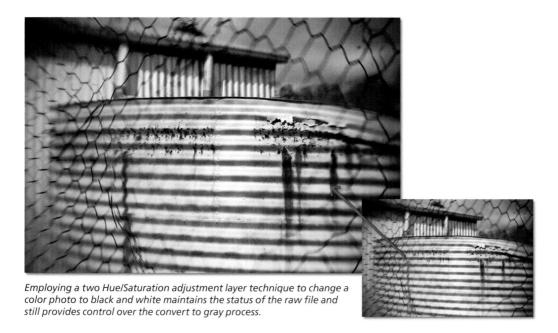

Employing a two Hue/Saturation adjustment layer technique to change a color photo to black and white maintains the status of the raw file and still provides control over the convert to gray process.

Convert to gray

Let's take this lossless enhancement approach a little further and look at a new twist on an old convert to gray technique. First proposed by the Adobe Evangelist Russel Brown, this method uses two Hue/Saturation adjustment layers to create an editable convert to gray technique that leaves the original pixels untouched. In our situation this means producing a grayscale picture from the raw file in its virgin state.

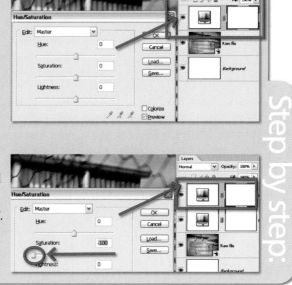

1. Embed a raw file in a new Photoshop document in the manner described above. Next make a new Hue/Saturation adjustment layer above the Smart Object layer. Don't make any changes to the default settings for this layer just create the layer and then close the dialog. Set the mode of the adjustment layer to Color. Label this layer 'Filter'.

2. Now create a second Hue/Saturation adjustment layer above the Filter layer and alter the settings so Saturation is -100. Call this layer 'Black and White Film'. The monochrome image now on screen is the standard result we would expect if we just desaturated the colored original.

Step by step:

3. Next double-click on the layer thumbnail in the Filter layer and move the Hue slider. This changes the way that the color values are translated to black and white. Similarly if you move the Saturation slider you can emphasise particular parts of the image. In effect you now control how the colors are mapped to gray.

4. For more precise control of the separation of tones you can restrict your changes to a single color group (red, blue, green, cyan, magenta) by selecting it from the drop-down menu before manipulating the Hue and Saturation controls.

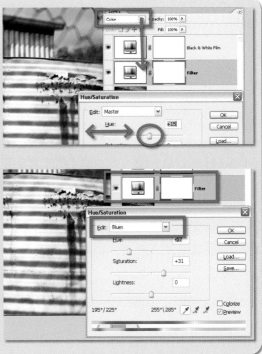

Adding texture

But why stop there? Many monochrome workers also love the atmospheric texture that old grainy film stocks added to their images. Simulating grain is not a particularly difficult task with Photoshop. Most users will have played with the Filter > Noise > Add Noise filter and in doing so would have instantly added digital grain to their otherwise smooth photos. But applying this texture non-destructively to an embedded raw file is another matter. For this to occur we need to think a little more laterally. Rather than trying to filter the smart object layer itself, which would require the layer to be rasterized losing the embedded file in the process, we will introduce the texture with the aid of layer blend modes.

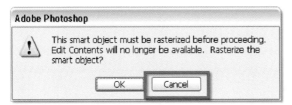

Trying to filter a Smart Object layer directly will result in this warning dialog being displayed. Selecting OK will convert the raw file to a standard picture format and in the process lose the file's ability to edit raw conversion settings at a latter date.
If you want to maintain a non-destructive workflow then you will need to find a way around this rasterization process. In the case of adding texture it is a simple matter of applying the texture to another layer and then altering the layer blend mode to mix the contents of both the texture layer and Smart Object layer.

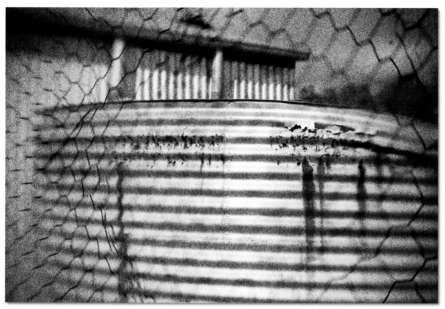

Add texture to your raw images non-destructively by applying the characteristics of a textured layer with layer Blend Modes.

1. Start by adding a new blank layer to the top of the Layer stack. You can do this by clicking the Create a New Layer button at the bottom of the Layers palette or by selecting Layer > New Layer. Rename this layer 'Texture'.

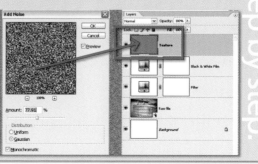

2. Next make sure that the layer is selected and then fill the layer (Edit > Fill) with the 50% Gray option available from the drop-down Use menu in the Contents section of the dialog. You will end up with a gray layer that sits above all other layers in the stack.

3. Now filter the layer with the Add Noise filter being sure that the Monochrome option is selected so that no colored pixels are introduced into the grayscale image.

 Note: For the sake of this example the texture settings used here are stronger than you will need to use.

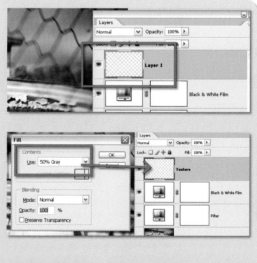

Step by step:

4. Lastly select the texture layer and choose the Overlay entry from the list of Blend Modes available at the top of the Layers palette. Now the original grayscale image returns to view in the workspace but the texture of the upper layer is combined with the pixels from beneath.

Pro's tip: To adjust the strength of the the grain effect select the texture layer and alter the Opacity of the layer.

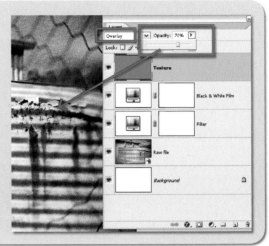

Reintroducing some color

Taking the monochrome scenario one step further it is a simple task to add back some color in the form of a simple tint by adjusting the settings of the upper Hue/Saturation Adjustment layer. Double-click on the Layer thumbnail (the left icon in the adjustment layer) to open the Hue/Saturation dialog. Now select the Colorize option and carefully adjust the Hue slider to choose the color to tone the photo. The Saturation slider in the same dialog can be used to control the strength of the toning effect.

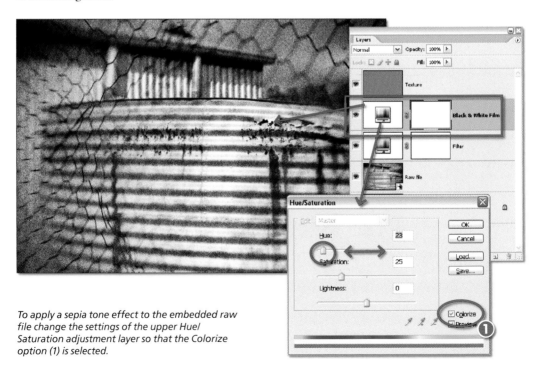

To apply a sepia tone effect to the embedded raw file change the settings of the upper Hue/Saturation adjustment layer so that the Colorize option (1) is selected.

Rather than rasterizing the embedded raw file apply pixel-based corrections to a merged copy of the non-destructive editing layers.

When you have no choice but to rasterize

Despite our best efforts there will be times when the particular Photoshop function that we need to use cannot be applied non-destructively to the embedded raw file. For example, features like filters just will not work on a Smart Object unless the file is rasterized first. In these circumstances there seems little option but to convert the Smart Object to a standard image layer (rasterize) before continuing the editing process. But even at this point it is worth looking for a technique that will still maintain the spirit of the non-destructive approach.

The way I work is to perform as much editing on the Smart Object as possible and when the need arises to rasterize I place all the non-destructed editing components (Smart Object layer, adjustment layers, retouching layers) into a Group (Layer Set) and create a single image layer that is the composite of all these editing effects. I can then apply the pixel-based editing techniques directly to the composite secure in the knowledge that if I need to go back to the original file later I can access the primary data via the Group. Here's how it works:

1. Start by creating a Smart Object layer from your raw file. Add in any adjustment and retouching layers and complete all the editing work that is possible using a Smart Object.

2. Multi-select all the layers (except the background layer) that are used for editing the Smart Object layer. Next place these layers into a new Group (Layer Set) by shift-clicking the Create a New Group button at the bottom of the Layers palette. Rename the Group Raw File.

Step by step:

3. Now make sure that the Group layer ('Raw File') is highlighted and then choose Select > All. You will notice a marquee is now around all the image. Next choose Edit > Copy Merged. This creates a copy of all the merged layers including the active layer and all other layers beneath. The copy is stored on the clipboard and can be pasted as a new image layer by selecting Edit > Paste.

4. With the composite layer created you can hide the contents of the Group by clicking on the eye icon on the left of the layer. Pixel-based enhancements can now be applied directly to the merged layer.

13

Lightroom Walkthrough

OK, it is not the norm for book authors to provide too much space for products that are still in the beta stage of production. After all, as anyone who can tell you who has been a beta tester, the feature set and interface design can change, and probably will, before the program is finally released.

Why then are we devoting a couple of pages to Adobe's new raw workflow product, which at the time of writing this book is still in beta? Well, simply because it is a public beta and we want you to have the chance to play with this great new technology and even contribute to its development, and Lightroom provides us with a unique vision of the future of raw file processing, manipulation and management. Along with other products like Apple's Aperture, the future is being forged now and here is your chance to contribute to the look and feel of things to come.

Adobe has released a beta version of Lightroom for the express purpose of getting real photographers to comment on, and contribute to, the creation of this new raw workflow product. Here is your chance to have your say over how the product develops.

What is Lightroom?

I don't think you would find any argument stating that 'Photoshop is a complex beast'. It is not that the individual parts of the program are overly complex in themselves (OK, some bits are!), it is just that when you start to layer and merge the many, many brilliant features it contains, you eventually get to a point where first time users are daunted by the prospect of trying to do even the most basic tasks. And with successive releases of the program it gets harder to simplify without diluting the power and reducing the extent of the feature set.

Lightroom, on the other hand, is a deceptively simple product. Even at this beta stage it feels like a well-designed and streamlined photographer's work tool. The Adobe engineers have been able to elegantly distil the core power and features of both the workflow and raw conversion elements of Photoshop and package them into a completely new interface. There are features in the program like the Tone Curve which are pure Photoshop, but even such familiar controls have been given a new breath of life, providing customization options that are way beyond what we currently have available. Add to this brand new controls like Split Toning and HSL Color Tuning and you have a very exciting addition to the Adobe lineup. And did I mention that all these enhancement tools, though being applied to your raw files, never actually change the original pixels captured at the time of shooting?

The whole workflow is lossless – read 'non-destructive'. Image enhancement and raw conversion settings are stored separately to the original image data and are then used to generate screen previews of the pictures, print output and the screen-based slideshows of the files.

Enough talk, let's get to it!

The program is based on two core technologies: a relational database that stores all the details, settings and metadata relating to your images and the engine that drives Adobe Camera Raw. The database provides fast reliable searching and cataloging options and the ACR engine supplies the tools needed for enhancing your pictures. The user accesses these technologies via a new interface and four workflow modules. Let's look at each of these sections in turn.

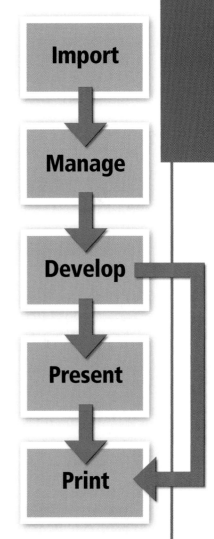

The workflow employed in Lightroom roughly follows a route that progresses from one module to another. Import and management functions are carried out in the Library module. Raw conversion settings are applied in the Develop module and output to screen or print processes are handled in the Slideshow and Print modules.

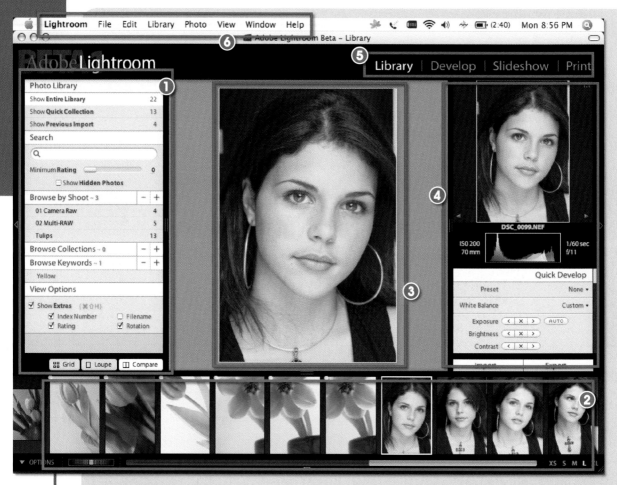

Lightroom is a brand new raw workflow product that has been beta released by Adobe. The program boasts not only a new interface but also a new way to work with raw files. The workspace is broken down into the following sections: (1) left panel, (2) filmstrip, (3) preview area, (4) right panel, (5) module menu and (6) program menu.

The workspace

The workspace can be divided into several sections (see image above).

1. The **left panel's** role changes depending on which module or mode you are in. The example screen shot shows Lightroom in the Library mode which is primarily designed for managing your photos and organizing your shots. So here you will see that this section of the screen houses Search, Collection, View and Library options. If you switch to the Develop, Slideshow or Print modules the contents change to display preset and saved options settings.

2. The **filmstrip** area is located at the bottom of the screen and displays all the images from the currently selected Library. Individual pictures or groups of images can be selected from the filmstrip in any module.

The contents of the right panel change according to the module selected. Shown here is the contents for (1) Library, (2) Develop, (3) Slideshow and (4) Print modules.

3. In the default setting for the Library module, the main workspace displays an enlarged **preview** of the picture selected in the filmstrip. A single mouse click on the image zooms the picture to and fro a 1:1 magnification setting. Images can be viewed in Grid (like a sorting area on a slide box), Loupe (enlarged to 1:1) or Compare (side-by-side comparisons of multiple photos) modes whilst in the Library mode. In Slideshow and Print modes the workspace displays a preview of the images as they will appear on screen or on the printed page.

4. The **right hand panel** holds the settings controls available for the current module. In Library mode it displays some quick adjustment options. In the Develop module the panel contains the complete set of enhancement controls and in the Slideshow and Print modules it houses layout and output settings.

5. The **module** menu appears at the top of the screen and not only lists the options available but also highlights the one currently selected. At the moment there are four modules included in Lightroom (Library, Develop, Slideshow, Print) but given the modular nature of the program, don't be surprised if other options become available in the future.

6. The **menu** bar provides access to standard menu commands, but like most screen elements in the Lightroom interface, this too can be hidden from view and restored when needed.

The workflow modules

Adobe consulted far and wide when they were putting together Lightroom. Who did they talk to? The answer is photographers! They asked them to describe their workflows and to list the sort of enhancement controls they regularly used. From these discussions the Lightroom team created a simple modular-based workflow.

Library

All image management starts with the Library module. Here you import your photos, arrange them in collections, add keywords, search your library or browse individual shots. All this activity is handled with the options in the left hand panel, whilst in the workspace you can view your images in magnified Loupe mode, side-by-side Compare mode or Grid mode.

One thing that you will notice immediately is the speed with which you can edit, rate and label your pictures. Unlike other browser products, Lightroom is not as tied down to the operating system file structure as is normally the case. When you import photos from a shoot, the program generates its own organizational structure (relational database) that not only maintains the management choices you make (rating, adding metadata etc.) but also holds the raw processing settings you choose. Although exposure, brightness and contrast can be quickly adjusted here using the settings in the Quick Develop section, the majority of enhancement changes are made in the next part of the process.

The contents of the left panel when the Library module is selected control all the settings for managing shoots, collections, searches and keywords.

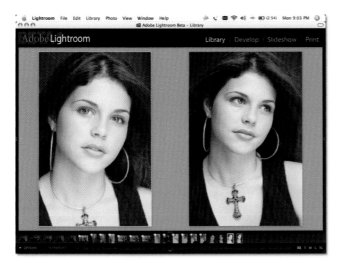

The Compare view shows larger previews of images side by side.

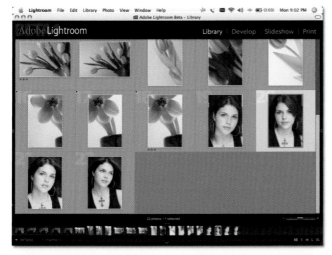

The Grid view differs from Compare view in that it works more like a light table and provides the chance to sequence images as well as label and sort them.

The Lights Dim mode along with the Lights Off mode provide a new way of viewing photos without the distraction of brightly lit menus, toolbars, dialogs or other screen elements.

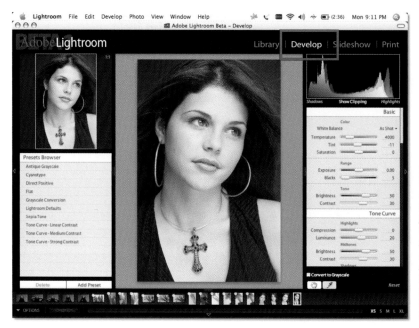

The Develop module handles all the raw conversion settings that are applied to the photos. Many of the controls listed here are similar to those currently contained in Adobe Camera Raw, but there are a couple of brand new features that will prove to be favorites.

Develop

The Develop module is the next step in the Lightroom workflow and is central to all enhancement changes that are applied to your photos. Just like when you are working in the Adobe Camera Raw dialog, the enhancement settings and controls are grouped in a panel on the right of the window and a preview of the interpolated raw file is also included. New for Lightroom is a Presets Browser panel (left) that houses ready-made conversion settings as well as those created and saved by the user. The speed with which these settings can be applied and the preview image updated is really impressive.

Develop contains familiar ACR controls such as White Balance, Exposure, Shadows now called Blacks, Brightness, Contrast, Detail (sharpness and noise), Lens Correction (fringing and vignetting) and Camera Calibration. These controls work in a similar fashion to their counterparts in ACR but features like the Tone Curve have been given a Lightroom makeover. Now it is possible not only to manipulate the shape of the curve manually (click and drag) but also make these adjustments via new slider controls. With these you can set highlight and shadow clip points, adjust contrast and brightness and also compress or stretch specific ranges of tones in the image. This new Compression slider provides real power for those photographers who like to push the tones around in their images.

In addition to reworking features like the Tone Curve, Develop also contains brand new controls that photographers in the beta program are finding. We now have a dedicated grayscale conversion tool called the Grayscale Mixer, a Hue Saturation and Lightness control and a great Split Toning feature that makes creating cool cross-processing effects a breeze.

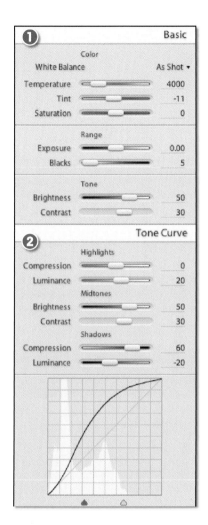

① Basic

Color

White Balance		As Shot ▾
Temperature		4000
Tint		-11
Saturation		0

Range

Exposure		0.00
Blacks		5

Tone

Brightness		50
Contrast		30

② Tone Curve

Highlights

Compression		0
Luminance		20

Midtones

Brightness		50
Contrast		30

Shadows

Compression		60
Luminance		-20

③ Split Toning

Highlights

Hue		165
Saturation		0

Shadows

Hue		305
Saturation		0

④ ☑ Grayscale Mixer

☐ Auto

Reds		-28
Yellows		139
Greens		114
Cyans		57
Blues		-25
Magentas		150

⑤ HSL Color Tuning

Hue

Reds		0
Yellows		0
Greens		0
Cyans		0
Blues		0
Magentas		0

Saturation

Reds		0
Yellows		0
Greens		0
Cyans		0
Blues		0
Magentas		0

Luminance

Reds		0
Yellows		0
Greens		0
Cyans		0
Blues		0
Magentas		0

⑥ Detail

Sharpen		25
Smooth		0
De-noise		25

⑦ Lens Corrections

Reduce Fringe

Red/Cyan		0
Blue/Yellow		0

Lens Vignetting

Amount		0
Midpoint		50

⑧ Camera Calibration

Profile		ACR 3.0 ▾

Shadows

Tint		0

Red Primary

Hue		0
Saturation		0

Green Primary

The enhancement controls in the Develop module of Lightroom include existing Adobe Camera Raw controls and brand new features.
(1) Controls for Basic enhancement changes.
(2) Improved Tone Curve feature.
(3) New Split Toning sliders are great for cross-processing effects.
(4) Borrowing from the Channel Mixer in Photoshop you can make great grayscale conversions with this new feature.
(5) HSL Color Tuning is a brand new color feature that is designed for fine tuning the hues in your photos.
(6) Sharpen and noise reduction controls.
(7) Lens correction settings for both vignetting and fringing control.
(8) Camera Calibration feature that is used for fine tuning white balance settings.

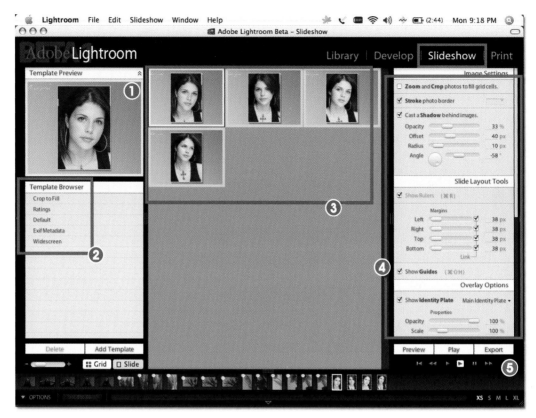

The Slideshow module provides creative presentation options that can be output in PDF, HTML or even Flash formats. The interface includes (1) a template preview, (2) a template browser, (3) individual slides in sequence, (4) slideshow settings and (5) preview, play and export options.

Slideshow

In Lightroom the Adobe guys have provided two ways to output your photos – as prints or as a presentation. The presentation options are located in the Slideshow module where you can lay out and sequence a group of images and then produce them as a PDF presentation, HTML or Flash website.

When selecting the Slideshow module the contents of the right panel change to options that alter the settings for your presentation. Here you can adjust border and shadow options as well as the layout and any overlay used for each slide. The production can be previewed by pressing one of the VCR type controls or Play and Preview buttons at the bottom of the panel and you can output the slideshow in one of the three formats with the Export command.

On the left hand side of the workspace is the template preview and browser panes. Here you can switch between different slideshow templates whilst viewing a preview of how your images will look with each different layout. The buttons at the bottom of this section provide the options to add new template designs based on your own custom settings or delete no longer needed templates from the list.

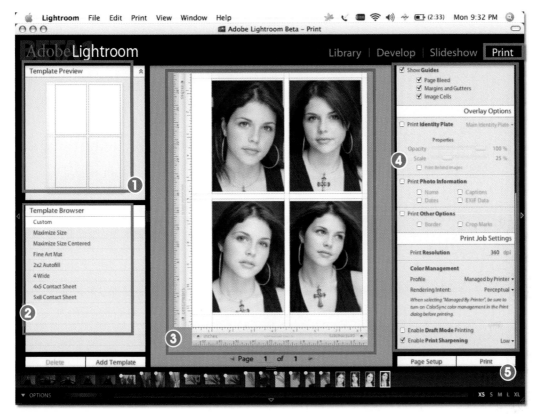

The Print module is the center of all hard copy output action including the production of contact sheets and individual prints. Like the Slideshow module the print interface contains (1) a print template preview area and (2) a template browser list as well as (3) a main print preview, (4) a print settings panel and (5) Page Setup and Print buttons.

Print

If you ever wondered if anybody at Adobe listens to the suggestions of its users, then the Lightroom Print module is confirmation that they do. Here in the one dialog are all the controls you need to output contact sheets, print packages as well as individual prints. The right panel contains print and layout settings. The middle of the screen has a preview of the photos as they will appear on the printed page and on the left you have a range of template presets and the ability to save your own print layouts.

It's true that Photoshop has its own print package and contact sheet features but the ease with which Lightroom lets you can change and customize these options is a real bonus for raw shooters using the new workflow software. The Print Job Settings pane simplifies yet another overly complex component of the print process. Gone are the layer upon layer of settings dialogs, replaced with a single pane of settings with all the critical controls and settings up front. Printer level control is still possible with the options accessed via the Page Setup button. All in all the Lightroom Print module provides a substantially easier way of creating and outputting prints in a variety of formats.

Where to from here?

Even though Lightroom is in a beta stage you can get a good indication of how the final production program will look, feel and, more importantly, function. Adobe says that a new beta is being released every eight weeks or so and as we go to press I notice that beta 3 is on its way and we should be seeing a Windows version around the same time as the next release. And yes, Adobe is listening to the comments made on the forum. The current beta contains a Crop tool and is in a Universal Binary format which means that it can run on the new speedy Intel-based Macintoshes.

With promises of more refinement as the beta program progresses and a Windows version to follow quickly, Lightroom is a sign of the way raw processing will be handled in the future.

14

Aperture Step by Step

DSC_0067

DSC_0070

C_0071

DSC_0072

DSC_0073

DSC_0074

DSC_0075

DSC_0076

DSC_0077

Image Date

Unrated

A pple was first to market with their full professional raw workflow program, Aperture. Announced in late 2005 the program created quite a sensation at its premier viewing. Never before had raw shooters witnessed a program that was dedicated to their preferred capture format.

Remember that until this release the main workflow available to them was the more traditional 'Convert then Edit' approach which positioned raw files squarely as an intermediary format that was quickly discarded for the more usable 'old school' file types of TIFF, JPEG or PSD. But here before their eyes was a program that maintained the integrity of the original capture format whilst providing much of the functionality that they had come to expect from their imaging programs. Sure Aperture seemed a little fussy about the hardware it worked on and yes the feature set was smaller than that found in Photoshop but all in all it was a real breakthrough for quality imaging proponents everywhere.

In response, Adobe lifted the lid on a pet project that they had been working on in secret for the previous few months. Spookily the Lightroom project that Adobe announced in public beta form in late 2005 was also a full raw workflow program and it too followed the principle of 'always maintaining the original pixels'.

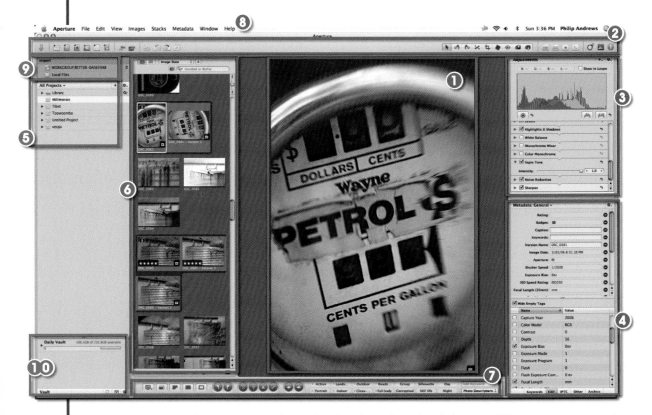

The Aperture interface contains multiple panels and can be configured easily for many different management and editing features. (1) Preview area or Viewer. (2) Toolbar. (3) Adjustments inspector. (4) Metadata inspector. (5) Projects panel. (6) Browser. (7) Control and keywords bar. (8) Menu bar. (9) Import panel. (10) Vault panel.

Despite which camp you find yourself supporting, the fact that both Apple and Adobe are vying for the right to reign in this new important part of the digital imaging market is a great bonus for raw shooting photographers. The competition will be fierce and the quality and feature sets of the software releases are bound to push the boundaries of how we currently work with raw files. The result is that quality photography and quality photographic workflows will be the winners.

With this background and the previous chapter's Lightroom walkthrough as a context let's now take a closer look at Aperture.

Aperture core components

Editing, management and output activities are all centered around an interface that has been designed from the ground up with the visually sensitive photographer in mind. The major areas are:

Projects panel

The Projects panel is the center for organizing projects, folders and albums as well as photo galleries and online journals.

Browser and Viewer areas

Groups of images contained in albums or projects are displayed as thumbnails in the browser section. Use this feature to navigate from photo to photo. When a thumbnail is selected in the browser a large preview of the picture is displayed in the Viewer section.

The Viewer can be set up to display one, three or multiple pics at a time. Photos in the Browser can be displayed in grid, list or thumbnail view.

Control bar

The Control bar contains buttons for moving from picture to picture in the browser space. There are also options for rotating, rating and applying keywords to the photos. To the left of the main buttons are other controls that alter the way pictures are viewed in Aperture. On

the right are the Keyword controls. Individual words are displayed as buttons.

The toolbar

The toolbar runs along the top of the Aperture workspace and contains New Project, Album, Smart Album, Book Album, Web Gallery and Light Tables buttons. Next are two buttons that provide a shortcut method of creating New Version from Master and Duplicate Versions and a group of buttons for stacking control. At the far right end of the toolbar is a group of adjustment tools such as the rotate, red eye, spot and patch and crop tools as well as copy (Lift) and paste (Stamp) settings commands. Also included are Layout buttons for adjusting the way that the workspace is configured, the Loupe tool, Inspectors and Adjustments HUD (Heads-Up Display) buttons.

Adjustments inspector

The Adjustments inspector groups together all the enhancement controls, their settings and a histogram whose display can be customized. Specific controls (Levels, Highlights/Shadows, White Balance etc.) can be added or removed from the inspector using the options in the drop-down menu activated via the button at the top right of the dialog. Histogram display and color value mode settings (RGB, LAB, CMYK) can be chosen from a second pop-up menu adjacent to the first. Adjustments made via the controls are reflected in the preview of the photo in the viewer.

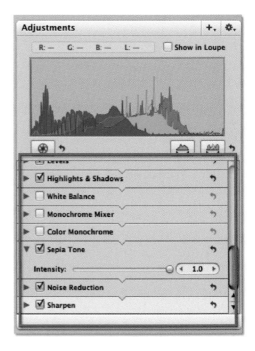

Metadata inspector

The Metadata inspector lists all the EXIF, IPTC and keyword data associated with the photo. As well as displaying data already attached to your pictures the inspector is the place to add custom metadata as well.

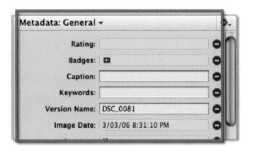

Import panel

The Import panel lists any card readers, mounted servers or external hard drives that are currently attached to the computer and also any local drives. Selecting one of these sources will display an import dialog from where you can set download options and start the import of photos into Aperture.

Vaults

Vaults is part of the Aperture backup system and is the hard drive space where archival copies of projects and libraries are transferred.

Auto or manual adjustments?

Like a lot of image editing programs Aperture provides both automatic and manual approaches when it comes to the basic image adjustment functions. The automatic adjustments available include:

Auto Exposure

Provides an automatic adjustment of the exposure of the raw photo. This option is not available for non-raw files or non-supported raw files. To adjust exposure automatically, press the Auto Exposure button (to the left under the histogram).

The knowledge:

Auto Levels Combined

This function sets the black and white points of a photo based on the combined tonal values across all channels (red, green and blue). Using this feature will help correct contrast in your photos. To apply Auto Levels press the Auto Levels button (second from the right under the histogram).

Auto Levels Separate

With this option the black and white points are adjusted for each of the channels separately. This has the effect of correcting color cast issues at the same time as adjusting the contrast of the photo. To adjust contrast and color automatically click the Auto Levels Separate button (far right under the histogram).

A manual approach

If you want to take a little more control over your results then use these manual alternatives to the auto options offered above:

Manual Exposure changes

Move the Exposure slider in the Exposure section of the Adjustments inspector.

Manual Contrast changes

Move the Contrast slider in the Exposure section or move the black and white point sliders in the Levels section of the Adjustments inspector.

Manual Contrast and color cast

Move the black and white point sliders of each individual channel (red, green and blue) in the Levels section of the Adjustments inspector. Drag both sliders towards the center of the graph till they meet the first image pixels.

Pro's tip: Auto features don't always produce ideal results. If you are unhappy with the look of your photo after applying one of the auto corrections undo the effect by selecting Edit > Undo. If the changes made just need a little fine tuning move to the manual feature and tweak the results.

Aperture in action

With the major program options clearly in our mind let's look at the type of workflow that a typical photographer would employ when using Aperture.

1. Download pictures

Files can be imported from connected cameras, memory cards that have been inserted into a card reader, or from folders on your computer. Alternatively files can be dragged from a Finder window directly into a project or imported from an existing iPhoto library. More details on import options are outlined in Chapter 3.

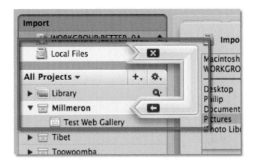

2. Create a backup

It is good work practice to ensure that the recently transferred raw originals are backed up before proceeding to apply any adjustment settings. Do this by creating a new Vault using one of the options listed under File > Vault menu. For more details on backing up check out Chapter 16.

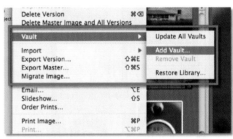

3. Correct orientation

Rotate photos that are not correctly orientated. Select an image or a group of images and then either click the rotate left or rotate right buttons in the control bar or one of the options from the Image > Rotate menu.

4. Compare and edit

Compare similar images in the viewer space by selecting candidate photos from the browser. Multi-selected photos will automatically appear in the viewer space.

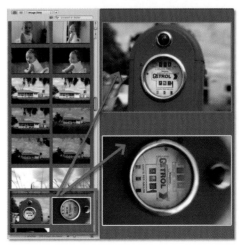

5. Rate

Add star ratings to selected photos by highlighting them in the browser and then clicking on the green up arrow key in the control panel to add stars or the red down arrow key to remove a star.

6. Check focus

To check sharpness and fine details view the photos at full screen by selecting View > Zoom to Actual Size or just press the Z key. Use the small navigator box to move around the enlarged picture. Drag the red rectangle to move the view. An alternative to enlarging the whole photo is to employ the magnifying glass like features of the Loupe tool. Select the tool from the right of the toolbar and move the tool over the picture to check focus.

7. Start enhancements

Now let's move onto image adjustments. Start with the Raw Fine Tuning section of the Adjustments inspector. Use the Boost, Sharpening, Chroma Blur and Auto Noise settings to alter the raw file.

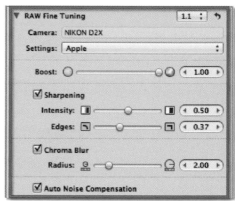

8. The Exposure panel

The Exposure section of the Adjustments inspector contains controls for Exposure, Saturation, Brightness, Contrast and Tint color. Alternate tonal controls are available via the Levels or Highlights and Shadows features.

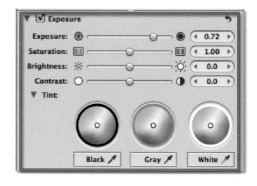

9. Cast control

The White Balance section contains both
Temperature (yellow/blue) and Tint (green/
magenta) sliders. The Temperature slider
works in units of kelvin, a measure of color
temperature.

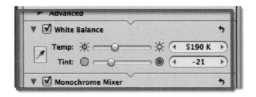

10. Monochrome heaven

For black and white and tinted monochrome
effects use the settings in the Monochrome
Mixer, Color Monochrome, and Sepia Tone
controls.

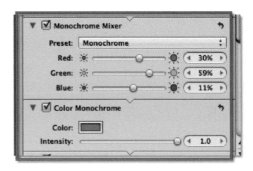

Output options

Aperture provides a variety of output options for raw shooters. Like Lightroom the two major
avenues for output are slideshow and print, but unlike the Adobe counterpart, Aperture also
contains a special feature that lets users custom design hard cover books. Using similar output
technology as is found in iPhoto and Photoshop Elements, it is possible to create multi-page, multi-
image books that are then uploaded to the production house where they are professionally printed
and bound. The finished result is returned to you by mail. Cool.

All print options within Aperture are color managed via Mac's own Colorsync engine. This means
that with the correct printer profile installed you can not only ensure that the colors you are
sending to the printer are correctly mapped to
the capabilities of the hardware, inkset and paper
combination but you can also preview how these
colors will appear before any printing takes place.
This soft proofing technology is available for
any image being displayed in Aperture's viewer
workspace.

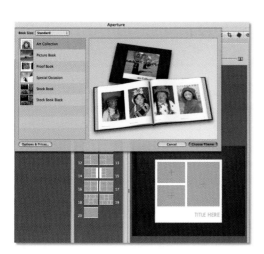

*The ability to produce bound books of selected photos
over the last few years has become a very popular
activity with both amateur and professionals alike.
Aperture provides an easy to use photo-book feature as
one of its output options.*

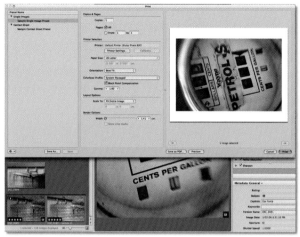

As well as offering good control over individual print output Aperture also provides the ability to print contact sheets.

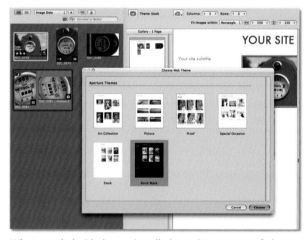

When coupled with the pre-installed templates groups of photos can be used as the basis for quickly producing online galleries or web journals.

Alongside a dedicated individual print dialog Aperture provides options for outputting contact sheets as well. Turning the conventional proof sheet printing workflow on its head the program can automatically resize and lay out a selected group of photos over a given number of pages. It is also possible to extend printing beyond your own desktop with options for online lab printing with either Kodak or Fuji.

Wanting to create web or journal pages on the fly? Well Aperture provides a sophisticated but easy to use 'output to web' feature as well. Using a bunch of professionally designed templates the finished site is previewed right in the Aperture workspace and can be uploaded to an ISP server, your iMac space or even a nominated disk folder.

15

Organizing Your Raw Files

With no film or processing costs to think about each time we take a picture, it seems that many of us are pressing the shutter more frequently than we did when film was king. The results of such collective shooting frenzies are hard drives all over the country full of photos. Which is great for photography but what happens when you want to track down that once in a lifetime shot that just happens to be one of thousands stored on your machine? Well, believe it or not, being able to locate your raw files quickly and easily is more a task in organization, naming and camera setup than browsing through loads of thumbnails.

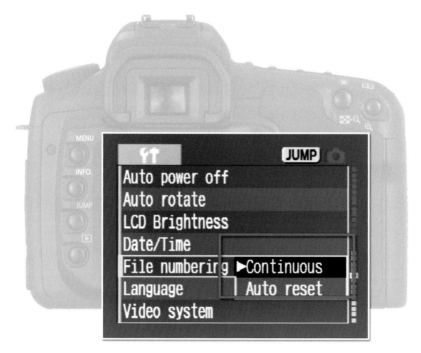

The Canon EOS 20D provides options for selecting the way in which files are numbered. The continuous option ensures that a new number is used for each picture even if memory cards are changed in the middle of a shoot.

It starts in-camera

Getting those pesky picture files in order starts with your camera setup. Most models and makes have options for adjusting the numbering sequence used for the pictures you take. Generally you will have a choice between an ongoing sequence, where no two photos will have the same number, and one that resets each time you change memory cards or download all the pictures. In addition, many models provide an option for adding the current date to the file name, with some including customized comments (such as shoot location or photographer's name) in the naming sequence or as part of the metadata stored with the file.

Search through the setup section of your camera's menu system for headings such as File Numbering and Custom Comments to locate and change the options for your own camera.

Pro's tip: Ensure that number sequencing and date inclusion options are switched on and where available append the metadata with the photographer's name and copyright statement.

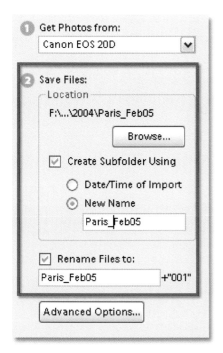

The Adobe Photo Downloader that comes bundled with Photoshop Elements allows the user to automatically apply naming changes and to determine the location where transferred files will be saved.

And continues when downloading

As we have seen in earlier chapters most camera manufacturers, as well as some producers of photo-editing software, supply downloading utilities that are designed to detect when a camera or card reader is attached to the computer and then automatically transfer your pictures to your hard drive. As part of the download process, the user gets to select the location of the files, the way that the files are to be named and numbered as well as what metadata will be included with the file.

It is at this part of the process that you need to be careful about the type of folder or directory structure you use. Most photographers group their images by date, subject, location or client. The approach that you employ is up to you but once you have selected a folder structure try to stick with it. Consistency is the byword of organization.

If your camera doesn't provide enough automatic naming and metadata options to satisfy your needs then use the downloading software to enhance your ability to distinguish the current images with those that already exist on your hard drive by including extra comments with the picture files.

Pro's tip: Nominate and create a new directory for the downloaded photos. Add extra metadata captions, keywords, photographer and copyright details.

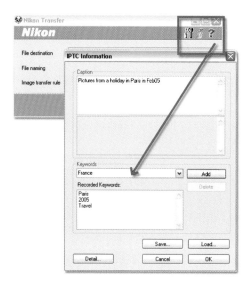

In addition to naming and location changes metadata keywords can be added to groups of picture files as they are being downloaded using the latest version of Nikon's transfer software. These keywords can be used later to help locate pictures.

Organizing and searching software

Most image editing software contains file browsing features which not only provide thumbnail previews of your photos but increasingly contain options for attaching keywords, editing the image's metadata as well as providing a variety of search mechanisms. Photoshop's own super file browser, Bridge, contains all of these functions and when used in conjunction with the feature's label and rating options provides a sophisticated method of organizing and locating files.

The latest version of Photoshop Elements (Windows version only) takes this organizational concept further by including the Photo Browser feature in the program. Here images are not just previewed as thumbnails but can be split in different catalogs, located as members of different groups or searched based on the keywords associated with each photo. Unlike a traditional browser system which is folder based (i.e. it displays thumbnails of the images that are physically stored in the folder), Elements Photo Browser creates a catalog version of the pictures and uses these as the basis for searches and organization. With this approach it is possible for one picture to be a member of many different groups and to contain a variety of different keywords.

Moving beyond these included browsers are the dedicated organizational programs that take the cataloging, searching and attaching keywords idea to a next level. These stand alone pieces of software range from those designed with the professional or dedicated amateur in mind and include products such as Extensis Portfolio and Fotoware Fotostation to lower priced but still sophisticated offerings such as Apple's iPhoto, Jasc Photo Album, Ulead Photo Explorer and the ever popular ACDSee. When considering any of these browsing products ensure that they are raw enabled and that the software supports the raw files that your camera creates.

Pro's Tip: try using the organizational or browsing utilities that came bundled with your camera or those that are included in your photo-editing software. When they prove not to be up to the challenge then move on to a dedicated organizational program.

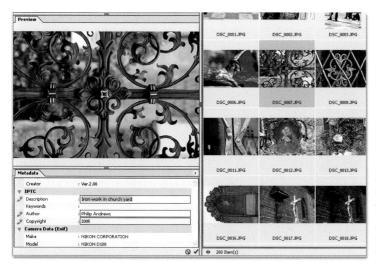

The Photoshop CS file browser (pictured here) or the new Super browser Bridge supplied in Photoshop CS2 provide preview, search and customized view options as well as the ability to add and edit the photo's metadata all from within the browser.

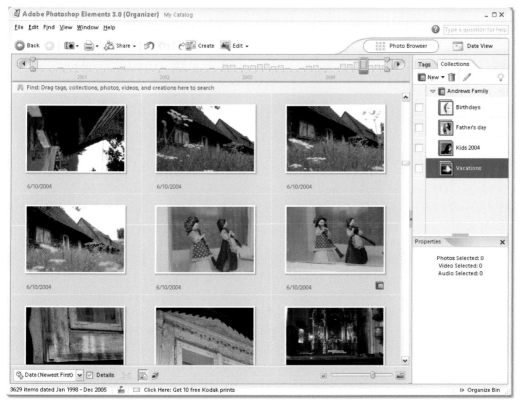

The Photo Browser in Photoshop Elements (Windows) provides an easy to use organizational tool complete with keyword tagging, collection creation and cataloging together with the proven editing abilities of the package.

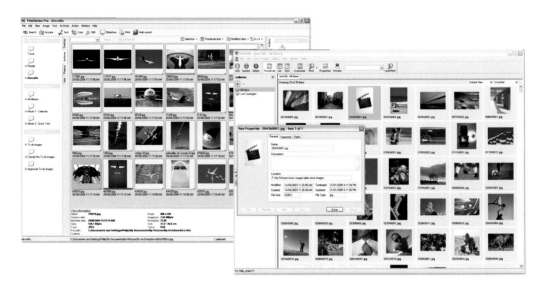

Both Extensis Portfolio and Fotoware Fotostation contain sophisticated cataloging, sorting, searching and displaying features and are firm favorites with professionals.

Grouping and keyword strategies

The best way to group or catalog your pictures will depend a great deal on the way you work, the pictures you take and the type of content they include but here are a few different proven methods you can use as a starting point.

- **Subject:** Photos are broken down into subject groups using headings such as family, friends, holidays, work, summer, night shots, trip to Paris etc. This is the most popular and most applicable approach for most readers and should be the method to try first.

- **Time line:** Images are sorted and stored based on their capture date (when the picture was photographed), the day they were downloaded or the date they were imported into the organizational package. This way of working links well with the auto file naming functions available with most digital cameras but can be problematic if you can't remember the approximate dates on which important events occurred. Try using the date approach as a subcategory for subject headings, e.g. Bill's Birthday > 2006.

- **File type:** Image groups are divided into different file type groups. Although this approach may not seem that applicable at first glance it is a good way to work if you are in the habit of shooting raw files which are then processed into PSD files before use.

- **Project:** This organizational method works well for the photographer who likes to shoot to a theme over an extended period of time. All the project images, despite their age and

file type, are collated in the one spot making for ease of access.

- **Client or job:** Many working pros prefer to base their filing system around the way their business works keeping separate groups for each client and each job undertaken for each client.

Most of the more sophisticated organizational software on the market allows you to allocate the same image to several different groups. Unlike in the old days, this doesn't mean that the same file is duplicated and stored multiple times in different folders, instead the picture is only stored or saved once and a series of keywords (tags) or group associations are used to indicate its membership in different groups. When you want to display a group of images based on a specific subject, taken at a particular time or shot as part of a certain job, the program searches through its database of keywords or tags and only shows those images that meet your search criteria.

Pro's tip: Find out how your organizational software categorizes pictures and then use these features to catalog, group or add keywords to your pictures. Where possible add multiple tags or keywords to the same picture to make it a member of several different groups.

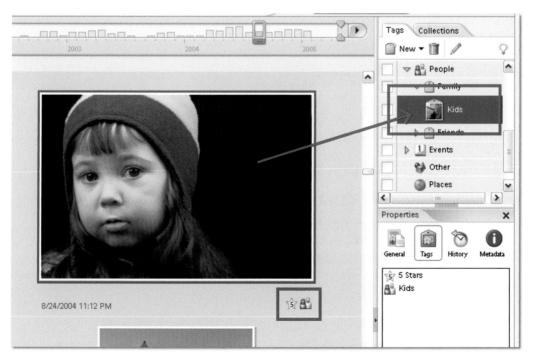

The tags feature in the Photo Browser of Photoshop Elements provides drag and drop subject organization or individual pictures. In this program one picture can have multiple tags and belong to several different groups.

Now we can search

With the pictures named in-camera, downloaded to a structured set of folders, grouped, tagged and cataloged we are all set for quick, easy, and, more importantly, accurate searches of our picture archives. Depending on the software you may locate pictures based on adding a variable in a search dialog, selecting a keyword from a list or clicking a group icon in a collections window. Whatever the approach, a little organization up front will work wonders when tracking down those elusive shots.

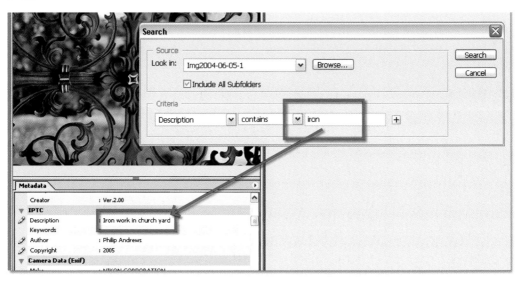

The search dialog (Find dialog in CS2) in Photoshop has options for locating files based on the contents of the caption metadata. Here the picture was searched for and found because the word 'iron' was used in the caption.

Managing raw files within Bridge

By replacing the file browser found in previous versions of Photoshop with the full featured Bridge application, Adobe made a big change to the way that picture files were handled. Bridge is not just a tool for viewing your photos, it is a key technology in the managing, sorting and enhancing of those files. And this pivotal role is never more evident than when one is managing raw files. So with the general theory outlined in the previous section let's look at the 'nitty gritty' of the ways you can bring order to your raw files using Bridge.

Using keywords

As we have seen keywords are single word descriptions of the content of image files. Most photo libraries use keywords as part of the way they locate images with specific content. The words are stored in the metadata associated with the picture. Users can allocate, edit and create new keywords (and keyword categories) using the Keywords panel in the Bridge browser and File Info palette in Photoshop.

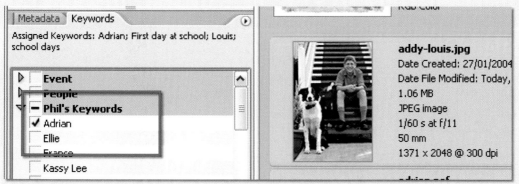

Attaching keywords to your pictures means faster searching especially when your picture library grows into the thousands.

New keywords and keyword categories (set) can be added to the Keyword panel by clicking the New Keyword Set and New Keyword buttons at the bottom of the panel. Unwanted sets or keywords can be removed by selecting first and then clicking the Deleted button. Unknown keywords imported with newly downloaded or edited pictures are stored in the panel under the Other Keywords set.

Rating and labeling files

One of the many ways you can organize the raw files displayed in the Bridge workspace is by attributing a label to the picture. In CS2 the labels option is supplied in two forms – a color tag, called a Label, or star rating, called a Rating. Either or both label types can be applied to any picture. The label tag can then be used to sort or locate individual pictures from groups of photos.

Labels and/or ratings are attached by selecting the thumbnail(s) in the workspace and then choosing the desired label from the list under the Label menu. Keyboard shortcuts are also provided for each label option, making it possible to quickly apply a label to a thumbnail, or group of thumbnails, or you can quickly add star ratings by clicking beneath the thumbnail in the workspace. Labels can also be attached to pictures in Adobe Camera Raw and Slideshow features.

A quick method for adding a star rating is to click the space just below the thumbnail in Bridge.

Star ratings and colored labels can be applied to photos in Bridge using the options in the Label menu or the associated keystroke combination.

Raw thumbnails can be sorted and displayed in different ways in the Bridge workspace by selecting different entries from the View > Sort menu.

Sorting images

The thumbnails that are displayed in the Bridge workspace can be sorted and displayed in a variety of different ways.

By default the pictures are displayed in ascending order based on their file names but Bridge provides a variety of other options in the View > Sort menu. Most of the settings listed here are self-explanatory. Once a sort entry is elected the workspace is automatically updated and the files reordered.

In addition, the following related features extend the control that you have over how your files are sorted for display:

- The Show options in the View menu,

- The Ratings and Labels features, together with the filtering options contained in the drop-down menu, at the top right of the Bridge workspace.

The drop-down Filter menu also provides a mechanism for adjusting the subset of pictures being displayed based on their Labels or Ratings.

Finding files

One of the great benefits of organizing your raw pictures in the Bridge workspace is the huge range of search options that then become available to you. Selecting Find from the Edit menu displays the Find dialog. Here you will be able to nominate what you want to search for, the criteria for the search, which folder you want to search in, what type of metadata to search and finally what to do with the pictures that match the search criteria.

To locate pictures with specific keywords, input the text into the Find feature in Bridge setting Keywords as the location for the search.

To form a search based on a rating level, select the Edit > Find feature and choose Rating, equal to, greater than, less than and the star value as the criteria.

A huge variety of search criteria can be used for the search. For many tasks, those listed in the Criteria drop-down menus are all that is needed but for complex find operations it is possible to add multiple search criteria in the same dialog.

The Find command also displays a subset of the total images in a library. Images are selected for display if they meet the search criteria input via the Find dialog.

The Find dialog provides the ability to search based on Rating as an alternative to the options located in the Filter drop-down menu.

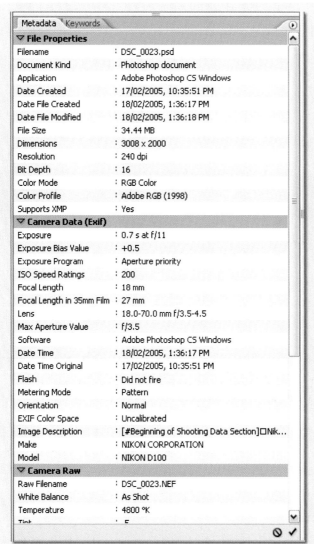

The metadata panel displays the metadata info stored with the picture file. It is a rich source of image and EXIF details.

Metadata panel

The Metadata panel in Bridge displays a variety of information about your picture. Some of this detail is created at time of capture and other parts are added as the file is edited. The metadata includes File Properties, IPTC (copyright and caption details), EXIF (camera data), GPS (navigational data from a global positioning system), Camera Raw settings and Edit History. To display the contents of each metadata category click on the side-arrow to the left of the category heading.

The data displayed in this palette, such as the copyright, description, author and caption information, can be edited here or via the File > File Info dialog in Photoshop and the range of content types displayed in the palette is controlled by the selections in the Metadata Preferences in Bridge.

Users can enter custom metadata details via the File Info dialog (File > File Info) in Photoshop or the Metadata Panel in Bridge.

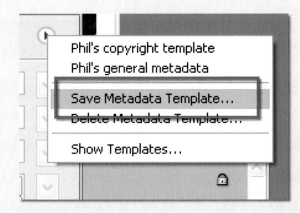

As well as entering metadata details image by image, a set of details can be saved and added to groups of files via the options available in the sideways arrow menu (top right) of the File Info dialog.

Metadata templates

The metadata options in CS2 also allow users to create and apply groups of metadata settings to individual or groups of files. The settings are created, saved and applied as a metadata template. This functionality really speeds up the management of the many files taken during shooting sessions, all of which need to have shoot, location, client and copyright details attached.

To create a template, open an example image in Photoshop and then display the File Info dialog. Add your own details and information into the editable areas of the various data sections in the dialog.

Next, select the Save Metadata Template option from the pop-up menu that appears after pressing the sideways arrow at the top right of the dialog.

The new template will be added to this menu allowing you to easily append existing details in Photoshop by opening the picture's File Info dialog and selecting the template from the pop-up menu. The same template can be applied to several pictures by multi-selecting the thumbnails first and then choosing the desired template from the list available in the pop-up menu in the Metadata Panel in Bridge.

The template files that you create are stored in XML format and are saved to a Metadata Templates folder in Documents and Settings\User\Application Data\Adobe\XMP for Windows machines.

Like a lot of settings used for image processing in Photoshop, the metadata templates that you save are stored as individual files in the XML format.

16

Protecting Your Raw Assets

Even in this era of alleged 'increased masculine sensitivity' it is a difficult thing to watch a grown man cry. But recently I had to witness such a spectacle when a professional photographer friend of mine related his story of the crashing of his hard drive and the loss of 5 years' worth of images. When I enquired whether he kept backups, the response said it all, a blank expression followed by a growing awareness of an opportunity missed. Ensuring that you keep up-to-date duplicates of all your important pictures, both the original raw files as well as any working documents derived from them, is one of the smartest work habits that the digital photographer can adopt.

Decide what to back up

Ask yourself 'What images can't I afford to lose – either emotionally or financially'? The photos you include in your answer are those that are in the most need of backing up. If you are like most image makers then every picture you have ever taken (good and bad) has special meaning and therefore is worthy of inclusion. So let's assume that you want to secure all the photos you have accumulated.

Organizing your files is the first step to guaranteeing that you have backed up all important pictures. To make the task simpler store all your photos in a single space. This may be a single drive dedicated to the purpose or a 'parent' directory set aside for image data only. If currently your pictures are scattered across your machine then set about rearranging the files so that they are stored in a single location. Now from this time forward make sure that newly added files or older images that you are enhancing or editing are always saved back to this location.

Pro's tip: Ensure that all your picture assets are organized and stored in a single location.

Organizing your image files into one central location will make it much easier to back up or archive all your pictures in one go.

Making your first back up

Gone are the days when creating a back up of your work involved costly tape hardware and complex server software. Now there are a variety of simpler ways to ensure that your files are secure.

1. Create duplicate CD-ROM or DVD discs

The most basic approach employed by many photographers is to write extra copies of all imaging files to CD-ROM or DVD disk. It is easy to create multi-disk archives that can store gigabytes of information using software like Roxio Creator Classic or Toast. The program divides up the files into disk size sections and then calculates the number of blanks needed to store the archive. As each disk is written, the software prompts the user for more disks and sequentially labels each DVD in turn. In this way whole picture libraries can be stored on a set of disks.

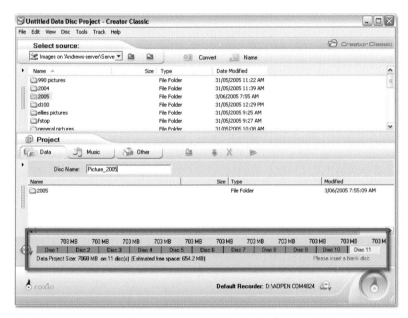

Most CD or DVD writing software has multi-disk spanning features built in. This technology allows you to archive large numbers of files across several disks without the risk of losing data.

2. Back up from your editing program

Both Photoshop Elements and Photoshop CS2 (in conjunction with Version Cue) have backup options.

The Backup feature (PhotoBrowser: File > Backup) in the Windows version of Elements 3.0 is designed for copying your pictures (and catalog files) onto DVD, CD or an external hard drive for archiving purposes. To secure your work simply follow the steps in the wizard. The feature includes the option to back up all the photos you currently have cataloged in the Photo Browser along with the ability to move selected files from your hard disk to CD or DVD to help free up valuable hard disk space.

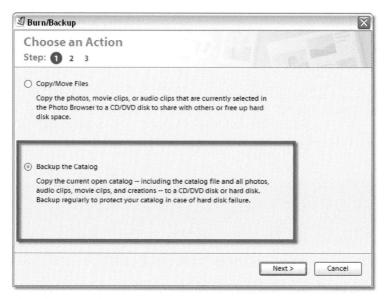

The Backup option built into the Photo Browser (Organizer) workspace of Photoshop Elements for Windows creates an archive of all the files you have in your catalog via an easy to use step-by-step wizard.

Adobe has also included sophisticated backup options in its Creative Suite 2 release. By placing your Photoshop files in a Version Cue project you can take advantage of all the archive features that this workspace provides. Backups are created via the Version Cue administration screen. Here individual archive strategies can be created for each of your projects with the user selecting what to back up, where the duplicate files will be saved and when the automated system will copy these files.

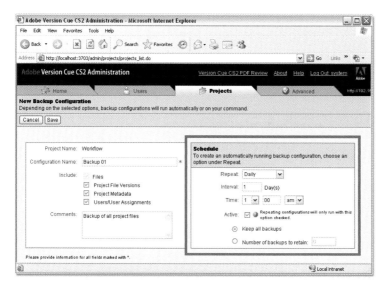

The Version Cue program, which ships as part of Adobe Creative Suite 2, can automate the backup of Photoshop projects via the settings in the Administration component of the program.

Apple's Aperture takes the task of keeping your files safe very seriously. The program contains a complete backup and restoration system and it always lets you know how up to date your archive is.

When backing up, Aperture makes a complete copy of the Library. Apple calls this archive a vault. Changes to your Library, such as adding and removing photos, are reflected in the vault after the next backup. For this reason it is important to back up regularly. Aperture permits you to make as many vaults as you want and so many professionals maintain two separate vaults on external hard drives. One to keep locally, in case of computer failure, and one to store offsite, for extra safekeeping if the unthinkable happens.

Aperture contains a sophisticated backup system that copies all the contents of the Library to another folder or drive.

Actions for managing your archives are centered around the Vault Panel (bottom left of the workspace, press Shift R to reveal if hidden). As Aperture tracks the backup status of your files on an ongoing basis you will always know how up to date your archives are. When there are image files that have been added to the Library but not backed up the Vault Status button (bottom of the panel) appears red. An up to date vault shows as a black button and a yellow Vault Status button means that changes have been made to existing images in the Library. Vaults can be updated at any time by clicking the Update All Vaults button.

If the worst happens and your picture files are lost or destroyed then it is a relatively simple matter to restore the Library from a vault by attaching the external backup drive, displaying the Vaults panel and then selecting the Restore option from the Vault Action pop-up menu (icon bottom right of the panel).

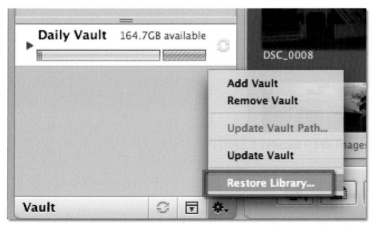

To remedy a damaged or deleted library restore the photos from the backup Vault via the option in the Vault Action pop-up menu.

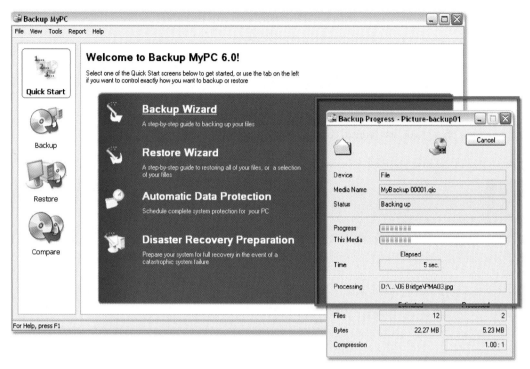

Dedicated backup software such as BackUp MyPC generally provide more features than the archive options built into other programs.

3. Use a dedicated backup utility

For the ultimate in customized backup options you may want to employ the abilities of a dedicated backup utility. Until recently many of these programs were designed for use with high-end networked environments and largely ignored the smaller home or SOHO users but recent releases such as Roxio's BackUp MyPC are both affordable and well suited to the digital photographer. The program provides both wizard and manual approaches to backing up your photos, includes the option to compress the archive file and gives you the choice of Full (all files duplicated) or Incremental (only backs up changed files since last backup) backup types.

Pro's tip: Use a backup solution that fits your budget as well as the way you work.

Back up regularly

There is no point having duplicate versions of your data if they are out of date. Base the interval between backups on the amount of work you do. In heavy periods when you are downloading, editing and enhancing many images at a time back up more often; in the quieter moments you won't need to duplicate files as frequently. Most professionals back up on a daily basis or at the conclusion of a work session.

Pro's tip: The quality of your protection is only as good as the currency of your archives.

Store the duplicates securely

In ensuring the security of your images you will need to protect your photos not only from the possibility of a hard drive crash but also from such dramatic events as burglary and fire. Do this by storing one copy of your files securely at home and an extra copy of your archive disks or external backup drives somewhere other than your home or office. I know that this may sound a little extreme but swapping archive disks with a friend who is just as passionate about protecting their images will prove to be less painful than losing all your hard work.

Pro's tip: Make sure you keep a second archive set off site as insurance against fire and theft.

The DNG or Digital Negative file format is an open source raw file format that Adobe designed to try to bring some stability and capability to the area.

Which format should I use for back ups?

After reading the bulk of this book it should be plain to see that the raw format has many advantages for photographers, offering them greater control over the tone and color in their files, but unfortunately there is no one standard available for the specification of how these raw files are saved. Each camera manufacturer has their own flavour of raw file format. This can make the long-term management of such files a little tricky. Backing up the original files is great, but what happens if, over time, the specific format used by your camera, and archived by you faithfully, falls out of favor and is no longer supported by the major editing packages? Will you be able to access your picture content in the future?

Adobe developed the DNG or Digital Negative file type to help promote a common raw format that can be used for archival as well as editing and enhancement purposes. The company hopes that the specification will be adopted by the major manufacturers and provide a degree of compatibility

and stability to the raw format area. At the moment Hasselblad, Leica, Ricoh and Samsung have all produced cameras that capture in the DNG format with more predicted to follow.

Adobe has included DNG output options in both Photoshop CS2 and Photoshop Elements 4.0, and other software producers, such as Apple (via Aperture), also provide DNG output options. In addition Adobe also provides a DNG converter that can change many proprietary Camera Raw formats directly to DNG. The converter is free and can be downloaded from www.adobe.com.

In addition to providing a common raw file format, the DNG specification also includes a lossless compression option which, when considering the size of some raw files, will help reduce the space taken up with the thousands of images that photographers accumulate.

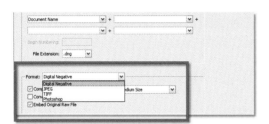

Saving DNG – To save your raw files in the DNG format, select this option as the file type when saving from the Adobe Camera Raw utility or other software with DNG save options.

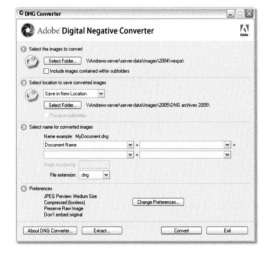

The DNG converter – Alternatively, multiple files can be converted to the DNG format using the free DNG Converter which is available as a download from www.Adobe.com. After launching the utility select the source and destination directories and determine the name and extension to be used with the converted files. The last setting in the dialogue is the Change Preferences button. Click here to alter the default settings used for the conversion.

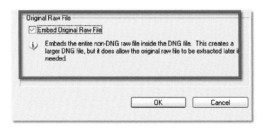

Embedding raw – The latest version of the DNG converter offers the option to embed the original raw file within the DNG conversion. This action will cause the resultant file to be larger, as it will contain two forms of the picture, but it does provide an added sense of security knowing that you can extract the original file at a later date.

Backup jargon buster

Multi-disk archive – A process, often called spanning, by which chunks of data that are larger than one disk can be split up and saved to multiple CD-ROMS or DVDs using spanning software. The files can be recompiled later using utility software supplied by the same company that wrote the disks.

Version Cue – Version Cue and the backup features it includes is included free when you purchase the Adobe Creative Suite 2 and is not supplied when you buy Photoshop CS2 as an individual product.

Full backup – Duplicates all files even if they haven't changed since the last time an archive was produced.

Incremental – Backs up only those files that have changed since the last archive was produced. This makes for faster backups but means that it takes longer to restore files as the program must look for the latest version of files before restoring them.

Restore – Reinstates files from a backup archive to their original state on your hard drive.

Backup hardware options

CD-ROM or DVD writer – This option is very economical when coupled with writing software that is capable of writing large numbers of files over multiple disks. The sets of archive disks can easily be stored off site ensuring you against theft and fire problems but the backup and restore process of this approach can be long and tedious.

Internal hard drive – Adding an extra hard drive inside your computer that can be used for backing up provides a fast and efficient way to archive your files but won't secure them against theft, fire or even some electrical breakdowns such as power surges.

External hard drive – Connect via USB or Firewire these external self-contained units are both fast and efficient and can also be stored off site providing good all-round protection. Some like the Maxtor One Touch models are shipped with their own backup software. Keep in mind that these devices are still mechanical drives and that care should be taken when transporting them.

Online or web-based backup –
Not a viable option for most image
makers as the number of files and
their accumulative size make
transfer slow and the cost of web
space exorbitant.

Versioning your edits

Backing up on a whole system level is pretty obvious but what about applying the same ideas
on a file by file basis? In this section we look at a sure fire method for protecting your files from
accidentally being overwritten in the editing process.

Save me from myself

OK, here goes. I'm going to make an embarrassing confession but please keep it just between
ourselves. Occasionally, yes that means not that often, I get so involved in a series of complex edits
that I inadvertently save the edited version of my picture over the top of the original. For most tasks
this is not a drama as the edits I make are generally non-destructive (applied with adjustment
layers and the like) and so I can extract the original file from inside the enhanced document, but
sometimes because of the changes I have made there is no way of going back. The end result of
saving over the original untouched digital photo is equivalent to destroying the negative back in the
days when film was king. Yep, photographic sacrilege!

So you can imagine my relief to find that in the new editions of Adobe's flagship editing software
programs, Photoshop and Photoshop Elements, the company has introduced a new technology
that protects the original file and tracks the changes made to the picture in a series of successive

saved photos. The new technology is called versioning as the software allows you to store different versions of the picture as your editing progresses. What's more the feature (in both Elements and Photoshop) provides options for viewing and using any of the versions that you have previously saved.

Let's see how this file protection technology works in practice.

Versions and Photoshop Elements

Versioning in Photoshop Elements is an extension of the idea of image stacks and works by storing the edited version of pictures together with the original photo in a special group or Version Set.

All photos enhanced in the Photo Browser space using tools like Auto Smart Fix are automatically included in a Version Set. Those images saved in the Quick and Standard Editor spaces with the Save As command can also be added to a Version Set by making sure that the Save with Original option is ticked before pressing the Save button in the dialog.

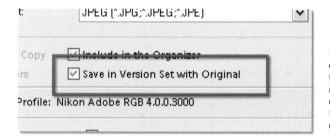

When editing pictures that have been opened from the Organizer into the Editor workspace Photoshop Elements provides the user with the opportunity of saving the edited file as part of a Version Set. To use the feature, click the option in the Save As dialog when storing pictures.

Saving in this way means that edited files are not saved over the top of the original, instead a new version of the image is saved in a Version Set with the original. It is appended with a file name that has the suffix '_edited' attached to the original name. This way you will always be able to identify the original and edited files. The two files are 'stacked' together in the Photo Browser with the most recent file displayed on top.

When a photo is part of a Version Set, there is a small icon displayed in the top left of the Photo Browser thumbnail. The icon shows a pile of photos.

The small stacked pictures icon in the top right of the thumbnails in the Photoshop Elements Organizer workspace indicate that the picture displayed is part of a Version Set.

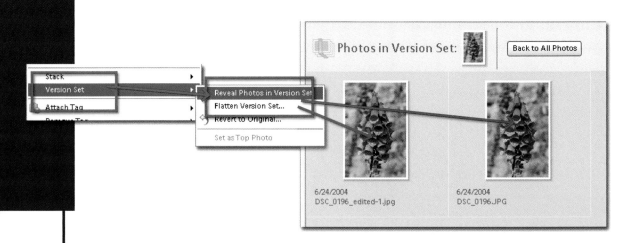

Selecting the Version Set > Reveal Photos in Version Set option from the pop-up menu that is displayed when a thumbnail is right-clicked in the Organizer workspace will display all the saved edited versions associated with the image in a separate display window.

To see the other images in the version stack simply right-click the thumbnail image and select Version Set > Reveal Photos in Version Set. Using the other options available in this pop-up menu the sets can be expanded or collapsed, the current version reverted back to its original form or all versions flattened into one picture. Version Set options are also available via the Photo Browser Edit menu.

What are image stacks?

An image stack is slightly different from a Version Set as it is a set of pictures that have been grouped together into a single place in the Organizer workspace. Most often stacks are used to group pictures that have a common subject or theme and the feature is one way that Elements users can sort and manage their pictures. To create an image stack, multi-select a series of thumbnails in the workspace then right-click on one of the selected images to show the menu and from here select the Stack > Stack Select Photos option. You can identify stacked image groups by the small icon in the top right of the thumbnail.

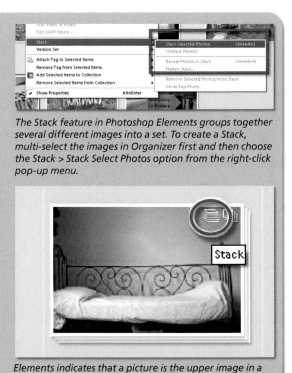

The Stack feature in Photoshop Elements groups together several different images into a set. To create a Stack, multi-select the images in Organizer first and then choose the Stack > Stack Select Photos option from the right-click pop-up menu.

Elements indicates that a picture is the upper image in a stack of photos in Organizer by displaying a small 'photo stack' icon in the top right hand corner of the thumbnail.

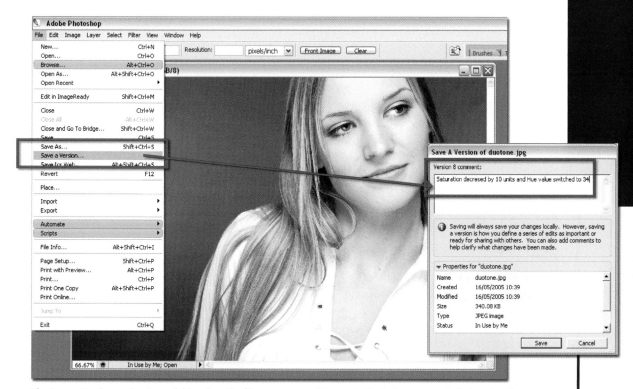

The Save a Version option is available when the files you are working on in Photoshop are part of a Version Cure project. The Save a Version dialog is displayed as part of the save process and allows the user to insert version-based comments before storing the new version of the file.

Photoshop CS2 and versioning

The Versions feature in Photoshop CS2 is a very useful tool for photographers who create multiple editions of the same image or design. When activated, the feature allows you to use the File > Save a Version option from inside the Photoshop workspace. This action displays a Save a Version dialog. The window contains all the details for the picture as well as a space for you to enter comments about the version you are saving. After clicking the Save button the latest version of the file is then saved and displayed in the standard thumbnail view in Bridge. To see the previous version saved with the file switch the workspace to the Versions and Alternates View (Bridge: View > As Versions and Alternates). This will display all the previous iterations of the photo.

Alternatively, right-clicking on the Bridge thumbnail and selecting the Versions option from the pop-up menu displays just the versions available for the selected image.

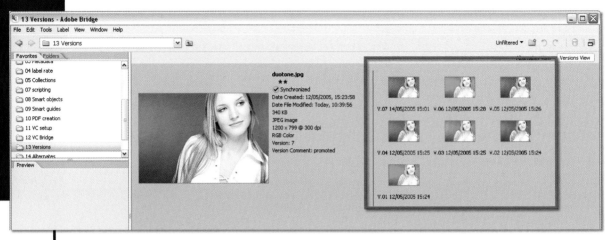

All the versions associated with a specific file can be viewed in Bridge, Photoshop's new file browser, by selecting the View > As Versions or Alternates.

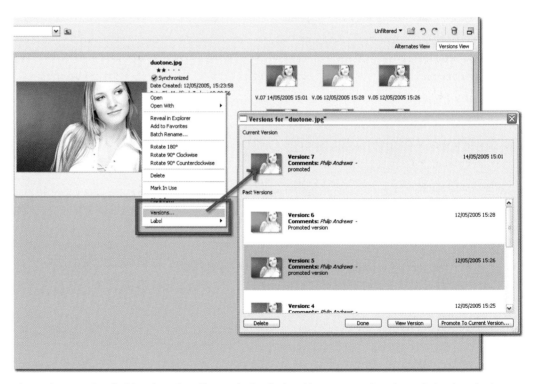

The versions associated with a Photoshop file can also be displayed in a separated Versions window by selecting the Versions option from the pop-up menu that is displayed when right-clicking the picture thumbnail in Bridge.

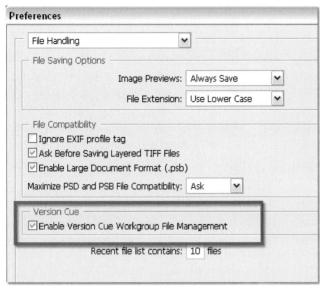

To use the versioning features in Photoshop and other Adobe CS2 programs you need to ensure that Version Cue is installed and active and that the Version Cue options are enabled in the preferences of the program you are using.

Setting up for saving Photoshop versions

In order to make it possible to use the Save a Version feature in Photoshop (or any other CS2 program) the folders or files that you are working with must be organized in a Version Cue project or workspace. In addition the Enable Version Cue options in the preferences of each of the CS2 programs also need to be selected. In Photoshop this setting is located in the File Handling Preferences dialog.

Now when a Version Cue protected file is opened and enhanced or edited in any way, the Save a Version option appears as a usable option on the File menu.

What is Version Cue?

To use versioning in Photoshop CS2 the Version Cue program must be installed and the Version Cue features must be enabled in the File Handling preferences in Photoshop. Version Cue is included free when you purchase the Adobe Creative Suite 2 and is not supplied when you buy Photoshop CS2 as an individual product.

Aperture provides the option to duplicate the original raw file with or without its current editing settings.

Aperture and editing versions

How does this idea of versioning apply in a full raw workflow environment? Well Aperture provides a slightly different interpretation of this method of protection. As we have already seen Aperture offers lossless editing, meaning that the processed photo can be returned to its original state at any time. The original image state is referred to as the master file. When versioning Aperture offers the choice of creating a separate copy of the master file in its virgin state, or making a duplicate of the photo with its current enhancement settings intact.

To copy the master file: Select the photo and then select Image > New Version From Master.

To copy a photo with current settings: Select the photo to copy and then select Images > Duplicate Version.

Copying the master file means that you can apply a range of different development settings to the duplicates commencing from the same starting point. In contrast, duplicating the photo at different times in the enhancement process can be used to document key points in the editing life of the picture.

Version actions are centered around the Images menu.

Last appeal

Now be honest, 'Have you backed up your photos lately?' 'Do you have a file by file protection method in place?' If you haven't, then I hope that I have convinced you to do so and that you will start today, otherwise, like my photography friend, you may just need to keep a stack of tissues handy for that day, heaven forbid, when you photos go missing.

D

DCT: Discrete Cosine Transform. A bit rate reduction algorithm that is used during JPEG image compression to convert pixels into sets of frequencies.

DEFAULT: A decision that your software or hardware makes for you, which is automatically carried out unless you intervene and change those settings. Most program allow the default setting to be changed by entering your own preferences.

DEVICE RESOLUTION: Refers to the number of dots per inch (dpi) that any device, such as a monitor or printer, can produce. Device resolution for computer monitors varies from 60 to 120dpi, but don't confuse this with screen resolution, which is the line screen (measured in lines per inch) that is used by commerc printers to reproduce a photograph with a press. Im resolution refers to the amount of information stor a photograph and is usually expressed in pixels per (ppi). The image resolution of a photograph determ how big the file will be: the higher the resolution, more disk space it grabs and the longer it takes to

DESPECKLE: The Despeckle filter in Adobe Photo (Filter > Noise > Despeckle) detects the edges of – where significant color changes occur – and bl selection except the edges. This has the effect of noise while preserving detail, although CS2's R Noise command (Filter > Noise > Reduce Noise a better job removing digital camera noise.

DIALOG BOX: A window that software uses to communicate with a user to achieve a specific

DIGITAL: Information represented by numbe Computers use information measured in bits digits. Binary is a mathematical system base numbers one and zero, and inside a comput signals are represented by positive and nega = off) current.

DIGITIZE: To convert into digital form: e.g. can be used to digitize a photograph and t pixels.

DLL: Dynamic Link Library. Microsoft Wi Dynamic Link Libraries for linking and s

DISK CRASH: The failure of a disk usua read/write head (of any drive) coming i with the disk surface.

DISPLAY: Another word for the box co cathode ray tube (or LCD panel), powe other components that enable you to displayed by your computer.

DITHERING: A graphics display or p that uses a combination of dots or t impression of a continuous-tone gr

DOT GAIN: An increase in the size during the printing

Glossary

Photographers have always employed a number of euphemisms to describe their pursuit of exciting images. They have been known to 'shoot' brides, 'take' pictures of kids, and 'snap' photos of their pets. So, it's not surprising that digital photographers have produced several euphemisms of their own. The most popular being is that they don't 'shoot' photographs at all; they 'acquire' images. That's just the beginning of some of the buzzwords and acronyms you might need to understand when working with digital image files, to paraphrase Oscar the Grouch, beginning with the letter 'A'.

A

ALGORITHM: In mathematical terms, this is a set of defined rules (or part of a program) that solves a problem.

ALIAS: A feature of the Mac OS operating system that allows users to create a small file that acts as a substitute (or pointer) which, when double-clicked, launches the original application or document. This allows users to keep original files buried deep in folders, or even stored on removable media or a network, and launch them without a lot of muss or fuss. Don't confuse alias with 'aliasing'. In Microsoft Windows, the alias concept is implemented as a 'shortcut'.

ALIASING: Sometimes when a graphic image is displayed on a monitor, you'll see jagged edges around some part of the object. These rough edges are caused by an effect called aliasing. Techniques that smooth out the 'jaggies' are called anti-aliasing.

ALPHA VERSION: This is the first version of new software that precedes beta and is typically only used within the environment in which it was created, i.e. is rarely seen outside the developer's company.

ANCHOR: A spot on your website that is linked to places on the same web page or on another web Page.

ANSI: American National Standards Institute. This is an organization that determines and distributes data processing standards that may be adopted on a voluntary basis by the industry. ANSI is the USA's member in the International Standards Organization (ISO).

API: Application Program Interface. A format used by a software program to communicate with another program that provides services for it. APIs carry out lower-level services performed by the computer's operating system. In Microsoft Windows, an API helps applications manage windows, menus, icons, and other graphic user interface elements.

ASCII: American Standard Code for Information Interchange. ASCII is a standardized computer code for representing text data. The code has 96 displayed characters (characters you can see on the screen) and 32 non-displayed characters (some of which you can see, others you can't).

ANALOG: Information presented in continuous form, corresponding to a representation of the 'real world'. A traditional photographic print is an analog image, but when this same image is scanned, it is translated into digital form and becomes bits of information.

APPS: Short hand for 'applications'.

B

BACKUP: A duplicate copy of data stored on media other than the original, used to reconstruct the data in case of hardware or software problems. Sometimes backups can be stored on some other form of removable media. One of the oldest rules in computing is backup, backup, and backup.

BASIC: Beginners All purpose Symbolic Instruction Code.

BATCH PROCESSING: The collection of data or images into a group or batch to be processed by the computer at the same time.

BAUD: Used as a measure of speed in data transmission, synonymous with bits per second.

BETA TESTING: The way software is tested with 'real world' data outside the manufacturer's environment. This software is usually called beta or prerelease software and is given to the press and selected users to try before final release of the 'shrink-wrapped' version. Beta testers are expected to report problems back to the manufacturer so they can be fixed before final release.

BICUBIC INTERPOLATION: This is a common form of pixel interpolation used in Adobe Photoshop and other image editing programs. It produces each new pixel by interpolating data from the nearest 16 source pixels. Two cubic interpolation polynomials are used; one for each direction. (If you really want to know about 'interpolation polynomials' this might not be the book for you.) This method of interpolation produces a balance between accurate detail and smooth graduation for the resampled (up or down) images.

BINARY: A mathematical system based on the numbers one and zero. This is ideal for computers, because electrical signals can be represented by electrical current being positive and negative, on and off.

BIOS: Basic Input-Output Systems.

BIT: Binary digit. The smallest unit of information a computer can work with. Because they represent all data (including photographs) by using numbers, or digits, computers are digital devices. These digits are measured in bits. Each electronic signal therefore becomes one bit, but to represent more complex numbers or images, computers must combine these signals into larger 8-bit groups called bytes.

BIT DEPTH: This refers to the number of bits that are assigned to each pixel. The more bits you have, the more photo-realistic the on-screen image will appear.

BITMAP: Graphic files come in three classes: bitmap, metafile, and vector. A bitmap (aka raster) is any graphic image that is composed of a collection of tiny individual dots or pixels – one for every point or dot on a computer screen. The simplest bitmapped files are monochrome images composed of only black and white pixels. Monochrome bitmaps have a single color against a background while images displaying more shades of color or gray need more than one bit to define the colors. Images, like photographs, with many different levels of color or gray are called deep bitmap, while black and white graphics are called bilevel bitmap. A bitmap's depth is permanently fixed at creation. No matter what I do, I can't change this. I can make them bigger, but not better.

BIT RESOLUTION: Often called color depth, measures the number of bits of information a pixel can store and determines how many colors can be displayed at once.

BMP (WINDOWS): Often pronounced 'bump'. This acronym is a file extension for a specific kind of Windows-based bitmap graphics file. Digital photographs may be saved as a BMP or any other kind of bitmapped file format.

BPS: Bits per second, sometimes called baud.

BRIGHTNESS: Brightness is the intensity of light present in a color.

BUFFER: This term refers to space that is typically reserved in memory to hold temporary file information. Information that is sent or spooled to a printer is usually placed in a buffer to await processing. This is especially true for large photographic files that are printed on dye-sublimation printers.

C

CAD: Computer-Aided Design.

CALIBRATION: A term used in Color Management Systems (CMS). All kinds of variables – including working environment – affect the way a device is calibrated. To produce optimum results, all color-reproducing devices must maintain a consistent, calibrated state. A variety of calibration hardware and software, such as Monaco

EZ Color (www.monacosys.com) and ColorVision (www.colorcal.com) are available to help calibrate your system so what you see on your monitor is what comes off your printer.

CCD: Charged Coupled Device, a light-gathering device used in flatbed scanners, digital cameras, and camcorders to capture light passing through a lens and convert it into an electronic equivalent – pixels – of the original image. Scanners use a CCD array consisting of several elements arranged in a row on a single chip. Three-pass CCD scanners use a single linear array and rotate an RGB color wheel in front of the lens before each of the passes are made. A single-pass scanner uses three linear arrays, which are coated to filter red, blue, and green light and the image data is simultaneously focused onto each array. Instead of a large CCD chip, some medium and large format (scanning) digital backs use a linear array of sensors that move across the image area.

CD-ROM: Compact Disc Read-Only Memory.

CGM: Computer Graphics Metafile.

CHARACTERIZATION: A Color Management System (CMS) term that establishes the relationship of your calibrated peripheral to a device-independent reference color space or RCS. This 'color space' describes how a device reads, displays, and stores color values.

CHROMATIC ABERRATION: A common defect lens in which the optical elements focuses different frequencies (colors) of light differently.

CLIPPING: The shifting of pixel values to either the highest highlight value (255) or the lowest shadow value (0). Areas of a photo that are clipped are either completely white or completely black and have no image detail.

CMOS: (1) A Complementary Metal Oxide Semiconductor is a type of Large-Scale Integrated (LSI) circuit that has low power requirements. (2) This is also what Windows computer users call the chip where system defaults are stored along with any changes to system parameters. Since it is RAM and is volatile, the CMOS chip is battery-powered to keep the information 'hot'. CMOS is similar to PRAM (Parameter RAM) on the Apple Power Macintosh.

CMYK: Cyan, Magenta, Yellow, and Black.

COLOR DEPTH: Measures the amount of color information each pixel can display.

COMPRESSION: A technique that lets you make a file smaller by removing irrelevant information from that file. As the resolution of a photographic image increases, so does its file size. As file size increases greater demands are made on your hard disk and CPU. Compression software removes unneeded data to make a file smaller without losing any data, or in the case of a photographic file, image quality.

CONTROL PANEL A small program that does something specific for your computer system or application. Each utility has its own dialog box for controlling various features or settings.

CRT: Cathode-Ray Tube.

D

DCT: Discrete Cosine Transform. A bit rate reduction algorithm that is used during JPEG image compression to convert pixels into sets of frequencies.

DEFAULT: A decision that your software or hardware makes for you, which is automatically carried out unless you intervene and change those settings. Most programs allow the default setting to be changed by entering your own preferences.

DEVICE RESOLUTION: Refers to the number of dots per inch (dpi) that any device, such as a monitor or printer, can produce. Device resolution for computer monitors varies from 60 to 120dpi, but don't confuse this with screen resolution, which is the line screen (measured in lines per inch) that is used by commercial printers to reproduce a photograph with a press. Image resolution refers to the amount of information stored in a photograph and is usually expressed in pixels per inch (ppi). The image resolution of a photograph determines how big the file will be; the higher the resolution, the more disk space it grabs and the longer it takes to print.

DESPECKLE: The Despeckle filter in Adobe Photoshop (Filter > Noise > Despeckle) detects the edges of an image – where significant color changes occur – and blurs a selection except the edges. This has the effect of removing noise while preserving detail, although CS2's Reduce Noise command (Filter > Noise > Reduce Noise) might do a better job removing digital camera noise.

DIALOG BOX: A window that software uses to communicate with a user to achieve a specific result.

DIGITAL: Information represented by numbers. Computers use information measured in bits or binary digits. Binary is a mathematical system based on the numbers one and zero, and inside a computer, electrical signals are represented by positive and negative (1 = on, 0 = off) current.

DIGITIZE: To convert into digital form; e.g., a scanner can be used to digitize a photograph and translate it into pixels.

DLL: Dynamic Link Library. Microsoft Windows uses Dynamic Link Libraries for linking and sharing functions.

DISK CRASH: The failure of a disk usually caused by the read/write head (of any drive) coming in touch (crashing) with the disk surface.

DISPLAY: Another word for the box containing a cathode ray tube (or LCD panel), power supply, and other components that enable you to see a digital image displayed by your computer.

DITHERING: A graphics display or printing process that uses a combination of dots or textures to create the impression of a continuous-tone grayscale or color image.

DOT GAIN: An increase in the size of the dots of a halftone image during the printing process. This is inherent in the commercial printing process and the best way to avoid having your images degraded when using this kind of reproduction is to plan ahead and anticipate the effect of increased dot size.

DOT PITCH: The classic definition of dot pitch is the distance between the red (center) dot of two adjoining pixel triads on a monitor. The smaller this number, the sharper the picture will be.

DPI: Dots per inch is a measurement of linear resolution for a printer or scanner. If a device has a resolution of 300dpi it means there are 300 dots across and 300 dots down. The tighter this cluster of dots is, the smaller the dot becomes. The higher the number of dots; the finer the resolution will be.

DRAFT MODE: The ability of a printer to produce output, approximating the original document or image, that has less than the printer's maximum possible quality. Draft mode is useful when you are in a hurry and low-resolution output can provide enough information for viewing or image editing.

DRAG AND DROP: This is a feature of graphical user interfaces (GUI) that lets users perform different operations by using the mouse to maneuver an icon that represents a file.

DRAM: Dynamic Random Access Memory.

DVD: Digital Video Disc aka Digital Versatile Disc.

DYE-SUBLIMATION: Often called just 'dye-sub' or thermal dye-transfer, this process is used in printers that have a printing head which heats a dye ribbon, which in turn creates a gas that hardens and is deposited onto a special paper. The more heat that's applied by the head, the denser the color and the denser the image on the paper will appear. Like most photo quality printers, output appears in the form of dots of color, but because these dye spots are soft-edged (instead of the hard edges created by laser and inkjet printers), they result in smooth continuous tones. This makes dye-sub printers work especially well with photographs, and even 300dpi dye-sub output can be striking.

DXF: Drawing Interchange Format, utilized by AutoCad's popular computer-aided drawing software package.

E

EDIT: This is the process of changing or modifying a text, graphics, or image file.

ELF: Extremely Low Frequency radiation produced by computer monitors. (See EMF.)

EMF: If you spend more than a few hours a day at your computer you should be aware of the potential problems caused by the Electro-Magnetic Fields (EMF) that some computer monitors produce. All monitors emit some kind of very low frequency (VLF) and extremely low frequency (ELF) radiation, and release most of this radiation from their sides and back. These days most computer monitors adhere to Swedish Tjanstemannens Central Organization (www.tco.se/eng) standards for low radiation emissions, and you should check your monitor's specifications to ensure they meet or exceed TCO standards.

ENCRYPT: This is a method used to protect the contents of a file or e-mail message from being read or seen by unauthorized people by converting the original data into a form that can only be read by someone who has the 'key'.

EIDE. Enhanced Integrated Drive Electronics. This is a connection for hard drives that extends the Advanced Technology Attachment (ATA) standard while maintaining compatibility with current Mac OS and Windows computer hardware designs.

EPP: Enhanced Parallel Port. The IEEE 1284 standard is an interface where data is transferred in and out of a computer on more that one wire (i.e. parallel). This standard defines the type of cable used in order to increase distances up to 30 feet and sustain high transfer rates. This standard is compatible with the 8-bit Centronics parallel port commonly found on most Windows-based computers. An EPP can handle up to 64 disk drives and other peripherals, such as printers and scanners.

EPS, EPSF: Encapsulated PostScript format. This is a metafile (combining both bitmapped and vector elements) format for graphics files that can be imported or placed into another application, such as a desktop publishing program. This type of file contains two aspects: the bitmapped image and the PostScript code that tells your printer or output device how to print the image.

ESC: The Escape key is found on Macintosh and Windows computer keyboards. Some software programs use keyboard combinations (the simultaneous pressing of two or more keys) that use the ESC key to accomplish an action.

ETHERNET: Ethernet was originally developed by Xerox, DEC, and Intel as a form of Local Area Network (LAN) to connect computers from different manufacturers and have them communicate. In order to do this, the computers need an interface card or Ethernet capability built in. Your computer's Ethernet port is often used for cable modem and other broadband Internet connections.

EXPANSION BOARD: Often called just card or board. This is a circuit board that plugs into a slot on the computer's motherboard and adds increased functionality to the computer. One of the most useful expansion cards that I have recently found is Keyspan's (www.keyspan.com) USB 2.0 card for Windows and Mac OS computers. Since most computers have only two USB ports, you usually need a hub after you plugged in the keyboard and one peripheral. The Keyspan card not only supports the faster (480Mbps) USB 2.0 format, but provides four more places to plug external peripherals such as a scanner or memory card reader.

F

FAQ: Frequently Asked Questions. An acronym for a section of text often used on Internet home pages, and containing the most frequently asked questions visitors to the website might have.

FILE: A single sequence of bytes of data that has a finite length and is stored on a non-volatile medium (like a hard disk) and is named as an individual entity; occasionally referred to as a document. Each program uses a unique file type that is readable by that program or compatible programs. Adobe Photoshop can saves image files in a .PSD format that's readable only by itself (and other compatible programs) but also gives you the option of saving the file in an industry standard graphics format like TIFF (Tagged Image File Format).

FILE CONVERSION: The process of converting one file type to another file type for another platform, as from Windows to Macintosh. While some graphics programs have a limited ability to read files from other platforms, file conversions usually require specialized software to perform the required translation. There are dozens of different types of Windows image files and bunches more for the Macintosh. Graphic file incompatibilities affect many computer users, none more than the digital imager. Understanding what a file acronym means takes some of the stress out of the conversion process.

FILTER: (1) A hardware device that separates specific signals or data from an electronic signal or groups of data. (2) A Photoshop-compatible plug-in that can added to your graphics or image-enhancement program to produce a special effect within user-definable parameters. Instead of screwing these filters onto the front of your lens, all you need to do is copy them into your program's plug-in folder and they'll appear within the program's Filter menu.

FLAT PANEL: A monitor or display that uses LCD (Liquid Crystal Display) technology instead of the CRT (Cathode-Ray Tube) in conventional monitors. Not to be confused with a flat screen monitor, which is really a glass-tube CRT, whose face is almost completely flat – maybe even completely flat – instead of the rounded front that is found on traditional glass monitors. A flat panel monitor always uses an LCD screen.

FRACTAL: A graphics term originally defined by mathematician Benoit Mandelbrot to describe a category of geometric shapes characterized by an irregularity in shape and design. Genuine Fractals (www.altimira-group.com) Print Pro software uses this technology to encode CMYK, RGB, CIE-Lab, Multi-channel and Grayscale images as files that can be used to generate any kind of output whilst remaining small enough to edit, store, and upload. The images have a feature called 'resolution on demand' which means you don't have to store multiple copies of the same file – at different resolutions – for different purposes. You can encode an image once at medium resolution, then output it at any size or resolution you choose. Genuine Fractals Print Pro lets you save images in two ways: the Lossless option produces a file that uses an approximate 2:1 compression and produces high quality enlargements. Near lossless encoding produces a file with approximately 5:1 compression but still lets you output an image beyond its 100% size at high quality.

FREEWARE: A form of software that's just what it sounds like – it's free.

G

GAMMA: Measures the contrast that affects the midlevel grays (the midtones) of an image.

GAMUT: Every output device has a range of colors it can accurately reproduce. This range is the gamut of the device and every device from every manufacturer, whether it's a monitor or printer, has a unique gamut that is part of a 'color space' and different types of devices work in different color spaces. Because of the way they are designed and constructed, monitors work in a different color space than printers, which creates part of the problem that we know as color management. If you discover that the output from your color printer doesn't match what you see on screen, you are beginning to understand the need for color management. The color you see on the display may be 'in gamut' for the monitor, but not the printer, and the problem is compounded by the fact that the gamuts of desktop devices, not unlike photographic film itself, is relatively small when compared to the spectrum of visible light.

GAS PLASMA SCREEN: Some flat panel displays use gas plasma – a design that uses neon and argon gases – to create a flicker-free screen. Glass plasma screens require less power and have long life but are (currently) more expensive than the conventional CRT (Cathode-Ray Tube) monitor design.

GB: Gigabyte. A billion bytes or (more correctly) 1024 megabytes.

GHz: Gigahertz. A measurement of frequency at one billion cycles per second.

GIF (pronounced like the peanut butter): The Graphics Interchange Format developed by CompuServe (www.compuserve.com) is a completely platform-independent bitmapped file format that's readable by both Mac OS and Windows computers, making it popular for use on the World Wide Web. Unlike other compression methods, GIF was designed specifically for online viewing. When there are a few (less that 64) colors in an image, a GIF will be smaller than an equivalent JPEG file.

GRABBER: A hand-shaped on-screen pointer that's used by graphics programs and some Photoshop-compatible plug-ins that looks just like a hand and is used to select or grab on-screen objects and move them around.

GRAPHICS DISPLAY: For a digital photographer, the graphics display is the most important part of the computer system and consists of two parts: the graphics controller (graphics expansion card) and the monitor. The graphics card plugs into a slot on the motherboard and has a port that sticks out the back of the computer's case. The video port is the place where you plug the cable that connects the monitor and the card.

GRAPHICS TABLET: Often called digitizing tablets because they convert graphics and drawings into digital information. While the product is referred to as a tablet, they really have two major parts: the tablet and a pen or stylus that's used to 'draw' on the sensitive tablet's surface.

GRAYSCALE: Most computer users call black and white images 'grayscale' which refers to a series of gray tones ranging from white to pure black. The more shades or levels of gray, the more accurately an image will appear like a full-toned black and white photograph.

GUI: Graphical User Interface. The term probably originated at Xerox's PARC (Palo Alto Research Center) and some people use the pronunciation 'gooey' but I must confess this usage makes me nauseous.

H

HALFTONE: The simulation of a continuous-tone image created with a dot pattern. Almost all printing processes print by using dots. In traditional halftones, a graphics arts camera photographs the original image through a screen, which reproduces the images as dots using smaller dots for lighter areas and larger dots for darker areas.

HALO: When using a selection tool in an image-enhancement program to select certain kinds of objects, a halo may appear around part of that selection. These extra pixels are caused by the program's anti-aliasing feature. (Sometimes when a graphic is displayed on a monitor, you'll see jagged edges around some objects. These rough edges are caused by an effect called aliasing. Techniques that smooth out the jaggies are called anti-aliasing.) Most image enhancement programs have a built-in anti-aliasing function that partially blurs pixels on the fringe of a selection and causes additional pixels to be pulled into the selection. The best way to eliminate these 'halo' pixels is by using the Defringe command.

HARD DISK: A computer's hard disk consists of one or more rigid (i.e. hard), non-flexible disks. Like a floppy disk drive, it has a read/write head, or multiple heads on multi-disk drives. You can think of your hard drive as a

file cabinet that holds all of the data inside your computer. Like a file cabinet, you can access this data whenever you want, and it's still there after you shut the computer down.

HEAD: Sometimes called read/write head. This is an electronic device (not unlike a phonograph arm) that can be found on all drives – CD-ROM, floppy, hard, or removable media – drives and can read and (usually) write information onto the medium.

HEAD CRASH: A hardware failure in which the read/write head comes in contact with the disk surface. This almost always results in loss of data.

HERTZ: It's not the rental car company, but hertz with a small h. Often abbreviated as Hz, this is the ANSI (American National Standards Institute) measure of frequency or electrical vibrations per second.

HighMAT: High Performance Media Access Technology is a multimedia technology developed and supported by those twin bastions of open standards, Microsoft and Panasonic. It's supposed to provide a standard way of combining music, photos and video onto one disc, with a one-click menu allowing it to play on a DVD player, CD player or car stereo.

HIGH RES: High resolution. More information (or pixels) filling your screen means that images will appear in finer detail, with smoother edges.

HP: Hewlett-Packard, a major manufacturer of computers and peripherals (scanners, printers) which was founded in 1939 by William Hewlett and David Packard.

HPGL: Hewlett-Packard Graphics Language.

HSB: Hue, Saturation and Brightness.

HTML: HyperText Markup Language, a format used on World Wide Web Home Pages on the Internet that uses multimedia techniques to make the web easy to browse.

HUE: An object's hue is based on the wavelength of light reflected from it. In plain English, it's a specific shade or tint of a particular color. See HSB.

HYPERMEDIA: A non-linear collection of numbers, text, graphics, video and audio as elements used in a HyperText system, such as the World Wide Web.

HYPERTEXT: A concept originally postulated by computer visionary Ted Nelson as a method for making the computer respond to the way humans think and behave. In a HyperMedia environment (such as the World Wide Web), all the various forms of information including audio, video and text are tied together – with HyperText links – so a user can move from one to another by clicking software buttons with their mouse.

I

ICC: The International Color Consortium is a group of the largest manufacturers in the computer and digital imaging industries. The consortium works to advance cross-platform color communications and has established base-level standards and protocols in the form of ICC Profile Format specifications to build a common foundation for communication of color information between devices.

IDE: Integrated Drive Electronics. Computer motherboards accept several kinds of circuit boards to control hard disks, the most common standard was originally called IDE, but the more commonly used current term is ATA (Advanced Technology Attachment). ATA drives are found in Windows and Mac OS computers and have the advantage of being reasonably fast and inexpensive.

IEEE: Institute of Electrical and Electronics Engineers.

IMAGEBASE: Database programs that keep track of digital photographs, video clips, graphic files, and even sounds are sometimes referred to as imagebase programs.

IMAGE EDITING PROGRAM: The broad term for software that allows digital photographs to be manipulated and enhanced to improve and change images much as you would produce similar effects in a traditional darkroom and then some.

IMAGE PAC: The system that Eastman Kodak uses to write photographic image files onto a Photo CD disc. This is a single file that contains multiple image files stored at different resolutions depending on whether it's a Photo CD Master or Pro Photo CD disc.

INDEXED COLOR: Photographic files using this color mode contain many different levels of color or gray and a palette that specifies which color is used at any given level. Indexed color image files tend to have color depths of 8 bits per pixel allowing them to produce 256 colors. CompuServe's GIF (Graphic Interchange Format) is an indexed color file. The first kind of indexed color file typically contains 256 or fewer colors. The second, called 'pseudocolor', is grayscale images that displays the variations in gray levels in color rather than shades of gray and is typically used for scientific and technical work.

INKJET: This kind of printer works by spraying tiny streams of quick-drying ink onto paper to produce high-quality output. Circuits controlled by electrical impulse, or heat, determine exactly how much ink (and what color) to spray when creating a series of dots or lines that form a printed photograph. Canon, HP, and Lexmark utilize the thermal approach, while Epson's piezoelectric technology uses mechanical vibrations, instead of heat, to fire ink onto paper.

INTEGRATED CIRCUIT: A self-contained electronic device contained in a single semi-conductor computer chip.

INTERLACED: Broadcast television uses an interlaced signal, and the NTSC (National Television Standards Committee) standard is 525 scanning lines, which means

the signal refreshes the screen every second line 60 times a second, and then goes back to the top of the screen and refreshes the other set of lines, again at 60 times a second. The average non-interlaced computer monitor refreshes its entire screen at 60 to 72 times a second, but better ones refresh the screen at higher rates. Anything over 70Hz is considered flicker-free.

INTERFACE: The 'real world' connection between hardware, software, and users. This is the operating system's method for directly communicating with you. It's also any mechanical or electrical link connecting two or more pieces of computer hardware.

INTERLEAVE: A factor that determines how computers read and write data to and from a hard disk. If the computer reads or writes one sector of the hard disk, then skips one, that interleave factor is referred to as 2:1. If the controller writes one sector and then skips two, the interleave is called 3:1. The interleave factor is typically established by the hard disk's manufacturer.

INTERPOLATED RESOLUTION: Scanners are measured by their optical as well their interpolated resolution. Optical resolution refers to the raw resolution that's inherently produced by the hardware, while interpolated resolution is software that adds pixels to simulate higher resolution.

INTERRUPT: A break in a program's execution that can be caused be a signal that directs the computer to leave the software's natural sequence in such as way that the normal flow can be resumed after the break.

I/O DEVICE: Input/Output device. This is another way to refer to peripheral devices such as CD-RW drives, printers, scanners etc.

IRQ: Interrupt Request Line.

ISA: Industry Standard Architecture.

ISO: International Standards Organization. Founded in 1946 with headquarters in Geneva, Switzerland, the ISO sets international standards for many fields, excluding electronics, which is controlled by the International Electrotechnical Commission (IEC).

J

JAGGIES: Sometimes when a photograph or graphic file is displayed on a monitor, you'll see a few jagged edges surrounding some objects. These rough edges are caused by an effect called aliasing. The aliasing features that form part of many graphics programs can cause extra pixels around an image's hard edges – especially those with diagonal lines. Software techniques that are used to smooth out the 'jaggies' by setting nearby pixels to and intermediate color are called anti-aliasing.

JAVA: It's not an acronym. Sun Microsystems' (www.sun.com) Java is a programming language that uses the most useful features of other languages and is designed to be easy to use.

JOLT: Java Open Language Toolkit.

JPEG: An acronym for a compressed image file format that was originally created by the Joint Photographic Experts Group, within the International Standards Organization. Unlike other compression schemes – GIF (Graphic Interchange Format) comes to mind – JPEG is what techies call a 'lossy' method. JPEG was designed to discard information the eye cannot normally see and the compression process can sometimes be slow. By comparison, the LZW (Lempel-Ziv-Welch) compression used by GIF is lossless and no data is discarded during the compression process. JPEG compression breaks an image into discrete blocks of pixels, which are divided in half until compression ratios ranging from 10:1 to 100:1 are achieved. The greater the compression ratio that's produced, the greater loss of image quality you can expect.

K

K: In the computer world, K stands for a different type of 'kilo' – in this case, 2 to the 10th power, or 1024. A kilobyte (or KB) is, therefore, not 1000 bytes but is actually 1024 bytes.

KELVIN: Color temperature emitted by our light sources is measured in degrees on the kelvin scale. The sun on a clear day at noon measures 5500 degrees kelvin. On a thick overcast day the color temperature of light rises to 6700 degrees kelvin, while 9000 degrees kelvin is what you will experience in open shade on a clear day. These higher temperatures are at the cool or blue end of the spectrum. On the lower side, however, light sources are at the warmer end of the spectrum. Lights used by videographers or tungsten type photographic lights have a kelvin temperature of 3200 degrees. Household light bulbs are close to that color temperature and measure about 2600 degrees. When we photograph that special sunrise, its color temperature may be well down on the kelvin scale – at about 1800 degrees.

KERNEL: The essential part of any operating system, including Linux, and is responsible for all of the nitty-gritty housekeeping such as resource allocation, low-level hardware interfaces and security.

kHz: Kilohertz or 1000 hertz (cycles per second).

KLUDGE (sometimes kluge and pronounced kl-oogh): This is an old expression you hardly ever hear anymore for workaround, but usually with a slightly pejorative connotation.

KILOBIT: A measurement of data transmission speed that equates to 1000 bits per second. This is different from baud, which is bytes (8 bits) per second.

KILOBYTE: What you get when you combine 1024 (not one thousand) bytes.

L

LAN: Local Area Network.

LANDSCAPE (MODE): An image orientation that places a photograph across the wider (horizontal) side of the monitor or print. Photographers call this a horizontal image, while computer users prefer to use the term landscape. Antonym: portrait or vertical. While most computer screens are horizontal, a few use a mercury switch that senses the orientation as the user physically rotates the screen from portrait to landscape.

LASER: Light Amplification from the Stimulated Emission of Radiation.

LASER PRINTER: A printer that uses the same kind of process used by copiers to print. Inside the printer, a laser paints dots of light onto a light-sensitive drum and powdered 'toner' is applied to the drum and then transferred onto the paper. IBM introduced the first laser printer in 1975, but it wasn't until Hewlett-Packard introduced their LaserJet, that desktop publishing was made practical for the first time.

LASERWRITER: A family of 300dpi laser printers originally introduced by Apple Computer in 1985.

LATENT IMAGE: (1) In traditional photography, this is the image that's created when a photograph is first captured – when the shutter is snapped – but the film has not yet been processed. When a roll of film is finished but not processed, it's full of latent images. (2) In the computer world, the definition is similar when applied to electronic and digital image making. A latent image is an invisible image created by electrical charges. For example, in a laser printer, a latent image of the page to be output is created on the drum – before that image is transferred to the printed page that emerges from the printer.

LAYER: Images in Adobe Photoshop and other image editing programs are composed of many parts including layers. The base of a Photoshop document is its background, which you might think of as the photographic paper used in a conventional 'wet' darkroom. Layers are like additional emulsions added to the surface of that paper allowing you to create new and additional effects without interfering with what's on the other coatings. One of the easiest ways to understand Layers is to imagine a photograph with sheets of clear acetate stacked on top of one another. Any image – text, graphics, or even another photograph – can be placed in its own separate layer. In the space where there is no image, you can see through to the layers below.

LCD: Liquid Crystal Display. A technology that uses rod-shaped crystal molecules that flow like liquid. This is the type of display found in laptop computers, but is found increasingly on desktop computers as well. In a dormant state, the crystals direct light through two polarizing filters, showing a neutral background color. When power is applied, the crystals redirect light that is absorbed in one of the polarizers, causing a dark appearance – or numbers, characters, and part of a photograph – to be formed.

LED: Light-Emitting Diode. LEDs use less power than normal incandescent light sources, but require more power than LCDs and are often used as light sources in film scanners.

LINE SCREEN: This is a method used by printers to reproduce continuous tone photographs. The technique, also known as line frequency, is created by shooting the original photograph with a graphics art camera through a halftone screen that has many tiny dots in it. These dots are lined up in diagonal rows and the number and size of dots vary depending on the type of reproduction desired. You will often hear printers toss around numbers like 80- and 133-line screen. Here's what they mean: the lower numbers inversely relate to the size of the dots. The dots on a 133 screen are smaller but more numerous than on an 80 screen. Newspapers, because of the paper stock they use, often use a coarser line screen. That's why if you look closely at photographs in newspapers, you can see the dots.

LogLUV: A raw image format developed by Silicon Graphics Inc. (www.sgi.com) that uses 32 bits/pixel and is based on human perception.

LOSSY COMPRESSION: This is exactly what it sounds like: compression techniques that reduce the amount of information in the data (photograph) rather than just the total number of bits used to represent that information. The theory is that the lost information being removed is less important to the overall image quality of the file and can later be recovered during decompression by interpolation. Some images can afford small losses of resolution in order to increase compression and reduce file size, but that depends both on the original image and the application you have for that image. The Joint Photographic Expert Group (JPEG) file format uses a lossy compression technique, whilst GIF (Graphic Interchange Format) does not.

LUMEN: A unit of measurement used for light. A 100-watt light bulb, for example, typically generates 1,200 lumens.

LUMINANCE: The amount of brightness, measured in lumens, that is given off by a pixel or area on a computer monitor. It is the black/gray/white information in a video signal. The color model used by Kodak for its Photo CD process involves the translation of data originally in RGB form into what scientists would call luminance and chrominance and the rest of us call color and hue.

M

M, MB, MEGA: One million.

MACRO: The shortened version of the term macroinstruction. A macro is a brief series of commands that are programmed to perform a series of actions when triggered by a single keystroke or combination of keystrokes. Adobe Photoshop's Actions are really macros that let you automate repetitive imaging tasks.

MAGIC WAND: The Magic Wand is a powerful selection tool found in Adobe Photoshop and other image enhancement programs, and selects part of an image based on similarity of color, not shape. When clicking on an individual pixel in a photograph, Magic Wand selects pixels that have the same color plus similar shades of that color. How many similarly colored shades are selected depends on the Tolerance specified in the palette.

MAGNETIC BUBBLE: A method that uses magnetic film for storing information as a pattern of magnetic fields. Magnetic bubble devices are non-volatile and hold data even when power is lost or turned off.

MASK: Many image enhancement programs have the ability to create masks that are place over the original image to protect parts of it allowing other sections to be edited or enhanced. Cutouts or openings in the mask make the unmasked portions of the image accessible for manipulation, while the mask protects the rest of the photograph.

MCA: Micro Channel Architecture.

MEGABYTE: What you have when you lasso 1024 kilobytes. Often called just 'meg' and abbreviated as MB.

MENU BAR: In a graphical user interface, the menu bar is that portion of a window at its top that contains a row of on-screen, pull-down menus.

METAFILE: This multifunction graphic file type accommodates both vector and bitmapped image information within the same file.

METADATA: Metadata describes the content or characteristics of a file. This data is visible in Adobe Bridge by looking under the Metadata tab.

MHz: MegaHertz or 1,000,000 cycles per second

MIPS: Million Instructions Per Second. A measure of computer performance that indicates how fast a CPU can process software instructions.

MONOCHROME: A monochrome monitor displays one color on a different colored background.

MOS: Metal Oxide Semiconductor

MOUSE: An integral part of any graphical user interface is the ability to use a pointing device. The most common is called a mouse because of its oval shape and tail-like cable that connects it to the keyboard (Mac OS) or back of the computer (Windows). Wireless mice are also available from companies such as Wacom (www.wacom.com).

MPEG: Moving Pictures Experts Group. An ISO standard for compressing full-motion video, which provides more compression than JPEG because it takes advantage of the fact that full-motion video is made up of successive frames that consist of areas that do not change.

MPV: It's not a Mazda minivan aka Multi Purpose Vehicle, although Google agrees with me. Instead, I got the answer from that stalwart supporter of open industry standards – Sony. MPV (MusicPhotoVideo), their website says, is 'a new open standard format to enhance the way consumers store and enjoy collections of personal music, photo and video content on storage media, such as data CDs and DVDs'. If that sounds a lot like HighMAT, you ain't the only one that's confused.

MULTISCAN: On a typical CRT monitor, a scanning beam starts at one corner and traces a single pixel-wide horizontal line, then goes on to trace the next line. How fast the monitor does both horizontal and vertical scans varies depending on the kind of graphics card that's used by the computer. A multiscan monitor automatically matches the signal sent to it by the graphics card (or motherboard).

MULTI-TASKING: often written as multitasking, but I find it easier to read with the hyphen. The ability of the computer's operating system to allow for two or more operations to be performed simultaneously. The current versions of the Mac OS and Windows operating systems both permit multi-tasking.

MULTI-USER: A system – or software – that can be used by two or more users at the same time.

NEF: Nikon Electronic image Format. The proprietary raw image capture format that's used by Nikon digital cameras such as the D2x.

NETWORK: A group of computers that are interconnected by hardware and software, as in a Local Area Network (LAN).

NODE: (1) In communications, a node is a point connecting a terminal or computer. You will also hear local telephone numbers that allow modem equipped computer users to connect to online services such as America Online referred to as nodes. (2) In computer graphics, an end point of a graphical element, a line or curve. (3) In database management, an item of data that can be accessed by two or more routes.

NOISE (1) Noise in a digital image is the equivalent of grain in a photograph made with traditional film. Digital camera noise, from either CCD or CMOS imaging chips, is produced by many factors including underexposure, slow shutter speeds, and (much like its film-based cousin) high ISO settings. Some cameras have a built-in noise reduction feature but while it does a good job it is far from perfect. (2) In Adobe Photoshop, there is a Noise submenu under Filter > Noise that lets you Add Noise (to simulate film grain or just plain noise) in non-noisy subjects but also includes Despeckle and other commands to minimize noise as well as Dust & Scratches in an image file.

NTSC: National Television Standards Committee. NTSC sets the standards that apply to television and video playback for resolution, speed, and color. All television sets in the United States (and Japan too as it turns out) follow the NTSC standard as do videotape and other forms of video display such as games.

OpenEXR: A high dynamic-range image file format developed by Industrial Light & Magic for use in computer imaging applications. OpenEXR is used by ILM on all motion pictures currently in production. The first movies to employ OpenEXR were *Harry Potter and the Sorcerer's Stone, Men in Black II, Gangs of New York*, and *Signs*. Since then, OpenEXR has become ILM's main image file format.

OPERATING SYSTEM: Often called simply OS, this is the master software that controls your computer. When you turn on any computer, the OS is the first thing that gets loaded into the computer's memory. It interacts with your computer's ROM (Read-Only Memory) or BIOS (Basic Input-Output System) chips to accomplish tasks like controlling the hardware components of your system and how they interact with you through on-screen communications.

OPTICAL DRIVES: Optical removable media drives are more correctly called magneto-optical and use a laser to heat and change disc reflectivity to produce media that can be erased and reused. Writing data to optical media requires three spins: the first erases existing data, the second writes the data, and the third verifies the data is there. When compared to fast magnetic drives, all this spinning tends to reduce performance.

OPTICAL RESOLUTION: Scanners are measured by their optical as well as interpolated resolution. Optical is the raw resolution of the scanner that's inherently produced by its hardware, while interpolated resolution is a software technique that's used to add pixels to simulate a higher resolution. How well your scanner does this depends on the software, but in general the average user will be pleased with the results. Purists, however, will ignore the scanner's interpolated resolution specifications and base their purchasing decision on the optical resolution only.

OS: Operating System.

OUTPUT: The analog form of information produced or generated by a computer. Whilst historically this means data printed on some form of device, it now means any kind of 'real world' translation of data, including photographs, overhead transparencies, slides, or even negatives. Output can be in many different forms: an image can simply be viewed and cataloged on a monitor. Photographs can be transferred to other computers in digital form by floppy disk or any kind or removable media and viewed on another computer. A printer attached to your computer can produce a grayscale or color page.

PAL: Phase Alternating Line. A European video standard that has a broadcast resolution of 625 lines (at 25 interlaced frames per second). DVDs recorded for PAL are not playable on equipment set up for NTSC and vice versa.

PALETTE: A grouping of graphics tools (e.g. Select, Paint Brush, Magic Wand etc.) that is found in graphics and photo-enhancement software and is usually indicated by a row of tool icons or toolbox. Mouse-clicking any one of the icons activates the tool and often brings up a dialog box containing specific options.

PARALLEL INTERFACE: A type of input/output port that is found on Windows-based computers and is typically used for connecting printers, modems and other peripheral devices. Data is simultaneously sent and received, several bits at a time, over individual but adjacent wires.

PARITY: The programming technique of adding an extra bit to a block of bits in data transmission that is used to verify accuracy. The extra bit is called a parity bit.

PARTITION: A method of dividing parts of a computer's hard disk into individual sections which the computer treats as separate hard disks with individual names. Each section is called a partition and the act of creating these sections is called partitioning.

PATCH: A small program that's used to modify an application to repair bugs or conflicts with other software.

PCD: This is an extension used in the Windows environment to describe Kodak's Photo CD graphics file format.

PCL: Printer Control Language was first used by Hewlett-Packard LaserJet printers, but has become a standard that is used by many printers and imagesetters.

PCM: Pulse Code Modulation.

PCX: Not an acronym and doesn't stand for anything specific. This is a bitmapped file format originally developed for the popular PC program Paintbrush.

PDF: Portable Document Format. A cross-platform file format produced by Adobe System's Acrobat software that preserves the fidelity of all types of content including text and graphics. The file format is compatible across a wide variety of computer platforms, printers and electronic distribution methods.

PFM: Printer Font Metrics.

PHOSPHOR: A rare earth material used as a coating inside the back of a Cathode-Ray Tube. When struck by an electron beam, a phosphor emits light for a few milliseconds. In color monitors, red, green and blue phosphors are grouped into clusters called triads.

PHOTO CD: A proprietary process of Eastman Kodak that places digitized photographic files onto a CD-ROM.

PIEZOELECTRIC: The property of some crystals that oscillate when subjected to electrical voltage. Epson uses this form of technology in their Stylus series of inkjet printers. On the other hand, piezo-electric (with hyphen) technology generates electricity when mechanical stress is applied.

PIXEL: Pixel is an acronym for picture element. A computer's screen is made up of thousands of colored dots of light that, when combined, can produce a photographic image. A digital photograph's resolution, or visual quality, is measured by the width and height of the image as measured in pixels.

PLUG-IN: Plug-ins are small software applications that increase the functionality and customize off-the-shelf graphics programs, such as Adobe Photoshop. You can think of plug-ins as additional blades or tools for your Swiss Army knife, and selecting the right one can make a tough graphics job easier and a difficult job practical. Plug-ins are easy to use and easier to install: they are simply copied into the 'Plug-in' folder of a program, and after that, they appear as menu items in that program. They are, in effect, 'plugged in' to the software and after installation become an integral part of it. The de facto plug-in standard was created by Adobe for their Photoshop image-manipulation program, but Photoshop-compatible plug-ins can be used with many other programs, including Ulead's PhotoImpact, Corel's Painter and Dabbler, Corel PhotoPaint, JASC's PaintShop Pro, and MicroFrontier's Color-It!, Enhance, and Digital Darkroom. Other graphics programs, such as Adobe PageMaker, Deneba's Canvas, and Macromedia's Director and Freehand accept compatible plug-ins as well.

PMMU: Paged Memory Management Unit.

PMT: Photomultiplier Tubes, a type of sensing technology used in drum scanners.

PORTRAIT MODE: The orientation of a graphic or photographic image in which its shorter dimension is the horizontal side. Photographers call this kind of photograph a vertical image. The opposite is horizontal or landscape mode.

POSTSCRIPT: A programming language originally created by Adobe Systems that defines shapes in as Bezier (Bez-e-ay) curves and interprets them using mathematical formulae. A PostScript-compatible output device uses these definitions to reproduce the image on your computer screen or as output.

PPD FILE: PostScript Printer Description. Since PostScript is device-independent, a PPD file uses its information about a specific printer to take advantage of its built-in features.

PSB: The Large Document Format supports documents up to 300,000 pixels in any dimension. All Photoshop features, including layers, effects, and filters, are supported by PSB. If you save an image file as PSB format, it can only be opened in Photoshop CS. Older versions of Photoshop and most other applications cannot, at this time, open PSB files. Before you can save documents in PSB format, the 'Enable Large Document Format (.PSB)' option must be enabled in the File Handling section of Preferences.

PSD: Adobe's proprietary Photoshop file format lets you also save the file's layers. Save your working copies in .PSD format and you can open them later and retain all the layers. The .PSD format will not compress the file so it can get to be quite large depending on how many layers are part of the file.

Q

QUICKTIME: Apple Computer's multimedia software that adds sound and digital video to applications that have been designed to take advantage of its capabilities. A QuickTime file can contain up to 32 tracks of audio or video information and some image-enhancement programs require its built-in compression capabilities.

QWERTY: A standard keyboard is called QWERTY because the top row of letter keys on the left side spell that 'word'. Computer keyboards typically have 20 to 30 more keys more than standard typewriters, and some of these additional keys are called function keys, e.g. Control, Escape and Apple Computer's proprietary command key.

R

RAID: Redundant Array of Inexpensive Disks. This is a type of disk drive configuration that is two or more drives working together to provide increased performance and improved levels of error recovery.

Radiance HDR: Radiance is a highly accurate ray-tracing software system for UNIX computers that is licensed at no cost to users for non-commercial use. The primary advantage of Radiance over simpler lighting calculation and rendering tools is that there are no limitations on the geometry or the materials that may be simulated.

RAM: Random Access Memory.

RASTER: (1) A pattern of horizontal lines on a CRT screen that's illuminated by a beam of light when data is input. The illuminated dots (pixels) produce visible images. (2) Raster graphics: a technique for representing an image as a series of dots or pixels.

RASTERIZE: The act of converting vector graphics images into bitmaps so that they can be displayed on a monitor or printed. With the exception of plotters – which use vector images, all non-bitmapped images must be rasterized for output.

REFRESH RATE: Sometimes called vertical scanning frequency, refresh rate measures the amount of flicker you see on your monitor.

RENDER: To draw a real-world object as it actually appears. Here's how it works in practice: programs, such as e-on Software's Vue d'Esprit, create graphics in the form of wireframes. Wireframes represent three-dimensional shapes and objects as if they were constructed out of bits of wire or pipe cleaners. In order to see the final image completed, it must be rendered. During rendering, color, shading, and shadows are applied to the wireframe to produce a realistic appearance. How quickly this happens will depend on the size and complexity of the image and your computer's power.

RESOLUTION: A digital photograph's resolution, or image quality, is defined as an image's width and height measured in pixels. When a slide or negative is converted into pixels, the resulting digital image can be digitized at different resolutions. The higher the resolution of an image – the more pixels it has – the better the visual quality. An image with a resolution of 2,048 × 3,072 pixels has better resolution and more photographic quality than the same image digitized at 128 × 192 pixels. At lower resolutions, digital photographs have a coarse, grainy appearance that makes it difficult to evaluate when looking at it on-screen. Unfortunately, a rule of thumb is that as the resolution of a device increases, so does its cost.

RGB: Red, Green, Blue. Color monitors use red, green and blue signals to produce all of the colors you see on the screen. If you've ever made Type R prints from slides in your own darkroom, you're already familiar with working with the additive color filters of red, green and blue. If so, the RGB setup used by computer monitors should make perfect sense to you. If not, the concept is built around how different colors of light blend together.

RIFF: Resource Interchange File Format.

RIP: Raster Image Processor. RIP is a process that prepares image data for the screen or printer. Before some dye-sublimation printers print images, they first save a temporary RIP file to disk – which is used to print the final output. RIP files rasterize specific types of data, such as PostScript or vector graphics images, as well as different kinds of bitmapped data.

RISC: Reduced Instruction Set Computing.

ROM: Read-Only Memory.

RSC: The device-independent reference color space used by color management systems to establish the characteristics of a particular color device.

S

SATURATION: Saturation, often referred to as Chroma, is a measurement of the amount of gray present in a color. You can use an image editing program's, such as Adobe Photoshop, Hue/Saturation controls to adjust the amount of saturation in a digital photograph.

SCANNER: These useful hardware peripherals convert text, photographs, or film into digital form by passing a light-emitting element across the original, transforming the analog image into a group of pixels that is ultimately saved as a digital file. There was a time when scanners were so expensive only large advertising agencies and service bureaus could afford them. Now, scanners have a wide range of prices to fit everyone's budget from the casual snapshooter to the aspiring professional. As their prices have dropped, scanners have become an indispensable part of the digital darkroom.

SEEK TIME: The performance of fixed or removable drives is measured by the amount time required for the arm of a direct access storage device to be positioned over the appropriate track.

SELECTION TOOL: The most important tools in any image enhancement program are its selection tools. Most programs offer three types of selection tools: Marquée, Lasso, and Magic Wand. The Marquee is used when you want to make regularly shaped selections. In Photoshop, double-clicking the Marquee tool opens its control palette and lets you choose either a rectangular or elliptical selection shape. The Lasso is a freehand selection tool you use to outline irregularly shaped objects. Mac OS users can create Polygons by pressing and holding the Option key (Windows users: Alt) and clicking on various points around a subject. Photoshop's Select menu offers additional commands to increase the efficiency of the tool used. Grow temporarily doubles the Tolerance range, while Similar selects all other colors that fit within the specified Tolerance.

SERIAL PORT: A jack on a computer's back that connects peripheral devices such as modems and printers. The serial port sends and receives data one bit at a time. Now all but obsolete, having been replaced by the faster Universal Serial Bus (USB).

SERVER: A shared computer on a local area network (or the Internet) that interfaces with a client in the form of Internet software and/or hardware. A server acts as a storehouse for data and may also control e-mail and other services.

SHADOW MASK: A thin screen attached to the back of a color monitor (CRT) screen. The mask has small holes through which an electron beam is aimed onto the phosphor dots that form on-screen images.

SHAREWARE: Shareware is a way of distributing software that lets you try a program for up to 30 days before you're expected to pay for it. The registration fees for shareware are usually quite modest, ranging from five bucks to $100. Freeware is a form of shareware that is just what it sounds like – it's free.

SLOT: Often called bus slots. They accept printed circuit cards that allow accessories or devices to be attached to the motherboard.

SMPTE: Society for Motion Picture and TV Engineers.

SPA: The Software Publishers Association is an industry-sponsored organization that offers a variety of educational materials about the 'do's and don'ts' of copying software. For more information, contact: SPA at: 1730 M Street,

NW, Suite 700, Washington, DC 20036 or call them on 202/452-1600.

STYLUS: A pen-shaped tool that – when used with a graphics tablet – can draw images as well as serve as a mouse substitute.

T

TARGA: TrueVision Advanced Raster Graphics Adapter. A raster graphics file format that was developed by TrueVision, Inc. Targa files are identified by a .TGA file extension and handle 16-, 24- and 32-bit color information.

TERABYTE: One trillion (or ten to the I power) bytes.

THERMAL DYE-TRANSFER: Often called dye-sublimation. A printer whose head heats a dye ribbon and creates a gas that hardens into a deposit on special paper. Like most printers, it prints in the form of 'dots' of colors but because these dye spots are soft-edged (as opposed to the hard edges created by laser and inkjet printers) the result is smooth continuous photographic tones.

THUMBNAIL: This is an old design industry term for 'small sketch'. In the world of digital photography, thumbnails are small, low-resolution versions of your original image. Since they are usually low res, they produce extremely small files. Thumbnail viewer software, such as iView Media Pro (www.iview-multimedia.com), lets you review an entire day's photograph at one time.

TIF, TIFF: Tagged Image File Format is a bitmapped file format developed by Microsoft and Aldus. A TIFF file (.TIF is the extension used in Windows) can be any resolution from black and white up to 24-bit color. TIFFs are supposed to be platform-independent files, so that files that are created on a Mac OS computer can (almost) always be read by a Windows graphics program.

TOGGLE: To alternate back and forth between two choices inside a given software program. A program may allow you to toggle back and forth between an image in color or black and white and similar 'before and after' modes. This switching can be done with keyboard commands or a mouse clicks.

TOOL PALETTE: A collection of on-screen functions (such as Crop, Magic Wand, Paint Bucket) that are grouped together into a single, unified menu structure to allow users easy access to the controls. Most image-enhancement and graphics programs sport tool palettes, but Corel's Painter makes extensive use of interesting looking palettes.

TRIAD: A computer screen is made up of many thousands of pixels which appear in clusters called triads. Each pixel is actually a combination of three colored dots placed close to one another, one each for red, blue, and green. On the screen, combinations of these pixels produce all of the colors that you see.

TWAIN: A hardware/software standard that allows users to access scanners, printers, digital and other computer peripherals from inside software applications. Some pundits have called it 'Technology Without An Interesting Name', but it is not really an acronym. For more information, visit www.twain.org.

U

UNDO: One of the most useful tools, commands and/or features any image enhancement program can have; it lets you go back to the way the image was before you made the last change. Unlike working in a wet darkroom, the Undo command lets you try new techniques without permanently changing an image and encourages exploration and experimentation. Some programs include Undo as a menu item or keyboard command – most often Command-Z (Mac OS) or Ctrl-Z (Microsoft Windows). Some programs have an Undo button on the toolbar. It looks like a left-hand U-turn arrow and clicking that lets you turn around and go back to the way the image was before you made the last change. Some image editing programs have so many levels of Undo that, essentially, allow the user to reconstruct the original image backwards from all of the operations performed since opening the file.

UNINSTALL: The act of removing software from a computer system often facilitated (in a uniquely Catch 22 way) by an uninstall program that's part of the original installation.

UNIX: A multi-user, multi-tasking (doing more than one thing at the same time), multi-platform operating system that was originally developed by Bell Labs for mainframe and mini-computers back in the bad old days of computing. Today UNIX is still alive and well and, in fact, forms the backbone of the Mac OS X operating system, allowing it to use various UNIX and LINUX software.

UNSHARP MASK: A technique included with some image enhancement programs, such as Adobe Photoshop CS, to – get this – sharpen a photograph. The oddly named function is a digital implementation of a traditional darkroom and prepress technique in which a blurred film negative is combined with the film original to highlight the photograph's edges. In digital form, it's a more controllable method for sharpening an digital image than the (boost the contrast only) Sharpen command.

UPS: Uninterruptible Power Source (or Supply) is a battery operated power supply that you connect to your computer and that automatically switches on (if and) when your office or studio power goes off – or drops to an unsustainable voltage level. Most photographers would never go on location without a backup camera body, but what about their computers? Purchasing a UPS may not be as much fun as getting new software or a faster processor, but like a backup camera body, it could save you a lot of time and money.

URL: Universal Resource Locator. The technical term for the location of a home page on the World Wide Web.

UTILITY: This is not your local power company but a small, useful program (often Shareware or Freeware) that enhances your system software or computer's operation. A popular package for both Macintosh and Windows users is Norton's Utilities that provides the ability to resurrect files that have been deleted as well as managing the health and well-being of your hard drives. The utilities a user has installed on their system customize it to be exactly how they want their system to work; your computer can't function without a great collection of utilities.

V

VARIATIONS: The name of a command found in Adobe Photoshop that gives you control over the hue and color intensity of an image. Similar features may be found in other graphics programs under various names. When Variations is selected (Image > Adjustments > Variations), you'll see a large dialog box displaying before and after windows in the upper left hand corner along with ten more thumbnails. The first seven thumbs display the original image in the center, whilst the surrounding pictures show what the image will look like when red, blue, green, yellow, cyan, and magenta are added or subtracted. A Fine to Coarse slider controls the intensity of the color corrections. Experienced darkroom and color lab workers will recognize this dialog box as the digital equivalent of the 'ringaround' method for producing test prints and test strips for color prints.

VECTOR: Images saved in this format are stored as points, lines and mathematical formulae which describe the shapes that make up that image. When vector files are viewed on your computer screen or printed, the formulae are converted into a dot or pixel pattern as bitmapped graphics. Since these pixels are not specified as part of the file itself, the image can be resized without losing any quality. Photographs are not typically saved in this format.

VESA: Video Electronics Standard Association. The organization that sets standards for video devices such as monitors and video circuits.

VGA: Video Graphics Array.

VIRTUAL MEMORY: This is a means of using hard disk space as if it were RAM (Random Access Memory). If you're working with a digital imaging program that requires more RAM than you have installed, the operating system will go to your hard disk and grab the amount of space you need – as if it were RAM – and use it to temporarily store data. In order to work with a file, image editing programs like Adobe Photoshop require memory to be three to five times the size of the image. This means you'll need between 54 and 90MB of RAM to handle an 18MB file. Photoshop uses a built-in virtual memory scheme called a 'scratch disk' that reduces RAM requirements by treating unused hard disk space as additional RAM. In order to use the program's scratch disk feature there should be enough room on your hard disk for other software and Photoshop's virtual memory. The program's Preferences menu lets you specify where the program should go to get this hard disk space, and you can designate primary and secondary disks for use as scratch disks.

If you don't have enough memory or scratch disk space, Adobe Photoshop will give you a 'Not Enough Memory to Complete that Operation' error message, and this often occurs after the program has been working for a while. Fortunately, there's an easy enough way to keep tabs on memory whilst you're working on a graphic image. In the lower left hand corner of any picture's window, Adobe Photoshop displays information showing how much memory that particular image takes. By clicking on these numbers, you have the option of displaying File Sizes or Scratch Sizes. While the File Size information is interesting, I recommend you keep the window set to show Scratch Sizes. That's because the number on the left will tell you how much memory all open windows are using and the number on the right tells you the amount of RAM available. If the first number is larger than the second, the difference is the amount of scratch disk space required.

VLF: Very Low Frequency radiation produced by CRT-based monitors; yet another good reason to switch to a flat screen.

VRAM: Video Random Access Memory.

W

WALLPAPER: A pattern or picture that's used as a screen background on Microsoft Windows or Apple Power Macintosh computers. Mac OS users call this feature 'Desktop Patterns'. Most operating systems include wallpaper patterns, and many third parties offer packages that include screensavers and wallpaper. There are many places to download wallpaper on the Internet too.

WEB CLIENT: A wirehead term for web browser.

WEBSITE: A location on the World Wide Web that contains a home page for a company, organization, or individual. You can consider it a combination of brochure, meeting place, and electronic storefront. It's a place where people and organizations can display information about themselves and visitors can ask questions and sometimes even get answers to them.

WINCHESTER: This original hard disk technology is often called 'Winchester' after IBM's original hard disk design that employed two 30MB platters.

WINDOW: An on-screen, rectangular, scrollable viewing area that is part of a graphical user interface, such as Microsoft Windows or the Mac OS operating system.

WINSOCK: Windows Sockets. A software standard that provides a common interface between TCP/IP and Internet software for computers using Microsoft Windows.

WIREFRAMES: A way of representing three-dimensional shapes in which all surfaces of the object are depicted as lines, including internal components normally hidden from view. When viewed on screen, wireframe objects appear as if they were constructed out of bits of wire or pipe cleaners. This allows graphics programs to manipulate the object faster and more easily than if the image was fully rendered.

WMF: Windows Metafile Format. A vector graphics format designed to be portable from one Windows-based program to another.

WORLD WIDE WEB: An Internet-based client server system that uses hypertext distributed information that was originally developed using a NeXT computer by Tim Berners-Lee at the High Energy Physics Laboratories in Geneva, Switzerland. Seemingly, the WWW contains everything you ever wanted to know about anything, including lots of misinformation as well.

WORM: (1) Write Once Read Many times. A type of optical disk or CD-ROM that can be recorded only once. The CD-ROM version is CD-R (Compact Disc-Recordable).

(2) A form of computer virus that continually duplicates itself over a network, such as the Internet.

WYSIWYG: Pronounced wissy-wig. As Flip Wilson's Geraldine used to say – and it had nothing to do with computers – What You See Is What You Get. This term refers to the ability to view text and graphics on screen the same as they will appear when ultimately printed.

X

XGA: A type of video adapter originally developed by IBM for their PS/2 computers. It outputs a resolution of 1,024 × 768 pixels (more than two and one-half times what's possible with the original VGA) with 16-bit colors allowing it to display 65,000 colors.

XMP: Extensible Metadata Platform. With an XMP-enabled application, such as Adobe Photoshop CS2, information about a project can be captured during creation and embedded within the file and into a content management system. Meaningful descriptions and titles, searchable keywords, and up-to-date author and copyright information can be captured in a format that is easily understood by you as well as software applications, hardware devices, and file formats.

Y

YCC: The color model used by Kodak in its Photo CD process. This involves the translation of data that was originally in RGB form into one part of what scientists call 'luminance' but the rest of us call brightness – this is the Y component – and two parts – the CC – of chrominance or color and hue. This system keeps file size under control while maintaining Photo CD's 'photographic' look.

Z

ZFP: Zero Foot Print. This term is used to describe computer peripherals that take little or no additional desktop space. Often this means they are designed to sit under existing hardware or even the computer itself.

ZIP: (1) Iomega's (www.Iomega.com) Zip removable media drive uses a proprietary combination of Winchester read/write hard drive heads and Bernoulli Box-like flexible disks and produces an average seek time of 29ms. Bundled software for Mac OS and Windows computers includes backup, file cataloging, disk duplication and management utilities that feature read/write disk locking, formatting, diagnostics, and hard drive emulation. Iomega also includes Guest software, which permits temporary use of a Zip drive on OP's ('other people's') computers. (2) Verb. To create a compressed archive (the 'ZIP' file format invented by the late Phil Katz) from one or more other files using PKWare's PKZIP or other compatible archive software. When files are 'unzipped' they are decompressed.

ZOMBIE PROCESS: A UNIX process that has terminated either because it has been killed by a signal or it has called 'exit' and whose parent process has not yet received notification of its termination by executing (some form of the wait) a system call. A zombie process exists solely as a process table entry and consumes no other resources. See also Bela Lugosi.

ZOOM: (1) A tool found in most image enhancement programs and is, most often, depicted by an icon in the shape of a magnifying glass. It's depicted by this icon so often that this tool is sometimes erroneously called 'magnifying glass'. This tool lets you zoom into a photograph by clicking your mouse's button. This is especially useful when viewing a portrait photo in landscape mode. It's usually a good idea to zoom in before rotating it to its proper orientation. Under Windows, which often has two- or even three-button mice, you can zoom in (make a section of the image larger) by clicking the left hand button or (make a section of the image smaller) by clicking the right hand button. (2) A useful tool in Adobe Photoshop that's buried in the Filter > Blur > Radial Blur menu tree and once you get to the dialog box, you have to check 'Zoom' instead of 'Spin' to get the classic 'zoom during exposure' look that can still be accomplished in-camera, albeit with much less predictability. (3) A hardware company that makes inexpensive yet powerful modems.